CHASING

THE

LIGHT

CHASING
THE
LIGHT

SAGAR KUMAR

PARTRIDGE
A Penguin Random House Company

To order additional copies of this book, contact
Partridge India
000 800 10062 62
orders.india@partridgepublishing.com

www.partridgepublishing.com/india

About the Author

Sagar Kumar is from Jamshedpur (Tata Nagar), Jharkhand, where he finished his schooling from Loyola on returning to India from England. Sagar then qualified for and attended Jawaharlal Nehru Medical College, Belgaum (Karnataka). He is currently pursuing an MD in pharmacology in Bhubaneswar, Odisha. He lives on sports and music.

Contents

'To my baby brother Sachin; whom I had the
honor of naming after the greatest sporting
hero our country has ever produced'

Acknowledgments

There are several individuals without whose support you would not be holding this book in your hands.

I would like to start by thanking my parents for always giving me the best life they could and showing me the world.

I would like to thank my cousin Suraj who I was staying with while writing the first draft and who made sure there was hardly a dull moment.

I would like to thank all my friends—Angad, Karan and Arvind in particular—for backing the project, for being in constant touch with me through the writing process, for reading excerpts, for giving valuable constructive criticism but most importantly for ensuring I didn't get too lonely.

I would like to thank my publishers 'Partridge Publications' for always being professional and guiding me through each step. I have to mention here that my editors did a wonderful job with the manuscript and helped me make it better than it originally was.

Lastly, I would like to thank all the people who directly or indirectly have been a part of my life, all the people I have met or talked to and more. Thank you for enriching me with priceless experience and allowing me to observe your absolutely unique and fascinating behavior. This book is as much yours as it is mine …

#1

Boy Prince

I wanted to start this as early as possible. As a medical student 'still not comfortable calling myself a doctor' (too much responsibility), I have some idea of the biology behind childbirth and the scientific dynamics of life to an extent.

The point I want to make is based on scientific facts. The CNS (Cental Nervous System) is differentiated in the embryo quite early at about six weeks and I wonder how that works. Can fetuses lodged in the mother's womb think? Well if Abhimanyu heard his karmic destiny, if science shows results of positive effect of music heard by the pregnant mother on the fetus, then why not?

It was a hot afternoon in Ranchi. I sat outside in the veranda with my maternal grandmother, 'Nani.' I was very young. Yet even at that age there was no doubt in my mind that Nani was by far my most favorite person. We sat there for ages looking out into the garden and Nani was feeding me oranges. The beauty of it was and this is why the memory sticks, she was meticulously peeling the rougher skin of each orange slice to perfection and then

and only then placing the smoother lush interior in my craving mouth. I loved oranges. So Nani and me we did this a lot and she would always have all the time in the world for me. I loved her the best.

I lived in Ranchi when I was very young with my grandparents, Nana and Nani. The reason was that both my parents being doctors and relatively young ones were struggling out there in the real world. They were both in their twenties.

I loved Ranchi. My Nana, also a doctor, was the head of over one thousand doctors working for Coal India and with great responsibility came great power. I was treated like a boy prince. I had everything. My Nana a flamboyant, dynamic and inherently charming personality would imprint in my mind even at that tender age that if I wanted something I would get it. I don't think I got spoilt but that attitude stuck and I was lucky that in the later years my Papa would continue the trend.

Cricket. Most children in India love cricket. Things may have changed now-a-days with the advent of football and other sports in the country. The introduction of this variety is a good thing. However, certainly when I was growing up in the late nineties, cricket was not just a sport. It was religion; and the only religion at that. My Nani was a passionate cricket fan. From as far as I can remember some of my most cherished memories were lying in the bedroom with Nani and watching India play.

This would have a huge impact on my life. My Nani takes full credit for my love for cricket and sports in general and this love would never die. I would live a sports-crazy adolescence. Countless hours watching the game, I was analyzing cricket even before I was confident with my ABC. The best thing with Nani was that she was a knowledgeable fan. She knew the game. Those who know cricket will know there are infinite nuances to the sport, infinite strategic dimensions. It may not always be as intense as other sports but I certainly know it's captivating, a more interesting dynamic chess of sorts.

I tested my Nani once. I was a little older and starting to feel I'm overtaking her cricket acumen. I presumed she may be like a lot of ladies who watch the game but don't understand its intricacies. I asked, 'Nani who is the best fielder in the world?' I expected her to say Ajay Jadeja or Azharuddin thinking she only knows Indian cricket. She replied, 'Johnty Rhodes.' I was impressed and surprised. She caught my expression and said, 'What do you think of your Nani??.' I have respected her cricketing views ever since.

I had a friend called Shweta who lived in the flat above us. We played lots of games, sometimes I even got her to play cricket. But mostly, we would hang out in Nana's clinic when everyone was asleep in the day and play a game called doctor-doctor. It involved alternately undressing each other and examining the other's body in detail. Sometimes I would be a soldier who had been shot in war (read 'in the garden') and needed medical help. One time, Rinku Mausi (my mom's youngest sister)

#2

Till the Echoes Ring Again'

I was almost thirteen when I returned to India after seven years in England. My parents had gone abroad primarily for academic reasons and they had both done well. The money was a bonus. A bonus we thoroughly enjoyed; I was lucky to travel a lot with my parents. My dad always says, 'Traveling is the greatest form of education.' I was young but my mind was very receptive. I soaked in a lot of atmosphere and observed all kinds of people.

Most of my parents' friends in England had been negative about my dad's decision to return to India. I was less skeptical. I had been promised a good school, a good city and most importantly, several sporting opportunities (convinced then that my future was to play cricket for India).

England was a nice country; the people were nice. The greatest gift I got from England however was football, my own skill and ability that I acquired on the lush green outfields playing for limitless hours and intense passion for the sport and Manchester United. At that age though I watched everything; all divisions, all teams and pretty

much all sports. The country allowed that freedom. I can't say that about all of India but certainly Jamshedpur (Tata Nagar) was a good place for holistic development.

It was my first day at Loyola High School, Jamshedpur. I was nervous. There was a long assembly. 'Let us strive to keep the Loyola flag flying high and the country's even higher,' the principal ended. I walked into 8C. The class was bustling with noise and infused with energy. I didn't quite feel the same way. I was nervous.

He was the first person in India to show true attitude to me. Neel. I fuckin loved it. It had been a week or so and most of the kids who had spoken to me were kissing my ass so much about me being from England that frankly it was embarrassing. Sushil Agarwal, Sanam Raj, to name a few; well-intentioned chaps, Sushil intelligent but guys who you can tell are inherently boring within five minutes of meeting them. Neel's 'go fuck yourself! I don't give a shit you're from England' attitude appealed to me on endearing and almost romantic levels. He was decent at football and supported Arsenal. We hated, we fought, we talked, we bonded.

You had to study in India. You had to cram. England was all about projects, assignments, drama classes, daily sports classes. No real pressure. India was different. It was in fact this reason that detractors had placed as number one argument against us returning to India, claiming that I won't be able to cope with the absurd academic pressure. The I.C.S.E 10^{TH} grade board exams were coming up in three years. And though in the longer run they wouldn't

hold much significance; the world was watching. I wasn't really a great student. I wasn't dumb but I hated to study. Things would have to change. Unless of course I made rapid strides on the cricket field and took my wildcard. That didn't happen. Football wasn't that big in India then. I loved the sport and was pretty good at it but playing football professionally in India wasn't really an option. And as far as books were concerned, I eventually learned to hold my own.

I initially struggled through 8^{th} grade on the academic front. My parents spent a lot of time helping me even after their long hours at work.

I played a lot of sports; Cricket, Football, Squash, Badminton. Beldih Club it was called. It was a multifunctional club with a swimming pool, squash courts, pool tables, tennis courts mixed with gardens and art; an associated golf club and restaurants and bars. There were other clubs like this in Jamshedpur. Like my school, Beldih was also just a five-minute walk from home and I spent a lot of time there. Tushit and Aarush were my Beldih club friends so to say. They also went to Loyola and were eighth graders but in different sections. Tushit would go on to become the biggest lady killer in the history of the city. He was a little crude initially but I would learn a lot from him.

It was 3 am. Things were different now. My parents had been successful in igniting interest toward academia in my heart and now I studied for fun. My grades too naturally improved. It was in the 9^{th} grade when I met

a guy called Kaushik, he had been reshuffled into my section. I have met a wide variety of people in my life but Kaushik would rank by far as the most complex and multilayered personality I have known. We would get close but fall apart in later college years. He was weird. Neel always said he was an idiot.

However Kaushik had a huge impact on my academic journey. He raised the bar and made me a better student. It was with him that I first started burning the midnight lamp. Staying up night after night cramming, we would be in telephonic touch throughout and talk every hour or so. There was a third person too; Harsha 'Chulu' he lived in the same street as Kaushik and these conversations through the night would usually be a three-way group call with Chulu and Kaushik. And we would talk about anything and everything.

Kaushik was an intelligent, square-headed bloke but very selfish deep inside beneath all the layers of sophistication. I can't say he was a bad person but he was very gray. I am gray too. Perhaps that's why we bonded so much.

Remo Sir, our sports teacher at Loyola, was a tough ringmaster. Football training was preceded by a gruelling physical workout, warmup exercises and running. Jogging laps, sprinting; we did it all. I wasn't in very good shape physically. I was a natural athlete, flexible and good on the ball but I was slow. In my defense, the high school team had players trying out a good 4 years older than me. Almost everyone on the team was bigger than I was. Four years is a long time at that age and my body wasn't ready.

I made the sixteen but rarely got to play in the 8th grade.
I would have my vengeance.

I had a love-hate relationship with Remo. To his credit,
he was an extremely informative and experienced coach;
a great tactician. His board-work sessions in the sports
room used to be excellent and in depth. He had a solid
understanding of cricket, football and a keen interest in
the sporting world. He was an ex-Loyolean and it was
evident that he had had a good education.

He did have his downsides though. On one occasion, we
were trailing 2-1 in a cup tie with some five minutes to
go. A junior coach who had seen me play suggested that
I was special and asked Remo to put me on. There was
nothing to lose. I was a striker and even Remo knew I
had the potential to create and capitalize. He nodded and
asked me to warm up. I had never been so pumped, my
heartbeat pounding, my thoughts racing. I had to score.
I would score. This would be my debut. I jogged up next
to Remo, expecting him to signal the referee and bring
me on. What he did next shocked me. He looked towards
me and said, 'No, leave it.' I stood there, looking back at
him. He had turned his face. I could feel tears building
up in my eyes. I gathered strength and said, 'Sir, please!
I'll score.' He said, 'No.' It broke my heart. I could not
hold back tears. I hated that prick.

What was worse was that Anish, a batchmate of mine
who would later go on to be one of my closest friends had
seen me cry and he will never forget this nor does he ever
forget to take the piss. Fuck Remo!

Remo's son Bharat studied in the same section as I did and I suppose it was some consolation that he was sat on the bench next to me. But Bharat didn't have one-tenth the ability I had besides he was a defender and we were trailing. Bharat was an insecure person. We sat on the same bench in class for a while and his insecurities, his lack of true inner confidence was reflected clearly in the conversations I had with him. He was a hard worker and money was extremely important to him.

I played for school for the next four years and was the highest goal scorer in each year. Still, I never got the feeling Remo ever liked me. Maybe he was like that. Because I never got the feeling he really liked his son either. He was a nice guy. But if he was Sir Alex, I considered myself no less than David Beckham and I didn't appreciate that metaphorical boot across my face.

#3

Nuclear Family

I must have been around five when I moved permanently from Ranchi to Patna with my parents. They had both completed their post-graduation courses. My father was now a surgeon and my mom a gynaecologist and they worked hard.

I was still an only child. It would be a while before that changed. For now, it was Papa, Mummy and me.

My father worked at the IGIMS hospital in Patna. It had a huge campus and provided residence to staff. There were enough playing fields and free roads to satisfy a young child's fancy. Many doctors stayed close to us with their families. There were several children of all ages some a little younger, some a little older and I had many friends. Cricket, football, kite flying, badminton, riding bicycles- we did it all. Even hide and seek with some twelve to fifteen kids playing in the evening would be exhilarating.

I used to love it when sometimes in the evening the lights in the whole area would go out and there would be no

option for our parents but to allow us to stop studying and go out and play with the other kids. This instinct has weirdly stuck. And even now-a-days when the light cuts out I feel a second or two of instant joy just out of conditioning as a child.

We were playing a very Indian version of cricket, 'gully' cricket, which basically means playing cricket in a tiny lane or driveway. We were right outside my house. It was evening time. My mom was watching and waiting for her cue to see me walk in, smile, and suggest it was study time. I was batting. We needed only a few runs to win and I had played a good knock. I had to take the team home. I got out on the next ball. I was pissed. My mischievous mind thought up an idea. The thing was I always wanted to be part of the game and hence in the later years I would become a wicket-keeper. I asked the guy taking guard after me to give me his 'life' his batting life, and I extended my palm. He said 'No!' I said, 'Let me at least run for you,' having accumulated enough knowledge about the game to know there could be a runner (I am actually unhappy that the ICC discontinued that concept, I thought it made things interesting.) He said 'Okay.'

He took guard. I stood right next to him, ready to run. The ball was delivered ... BAM! All I could see was blood but I felt no pain. My teammate had played a classic hook for four runs but had hooked my head with the bat too and pretty hard. My head was split open, blood everywhere. My mother inevitably crying. My dad was out of town. A neighbour doctor uncle was taking me to the hospital. On my way out, I ran back into the

house. My mom screamed. I looked in the mirror. There was a lot of blood. It looked rather cool and I don't know if it was the adrenaline but again, there was absolutely no pain. I ran out. Mom asked what I had gone inside for. I said, 'Mummy, I wanted to see if I am looking like a hero.' Fuckin Shah Rukh. True story.

It was summer holidays. I was in Ara, the home of my paternal grandparents, Dada and Dadi. I alternated on holiday seasons once in Ranchi, once in Ara. My parents were happy to send me. They thought it was important I spend time with my elders and family in general and they were right.

I loved it in Ara. No one ever told me to study. Again, I had several boys my age happy to play cricket all day. Dadi never said no to me. She was blind but saw more than the average person. I will never forget that perpetual smile on her face as she would open her handkerchief and take out money wrapped inside and hand it over to me. Mostly to replace tennis balls lost in the gutter or hit into the woods. She never said no.

We had a proper joint family in Ara. My father's younger sisters, my uncles and aunties and their sons and daughters all stayed in our Ara home. I was lucky everyone loved me whole-heartedly. I was the first male child of my generation and only Sunayana di had been born before me. My dad was my Dadi's blue eyed baby boy and the whole family loved him so obviously, I being his son, got a lot of warmth and joy.

The whole day would be spent with the boys playing cricket at different locations sometimes on the roof, sometimes in the driveway and other times on the field.

However with sundown I would return home. A big family, Ara had a big house and all types of people. There was hardly ever a dull moment. I would spend a lot of time listening to stories and legends. Chhoti di was my favourite person there. She always made the stories very interesting and helped me with all kinds of self-assigned art projects that I undertook from time to time. Most importantly, she believed me when I said I would play cricket for India. Rauli bua, my father's youngest sister, was also one of my favourites. I was very attached to her. She was like my mom in a lot of ways. She even looked similar but she didn't have the moral responsibility to get me to study and that was good.

I talked to Dadi mostly at night. She was an interesting person and I would love to hear stories of her village, stories about my father when he was young and more. As I grew older I would ask questions about her blindness and she would happily answer. I learnt that she had memorized the exact count of steps and directions to each room in the house. She had done the same when she stayed with us in Patna. Her blindness was a result of glaucoma, a disease process I would read in detail in college. It was a painful condition but my Dadi she never showed it. She was always smiling especially when she heard my voice. Although she was blind there was no doubt that she was the woman of the house, the 'malkini'

or the head. She ran the house and all financial exchanges and she did it well.

I would count down the days of my freedom. And as the school opening date approached; my return to Patna and relative discipline loomed. These were my first encounters with depression. A mood I would explore in great depth in the later years of my life. I cried! I always cried the day I had to leave. The whole house would also be dull and gloomy. My family didn't like to see me leave.

One detail has to be mentioned here. I remember clearly the breathtaking knock Sachin played at Sharjha to help India qualify for the finals. I witnessed this magical innings in Ara on one of my holiday trips. I will never forget that day as I am sure those who saw it like me will understand. Also, the power never got cut that day, the whole day. This was rare for Ara. We got to see the whole innings and infact the whole match without interruptions. I will be eternally grateful that I was so lucky.

#4

The Birth of Philosophy

It was 1995 and it was my parents' dream to get higher degrees in their respective fields. For this, they would have to make the journey to England. It would be an adventurous but tough time for us especially my dad who left a little earlier to give his exams and try to settle down with a place and a job by the time my mom and me reached British shores. As it turned out my mother got a job before my dad. However my dad cleared his FRCS exam and that was a big deal.

We were comfortable in Patna. Both my parents were doing well professionally. My dad was an assistant professor and a young one at that. Yet they would not settle. They had big dreams and aspirations and I learnt that if you wanted to succeed you had to be prepared to take yourself out of your comfort zone and play poker with life of sorts. They had quit their safe jobs and invested a lot of hard-earned money on England. Failure was not an option.

I was not too excited about this move. I would be leaving behind my friends, my 'gully' cricket and at that tender age I really didn't know what to expect.

My father often took me to this video game parlor in Patna. I would play the racing games and love it. One evening on the way back he said, 'You know, Samar, if you come with us to the UK, I will get you a video game like that which can be connected to the TV and you can play it whenever you want.' He told me, 'You won't have to study as much,' and again assured me that there would be a lot of sports. I was sold; and from then on I was excited about England.

My mom and I were on the flight to Manchester, UK. Papa was already in England waiting for us. On the flight, I turned and asked my mom, 'So, Mummy, when is it going to happen?' She was puzzled and asked, 'What? … When will what happen?' I said, 'When will I become white?!?' I had had this dream a few days before that when I reach England I would automatically turn into a white kid. My mom broke out into fits of laughter as I explained my theory and then assured me that I would look exactly the same. 'Well, thank god for that,' I thought.

We were received at Manchester by my father and some family friends. Raman Uncle and Veera Aunty. Uncle had gone to the same med school as my father and they were the closest of friends. Academically too they had made plans together. Uncle had come to England a couple of years before us chasing the same dream.

The cars were faster, the roads cleaner and the people predominantly white. I was still the same. Mommy was right. They took us to their home in Manchester and we

stayed with them over the weekend. I got my first ever gaming console; a 16-bit Sega Mega drive with Sonic the Hedgehog. I was thrilled. They had two children, Piyush and Shreya and we got along well. It was a new place a new country and so even those few days of warm familiarity in Manchester with Piyush and Shreya and their family felt really comforting. Veera Aunty treated me like one of her own children not only during that short stay but whenever we met thereafter and her affection towards me was very genuine. I could pick up on these things from an early age.

We boarded the taxi to Dewsbury. A quiet little town situated in the county of Yorkshire. We arrived late in the evening; it was dark. Our street was called Bronte Close and I remember my father pointing out our house as the taxi did a U-turn.

My mom started working at Dewsbury General Hospital. My father, on the other hand, had just given his exams and had been missing us severely. A man with a tough exterior deep down he was very emotional and sentimental. I hadn't joined school; it was winter holidays. I remember spending a lot of time with my dad in the mornings just playing catch in the relatively empty living room. After, we would take strolls into town maybe get a sandwich or a burger.

Bronte Close was full of children. There were two Indian families on the street one of whom my parents had known from post-grad days and the other we got close to pretty soon. Puja Aunty and K.B Uncle who

had two sons Sunny bhaiya and Abhishek bhaiya; and Soham Uncle and Raj Aunty who had a son called Aashish. There was a girl called Surabhi who lived close by. She was uncannily good at sports so we all liked her. Aashish I felt liked her a little more. Up the street lived a Pakistani family with two sons Ali and Mush and diagonally opposite our house lived an English couple and their son Joe who was a crazy Leeds United fan and a very skilled footballer.

Things weren't that different from India. The only major change for me personally was that in the evenings we played more football than cricket. Life is really that simple when you are a kid. My love affair with sports had just begun and life was good.

Holy Spirit school was my first school in England. I did not know then that it would be the first of many. Now there are a lot of Asians and Africans in the UK and almost all schools have a considerable foreign population. However Holy Spirit was different, this may be hard to believe but in the whole primary school I was the only non-white student. I was seven and I didn't even know what racism meant. I was lucky I was very well received. All my teachers and most fellow students both senior and junior took a liking to me. My class teacher Mrs. Clair, an affectionate lady was a sweetheart. A few years later after leaving I would return to Holy Spirit for a brief while and she would find me and tell me that when she heard I was coming back it was one of the best moments in her life. I was touched and rate that as one of the best compliments I have ever received.

It was reading class and we sat on the carpet waiting for mam to arrive. I remember I was sitting next to a cute little girl called Heidi. We were talking and suddenly I noticed she was staring at my hands and then looking up at me. She held my hand and touched my palm and placed her other hand next to mine. She continued to stroke my palm and said it is so weird that this side of my hand is white like hers and then flipped the hands over and said but the back part of my hand is brown and hers is white. 'Why is it like that?' she asked. I didn't have an answer. I didn't know jack about genetics and evolution back then. However the innocence of these questions and the cryptic curiosity in Heidi's eyes ensured I would never forget this conversation.

No place on earth was more comfortable than under the soft quilt in the winter nights of Dewsbury. The moments of dazed awareness just before you fell asleep and the time your dad let you snooze in the mornings were pure bliss and perhaps one of the most relaxing feelings I was fortunate to have.

It was around this time I started thinking about the basic aspects of philosophy without even knowing the term. I started thinking, for once not just about cricket. An insightful hobby yet this would prove a costly pastime in years to come.

It started in Dewsbury. I could not sleep at night. I would stay up for hours and hours just thinking. Some nights up to 3-4 am, some nights till sunrise. The simplest, most basic questions of life somehow took birth

or were seeded in my mind space and refused to leave. Wondering about the origins of life. Wondering about death and the possibility of an after-life. Wondering why we were here in the first place, if there was any greater purpose. Queries about time and elemental astronomy crept into my mind. Whether we were alone in the universe. Was there a beginning of time? How could life, the existence of consciousness, be so random? I thought about religions and the holy men of the years. When and how did it all begin? What happened before that? If the universe is defined as everything then what is beyond that? I had many doubts and questions. Some nights I would almost cry out of frustration because it was painfully obvious I wasn't getting anywhere. I would try to block these thoughts out but usually I was unsuccessful. My mind developed a perversion and started to love torturing itself.

Dewsbury saw the birth of philosophy and also the birth of an alter ego which would flourish with time and become a permanent aspect of my personality. There was a lot of collateral damage and in both cases I would suffer. I guess it would be wrong to say I didn't make any strides however it was very little compared to the hours I dedicated in the search for an answer.

I spent a lot of time with Aashish. The idea was that my English vocab would improve with him as he didn't know a word of Hindi. I was obviously not the most confident speaker of English back then. Hardly anyone in India spoke in English. The little I did know was all thanks to Tony Greig's and Geoffery Boycott's cricket commentary.

A couple of months later, Aashish had picked up Hindi very well and had even started using basic Hindi swear words. My English however hadn't made great progress.

It was not a big deal. I would pick up the language very quickly in school. And with a lot of help from the British TV network, in a matter of months I spoke just like any other kid from Yorkshire. I learnt how to speak in a particular way. Ask anyone in England and they will tell you the Yorkshire accent is one of the weirdest and toughest to grasp. I loved it and spoke it at will. With my parents and other Indian families I would still speak without an accent so I didn't seem like a dork. This skill I would maintain in the future too.

That time with Aashish and in fact the whole year or so we stayed in Dewsbury was beneficial to me because I learnt a lot of football from him. Initially being a typical toe poker from India, Aashish showed me how to use the inside of the foot for control and finesse and how to hit through the ball with your laces. Invaluable tips that were crucial to the development of my game. We would spend hours in the back garden; playing penalties or trying to get the ball to curl, buying skill books and practicing all moves religiously. Attempting over and over to master the bicycle-kick. We would play one on one football in my living room. He would always win but I didn't mind. I knew I was improving. Boris Becker couldn't have said it any better when he said, 'I like to win. I don't like to lose. But most of all, I love to play.' This quote would apply to my life and my special kind of love for sports in general.

'... And Beckham saw Sullivan of his line,' Martin Tyler's voice still echoes in my head. It really was quite a spectacular strike and from behind the halfway line. This was David Beckham's explosive entry on the world footballing stage. I was already a keen football fan. It wasn't simple like cricket where I just had to support my country, deciding which premiere league team you are going to support is a big thing, a decision that will stick for life. Aashish supported Manchester United and so did most of my friends from school. Joe, who would play football with us in the evenings supported Leeds United, a Yorkshire team whose home ground Elland Road was just a half an hour drive away from us.

I suppose you could argue that I should have supported my home team but Man-United were going through their golden era. Gifted players with almost limitless calibre; young and mostly from the youth ranks were taking birth. The likes of Ryan Giggs, David Beckham, Paul Scholes, Roy Keane, Cantona and a mercurial Peter Schmeichel (in my opinion the greatest keeper of all time.) I loved watching them play and decided to support them. A few months later I would buy my first of many Manchester United jerseys and wear it with just as much a sense of honour as a United player walking out on the Theatre of Dreams.

Scotty was probably my first friend at school. A small sweet fella' with a big heart, he and I hung out together most of the time. We did group assignments and projects together and really enjoyed each other's company. I wouldn't call it racism but the one incident of rude

behaviour I did face in the playground as a senior wouldn't let me play, Scott was right by my side. He held my hand and requested I just walk away.

It was Euro-96 and Paul 'Gazza' Gascoigne had scored one of the goals of the tournament. England was loaded with football fever and even more so because they were hosting the tournament. Countless magazines and merchandise were on sale. England played well; however they lost to archrivals Germany in a knockout game on penalties and the country went into depression.

#5

Oh, Heisenberg!

By the ninth grade I had become close to a guy called Shikhar. He was Neel's cousin and was one year below us in school. We used to talk a lot during the nights. We bonded on a bunch of stuff; movies, music, football (like Neel, he was a passionate Arsenal fan) and talking about chicks.

This was just foreplay. We got into the real stuff a while later when we started talking about Science, God and philosophy. The questions I had somehow managed to shut out in a Pandora's box of my mind resurfaced, though at least now, I wasn't alone. It would not be an exaggeration to say that we have spent many nights sometimes all night talking about these topics.

I will always be thankful to him for forcing me to listen to and fall in love with Metallica. He was highly interested in astrophysics and was quite knowledgeable. We hadn't even got to Newton's laws yet in school and here we were discussing black holes and quantum physics. We talked about Heisenberg's uncertainty principle. He would introduce me to a book called A Brief History of Time

written by Stephen Hawking and that would change my life.

We were both huge Eminem fans. We heard and discussed everything, dissected all lyrics. We were real close. There were a few more like us none more important to me than my batch mate Akshit; an exceptional drummer; Akshit had a huge house and most night overs, pizza parties and movie marathons used to take place there. Neel, Shikhar and I were on the A-list. Akshit was also well-known in Jamshedpur for having the most diverse collection of porn. Personally, I had lost interest in pornography after a couple of years in England where the Internet had come earlier. Besides, the idea of a group of guys watching that stuff together never appealed to me.

A musical family; Akshit's father was a great singer and could play pretty much all instruments. His elder brother Ramit was an ace guitarist. Akshit on drums and Aunty would join in with a shaking hand instrument of sorts and the whole family would jam. Uncle always asked us to join in. Neel was a good singer.

I suppose Akshit's family description would be incomplete without mention of their beloved dog Brownie. She was a vicious Doberman; loud and scary. Not much of a dog person myself I never felt totally comfortable with her around. However, all my friends loved her and she would often curl up next to us when we went to sleep. She was a good dog and once she knew us well she didn't bark that much. I too started feeling more at ease in her company and slowly she became part of the gang.

After exams we would stay over at Akshit's place sometimes for three to four days at a stretch. Akshit used to drive and after several nights of hardly any sleep when we woke on lazy 'non-alcohol' hung-over mornings we would go out into town for a masala cold drink.

Akshit was crazy. Some nights he would just storm of into the music room in the middle of the night and explode onto his drum set. He would play the craziest of beats and it almost used to seem like he was in a different zone. This would continue for some twenty to thirty minutes and afterwards he looked so peaceful. It was like he was high or something.

Most kids in India took private coaching lessons after school for a few hours to help with certain subjects. I had perhaps the best high school science tuition teacher in Jamshedpur. His name was Mukesh Sir. He was just starting out then and I was one of his first few students. His reputation along with his fees escalated rapidly in the coming decade or so. He was a very efficient teacher and also a very nice man. I liked his approach to imparting education which was concept based. He never lost patience nor did he ever lose his cool. I got very close to him and he soon became more of a friend.

I obviously had to take Hindi classes. After seven years in England, I had forgotten just about everything. I didn't know how to read or write the language. I was okay verbally because even in England my parents always spoke in Hindi at home so I never really forgot how to

speak or understand. I took Hindi tuition from Santosh Sir; a young handsome man; he was Mukesh Sir's friend and an able enough teacher. The boards were coming up and at the very least I had to pass in Hindi.

I was doing well in most subjects but I didn't understand computers. Our computer teacher at school was way below average and I needed help. It was important I understand the basic crux and logic of programming. After that, the subject was a cake walk. Kiran was a classmate of mine and his mom was the best computer teacher in town. Her classes were a lot of fun. Usually, at absurd times like 5:00 am, I knew if I wanted to attend class just like football practice I would have to stay up all night. I wasn't very good at waking up early in the morning actually I was abysmal and that has never changed. I even found a term for this condition. It's called 'dysania'. Computer classes also provided an opportunity to interact and socialize with other girls our age from different schools of the city. Basic flirting tactics, exchanging numbers, hanging out and parties were all a part of the tuition experience. Loyola till the tenth grade was an all-boys school. It was around this time that I began to get close to Kiran and another guy called Bhanu.

Kiran had a beautiful home. Jamshedpur is a small town and my house was centrally located. Kiran's house was just a ten-minute walk. We would play football in his garden for ages mostly after tuitions. A small pond on one side was the goal. I have seen some hilarious falls into that pool. Tushit also came for tuitions and he would also

play. Bhanu, Neel, Shikhar and a few other guys would come too even if they didn't come for classes; and it used to be a lot of fun.

A lot of this footballing crowd would be invited over to Akshit's house for night overs. They were a clever interesting bunch and we talked a lot of sci-fi. Shikhar would get us started on the G.U.T (grand unified theory) or the T.O.E (theory of everything) and their possible existence. He claimed it is the next big thing, a concept where scientists try to link modern theories into a single equation that combines gravity, magnetism, thermodynamics and more. In search of a way to connect astrophysics and quantum physics. Sure, most of this was above our grasp then and probably still is now but that didn't stop us from exploring our minds and trying to understand.

I didn't plan on this but my friend circles got demarcated. There were these guys who were cool, smart and funny but they didn't really study much. I hung out with them (just them) usually after exams. The other group mainly revolving around Kaushik helped me concentrate more on my books and get better marks.

Jenny Aunty was our neighbour. She was an English teacher and a very good one at that. She taught at Loyola; she taught the eleventh and twelfth grade and was also pursuing a PhD in English literature. Her son Puneet, a grade below me in school, was a good friend. We would often play one-on-one cricket in the evenings either in his or my garden, rules bent obviously to suit the playing

area. He was a competitive individual, we kept scores, and the last I remember I led 217-214. He was a good sportsman and someone who I felt would have thrived more in a place like England because in India people easily got to him.

Exam times were unbelievably hectic. We had a weird system in which all exams ended in one week with no breaks. Apart from a single-paper Wednesday, we would have two papers each day. Combinations like history and biology or physics and geography would drain the heart and soul the night before. The only good thing was that the exams would end quickly. During these exam weeks Puneet and I would often hang out in evening breaks and a lot of the times cycle around to get some fresh air. It would be in medical college when I would next feel this kind of pressure.

Probably shading Neel as the funniest guy I had met till then I instinctively became close friends with a guy called Imran. Imo. His story was a little unusual. He was a Punjabi Sikh named Imran. The explanation was that his father, an ardent sports enthusiast, was a crazy Imran Khan fan in the days. A dashing, flamboyant, charismatic Pakistani captain who had won them the World Cup; naming your son after the legend could be understood. However the fact he was Pakistani and the name very Muslim would have put most people off. I loved it. Imran was super funny and very talented. He specialized in all sorts of humour; slapstick, situational, guy jokes. He was even good with Santa Banta. My mom would not need to ask me who I am

on the phone with to know it was Imran, the minute she saw me giggling away uncontrollably, she would say, 'You're talking to Imran, aren't you?' She was right most of the time.

Imran was a very decent student and I remember usually scored the class highest in biology. I would often be in second place and since my interest in biology and medicine was growing with each day this was one more reason we bonded. I mean it was no mean feat. We had fiercely competitive students in the class mostly spoon-fed Bengali children putting in unbelievable hours even at that young age.

However biology or math for that matter was not Imran's area of interest. He was very passionate about wanting to be a fighter pilot. His room was full of model crafts. His hard disk had videos and information about the academy. He took all kinds of precautions. There was a screen placed in front of his computer to protect his eyesight. Even the way he read was scientific so as to put minimal strain on his eyes. 6/6 vision was important to him like no one else.

There were roughly two months left for the I.C.S.E tenth-grade board exams. The pre board papers were over and I had done reasonably well but there was still a long way to go. 90% was the benchmark in India then; anything even remotely less than that would be considered a failure. The school closed for a pre board study break.

I started putting in the tough hours. Passionately motivated 'drunk in the wine of my youth' I started pushing my limits. 8-10 hours of core cramming mixed with a couple of hours of solving past papers and model test papers became a daily routine. I really didn't leave any stone unturned. The phone conversations into the night continued. Kaushik, Chulu, Aarush, Tushit, Imo … everyone was striving in their own ways, some more than others but still it was evident that whatever people said these exams were important to all. They were the first real exams a student faces. For the first time the city would want to know what percentage we scored and whether we liked it or not we would be judged. In my case there was international interest too. If I screwed up, our friends abroad would get a chance to say, 'I told you so.'

… It had almost been ten minutes into the paper ... All I could see in front of me were lines that had been crossed out with 'Please omit' splashed everywhere. English language was the first paper of the ICSE exams and the nerves had most certainly gotten to me. I was supposed to be writing an essay and by my calculations had to finish the piece in forty-five minutes at the most. I struggled through and finally finished by fifty-seven. I had written about a boy called Raheem and about attempted suicide. The hour or so build up before we had walked in had been indescribable. I had never felt nervous energy like that before. For the first time in our lives we were armed with exam admit cards (a pattern that would unfortunately repeat itself a few too many times in the future) …

I was doing pretty decent. We had decided that we would not discuss the paper after each exam but that was almost impossible to stick by. The science papers had finished and I had done well. Physics had been a little tricky.

We had a two-day break before history-civics and geography which were on successive days. History was one of my strong subjects and I remember completing two out of the three sections by the eve of the exam when I started to feel a little nauseous and heavy. I figured it must be a tummy upset and decided to go to bed early. I planned to get up around 4 am and finish the last remaining section on world history. I fell asleep.

I woke up at around 2 am in excruciating pain and discomfort. I started puking yellow watery fluid all over the floor. There was no relief and my abdomen hurt like crazy. I must have thrown up at least ten to twelve times by the time I got some respite. I walked over gingerly to my parents room woke my mom up and called her over to see the mess I had created.

I was rushed to the hospital and given three rather large bore injections. I think it was to alleviate the pain and maybe sedate me a little. They still hadn't come to a diagnosis. I was still in severe pain and I went to sleep on Mummy's lap. She woke me up at around 'noon'; an hour or so before the exam. Someone who normally underlined and re-underlined the text I somehow managed to get through a few chapters like reading a novel. To be fair to myself I knew most of these chapters inside out and this

final revision was for psychological confidence more than anything else. However, I did not know this then.

I sat through the whole three hours, hardly moving an inch. Whenever I moved even a little my abdomen hurt. I found the paper easy and direct. My mom was waiting for me by the school gate as I strolled out the exam hall and I was taken straight to the hospital where I was put on IV drips and loaded up on pain-killers. I was admitted there for a few days and I gave the next few board exams traveling to and fro from the hospital.

I entered the school with an IV plug inserted above my wrist and with stains of blood on my forearm. To add to that, my hair had grown really long. I was getting a lot of attention. Bhanu walked up to me before the geography paper, looked at my wrists, and said, 'So history was really that bad huh?' My mom and I both smiled.

It was an acute attack of appendicitis. My appendix, a vestigial organ, had become inflamed and dilated. The risk was that if it ruptured the inflammation would spread to the rest of the GIT (gastrointestinal tract) and a simple curative half-hour appendix operation would not be enough and a more dangerous and strenuous almost four-hour exploratory cum curative surgery of the abdomen would have to be done. My dad, himself a GI surgeon, was well equipped to make the call. If I underwent surgery I would have to miss a few exams and that would mean I would have to repeat the year.

They wanted me to give the exams. They knew I had worked really hard. Plus, I didn't want to be separated from my friends. They decided to try and control the disease on drugs and we were lucky it worked. There would be another attack of appendicitis months later and I would get operated. However the drugs gave us a solid window period and I was better and discharged towards the last few papers.

I had given all the papers and in my opinion had done well. I calculated my marks; some straightforward like numericals and some based on hypothetical presumptions. I was expecting 88 percent with an outside shot at 90.

Imran called me on the eve of the day of the declaration of results. We were both obviously shit scared. We decided he would come over to my house stay the night and we would check the results together the next day. As it turned out quite a few people turned up at my place when it was crunch time.

Two hours to go, one hour to go ... we counted down. Imran and I had become fixated on a song by The Rasmus called 'In the Shadows' and we played it almost non-stop. 'The Final Countdown' was another song that was being played often.

Apart from Imran and me, we had been joined by Varun, Jevin 'Sardar' and Vikram. I did not know then I would be spending a lot of time with these three guys in the coming few years.

Imran said, 'Hit the refresh button!!' I had gone numb by this time.

Roll number —

I entered mine. I remembered it better than my birth date. I still do.

 T/1532/078

ENTER

The next five minutes or so would be a crucial time period for all my life. I had the calculator app open. I had given six subjects and the percentage would be calculated on the average of English + best 4. So English was compulsory and besides that you could effectively screw up in one subject without it affecting your percentage. For me, I knew that subject had to be Hindi;

Samar Kumar

 English – 94
 Hindi – 72
 Science (phy, chem, bio) - 94
 Maths - 88
 History-civics Geography - 94
 Computers – 80

I was really too shocked to register much. People were screaming, laughing; I zoned out. After a while, I saw my result again and it seemed pretty decent. Computers

stood out as the major disappointment. I had never scored less than 90 in computers in all the school exams that year and my paper had gone okay. Hindi 72!! For fuck's sake, I wasn't expecting that much! As it turned out many of my friends who had been struggling with Hindi for thirteen years or so got less marks than me and I had only really studied Hindi for three years.

I started entering my numbers on the calculator. Sardar was thinking something- all five feet one inch of him, he had this look when something was going on in his head. We knew it was going to be close, the 90 mark I mean. By the time I got to my third subject Sardar started jumping and screaming, 'It's 90! ... It's 90!! ...' I tried not to pay attention but I felt kind of good. 4+4+4-2-10 he argued. A few seconds later, the calculator proved him right.

That moment, it felt better than ecstasy.

This may sound a little 'sad' but this result, this 90% and the way it happened easily qualified as one of the best moments of my life. Not to mention the fact that I was actually admitted in the hospital through the exams. I ran to Mom screaming out the lyrics of some lame song dancing and hysterical. She had to go to the computer and check again to be sure. My dad, who was in England at that time was talking to me on the phone and sounded happier than I had ever heard him.

Meanwhile in my room my friends were facing the heat. I was exceptionally lucky; a spiritual-esque 'agonist' at most times, even I had to thank God. 90.0. The perfect score!

Varun and Imran both were around the 87 mark. Aarush and Bharat 89.8. ... Ouch! I would have been depressed for months if I had gotten that score. Chulu was the only friend who had had a shocker, an emotional person, I knew more than anyone else that these marks though eventually irrelevant would haunt him for long. Kaushik got 94.4; the school was topped by a guy called Ravi who toppled the 95 mark. I was fifth on that list. The whole school had received terrible marks in computers and the papers I am sure had been sent to a dodgy center. However, I could not be too critical. I was over the moon.

I'll tell you something I haven't told many people. On the eve of the geography exam I was lying motionless in the hospital bed. I couldn't revise a single word. My dad sat with me for hours and never budged. I had instructed him to just read through each chapter and I would listen. That night I was feeling low and miserable. My confidence was shattered. I had somehow managed to salvage history but I was hardly prepared for geography I thought. For the first time in my life I closed my eyes and went into serious meditation. I wasn't thinking about God or faith. I was simply talking to my body for the next ten minutes or so. I spoke to my immune system. I spoke to all my cells my RBCs my WBCs my organs even my appendix. I said, 'Look, guys, I have never been admitted in a fuckin hospital before. I have never worked so fuckin hard for anything before. Staying up all those nights, laughing through mental and physical exhaustion.' I spoke to my mind and I demanded we pull together and fight this condition. I demanded time and pain relief. I even spoke to the drugs I had taken and with my body I requested

we pull this off. After this, I closed my eyes and went into comfortable and positive sleep.

Mukesh and Santosh Sir were getting new shirts from England. It was party time. I called my dad still in the UK and asked, 'Papa, I want to try something.' He said, 'You can do anything!' I dyed my hair blue!!!

#6

Mama Said

Holy Spirit, Dewsbury was mostly about football. Tommy, Banksy, Richard, Euwen, Gazza and many more including me; our whole lives revolved around football.

A few of the guys used to bring United jerseys and wear them during breaks when we played. Some would leave the jersey on in class too. One particular afternoon we had a teacher called Mrs. Bruce teaching us math. She noticed the guys at the back of the class wearing jerseys and it was one of the very few times I saw a teacher in England lose it. She got them to change immediately. The sweet old lady was trembling with anger.

What happened next though I was not expecting. Shy and obedient at that age, not to mention the discipline that had been grilled into me in India, I had made quite an impression on Mrs. Bruce. She went into a soliloquy of sorts for the next twenty minutes and talked just about me, how my behaviour, the fact I always asked for permission and my discipline in class was exemplary and should be followed by all. I usually did not mind compliments at all however I was used to them being

about cricket or football. So much adulation thrown at me in front of the whole class for being a 'good' boy!! sheesh!! I understood one fact then and there that it totally didn't feel 'cool' being good. I made a mental note to try and avoid such situations. I wasn't going to be a badass but being 'good' was definitely boring. The class ended and I ran out to get some much needed fresh air. One of my friends who ran out behind me and had seen me gasping yelled, 'You feeling suffocated, Samar?' I screamed back, 'You can say that again!'

Sunny bhaiya and his elder brother Abhishek bhaiya along with Aashish, Joe and me went through a phase where we watched a lot of Bruce Lee movies. Fist of Fury, Enter the Dragon, Return of the Dragon and more. We watched a bunch of flicks. We would rent the videos from the local Blockbusters pretty much every week.

One time, Aashish purchased an expensive remote-controlled car that hit speeds touching 60 miles per hour. Well, it wasn't ready-made. We just had the parts. It was Abhishek bhaiya who did most of the work, reading the manual and putting it together. We all helped doing whatever we were asked to do, placing the stickers and so on. Once finished though it was awesome. We made obstacle courses and took turns controlling the car, competing over time trials.

Apart from evening football and a few times I got the crew to play cricket we also did other things. Aashish, Joe, Ali, Mush and I spent a lot of time climbing down most of the trees on the street. There were several apple

trees and it's a whole different kind of joy eating fruits from a tree that you have scaled and plucked. We also found a couple of trees where we could make personal tree houses and hung out in them for long periods.

My father had started working in a place called Scunthorpe. The good thing about England was that being a small country, most places, be it the workplace or the homes of family and friends would usually be in a one-hour radius.

One evening on the way back from work a little earlier than usual my dad saw me atop one of the many apple trees in the compound. I saw him see me. I knew I was doomed. I got roasted and lectured about the lack of safety and how dangerous this was. Maybe I'll see it his way someday but for me a childhood without climbing trees is incomplete.

By now it had become norm to have get-together parties at one family's house every week. Often, it would be a Bronte close affair. Sometimes Piyush and Shreya's family also came and other times we went to their place.

It was around this time that my uncle Randhir mausa and aunt Minu mausi came to England. Minu mausi was my mum's younger sister. Mausa and Mausi, both doctors, had also made their way to the UK in the quest for academic excellence. They had two sons, Manu and Yash, both of whom I was very close to.

Intelligent, hardworking and dedicated they did not take long to clear their respective exams.

Randhir Mausa had prepared for his exams in our Dewsbury home. While my parents would be at work it was me who spent the most time with Mausa. The most interesting thing about him at that point was no doubt the fact that his elder brother had represented India in archery at the Olympics. Sanjeev mausa was an Arjuna awardee, a hero.

Randhir mausa was a highly efficient and clinical student. I can't recall a single occasion when he looked under any kind of stress. He cleared in a single attempt the pediatrics fellowship exam that Soham Uncle, Aashish's father, had taken over five attempts to pass. I don't mean any disrespect to Soham Uncle who was probably the nicest of my father's friends.

Minu mausi too cleared her fellowship exam and started practising OBG like my mother. Mausa and Mausi settled in a quiet town called Doncaster which again was only an hour drive away from us. We met almost every weekend and with time the families got very close.

One of the many things I really liked about England was that each town had at least one or more sports centers. These were recreational hubs with a swimming pool, tennis courts, badminton, squash, T.T and more. We got to use these facilities at minimal costs and they also conducted training courses in the holiday seasons. I played all kinds of sports and got my dad to enrol me in most of the courses.

It was clear that England as a country was very serious about its sports and they did everything possible to

encourage a healthy sporting culture. This trend would continue in all the places and schools I went to in the UK. We moved a lot but this general attitude never changed. Even the not-so-rich schools I went to in England, the principal or some staff would go out of his way for no extra gain to organize sports activities and have school teams. As for the rich private schools I went to, well, they were in a class of their own. I doubt even the BCCI treats our players like us little boys were treated if we made the school team.

While almost all of India fixated about IIT and just IIT; in England, we were explained that there is no greater honour than winning an Olympic medal for your country or an Ashes series. Just out of interest, I lived in England during a time when Australia dominated embarrassingly easily the Ashes and to be honest world cricket.

We had lived in Dewsbury for about a year. It was time to move. We had gotten close to our neighbours especially the two Indian families. I remember the evening we were leaving; almost everyone was in tears.

We moved to a place called Hull. Hessle to be more precise. We moved into a picturesque little flat situated on the bank of a huge river. My mom had decided to take the place based mainly on how lovely the view was from the kitchen and living room.

Our neighbours were young rich British couples who partied hard and had flashy cars. Porsches, Lexuses, Ferraris and more; we saw them all and they would often

be parked in the enclave. Hessle was perhaps the first place I was living where I didn't have any friends close by. This colossally sucked! I ate too much chocolate. I got fat.

I joined a school called Hymers College. It was my first private school. Although all schools in England maintained a decent standard, private schools were different. They took hefty fees. However they used this money for development of school facilities unlike some Indian colleges. These schools concentrated a little more on academia, mostly dynamic holistic academia. This was no doubt an important reason my parents enrolled me at Hymers. On the other hand, I was happy too because private schools had an impressive sports infrastructure. It was like a requirement or something. Hymers had countless well maintained rugby, cricket and football fields not to mention a swimming pool, multi-purpose indoor and outdoor courts and acres of land for cross-country running.

We enjoyed our Hessle flat as much as we could. Friends were invited on weekends; and sometimes we would take sheets, a barbeque oven and some beers for the big boys to the bank of the river and have a very Indian picnic.

The flat, though pretty, was rather small and it was quite a way away from the hospital and my school. To be honest after a few months Hessle had become depressing. Yes, there was a beach of sorts but the water used to be so cold and winds so chilled we hardly got to enjoy the environment. My parents decided to take the hospital

accommodation which was more conveniently located and near town.

Mr. Bryan who was the principal at Hymers was also my class teacher.

When my mother is angry it does not matter who is standing in front of her. I had had to give a test to qualify for Hymers. Basic Maths and English. I had done well in Math but my English still needed to improve. Mr. Bryan was making this point to my parents while I was told to wait outside. My dad later told me that first my mom's eyes became teary. Fiercely protective about her child, she went into a counterattack and blasted poor Mr. Bryan. Her point was that it was unfair to judge an eight-year old on a language he was new to. My mom went on and challenged Mr. Bryan to learn Hindi. Taken aback and surprised, Mr. Bryan waved the white flag and said he would let us know on the phone in a week or so if I had made it.

It was a good job that I had because I had already begun fantasizing about the various football fields I saw on campus.

It was my first games period at Hymers. The batch had been divided into three groups based on ability. We were playing football. Mr. Gilbertson, our sports teacher, asked me to start in group 2. After less than five minutes I had made an impression and was moved to group 1. Out of the five-day week we had triple period games on three

days and the other two days we had double period P.E (physical education). Life was good.

Sports in England was considered just as important as academics, if not more. This was, for me, the best thing about the country. In school they had a proper planned out approach to physical education. Kids were graded on athletic ability and whether they were improving. It wasn't like how it is in India where a group of 40 kids are simply thrown a ball in the mid-day heat and expected to run around for one period every week. Yes the school teams got special attention but the whole batch was worked rigorously during those periods. Games lesson didn't mean you could fool around or relax. It was serious business. If you ran a cross-country taking more time than what was expected of you (they had different targets for each student) you would have to run it again and you would have to improve. They had a proper sports department and several specialized coaches. They knew their shit.

There was a cute girl in my class called Alice and from what I can remember; she was my first real crush. Well, after the Swiss tennis star Martina Hingis of course. Alice and I were friends but I never told her how I felt. I guess I was not confident and though everyone treated me well the fact I was not white was definitely a factor, more for me than anyone else. Meanwhile another friend of mine, Matthew, who felt the same way about Alice gave her a card on Valentine's Day. Matthew, one of those genuine, nice people wasn't really a looker. He was the first guy at Hymers to invite me to his birthday party. It

had meant a lot. It meant acceptance. Matthew was short, fat and cock eyed. This did not matter. Alice really was a sweetheart and she did not judge people based on looks. She knew Matthew had a good soul, so she said yes to him and they started dating. Baby love.

I stayed in touch with Matthew for years even after leaving Hymers. It is a shame this was before the advent of social media and unfortunately I eventually lost contact.

Mr. Bryan was a die-hard Liverpool fan. He was also a season ticket holder at Anfield. This meant he could go and watch all games Liverpool played at home, every season!! This ticket could be passed on through generations. Mr. Bryan himself was a third-generation holder. It is not something that is easy to get.

One day, Mr. Bryan walked in to take English but soon forgot about the class. He spent two whole periods explaining the u-15 Yorkshire Rugby trials that had taken place the day before. He described each stage of elimination in detail. Four Hymers students had made it to the last stages. Unfortunately one out of the four got left out. This was a matter of great pride for the school. Towards the end, Mr. Bryan told us that one of the three kids who had been selected was his son.

He was like that Mr. Bryan; intensely passionate about sports and music. He would also spend a lot of time telling the class about his favourite musicians and show us concert tickets whenever he went.

I played cricket and football for Hymers. Rugby was pretty much the only sport I didn't really like and was not that good at. In cricket, the sports faculty recognized me as a special talent and I played for the school team two grades higher than me (most kids from India can play decent cricket).

Time flew by fast and before I knew it, it was time to move places again.

School was closing for summer holidays on my last day at Hymers. There was a special assembly. Towards the end, Mr. Bryan casually asked, 'So will any of you be leaving us after this term?' I stood up. To my surprise many other students stood up with me. Mr. Bryan looked perplexed. He asked, 'You, Greg, where are you going?' The kid replied, 'Switzerland, for a couple of weeks, sir.' Mr. Bryan smiled and said, 'No! I mean anyone 'leaving' school.'

Everyone sat down. I was the only one standing. Still shy, I felt odd. He went on to speak about me and said that it had been a pleasure having me at Hymers and wished me all the best for the future. It was a heartwarming gesture and I could not help but feel a little emotional. I did not know then that I would meet Mr. Bryan again but that was a while away.

#7

I Want to Break Free

We moved to a place called Barnsley. Barnsley was a town situated in the heart of Yorkshire. A robust town with lots of energy. The majority of the public supported the local football team Barnsley FC and were dedicated loyal supporters. Barnsley had been doing well and at that time were a strong premiere league team.

Cricket too was well followed. One of England's favourite sons and certainly one of my heroes, Darren Gough, hailed from this town. In fact, Gough's mother was a midwife at the hospital and worked with my mom.

After a brief lull at Hull where I was pretty much alone I was lucky to move to a street filled with kids. There were two Egyptian families on the street one with three boys Taz, Izat and Karim; the other with two boys, Raider and Rami. There was a Pakistani family with two boys, Muhammed and Mehmood. One other Indian family with a son called Mayank. A couple of guys called Kenneth and Twigie who both lived close by would also come down in the evenings. Like in India where most kids can play good cricket, the same holds for soccer in England.

It was summer holidays when we moved into 23 Helensburgh Close, Barnsley. I remember knocking on the door of our neighbours hoping like hell that someone around my age opened the door. Mayank had greeted me.

He introduced me to the rest of the crew later that evening. Everyone seemed nice enough and they seemed happy too as now they had one more player.

It was holiday season. Mom and Dad would leave for work early and not return till late in the evening. The guys and me; we literally played footy all day. We played in the mornings, we played in the day, we played till dark. We played hard. We played till our legs hurt, till our socks got stuck to our feet. And then, we played some more.

My mom was bemused as I had picked up a peculiar habit from some American football movie; cutting my socks off my feet in the bubble bath instead of taking them off after hours and hours of game. After a couple of weeks I had to buy new pairs of socks with a strict warning not to destroy them.

Summer vacations in England are very different. The sheer length of the holidays makes it stand out, roughly two and a half months. This can seem like a very, very long time. Yes I had friends and yes we played all day, every day. Even so, sometimes it can get a little boring. I watched a lot of movies. There are certain flicks that have heavily influenced me as a person, none more so than The Matrix. I watched this movie more than thirty times

during these holidays. I even made a website on it. One evening just to show off I played the movie for my mom and put the volume on mute. I began saying the dialogues for each character for each scene. I kept this up for a good five minutes before she told me to stop. I could have done the whole movie. My mom had a mixed expression on her face and it may have been the first time she thought her son was a little crazy.

A little older and a little wiser but I still had no definite answers to the questions my mind thought up at night. Nor had I been successful in locking up these questions. They still tortured me. However, amid all this thinking, I did come up with a quote I still remember today 'Life is a dream and when you die you wake up.'

As for The Matrix, I mean even if you forget the mind-blowing action and special effects, the story alone could stroll comfortably into 'classic' status. Just the ability of the writers to not only think on that level but be able to portray it with a watertight scintillating storyline deserves respect. (I hope most of you have seen the movie and the sequels thereafter and if not, I sincerely suggest you do.) Now I am going to try to get back to my story and hopefully stop talking about The Matrix.

Did I mention we played football? We played a lot of football.

I would often in the later years in India, in school and in college be asked, 'Where did you learn to play like that?'

I would have no answer but I would try to explain that I spent serious amounts of time playing the beautiful game.

Finally, the summer break ended. I was supposed to join another private school in Wakefield; however for some reason I could only join a couple of months later. I joined a local school called Kier Street in the meantime. I made some good friends and unlike typical snobbish kids who may have frowned on being shifted from a private school to an ordinary one, I did not mind at all.

I had started collecting football stickers. The logic was simple: you had to buy packs of stickers and place them in an album which had places for all teams and all players in the Premiere League. If you had already filled out a spot and you got another sticker for the same you could keep it in your collection of 'swaps,' the logic in this case being that you could swap or trade this sticker and other such stickers you already had with a friend or co-collector hopefully for one that you didn't have. Hence it would help in filling out the album. I have always had an addictive nature. I would have it all my life. I got addicted to these stickers and my collection. I used to sleep with the book under my pillow. Late at night when I couldn't sleep I would open the pages and sometimes just smell it. Yes, I was weird like that!

Collecting stickers was an expensive hobby, attempting to finish the collection and filling out the whole book even more so. Many of my friends collected these stickers but I did not know anyone but me who finished it. My dad, who knew I was a sports freak bought me loads

and loads of these sticker packs. He tried to maintain some discipline, even tried fixing a one sticker pack per-day policy. It didn't work. He had this big brown coat and one evening when it was hung on a rack, just out of gut feeling I dived into its big deep pockets. There were ten packs of stickers. I had struck gold! I felt like a kid who had found a key to a candy store. Papa didn't get angry when he found out. He knew I really couldn't help myself. He just smiled and said, 'You know, I was planning to give them to you one a day.'

My stack of swaps had slowly become huge. I had two, sometimes even three extra stickers of certain players. I had more swaps than most people's entire collection. I remember I was almost finished. Just this one sticker had been eluding me and I couldn't get it through swapping either. It was a Dion Dublin shiney. It had become frustrating till one day I found a kid who had it. I was stupid. I got super excited on seeing the sticker and blurted out everything, the fact that it was the last sticker I needed and that I was very desperate. This is not a good way to bargain or even negotiate. The kid picked up on this and I ended up having to give him some twenty stickers he needed plus three pounds of my parents' money. I did not care one bit. I was cock-a-hoop. I was done! This was no meager achievement. It meant a lot to me. It is when I think back about things like this that my love for my dad increases or becomes consolidated. Also, I hate myself every time for being careless enough to have lost the album.

I was the first person in our friend circle to buy the latest 32-bit PlayStation console. The first game, Fifa 98, with United star David Beckham on the cover. I changed the half-time interval from four minutes each half to forty-five minutes each half. I created a player called Samar and had him smash over a 100 goals in every match just for fucks; to feel good and stroke my sporting ego. I may have been better served to use the Net and look up things maybe read up about science or philosophy or whatever but I was me. So the routine was to gobble down packet after packet of chocolate-chipped cookies and play Fifa. The good life!

I am not much of a gamer now. But the latest Fifa games on the new generation consoles are quite honestly astonishing. The level of technical craft and the insane attention to detail mixed with unbelievably real game-play makes the Fifa experience unquestionably awesome. They really have made a lot of progress in the last fifteen years or so. It is hard to imagine how they can improve further. But they will; they definitely will; and like always they will prove it every year. 'E…A SPORTS! Its in the game!'

My class teacher was a young attractive female called Ms Boon. She introduced me to the class and told me to sit on a particular table. A class of twenty; five tables; each with four kids sitting on it. I am explaining this because here almost everything depended on which table you were sitting at. Class projects, homework, discipline; everything. The table that had behaved best through the day got to leave early when school ended. We were not

competing individually but table to table. My table had a bloke called Mikey; two girls, Laura and Natalie; and me. Quite obviously I got close to my table mates. Mikey was a real nice person and we became the best of friends. I was close to the girls too especially Laura. We lived close by and we would often walk home together. Laura was Twigie's little sister.

One afternoon I was walking back from school with Laura when I spotted the guys walking towards us; Izat, Taz and Kenneth. I was still pretty shy then. This would change. However at that moment I did not know what to do so I just started walking real fast and ahead of Laura and tried to pretend that I was not walking with a 'girl'. They spotted my futile attempt and took the piss not only then as they crossed by but also later on the football pitch. Laura was unfazed as they blurted out some lines when we crossed. She laughed and told them to shut up.

There was a girl who unfortunately for me sat on a different table called Lauren. Now Lauren; she was beautiful. Short blonde hair, mesmerizing eyes, a cute face and like me a small black mole on the side of her chin. I had a huge crush on her. This was a tad different from how I felt about Alice primarily because my liking for the first time in my life had sexual undertones. However like with Alice I never told Lauren how I felt despite being good friends. I don't regret much in life; but not telling Alice not telling Lauren; I wish I had.

From a very young age even in India most people in school thought I was a shy kid. Thinking back now I

realize I was not so much shy but usually just zoned out. In the school in Patna I remember classes being taught and I wouldn't hear a single word. Lucky to have a window seat, I would stare out all day, looking on at the construction workers, blowing spit bubbles to amuse myself. This trend continued for a while in England.

I remember going out into town with Mom and Nani in the early years in the UK and feeling very uncomfortable. They stood out, wearing exotic grand saris and I could feel the public eyes and it would be weird. My dad would often wave on his way to work when I was waiting at the bus stop with the other kids for school. And often, I would try to ignore him. He would never let me, if I turned away he would switch off the car and wait. He never left before he got that wave. These were important lessons that were being taught to my subconscious; to a brown Indian kid who has moved to a predominantly white country. I would change and change fast. I would slowly build a sense of self-pride and self-confidence; both crucial elements to my character today.

The process of change would begin at my next and last school in England, Queen Elizabeth Grammar School (QEGS)–Wakefield. QEGS was like Hymers in a lot of ways, the feel and infrastructure was very similar and I fitted right in. I suppose the only drawback was that unlike Hymers, QEGS was an all-boys school. It sucked because I was just at that tender pubertal maturity age. I still liked sports more than girls though and on that front QEGS was a little superior so I wasn't too displeased.

Our class teacher at QEGS was an Irish chap called Mr. Watson. He had a thick Irish accent and funnily enough, he taught English. Shashwat 'Shash,' Jonna, Parki—friends of mine—took the piss out of Mr. Watson pretty much all the time and you could just keep listening to their mimicry and never get tired. A cool man, he would talk to us about Ali-G sometimes. He was a Lord of the Rings freak. Once, he claimed he knew the first few chapters of the first book by heart because he had read them so many times as a kid. We decided to test him. He just sat on his chair and spoke the lines non-stop while we stared at the book in amazement. He got it right to the punctuation.

'The HOBBIT' he wrote in big letters on the board, 'okay, children, who can tell me something about the hobbit?'

We read a short book called The Hobbit for the next few weeks. It was a prequel to the Lord of the Rings series. We did several assignments all related to this book. It was a lot of fun. When we were done, Mr. Watson took the whole class to a professional theater and we saw the play The Hobbit. It really was quite a marvelous experience and one I thoroughly enjoyed.

Mausa, Mausi, Manu and Yash often came down to Barnsley. I was good with kids. I always have been. I find it easy to bond and relate to children. Manu and Yash were cute kids and I spent considerable time with both of them. Manu had become a little aggressive towards the later toddler years. I was years older than him but still

most of the times he beat me up. Yash, on the other hand maintained his sweet innocence for long. Add to that his film-star good looks and it was easy to see why most people had a soft spot for him.

They made me watch Power Rangers and worst of all Pokemon. It would be a battle to get to watch Match of the Day on Saturdays.

I was not a materialistic person at all. But Mausa and Mausi got me the coolest gifts. It was hard not to get spoilt. The best thing was that their choice of clothes or accessories were as good if not better than mine. I got countless sporting goods, the classy brands without being too stereotypical. Even till date whenever Mausi buys clothes for me I know almost for sure that the colour is going to look good and the fitting will be comfortable. It is no coincidence that the tops, jackets or pants I wear most often have usually been gifted to me by Mausi. Sensible and receptive from the start I only get excited about gifts if I feel the genuineness of the giver; and in Mausa Mausi's case, the warmth was always there. I felt comfortable.

Shash was perhaps the only guy of Asian origin I met in England who was genuinely popular in school. He was definitely the most popular guy in our class. Witty, funny, smart and quick. It was almost impossible to win against him. You could say your best jokes and time it to perfection but within seconds he would have a better comeback. Everyone seemed to like him, students and

professors alike. I guess it would be fair to say that he was inherently 'cool.'

We traveled a lot. We went to France with Aashish's family. We did all the tourist activities, scaled the Eiffel tower. The high point of the trip however was when we went to the world-famous art museum Louvre. I noticed there was a huge crowd outside and the cyclists competing in the prestigious tour de France race were going to pass by. I begged to wait outside so I could see them cross. Nani, who was with us on that trip, gave me company and it was exhilarating seeing the cyclists go by at such high speeds. Louvre itself was also incredible. While the famous da Vinci painting the Mona Lisa was a bit of an anti-climax, some of the other art on display was incredible.

We went to Amsterdam for a short two-day trip, again with a couple of Indian family friends. It was a cruise that took us there. They had magic shows, screened movies with live music and dinner at night. They were playing country music I think and my dad a little tipsy on beer walked in front of the band and started dancing. My friends were laughing and I was hoping the earth opens up beneath me so I can jump inside. Soon, though, many other people joined my dad on the makeshift dance floor.

I guess I was too young to enjoy Amsterdam fully. I didn't even know about marijuana back then. I didn't know I was in the weed capital of the world. I didn't know about hash brownies.

My mom bought a diamond set there. I was excited for some reason. Whenever it seemed like she may give the idea a pass, I convinced her that the set was very pretty and she should buy it. She did. She bought a t-shirt for me that had 'Amsterdam' written across it and had a picture of a leaf of a cannabis plant pasted under. Neither Mom nor I knew what this was back then and perhaps it was divine providence.

We went to Spain, just our family this time. It was a long trip and we covered quite a bit of the beautiful country. They had water problems though; a bottle of water cost almost as much as a bottle of Coke. We went to this huge vineyard and were shown around the plantation. We were explained the wine manufacturing process in detail and shown how it was stored in massive barrels kept underground. Each barrel had a year written on it which indicated when it had been brewed. Towards the end my parents got to try out different types of wine. I was too young and had to make do with drinking juice that looked like wine. Reddish juice in a wine glass. At least, I looked the part.

We were staying in a very fancy hotel which had a huge swimming pool. I spent a lot of time in the pool, made some friends and played water polo. One time, I was walking back to where my parents were chilling; poolside on their recliner chairs and I saw a sight that bedazzled me; there was this hot, attractive young female sunbathing and she was completely topless. She had perfect shaped tanned breasts and it was hard to keep my eyes of her. I had to though. I didn't want my parents to

see me and think I was a pervert. When I reached them acting totally innocent and like I hadn't seen anything I noticed that even they were quietly talking about the same thing.

The topless babe as it turned out was no competition for what I saw next. We were on our way back from some tourist site on a bus and we crossed well what can only be described as a nude beach. I saw couples naked lying on top of each other. It was like Playboy had come to life. Unfortunately, my voyeurism lasted only a few seconds till the bus took a turn.

Naked chicks aside, our stay in Barcelona was the real peak of the trip for me. We walked around the Olympic village, took clicks, heard stories and visited most of the stadiums. Nothing though came close to that feeling I felt when we walked inside the Nou Camp, the official home ground of Barcelona Football Club. Just the sheer size of the Catalan Stadium made me catatonic for a while, gave me goose bumps and it was a very special feeling being there. I bought a Barcelona t-shirt as souvenir; it had Ronaldinhio '10' written on the back.

Wednesdays were my favourite days at school. We had a double period of religious studies where we studied the basic fundamentals of all religions. This class was taken by a Mr. Parsons who was a cricket enthusiast and he would spend a lot of time talking to us about the game. I sat next to Adam 'Parki' Parkins who was a close friend and along with Shash opened the bowling for the school team. Jonna was a middle-order bat and with me it was

us four from our section who were a part of the school cricket team. We became close friends on and off the pitch.

This was followed by a single period of drama. Drama classes were a lot of fun. Our teacher, Ms. Layla, a middle-aged lady who must have been very pretty in her youth, gave us absolute freedom to express ourselves. We would get a basic plot or topic, be divided into small groups and then asked to present our skit in front of mam and the whole class. The best group performance would be rewarded.

These classes, even though we had only one such class per week, would have a big impact on me. I feel it was here when I started to come out of my shell and lose that shy demeanor. I started opening up and started taking major roles in the plays and poetry recital. I was not afraid and certainly not embarrassed anymore. I acted and I entertained. Mam started to take a liking to me.

I wrote my first poem. It was about a football match that England had won and Ms. Layla was the first person I showed it to. She said she loved it and smiled.

If this wasn't enough, drama class would be followed by a triple period of games.

Schools in England were different from India especially the private schools like QEGS. Where at Loyola; school timings were from 7:40 am to 1:00 pm; at QEGS the day started at 8:00 am and finished at 4:00 pm. Add to that

the one-hour bus commute to and fro from Wakefield and almost the whole day would be spent at school. Winters could be depressing because it would be dark in the morning around seven when I left for school and it would be dark around 5 pm when I came back. It would be very cold.

The only good thing I suppose with these school timings was that we got a long lunch break. We would finish lunch quick, maybe grab some crisps and a Coke from the tuck shop and line up at the huge tarmac playground. Sometimes we played cricket but more often than not we played football. Now why this was so important to me and my game was because we were not permitted to play on the concrete with a proper football. Only tennis balls were allowed. We still played football. We played full pitch 11-on-11 footy for more than an hour every day but we played it with a tennis ball. Finishing, crossing, heading, volleying, tricks and skills; everything we did with a tennis ball. As far as ball control was concerned this was the best way to improve because if you can control a smaller ball with your feet and body then you will find it easier to do the same with a full-sized football. My game improved in leaps and bounds and if Shania Twain is to be quoted, I found my 'touch.'

Mr. Coughlan was our math teacher. Like almost all teachers in England he hardly ever lost his cool. I suppose it is easier to handle a class of twenty kids as compared to the forty-five or so teachers have to manage in India. After Mr. Bryan, it was Mr. Coughlan who would next face the fury of my mom's rebuttal when he had a few

negative things to say about me at a parent-teachers meeting.

Mommy was always like this. Even in India when we went for report cards I would be more scared about what my mom would say back to the teacher than what the teacher had to say about me. One incident comes to mind where this pathetic computer teacher at Loyola nicknamed 'Muchhi' after the moustache she seemed to have went on about me for ages. Not only did she complain about the fact that I was not doing well in the subject which was her right but she went on to take digs at my character. She said a lot of hurtful things. I could feel my mother boiling next to me and I knew this bitch Muchhi is going to get it. But by God, I wasn't expecting Mom to fire nukes.

Mommy gave back to her everything and more. She went on to finish by saying, 'Listen, you're a computer teacher who teaches in the eighth grade and from what I hear you're not even that good … Samar is the son of two very intelligent and successful doctors and we know how to raise our son, so please keep your views to yourself.' While I appreciated Mommy's support, from that day on we banned Mom from going for report cards. My dad, a cooler head, would now be thrust with this responsibility.

It was tradition at QEGS that the form 2 batch which included me that year would go on an excursion of sorts to a place called Lake District for about a week. As the name suggests there were several lakes interspersed with majestic mountain ranges and extensive woods, a

beautiful symphony of natural elements. There was a lot of opportunity for water sports and other adventurous activities. There were more than a hundred of us.

Trekking up a river, jumping into nature's pools, taking in the landscape and more. We had certain tests and baptisms too. We had to jump of a cliff into the water below. Now, I kid you not this jump was pretty high and felt even more so at that age. I was hesitant initially but standing in front of my class, everyone cheering me on, I mustered up the courage and just jumped! There were quite a few who didn't take the leap.

There was another such test. Our instructors, regulars in the area found a huge natural slide made up of smooth rocks and water flowing over. We had to jump on and then slide into the water pool below. The rocks were relatively smooth but the ride would still be bumpy and would hurt your backside. Plus this was at a precarious height and the water was flowing at a brisk speed. I decided not to go. But my friends again started screaming from below as I turned back. And I saw Shash scream, 'Just do it!'; so I did and it was so much fun that I climbed back and did it again.

One afternoon, we were going canoeing. After explaining the basics the instructor said, 'Now kids if someone gets toppled into the water, you have to scream 'Sailor overboard' or you could just shout out 'FREE BEER!' to get our attention.' As he said this, Mr. Coughlan who was walking past jumped and then jumped some more screaming, 'Where?! Where?!.' Our instructor chuckled

and said, 'See kids, it gets people's attention.' Canoeing was fun but towards the end very tiring. It was hard to keep up with the pack.

One activity involved a group of us camping and sleeping out for one night on an island all alone with one instructor. It was a painful experience. We all tucked into our sleeping bags, it started raining. We had no overhead cover. It rained all night and as you can imagine it was very wet and uncomfortable.

We went mountain biking, over fifteen kilometers, through tricky terrain and glorious views. We went rock climbing. In the little free time we had we would play volleyball at base camp or stay up at nights and share ghost stories. We returned rejuvenated.

Cricket season had begun. I had been spotted by a teacher while I was playing on the ground at lunch break and he had passed on the word to our cricket coach that year, Mr. Gangley. I was facing Smithy, Parki, Addala and Shash in the nets. Smithy was probably the quickest; Parki also quick got beautiful shape on the ball and had a pretty release; Shash was all about swing and accuracy whereas Addala was a feisty little bowler with decent pace and a good cricketing mind. Mr. Gangley had told me to pad up first and all these guys were balling with new balls. I played them fine. I got right behind the ball. I held a pose once or twice; leaning into a drive or two.

I had had a good hit. I knew I would make the team but when I saw the list on the notice board it surprised me to

know that I was the first opener. I batted at this position for the rest of my life and it was a role I started enjoying.

My opening partner Nicko would later tell me at the end of the season, 'You know Samar, I didn't bat with anyone but you the whole season.' It was funny because I wasn't aware of this and it was a long 14–16 match season. Nicko had always gotten out before me and had scored more than me in only one game in the whole fuckin season. It was an astonishing stat. Quite obviously I had thrived as an opener and scored a bunch of runs.

James 'Smithy' Smith was probably the best all-round athlete I met in England. I won't start stating the sports he played and played well because he played them all. I respected him because he would challenge me even in sports I felt I was good at like badminton or squash apart from being a livewire on the rugby team or an ace swimmer. A nice guy, a good friend and my no.3 on the batting card. We spent considerable time in the middle.

I was a good fielder; I really was. I had harnessed these skills from a very young age. I always loved diving around and I never became the donkey when we played catch-catch donkey. At a Yorkshire schools tournament we were playing Leeds and I was fielding at third man while Smithy was bowling. I had just affected a run out in the previous over from this position with a direct throw and I was pumped. Smithy was quick and the batsman flashed hard. The ball took an edge and started soaring towards me. I concentrated on the trajectory of the ball, took two steps forward then one back. I was too far ahead. I had

gotten under the ball, this couldn't be caught. I guess out of reflex I flung my right hand backwards and leapt back. The ball stuck! I stood up gingerly and looked towards the wicket.

My whole team was sprinting towards me. Woody, the keeper that day reached first and asked, 'How the fuck did you do that!?' Mr. Gangley also told me later in front of the whole team that it was one of the best catches he had ever seen. Other kids from different schools who had seen the catch came up and congratulated me. It felt really good. We went on to win that tournament; we were crowned champions of Yorkshire. The medal I got for the same was the first of many cricket medals I would bring home. I remember showing it to Mom when I got back. She started smiling and looked very proud.

Everyone was excited. We would have our first sex education class. A boys' school, there was nothing to be shy about. Mr. Coughlan was taking it. He started explaining that around this age most guys would develop an interest in members of the opposite sex. He told us about the first girl he had had the hots for and how he would turn red when she was around. He was funny. This was followed by a video that gave us basic sexual information. To be honest I think most of the guys including me already knew the stuff that video was trying to impart.

Apart from playing for QEGS I joined the local Barnsley club cricket team. My dad had taken me the first day and we had seen two groups of kids practising. He took me to

the older group saying the others looked too small. As it turned out I joined the senior team for practice. I bowled, I batted and I could tell the coaches there were impressed. They said I could play for both teams, the u-11s as well as the u-13s. While my debut for QEGS had been a good one, I had scored a well-compiled 31 before being run out by our then captain Addala. My debut for Barnsley was less impressive. I played my first game for the u-11 side. My team hadn't seen me play and I didn't know most of them. I was a direct draft and the word around was that I was really good. I went out to open the batting, took guard and got bowled of the very first ball. The walk back sucked balls! It was worse than missing a penalty.

Slowly, I would start performing for Barnsley too. An opening bat, an erratic bowler and an electric fielder. We weren't even 11 years old but we already had specialized positions for certain fielders. I usually fielded at slips or short cover.

Like the Internet, technology too came earlier to England. My dad was not really a techno geek but he did make sure that the house goods were never out of date.

There was a sudden explosion in the sales of mobile phones. Everyone wanted one. The kids in my school, most of them rich, started purchasing and bringing their cells to school. I wanted one too. I convinced my dad that I needed a phone. I was in such a hurry that instead of going to the shop I just ordered a piece on the TV Sky network. The phone reached in two days and for a while I was happy with it, although I soon realized it didn't

have many features I wanted. Most importantly, it didn't have the game 'Snake.' It was a trend game back then. Everyone on the bus would be playing it and the common question would be 'What is your top score on Snake?' So after a few days I broke the news to my dad, I told him I wasn't happy with my phone and I wanted a new one. He wasn't too impressed initially but by the evening, he agreed. We went to the local phone shop and bought a Nokia 5110. The phone looked supremely pretty in blue.

We traveled a lot of Europe in our time in England. The UK itself had many tourist locations and we covered pretty much everything. Be it the hills and castles of Scotland or the caves and dungeons of Wales. We went to Shakespeare's hometown; took pictures in his home and garden. I did not have a clue then that almost a decade later I would read Julius Caesar, my first Shakespeare play and get hooked. After Julius Caesar I read Tempest and then Othello.

Like at Loyola even at QEGS there was an all-girls school close by; it was like a sister school. The social events and the school play in later years would be clubbed together with our female partners. There were plenty of girls on my bus from that school and I got on well with them. There was Tonie, who was a year senior to me then there was a girl called Lizzie who I really liked and was friends with. Later, she would start dating Smithy. I told Lizzie that Smithy does drugs. I got Sam, a friend on the bus, to agree with me. I guess I was only kidding.

A dance had been organized and kids from both schools were invited. I told my parents. They really wanted me to go. I got the tickets. I stayed back in school to go for the event. A few minutes before it was about to begin I got cold feet for some reason and I just didn't feel like going, so I didn't. It probably was a confidence issue again. I walked down to McDonald's had a full meal and made my way back home. The next day in school, all the guys were bragging about how many girls they 'pulled' or how many phone numbers they had. Shash pulled six; Jonna thirteen and Parki—well, Parki just made up with his girlfriend. Even Rishi, the happy-go-lucky sardar in our batch claimed to have pulled eleven chicks. I should have gone! 'What a fuckin pussy.'

When we were in Barnsley, a guy called Vikram bhaiya and his wife, Reena di, came to stay with us for a while. Our families had known each other for generations. Vikram bhaiya was a computer engineer and in England searching for a job.

He was a sports fanatic just like me. I would listen for hours to stories of his childhood. I was awe-struck hearing him tell me about India's 1983 World Cup win which he had heard on the radio as a kid. He told me sweets and samosas were being distributed in the morning and the whole country was in joy. I played a lot of football and cricket with him. He was good at both and taught me certain tidbits that helped but more than anything, it was a lot of fun being with him.

Reena di too was a sweetheart. She taught me how to play '29,' a mind-boggling card game; and we would play for hours sometimes all day. She bought me a lot of candy. Sometimes, when my parents were out we would experiment with self-made recipes, mix things up and see how it tasted. She would help me with drawing or art homework.

One night they were going out to take a stroll. I decided to join them. It was a lonely road with huge trees and the breeze blowing. Reena di started telling me ghost stories. She had me spooked and suddenly she screamed 'Samar! Bhoot!!!' I thrust my face into her coat. I was scared. Vikram bhaiya told her to stop. Then he looked at me and said, 'Samar, don't tell your parents about this,' as he lit up a cigarette. I replied, 'Obviously not.' We laughed and talked; all three of us bonded really well. I thought it would have been nice to have an elder brother like Vikram bhaiya.

Vikram bhaiya would try to convince me that I should switch into being a left-handed bowler. He talked about the natural angle southpaws get and talked in bewilderment about the likes of Wasim Akram. I told him it was impossible to switch bowling hands now. I had no strength in my left hand or foot and I still don't.

They did a lot of cool things for me. They got me a United goalkeeper jersey. I loved Peter Schmeichel and it had my name and number on the back. It was a very pretty white-and-green shirt and I loved it.

We couldn't find the video at the local Blockbusters but Vikram bhaiya tracked it down. It was a movie that he said I just had to watch. It was called Escape to Victory. It featured Pele and a few other footballers; it was based on a touching storyline about a group of prisoners. I really enjoyed the movie and it is one of those movies I am going to make my friends watch and someday insha Allah my children. Like a Godfather or a Schindler's List or more recently an Interstellar.

#8

Raja Babu AA Gaye!

Like I said everyone was tense before the first paper of the tenth-grade board exams. We were all standing in groups surrounding the entrance gate. An innocent low-profiled Christian tribal boy named Raja Babu was walking in.

Anish, the text-book badass was standing close by with his group of goons. 'Raja Babu aa gaye! Raju Babu aa gaye!' he started screaming frantically … actually, it was more like 'Llaja Babu aa gaye! Llaja Babu aa gaye!' he was jumping around and clapping his hands as he did this. This was a line said by Shakti Kapoor in some low-grade Hindi movie. Everyone there, and there were easily at least a hundred of us turned to look at Raja Babu. The poor guy looked beyond embarrassed but somehow managed to force a smile. The crowd initially like Raja Babu first got over the shock element of the whole act; took a while to take it in maybe play it again in their heads and then unanimously broke out into laughter.

I am certain that in the decade or so in school Raja Babu and Anish had never talked. I have no clue why Anish did what he did. The good thing was that this brought

down tension levels and we all felt a little lighter. I don't know what happened of Raja Babu after that. He wasn't with us in the eleventh and twelfth grade. I later heard that he became a dentist. It wouldn't surprise me if it was Anish's act that had made the difference between him being a doctor and ending up as a dentist. It must have shattered his confidence. It was funny as hell though; the scene, the expressions, everything. Raja Babu was the only one who wasn't laughing.

#9

O' Sweet Child of Mine

We had to move again, this time to a place called Pontefract. I wouldn't have to change schools though; just my bus. My neighbours changed however, luckily for me like in Barnsley there were many kids in Pontefract who loved to play football.

There was a Sudanese family who lived on the compound and I got really close to the boys, Ahmed and Fateh. A Pakistani family lived right next to us with two girls, Hamna and Tehreema and next to them lived a Kashmiri girl called Privesh. Up the hill stayed two friends of ours called Anup and Ajit. Shash would often stay back at my place for a while after school before his parents came and picked him up. He lived in one of those lonely mansions that no bus would go to.

Ahmed, a year older than me, was the rock and hard man of the group. You could see in his eyes he was committed to living with honour. A few times, a couple of white kids would come close and shout racial slurs at us. While most of us initially chose to ignore; Ahmed used to stand up

to them. He looked big even at that age and at times he would chase them away, the pranksters would fear him.

Fateh, a year younger than me, was the better sportsman of the two brothers; and I was closer to him. A natural athlete and very flexible, Fateh dived around for fun just like me. One more thing that bugged me about Ahmed was that he was a Backstreet Boys fan. And that—well, it just put me off a little.

Apart from conventional sports we did other things too. We spent a lot of time riding around on our bicycles and exploring local landscape. We played our modified versions of police and thief. When we got tired of the outdoors, all the guys would get together at someone's house and we would play multiplayer video games. All of us were huge wrestling fans back then, the WWF. We never missed a show of Friday night Raw or Saturday Smackdown. Often, we watched these shows together. We all had wrestling video games and four-player tag-team matches were the essence of the times. My favourite wrestler by far was Stone Cold Steve Austin—the Texas Rattlesnake, Austin 3:16—while the Sudanese brothers along with Anup and Ajit swore by the Rock.

One morning, my parents were at work and the living room in our house was stacked up with quilts, bedsheets and pillows. It had been made into a makeshift bed for me because I was sleeping downstairs to make it easier for me to get up around five in the morning to see the Indian cricket team playing Down Under. I used to get up early every morning only to watch India crumble

under Aussie pressure. As Bumble would say we got 'walloped.' It was the same series where Ajit Agarkar got a world record number of consecutive ducks. You felt for the kid; to be fair to him he did have his moments when he was bowling. Ahmed and Fateh joined me on one of those mornings and somehow the arrangement of a soft landing and sofas and chairs all around appealed to us like a wrestling ring. I will never forget Fateh doing all sorts of acrobatic moves and jumps. It was like he was flying. He was doing the Superman at will. We took photographs using an instant Polaroid camera and in one pic I even caught Fateh in midflight. I did the Austin stunner on Fateh several times while I was given the people's elbow and Rock bottomed till my ass hurt.

I was outside my house and I had all my cricket equipment out the bag. I was cleaning and arranging my kit. Pads, gloves, thigh guard, inners—the works. Tehreema, who looked very similar to the Indian actress Kajol (at least her eyes were very similar) walked over to me. My guy friends were also there. Of all the equipment she could have inquired about she picked up my 'box.' It was a triangular-shaped penis guard to put it bluntly. It would be placed inside my underwear every time I walked out to bat.

Before I could stop her she took the guard and put it over her nose and mouth, pretending to breathe into it like in an oxygen mask she asked innocently, 'Samar, where does this go?' She obviously had no idea. I will leave it to you to imagine the next five minutes. There was a lot of laughter and Tehreema, once she knew what it was

jumped around in disgust and kept saying, 'Euww, that's so gross!'

In the summers when we got back from school we often played cricket. Tehreema and Hamna's dad, a very peaceful and honest-looking Muslim man with an ever-present cherubic smile, would join us. He would bowl to everyone and all players got two overs to bat; and obviously, the person with the highest number of runs would be declared the winner. I pretended like I had to try but I always won easily and I guess I was a bit of a show-off.

Privesh, the Kashmiri girl, I would learn later had developed a crush on me but she never told me. One time, I asked her out as a dare and I could tell by the expression on her face that she didn't think I was joking. Nothing ever materialized and though she was a good friend I don't think I was ever attracted to her. Yes, we did that stupid stuff too, you know, play truths or dares or talk about who you have a crush on. We were going through puberty.

There is a lot of tension between Hindus and Muslims in the world especially in India. We are taught to hate Pakistan; losing to Pakistan in cricket is the worst form of defeat. Sporting rivalries are healthy however it is not just sports. A lot of hate is imbibed by young children in both countries. Children who can't even spell diplomacy are made to carry the baggage of a violent past between the two nations.

Here we were, thousands of miles away from home and our families bonded and became friends. We bonded on the fact that we looked alike that here in an alien country we spoke pretty much the same language. Tehreema's mom would invite me over when she made her famous Tandoori chicken and on other occasions too. Life was so simple, there were no boundaries, no systematic brainwashing. Years later in college, I would fall in love, for the first and last time, with as fate would have it an Indian Muslim girl.

Tehreema had taken pictures of the whole group when she went home to Pakistan for the holidays. She came back excited to tell me that her cousins over there had asked several times about me: 'Who is this little Rahul Dravid?' (insert nostalgic huge grin) I was very happy. Sachin is the law but I had this thing for Dravid; and therefore to hear that these Pakistanis thought I looked like the legend was very pleasing.

#10

ENTER; the Prodigal Son

A casual Sunday evening, I was hanging around in the living room watching TV. I couldn't imagine in my wildest dreams the news that was about to be broken to me. My mom called me over to the sofa and switched the telly off. She said, 'Samar, I have something to tell you.' My dad though not on site was in the kitchen in the next room. I could tell she was nervous and this was making me nervous.

She said, 'Samar, I am pregnant; and in a few months' time you are going to have either a baby brother or a sister.' She looked at me and smiled. She seemed a little relaxed now. This was short-lived because my reaction caught her off guard. Well, it was misinterpreted and poor mommy got worried.

As soon as my mom had finished the sentence I had almost gone into a state of temporary paralysis. It was like I had been struck by lightning. I couldn't think. I couldn't function. I felt numb. No emotions or feelings were palpable. To add to the melodrama, huge teardrops started to form in my eyes. I tried to fight them away

but soon it felt like a cloud had burst in my eyes and tears gushed down with incredible force and speed. I wasn't sad. Like I said, in that moment, I felt nothing at all. I wasn't really crying but unfortunately that's how it seemed.

My mom naturally got worried and immediately called my dad. He seemed puzzled too that there were tears in my eyes. I remember asking him, 'Really, Papa?' He said yes, nodding his head. My mom by this point had become a little frantic and was even more worried because the tears on my cheeks continued to drop. She asked me, 'Why are you crying, Samar? Why are you crying?' Then she asked my dad who looked toward me. I mustered courage and after twitching a little regained control of my facial muscles to say, 'I'm not crying … It is just overwhelming and I did not expect it.' My dad understood and told Mommy not to worry and it was just that the emotions of the moment had gotten to me.

I was 11. I was not so young that I would not know anything but I wasn't that old either and there was a definite lack of pubertal maturity.

I remember going to bed that night. Suddenly, things seemed really weird. It hadn't sunk in at all till then that there would be a baby in the house in less than a year. I thought about a lot of things for the first time that night. I thought about what I would like more, a baby brother or sister. Definitely brother, I thought to myself. I almost even started thinking about how I would coach

him cricket. Then I realized Mommy would soon be getting fat—very, very fat.

Just a few weeks before this the lads at school were discussing pretty touchy topics certainly for the Indian mind-set. The discussion was based on determining how many times each person's parents had made love to each other. Okay, bear with me here! Now the theory, which was confidently put forward by an interesting kid called Johnny was that it was the number of kids that each couple had. Everyone did the easy calculation; number of siblings plus 1. Some guys seemed grossed out; Binksy said, 'Oh! My god, three times.' Shash was worse of that day because with three sisters it had been calculated that his parents had done it a mammoth four times. I was the happiest, just the once. I was comfortable with that.

It would take a while before it started sinking in that I would no longer be alone. Yet slowly but surely it did sink in.Gradually the nervousness about the whole event began to fade; and ever so gently it was replaced by joy and wonder.

A few months later around the time Mommy was getting really big, we had gone shopping into town. People in England are generally more sensitive than in India so I doubt this actually happened but I felt people were staring at us. Mommy was walking really slow. I felt like I was in the spotlight and I didn't really like it. Still, I stuck with my Mommy that day, all day, helped carry bags and tried to make her laugh as much as I could.

No one was more excited about this baby than my little cousin Yash. A very cute kid himself he had picked up certain peculiarities in the pronunciation and expression of the English language and I wish I could have filmed his queries about the baby to my mom who he lovingly called 'Mauussii.' I could tell he was genuinely excited and it felt nice at some level. I really felt like he was my little brother too, Yash. On the other hand, my other brother Manu bhai, the first 'gunda' of the family continued to wrestle me sometimes over which show to watch other times to decide which video game to play but mostly just to show he was Boss! It comes as no surprise to me that Manu is huge now with monstrous biceps. However the spite in his character as a toddler has been replaced by gentleness and affection.

Mausa and Mausi with the bros often came over during the time Mommy was pregnant. They showered a lot of warmth on us and it felt nice and safe when they were around.

We were driving back from somewhere. Randhir mausa was driving and I was in the back with Manu and Mausi. Out of the blue Manu started asking tricky questions about childbirth. I tried to deflect but Manu bhai couldn't be fooled. He had this trademark mischievous smile and he could smell something fishy, so he probed further. Randhir mausa simply ignored; Minu mausi wasn't of much help either as she giggled away. I tried explaining to my little evil imp brother that women got pregnant when they ate a lot and after a while a baby would be born. Manu, who by this time had noticed the uncertainty and

tenseness of my response was having none of it. He kept saying, 'No! Saammarrrr, you are lying.' Luckily, we soon reached home and the conversation fizzled away as Manu ran ahead to put the Pokemon game on.

Before long, the big day arrived. July 27; my brother/sister would be a Leo like me. I don't really believe in any sort of foretelling or horoscopes but I always thought Leo was a rather cool sunsign to have.

My mom would be having an elective caesarean section delivery.

It was scary. I was woken up around seven in the morning. My mom had to be admitted in the hospital which was close by. There was no noise about the moment unlike how things go down in these situations in India. My dad was ready and he would take Mommy. All they had on them was a small bag with clothes. Mommy hugged me tight. I told her I love her and I would see her soon.

Oh, I forgot to tell you our whole family had been researching baby names for months. We were honing around Siddharth for a boy and I liked the sound of Ria if we got a girl. There would obviously be a last-minute change because I neither a brother called Siddharth nor a sister called Ria.

As soon as I shut the door after saying a final goodbye, I ran up to my room and took my window as vantage point. I gazed at my parents making the short long walk to the hospital. I stared as long as I could before they took a

turn and went out of sight. My heart was pumping. I was scared for Mommy. Ridiculous images flashed through my head. Fuck Sharukh Khan and fuck Kuch Kuch Hota Hai!

I walked back downstairs and started watching TV. My mom was undergoing major surgery and still I was watching highlights of an old India versus South Africa match. What is more I had a cricket match later that day for the u-15s. I was still 11. And for the first time, I needed to wicket-keep for Barnsley as the regular was out of town. I had started keeping for my Pontefract team. Yes, at this time I was playing for three … no wait, four different cricket teams. The season was in full swing. Perhaps it was fate that on my baby brother's/sister's birthday I had a very good game both with the bat and the gloves.

I had been told that the delivery should be complete by 10:30 am and I would get a call. I had also been given the honour to inform both my Dadi and Nani when the news came.

It was around 9 am and I was getting nervous. I missed Mommy and I was scared. I don't know what came over me but I switched off the TV and jumped into my bed. I took out a notebook and started writing. I wrote an essay describing the whole morning and left it incomplete. Then I wrote a little poem dedicated to my future sibling, making promises of love and stating I would do anything but clean nappies.

This literal outburst helped me pass time more than anything else. Besides, it would be nice to hand these over to my baby brother/sister I thought. But being careless as I am I lost these pieces before he/she could read.

It was pressing 10:45. It had been an up-and-down morning. Suddenly, I felt palpitations again. 11:20 and still no call.

I was unaware that during this time period an emergency had come to the hospital and Mommy's surgery had been pushed back an hour or so. Papa, the responsible adult, had not considered it important enough to inform his paranoid 11 year-old son at home having an anxiety attack.

Around 11:40 am or so, I got the biggest call of my life. It was my dad. He said, 'Samar, you have a baby brother and Mommy is fine. You can come and see him in a while. Get ready.' I didn't know how to react. I was overjoyed, excited and a sense of calm now started to engulf my trembling soul. Before hanging up, I asked my dad, 'Papa, can we name him Sachin?' My father chuckled and said, 'We'll see.'

#11

Breaking the News to the World

I was over the moon at having a baby brother. Everyone was happy I suppose. My mum and Minu Mausi had held the view before the delivery that we wanted a healthy baby and that was all that mattered.

However, on being pressed, they were leaning towards wanting a girl slightly more primarily because they were all girly and they wanted to be all girly with the kid. Besides, my mom and her two sisters at that point had a cumulative total of four boys and zero girls. So they wanted their little princess. Unfortunately for them boys would win this competition six is to 'o'; the wait for their little princess continues. Its funny how these things work; you know genetics, probability and Mendel and shit. For instance, my Nana and Nani had three daughters; these three daughters then had six sons. Weird! Talk about odds!

I had the duty to inform my grandparents who like me had been waiting anxiously next to a phone. First I called Ara and someone -I can't remember who- picked up the call; it was a lady. I passed on the news but the important

dialogue still had to be completed. The receiver was passed to my Dadi. I broke the news straight away. I said, 'Dadi, I have a baby brother.' She was very happy and conveyed the same to me. I loved talking to her; the conversation would always be very simple very childish. Unfortunately, this is the last vivid recollection or memory I have of talking to Dadi as she passed away a few months later. God had been a little cruel. Had he waited just a few weeks, baby bro would have had a chance to meet his Dadi; and like she loved me, she would have loved him. No, wait, she did love him. When she passed, she knew he existed. She would hear his voice. She did love him.

Nani the jumpier of the two grandmoms picked up the call on the second ring. 'Nani, I have a baby brother.' I had rehearsed these lines. These were big moments and I really didn't want to screw them up. Mommy had instructed me not to say 'It's a boy' or 'It's a girl.' What I said sounded warmer. The thing with Nanis and Dadis is if the couple wants a girl and it's a girl, they are happy; but if it's a boy, they are happy too in a different way. Imagine Sachin failing and Ganguly scores.

I was born in Ranchi. Two days before my birth, a major earthquake had hit the city.

The day my brother was born there was a storm that hit Pontefract. A lot of thunder, lightning and even more rain. Now England is not a storm country. It drizzles more than pelting it down, sometimes for hours but with less force. It gets dark early in the winters. Very early. In the summers sometimes the sun stays out in full effect

till 10 pm. The climate is unique but it is not a storm country. That day there was a storm, not a destructive one but a pleasant one. We felt nostalgic. We sipped tea.

Minu mausi and Randhir mausa took me to the hospital. I could tell by their faces that they were happy. As a doctor now and also before as a child I know that any normal delivery is followed by joy but also a sense of relief. There is nothing more painful than when the God taketh as he giveth. Seriously, Fuck Kuch Kuch Hota Hai. No offense SRK, I am a fan. Anyways all of a sudden I didn't have to worry anymore and I could just be happy.

I walked into the hospital room. My mom was on the bed, holding an unbelievably small baby. I mean he was 3.7 kilograms and big medical wise but … it was the first thing that hit me even from a distance. When I got closer and I saw his little fingers … my heart skipped a beat … It really felt like an out-of-world experience … I felt instant peace. They really were unbelievably small fingers all curled up neatly. I had never seen anything cuter in my life and I doubt I ever will.

I asked Mommy if I could hold him and she passed him over. I never thought I could concentrate more than I did with my palms open at slips playing for QEGS, or hesitate more be more nervous than I felt taking guard to face the first ball against the red cherry; but by god these beliefs were rudely shattered. My baby brother—I held him for the first time. As careful as I could be. Some moments imprint an indelible mark on the soul and live

with you forever like a Salvador Dali painting. Holding my chhotu was one of those moments.

A few minutes after meeting my brother, I sat down, trying to feel the moments that were rushing by. My dad looked at me smiled and asked, 'So you want to name him Sachin?' I was too overwhelmed to be thinking about names then. But I smiled back and said, 'Yes.' My mom, who was hearing us held a status quo. Papa said, 'Well, why not?' and there in that moment it was sealed my baby brother would henceforth be known as Sachin Kumar. His name a tribute and celebration of the greatest sporting personality India will ever produce and a legend of the game cricket: Sachin Ramesh Tendulkar.

Tendulkar is a global charmer. This love for Sachin is just as palpable in the blood of 70-year-old village folks in Yorkshire who love the game of cricket and who saw Sachin in his boy years play a season for the county of Yorkshire; in a haven of swing and seam our hero averaged a fighting 50+. I say this because I have talked to such people. One such nice old man who was sitting next to me in an India versus England match at Headingely had these super cool binoculars. He let me use it to see Sachin walk out as the crowd went crazy. This was at a time when one-day games were still played in whites and Tendulkar was still a boy.

He went on to tell me that he had seen a lot of Sachin when he played for Yorkshire. I remember him telling me about the majestic touch when Sachin plays straight. Oh, madness! Thank you sir … Thank you so much. The

little master is retired now and though it was a dream to see him play at Wankhade, Mumbai; I will be able to live with the fact that I saw him at Headingely which in a way was his second home. Perhaps it was fate that I held my brother, as 'Sachin' this time, in Pontefract, a cricket-loving town situated in Yorkshire, the very county Tendulkar himself had represented.

To add to that it was a cricket day for me and like so many times in the nineties, like Sachin, I had played well but the team had lost. I am not even close to Sachin. On good days, I can briefly mimic a Dravid though. I'll force myself to stop with cricket.

I would have to teach my bro everything; how to bat, how to bowl and mostly how to catch because we all know catches win matches. Okay, STOP!

Randhir mausa, a trained pediatrician, gave Sachin his first bath. Again, ever so careful and ever so gentle.

My mom had gotten pregnant once before in Patna but unfortunately she had had a miscarriage and it had been painful. We had a small maruti 280 then and were living in a relatively small place. Mausa joked that little Sachin didn't come before and waited because now after years in England he didn't have to ride in a 280. In fact, he took his first ride on this planet in a Mercedes. Mausa struck a chord and everyone laughed.

We returned home and brought one more soul with us. Mausa, Mausi and my two little cousins Manu and Yash

who had been jumping around all day returned back. I think they wanted to give us, the nuclear family, some time together.

It felt so soothing being at home often just staring at little Sachuu. My dad got a little cake with a special type of just-born candle lit up. We cut the cake together and did our best to make Sachin smile as much as we could. And he did; he was a good kid. I can't tell you how it feels to see someone so close to you, genetically more close to you than any other human on the planet, debut with his first few expressions. When he smiles, you glow; when he cries, you hurt.

#12

'Skippy' Skip

For the last time in England, we had to move again. This time was a little special though. Not only did we have baby Sachin with us now but we were moving back to Barnsley and what is more in the same 23 number house we lived in before.

It was the first day of practice. The new cricket season at QEGS had officially begun. I had done well the year before as opener. Mr. Parsons was on the coaching staff this year and now we were in senior school. He knew I was on the team before and we often talked about cricket in class. In the last class before practice Parsons had said, smiling, 'We'll see what you are made of Kumar!'

Nicko and me padded up first and walked into the nets. Kids grow fast at this age. The guys who are quick the year before are quicker the next. Smithy, Parki, Addala and the rest were letting it rip. Besides, everyone was trying hard to impress. The team management had changed and no one's place was for granted. The coaches proved this as they made changes. Some changes were obvious. For example, Eddie was a new boy and he was

a very solid technically correct batsman so he made the team. Other changes were a little controversial.

Nicko, a permanent feature of the team the year before and my opening partner was mercilessly dropped to the B team. The biggest decision though was yet to come. Dinesh Addala was stripped of his captaincy. They talked to him politely. They told him he was still an important member of the team but at no point did they ever sound or try to sound apologetic. They were clinical. I know this because I was standing next to Addala. We had been summoned and one of our coaches, Mr. Kent, had passed on the decision to us firsthand that I would be taking over the captaincy for this season and Addala would be relieved of this job.

To be fair to him he had had a great season too and the team had done well under him. This decision was taken after a single practice session and I don't know how they came to it but I suspected Parsons had a hand to play. He had seen me bat and had told me he was very impressed. He would support me through highs and lows and at times gave me valuable advice along with the occasional compliment. Addala looked a little stunned. I don't think he was expecting it. I certainly wasn't. However, he recovered well and it was he who told the team that I was the new captain. As they say, 'The old king is dead. Long live the king.' I wasn't going crazy about this but I did feel a gentle sense of achievement and excitement for the season ahead.

Part of the coaching staff that year was a passionate Aussie called Clive. We had a while before the first match and in this time Clive spent a lot of time with me just talking cricket.

He shared an experience with me that took my breath away. He told me how he had once gone to a school in Australia. He said he saw more than fifty kids on a field with a tennis racket in their hand but no ball. And he said for the whole period all they did was shadow throwing a ball up and then swinging the racket like a serve.

The next day the same bunch of kids were at it again; but this time they just had a tennis ball in their hand and they were throwing it up and catching it. Clive said he was puzzled and asked the coaches what they were doing. The response was that they hoped that with this exercise maybe two or three kids will perfect the judgment of flight of a ball and the swing of a racket. That these things will then come to them naturally; it will help perfect their serve. This is the kind of effort and passion it takes to be a great all-round sporting nation. Medals and World Cups don't come easily. A sports fanatic from as early as I can remember this story really stuck with me.

I have always enjoyed watching and playing cricket in India. However, there is a definite romance about the game when you play in England. Personally as an opening bat and then a wicket keeper you start falling in love with swing, shape, seam and lateral movement. We were kids but we had players who genuinely swung the ball none more so than my opening bowlers Parki and Shash.

Parki got both swing and seam movement and he was quick. Shash was a little less on speed, rarely got seam movement and was perhaps less lethal; but he swung the cherry like an artist and a lot of times built up pressure from one end while our speed guns; Parki, Smithy and Addala blew teams away from the other.

Addala was different this year, not only had he lost captaincy but he had been demoted in the batting order. I think he had lost some confidence; nevertheless he would always give his all.

I was nervous and excited on the eve of our first match. I talked to Shash for hours on the phone, discussing in detail the batting order. I read a bunch of cricket books, planned fielding positions. I hardly slept that night.

I walked out for the toss; whites and blazer on for the first time. We won the coin flip and I decided we would bat first. Eddie was my new opening partner. I faced the first over, which was an exceptional one, both fast and accurate. I was so fixated about getting off the mark that when I did I switched off. The next over was bowled by a very mediocre bowler and I got out to a very mediocre ball. Dismissed for 1 in my first game as skipper … Shit!

The only consolation was that in a low-scoring game, Smithy not only top scored with a 23 but also took 6 wickets and single-handedly won us the game. Parsons, who was umpiring a different game, came over after the match and asked Mr. Kent about our game. I could see the excitement in Parsons' eyes. Mr. Kent told him

we won. Parsons immediately asked, 'And what about Kumar? How did our new skipper do?' 'I got out on 1, sir,' I told him and felt like shit. He smiled and said, 'No worries Kumar. Long season ahead.'

It is not that there are no sports enthusiasts in India but you have to marvel at the way they do things abroad. They do things the right way; they talk the right way. And they give huge importance to their school teams. School sports are a matter of great pride and honour for the institution. Teachers volunteer; the school supports fully all sporting ventures. Even in Loyola, one of the best schools in India, Remo was good but he did it all alone and for no extra pay. He even had to buy a new cricket ball for every match with his own money; the school didn't deem this important. My personal relationship with the man may have had its ups and downs but no one can argue with his passion for sports and while he was at Loyola alone carried the school's sporting flag.

Sachuu was getting bigger every passing day. I noticed his fingers were not as small as they used to be. He had his cot in Mommy's room. And he had a swing in the living room between the two sofa chairs facing the TV. I learnt how to burp him. I never changed his nappy. Sometimes when he cried I would pick him up and start gently scratching his back. My mom asked me one day what exactly I was doing. I replied, 'Muma, maybe Sachin is crying because he has an itch in his back but he can't tell us. Imagine how frustrating that would be, so I am rubbing his back just in case.' My mommy laughed.

Cricket wise it was turning out to be a funny odd year. I was in horrendous form for school. I was struggling to reach double figures. Everyone, my team and the coaches, supported me initially but in sports there is no role of emotion. You have to perform, I wasn't. Weirdly enough during the same time I was in great nick for Barnsley, I was scoring the big runs and I was doing it consistently. The level of cricket was just as good and it is one of the mysteries of the sport how these things work. As a batsman, a lot depends on confidence and for some reason I had lost confidence for QEGS.

Maybe, just maybe, the captaincy was getting to me. Even Tendulkar hadn't done well as captain. Again, I am nothing like him but I'm just saying.

I was also playing for Pontefract and there I was concentrating mainly on my wicket keeping. I had taken up the job initially because they didn't have a regular keeper. I was a good fielder and had good reflexes so I tried it out and soon I started enjoying the job. Slowly, my keeping started to improve. We had a player called Robbo for Ponte. He was the best cricketer in my age bracket that I have ever played with.

A few matches into the school season came the biggest fixture for me personally. We were going to play Hymers at Hull, my old school. I told my teammates that I knew most of the guys who would be playing against us.

I was walking towards the changing rooms when I noticed a familiar-looking man chuckling with enthusiasm and

laughing with glee. It was Mr. Bryan. I walked over to him and smiled. He said, 'Welcome back, Samar. I knew you would come … I just knew it. I have been waiting here for you.' I had told Mr. Bryan that I would be joining QEGS and he had remembered. He asked me my role in the QEGS team. I told him I open the batting and after a little pause fighting embarrassment, I told him I am the captain.

He wished me luck but then said, 'But I hope you lose,' and laughed. He then followed me to the changing room put his arm across my shoulders and told the coaches and my whole team, 'You've got one of our old boys playing for you today guys!' This whole interaction and everything about that day was all about nostalgia and love. It was a very touching gesture the way Mr. Bryan behaved and I felt special.

I needed to score today. I really fuckin needed to score. To be honest, this Hymers team we were playing against was very ordinary and we were a far better team. Still, I was nervous. Eddie told me to take it easy. I was caught on the boundary in the third over but not before making a quick-fire 21, which included a massive 6 of Sam (one of my best friends at Hymers) their opening bowler and three other boundaries. I didn't score many but I made a statement and considering the kind of season I was having this was actually a good outing. Our middle order piled on the runs and we won the game comfortably. I met Mr. Bryan and said a final good-bye before getting on the bus. Mission accomplished!

Mommy had taken a maternity leave after Sachin was born. Soon, this leave ended. Both my parents were working and I had school. We needed someone responsible and experienced to take care of baby Sachin. Nani, who had raised both Yash and me was drafted to England for Sachin. Nani knew most things needed to look after a kid and she did a very good job. I loved Nani and I spent a lot of time with her and Sachin during this period. She really was an expert. She was the best at getting Sachin to burp or to get him to piss. She used the concept of conditioned reflex. She would make a whistling noise slowly and Sachin would urinate. I remember clearly that this used to work on me too when I was a kid. Things came naturally to her.

I would like to make a point here that as little kids, it is hard to appreciate the effort that goes into raising a child. I only realized this when I saw Sachin grow. Nani looked after me as a kid and I want to thank her for the same because it really isn't an easy job. The good thing was that she never looked flustered or tired. She enjoyed it.

My father, even though he was very busy at work, made sure I didn't miss any practice sessions. He would drive and drop me of wherever I needed to be. He never complained. He had seen me play a few times.

However, Mommy and Papa had never seen me play together until one evening when I was playing for my district side. They hadn't told me they were going to come and when I saw them walking towards me, I felt nervous. We were playing a quality side with a quality

bowling attack. I was batting at no.3 and I walked out into the middle when our first wicket fell.

I probably played the worst eight to ten overs in my entire life. I remember a guy bowling quick while a spinner was bowling from the other end. I didn't get out for a while but I got stuck at the crease. Like Dravid of old, I struggled to get the ball of the square. After a while, I almost started wishing I got out.

When I did eventually get out I walked over to my parents who were sitting comfortably on fold-back chairs. My mommy, a little more honest and blunt in comparison to papa told me straight away that I was too slow and I should have scored at a faster rate, although they did realize that I was facing a tough attack. My father said, 'At least, you didn't get out for so long.' This was little consolation. I knew I had screwed up. Looking back now I wish I had done a little better because this was the only time both my parents had come to see me play.

For QEGS, my poor run continued. It's hard to lead a team when you yourself are totally out of form. I felt like a Ganguly; and like the prince of Calcutta, I finally broke my shackles with a laborious 48 in one of the last few games of the season. After this innings, Parsons seemed more relieved than me. He came up to me, shook my hands and said, 'Well played, Kumar. I knew you had it in you.'

Long before I had started regaining form for QEGS, when I was still going through a rough patch Eddie and I

were called for a meeting by Parsons. I was called in first while Eddie was told to wait outside. Parsons broke the news to me that I was going to be removed as captain. He explained that I was one of the top batsmen on the team and that it was important I play well. My lack of form he deduced may have been due to the extra pressure that came with captaincy. He was probably right. Either way I had to go. Eddie was the new captain.

Parsons then held a meeting with the entire squad and passed on the news. He spoke a lot about my ability and repeated what he had told me. I was not upset. I honestly didn't mind at all. But again, as they say, 'The old king is dead. Long live the king.'

To be honest, the send-off I had been given was far more gracious than how the team management had dealt with Addala. There was no change in my batting position, I was still going to open. I would still field at slips; I made sure of this as I caught a hold of Eddie after the meeting. Obviously we were close. He laughed and said 'I'll make you field at short-leg Samar.'

My Baba, Papa's dad, came to visit us in England. A gentle, modest personality, he had a demeanor that emitted grace. Like Dadi, he also almost always had a calming, soothing smile on his face, which was infectious and time spent with him would always be peaceful. One thing he didn't like at all was cold weather. I remember him wearing multiple layers of clothes, a skullcap and a muffler not only when he went out but also when he was in our centrally heated house.

A few weeks later Nana also joined us. Nana and Baba who had known each other for decades were the best of friends.

There was one particular evening that will always be etched in my memory. Papa was in the kitchen making us chicken. Mommy was on call and she was at the hospital. It was just the boys. I was in the living room with my Nana, Baba and baby bro; the oldies were engaged in an argumentative political discussion. I didn't know jack-shit about politics. I still don't. However, after a few minutes, I understood the crux of the talk and the views that my grandparents were trying to express.

Nana, like I've told you before is an intelligent extrovert who loves being in the limelight. In fact, in certain aspects, my Nana and Baba were opposites. When in a tête-à-tête at times Nana gets so fixated on putting his point across that he unconsciously still rather rudely hardly lets the other person speak. After Nana's long monologues, when he would pause to take a breath, Baba would speak. He was lucky if he got a few sentences in before Nana finished sipping his scotch and got ready to speak again inevitably cutting Baba short. This happened multiple times and I sat there trying to read Baba's expressions, to notice if there was any irritation or anger. But no, nothing. Every time Nana interrupted Baba, he didn't react at all. He just turned to me and smiled. An angelic calm smile. This man had a lot of patience. A quality I don't have at all.

Papa walked in from time to time. He seemed happy. His father who he loved and respected greatly was there along with his sons and father-in law.

The discussion raged on. By now, I had heard both sides and formed my own opinion. Though Nana had made some good points, I was leaning more towards Baba's view. As I explained my opinion, Baba turned toward me nodded his head in affirmation, smiled and said, 'Yes.'

The chicken was ready. I could smell it. The debate ended for the time-being but not before Nana got his last words in. Nana would always have the last say no matter which situation he was in or how many people he was talking to. Hence it is almost impossible to win a verbal battle against him. He does not do this on purpose. He is just like that, full of energy and spark.

I had been keeping for Pontefract for a while now and my glove work had improved. One random training session at QEGS; Jonna, our regular keeper was getting padded up to bat so I took the gloves and started keeping. Clive noticed that I was doing a good job. He walked over and said, 'I never knew you could keep.' 'I just started sir. I have been keeping for a club side' I replied. He went and had a chat with our team management and after a few minutes came and informed me that I was the new keeper.

This move was a little like when Dravid was asked to keep for India to accommodate an extra batsman. I was happy and deep down I also felt safer knowing I have

an extra important job on the team. It would be tougher to drop me now even though I was having an abysmal season with the bat. As it worked out I hit decent form soon after I had donned the keeping gloves for QEGS.

The first match I played as keeper for QEGS was on a horrendous twenty-two yards. I was a tad bit nervous. I remember the first ball I faced. Parki bowled a peach of a delivery which beat the outside edge then climbed sharply and beat me too. Parki ran up, hands on hip in frustration, and yelled 'C'mon, Samar!' Fortunately, those were the only four byes I conceded in that match. Hesitant initially, soon I regained enough confidence to start the traditional trash talking a keeper is obliged to engage in. I got my team to laugh once in a while. A lot of balls were coming through to me. Otherwise wherever fielded elsewhere they would normally be thrown back to me. This was an Australian concept that Clive had introduced. I was always a part of the game, a part of the action.

There are positions in cricket where you could field for a whole forty overs but still get to field only three to four hits. I got more catches and stumpings than anyone else. The standard of my trash talking also improved. Clive walked over to me after the innings and told me, 'Well kept, Samar. If you can keep on this pitch you can keep anywhere.'

Earlier in the season, I would be working on the batting order the night before matches. I would now be thinking up punchlines I could use in the match.

The cricket season was coming to an end. It was time for awards and cricket dinners. My father accompanied me to the QEGS dinner. Mr. Parsons went on stage and said a few words about the season. He touched my heart when he spoke about Addala, praising him and speaking about a cup game he had rescued for us. Chasing a small total our batting order including me had collapsed and Addala batting low down had taken us home with a courageous innings under pressure. I am sure Addala too appreciated these words. There were three awards: one for the best batsman, one for the best bowler and one for the best fielder. I had had a crappy season and I wasn't expecting anything. Eddie got the award for the best batsman; Smithy rightly so got the best bowler award. Parsons went on to say, 'And lastly, with a total of nine catches, four stumpings, three run outs and many runs saved the best fielder award goes to an exceptionally talented young cricketer called Samar Kumar.' Again, I wasn't expecting this but it came with a lot of joy. I took just as much pride in my fielding as I did in my batting. My father congratulated me and we headed back home.

It was now time for the Pontefract awards. While Robbo grabbed most of the honours the most interesting award was for the 'most memorable moment' of the season. Our coach said, 'This was a tough call to make.' He spoke about an incident when our opening bowler had been whacked for a huge six of the first ball. It was a demoralizing piece of action for the whole team. Shoulders had dropped. He said Samar standing behind the stumps broke the silence by saying 'No worries boys that was just a lucky top edge.' The batsman had turned to look at me, to be fair he had

middled the hit and I could see the annoyance in his eyes as he glared at me. I had glared back. My whole team had broken out into laughter. Memorable though it was he went on to say, 'The award will have to go to Ben for claiming a crucial wicket in a cup tie when he removed their best batsman with a ball that glided into middle 'n' leg straightened and spun to take the off stump.' He went on to say, 'Well, Samar said it did anyways.' Everyone laughed.

#13

Tragedy

Summer season was over. There is no time more depressing in the United Kingdom than the winters. To add to the misery they last a good six months and are often interspersed with dull cold showers which make it impossible to go out. It is very cold and very dull. I remember going to school in the dark and by the time I got back it would again be pitch dark. The sun hardly came out. We would see daylight only briefly in school and even that was chilly.

Winters meant less cricket and more rugby. A physical sport that involved a lot of being tackled to the ground which would often be covered partly in sharp frostbitten splinters like a razor's edge. I wasn't into rugby and the sports periods that I used to adore in the summers didn't hold the same charm anymore.

The plan to move back to India had already been made. It was our last few weeks in England. The farewell dinners had started. It was at one of these dinners at Mausi's house where quite a few people had been invited that my

dad got a call that shook him. He was given the worst news he had ever received.

My Dadi, my father's mom, had passed away. Mausi came to get me from downstairs. She was trembling and had tears in her eyes. I felt very nervous. She took me upstairs where my mom and Nani were crying. I turned to look at my father who had no particular expression on his face. Though he seemed stoic I could tell he was in a state of shock and perhaps too paralyzed to react. The terrible news hadn't sunk in yet. I can only imagine the thoughts that were racing through his head. Not only did he have to deal with the news of his beloved mother's death but at the same time had to organize the quickest way for us to return to India so we could say a final good-bye and he as Dadi's son could fulfil the funeral responsibilities.

Papa hadn't told anyone there initially. He had tried to book the tickets and make the necessary arrangements on his own; however he was too taken aback to function so he called his best friend Ganesh Uncle who was also at the party. With a little help from Uncle, the tickets were done and we were to leave in the wee hours of the morning.

On a call from Ara, the phone was handed over to Rauli bua, my dad's youngest sister who was in bad shape and was fainting on and off. All she said was 'Bhaiya.' I was in bed right next to Papa and as soon as he heard Rauli bua crying on the phone, all that pent-up emotion that had been blocked to put up a stoic face burst out exploding into my dad's consciousness. He was a tough man, I had

never seen him cry; but then in that moment, he broke down inconsolably. He leaned over me and howled in pain with tears now flowing at a brisk pace and for the next few minutes no one could stop them. This was the only time he cried in public. Later, he would lock himself in the bathroom and taste his tears alone. My mom and I tried our best to relieve some pain but this was a fruitless endeavour. Maybe he needed to let out his emotion and I guess in a way his reaction numbed the pain of an unfathomable loss, for a little while at least.

It is not easy to deal with the passing away of your mother. It is not something you deal with every day. To be honest, I think he handled himself well. I am sure that the fact Dadi would never hold Sachin was one of the several factors that were going on in Papa's head and inevitably causing pain and melancholy.

I remember going to bed that night feeling sad that we had lost Dadi, a lady who had loved me immensely but I felt even worse seeing my dad in such anguish and with so much misery in his eyes. The rock of a man I had always known for the first time showed signs that he too was just human.

We returned to Ara. I had never seen a dead body from so close in real life not to mention someone I knew so closely. Dadi looked like she was in a calm, peaceful sleep. I touched her feet, which were cold; said a small prayer in my head; and asked her for her blessings. We placed Sachin, who was not even one at that time, next to

Dadi. This would be the closest my baby brother would ever be to his grandmother at least in this life.

In the evening, Dadi was carried to the cremation ground with chants of 'Ram naam Satya hai.' My father had the responsibility of lighting the pyre. He closed his eyes, said his last words and did what he had to do.

The traditional two weeks of funeral rights that are carried out on the death of a family member according to the Hindu customs were performed, my dad had a big role to play in most of them. He took time to let the permanence of the loss sink in. My father was very attached to his mom.

Return plans to India had changed. Since we were going to return in a few months anyway, my parents decided it was pointless for the whole family to go back to England again. My dad made his way back to the UK to organize the return of our belongings and also to formally resign. Mommy and I moved straight to Jamshedpur where both my parents had been offered jobs at Tata Main Hospital. The only downside to this arrangement was that I didn't really get a chance to say good-bye to my friends in England, to my coaches and teachers and to Mr. Parsons.

#14

'B' for Biology

Eleventh grade had started by the time the ICSE results were declared. For the first time in Loyola, we had girls in our class. Excited we all were; what an anti-climax it turned out to be.

I was close to Urvashi, Aarush's sister who was two years senior to us. I also knew a lot of the guys in her batch through cricket. I remember in the tenth grade I used to look up to Urvashi's gang of friends which comprised of a bunch of guys and girls. Sure, some of them were dating; but mostly, it was evident that there was a strong camaraderie that existed within the group. Apart from the odd romance, it was clear that these guys were good friends first.

There was no gender issue. They didn't think twice before using the dirtiest of Hindi abuses in front of one another. There are few things sexier than a chick telling you to fuck off in full desi Hindi. The guys would be just the guys even in front of the girls; hanging out with chicks didn't require them to be transformed into polished, well-mannered and worst of all fake individuals

as is unfortunately so often the case. They listened to the same music, talked about the same movies and so on.

I had hoped that when we make our way to the eleventh grade we would have the same kind of friend circle. Girls you could be friends with. Cute girls who were intelligent was the dream.

There were two guys in Urvashi's group, Rup and Gov both of whom I was close to. The biggest impact they would have on me was that I would inherit their love for music and especially for a band called Pink Floyd of whom I hadn't heard of till then. We were kids starting to think we are growing up; they were the cool seniors who hung out with the cute chicks; we looked up to them.

It was a time when we listened to a lot of Metallica, Iron Maiden, Nirvana and Guns n' Roses … basically classic rock … mixed with the odd song from here and there which Varun short-listed and approved before he played it for us in his car to and fro from tuitions or on the many drives we went on.

'High Hopes' was the first Floyd song I had. I had stumbled upon it, I didn't even know I had it on my computer when it played on shuffle for the first time. It blew me away. I wasn't even high. I had done a school project on Elvis back in England. I had an Elvis top 40 album which I played over and over. There was the odd Doors song too on my playlist. I did not know then that later in college I would spend hours and hours listening to Floyd and the Doors, that as clichéd as it

sounds this music would eventually play a huge role in defining me. At that young age though this kind of music slowly became like a lullaby playing in the background, a familiar and pleasant tune whose lyrics at that time were not researched or dissected. This would change in the later years.

Maybe it is wrong of me to say this but we hardly had any decent girls in our batch; the one or two that looked okay lacked intellect. I am not claiming to be a Brad Pitt or a Stephen Hawking and it would not surprise me one bit if the girls in my batch held a low opinion about me. Even so, it was a precarious situation to be in and perhaps it was one of the many reasons that I got so close to the guys in my section and also my batch.

We hung out in groups but we didn't have a girl to call a friend. In a way, things were very similar to how it was in high school. The guys, just the guys. All the excitement of being in a co-ed atmosphere faded away. One thing was clear, if I was to fall in love at sweet sixteen, I would have to find someone from a different school. I did. Her name was Ritika. This was not a mission; the stars aligned and it just happened.

I did not learn how to be friends with a girl in school and this would haunt me in college too. Unlike a lot of the guys who had the experience of strong relationships and had matured enough to respect women, I would learn this quality the hard way.

Most of my friends from high school had taken pure science and were in the D section while I, in pursuit of a seat in a medical college, had taken biology and was in the B section. Though cricket was my first love I had realized in the ninth grade that I probably didn't have it in me to play at the big level. There was no IPL at that time and it was a big risk to take cricket professionally. You had to be confident that you can make the top eleven players in a country of over a billion individuals and cricket being the only sport that the majority of the people were interested in and played. I had started enjoying human physiology and I decided that I wanted to be a doctor.

In a class of over forty students, I got close to only two guys, Varun 'Gadi' and Vikram 'Guda' who like me were also in the B section. I had known these guys from high school but in the coming two years we became so close that they became brothers. We went to the same tuitions, we hung out in the same clubs and we talked a lot over the phone.

Gadi came from a political family. His Baba was a senior member of the Congress party, a self-made man who had also done well as an entrepreneur.

The guys often took the piss outta Gadi, making blunt shameful jokes about the money he had locked up in his basement or the arms that were present in his house. Of course, these were lies. There was no money hidden in the basement and there were certainly no guns at his house. This did not stop the guys from making hideous accusations on poor Gadi and like I read somewhere, there

can be nothing meaner than a bunch of school-boys in a mischievous mood picking on a kid. Gadi was picked on more than anyone else in the coming two years but there was never any malice. We loved him and he knew this.

Guda was an interesting character with several angles to him. On one front he was very laid-back and his mere presence had a relaxing effect on people around him. He was the kind of guy who I liked to be with when I screwed up an exam or was feeling low. He had a hilarious characteristic laugh that involved not just his face but his whole body which would shake as would his tummy with movements of his hands. It was a joy to see him laugh. Anish had rightly observed that a lot of times when we were hanging out with Guda we tried to say funny things mainly to get Guda to laugh. It was a sight we thoroughly enjoyed.

One of the big things the three of us had in common was our decent ability at cricket and our sheer passion for the game. By the end of the two years the one-tip one-hand short cricket game at my house had become the stuff of legends. Gadi had represented the state team, though we had our own theory on how he got in. I would sledge him mercilessly on this topic whenever he batted. Teams were fixed: it was always Gadi and Guda against me and Jevin 'Sardar.' Jokes aside, Gadi was a solid all-rounder on the big field and he probably deserved to be on the state team.

There were hardly any guys in my class who I really wanted to be friends with either. Guda and Gadi felt

the same way, so naturally, we bonded a lot. In a very short period we became a supertight trio. We planned everything together; which tuition to bunk or when to bunk school to stay back and study. I guess there were two other guys, Bhanu and Tarun, who we got on ok with.

According to opinion polls general perception was that there were two girls in our section who qualified as decent looking; Alia and Priety. Bhanu had liked Priety from before however she chose to date a Bengali boy who was a renowned student and a 90+ holder. I felt this decision was pushed through by Priety's mom who treated Ansh like royalty. I can't say I think it's a good approach to healthy parenting. Ansh had been an ace student, an intelligent boy who had never come below rank one in his whole school life which involved some years in fiercely competitive classes. I was with him in high school. He didn't just come first. He didn't even seem to have to try. In a list where the difference between the second ranker and the seventh ranker used to be a meager 2 marks or so, Ansh led the closest competition by a whopping 20 marks or more.

I don't know what that girl did to him but in the first terminal physics exams the great Ansh scored 21%. People were surprised. He never really recovered after those papers academically. The once perennial topper had managed to flunk in multiple subjects. His marks never improved. Priety dumped Ansh. Who knows if her mom was involved?! She started dating Bhanu.

This relationship would last into college but would end abruptly.

Gadi would come to my house first and ask me to call Guda as soon as I got into the car; a white Santro that had been delivered to him with a red ribbon on his birthday, a gift from his Baba. A few months later, we genuinely began to consider Gadi's car as our own. I almost always sat on the front seat next to Gadi. Guda's house was less than a five-minute drive away. We always picked him up first. He would invariably be waiting outside by the time we reached his place.

I suppose one other common factor between us was that we always had plenty of money. All our parents were lenient in this aspect and this was important because we became seasoned foodies and would eat out a lot. City Café and the local CCD were our primary hangout locations.

We always sat together. In a mob of a class that often only functioned under their leader a guy called Shashmit, we three—Guda, Gadi and I—were an autonomous body. Along with Alia and Tarun and a few other people we sat on the left side of the class and soon our class-mates labeled us 'Leftists.' Their main problem was with me. I was a cocky, arrogant person back then. Our class teacher was my neighbour Jenny mam and though she never favoured me directly when it came to stuff like grading, she was very helpful otherwise. This very obvious in-your-face fact also pissed them off.

Jenny mam knew I was studying hard for the medical entrance tests and wouldn't inquest into why I bunked school so often. Many class teachers like the D section math Sir Nima sent the student to the principal with a note if he had taken a leave without informing. Jenny mam never had these stupid demands. After all, we weren't kids anymore; being sent to the principal for trivial matters really didn't seem right. Nima was a good math teacher though he was the kind of guy who tried very hard not to accept change. As a result his attitude didn't change either. He clung onto old-fashioned approaches to education and demanded discipline. I wish I could tell him, 'Take it easy, man.'

It was a big call to make at this time to decide which tuitions to join. Most of my friends had initially joined Tanki IIT coaching including Guda and Gadi. This wasn't the usual one-hour teaching class. Tanki used to last from 9 am to 7 pm on weekends and from 2 pm to 8 pm on school days. It would drain the soul out of the kids who attended these classes.

There was no respite. Many people would drop out in a few weeks. The hours were just too long. I remember when my friends went to Tanki; I would get up, study for a while, take a shower, have breakfast … study some more, have lunch, take an afternoon siesta, get up and maybe play a quick game of football. All this while my friends would be crammed up at coaching, trying to grasp concepts that to be honest were quite a few degrees above and more complex than what we had studied in high school.

The first tuitions I joined were for chemistry. The teacher PM had a good reputation. Urvashi and her friends too had gone for PM's classes. I knew in just a week or so that he was a very good teacher. A young man maybe around 30 years of age, he taught classes that would be interactive, fun and most importantly, informative. He would clear complex concepts like achirality with real life examples making it easier for us to remember and imbibe.

Priety was the only known face at PM's classes when I walked in. She was talking to a girl. They turned toward me as I walked up to them to say hi. Priety introduced me to Ritika. Priety and Ritika were in the same school till the tenth grade; our sister school Sacred Heart Convent. Priety moved to Loyola while Ritika stayed back at Convent. We made little talk for a while before class started. We sat together, Priety in the middle. I didn't get to talk much to Ritika that day. She was cute and had very innocent eyes. A comforting smile, a graceful peace on the surface but with some hidden hurt buried inside. She was the kind of girl I liked, the kind that made me curious. She wasn't into rock music nor followed any sport but still we instantly struck a chord, or maybe we were just too fuckin young; too fuckin sixteen.

God helped me in the next class. There was a massive thunderstorm and a few students including Priety did not attend. Luckily, Ritika was there as was I. We were drenched. We sat together and started talking. We didn't have Priety to sit between us. Missing that class is probably the nicest thing Priety has done for me albeit unknowingly. Random conversation mixed with a little

careful flirting and the odd joke thrown in; and Ritika when she smiled; life seemed simple.

She didn't speak much but when she did she spoke a lot of sense. She was a child … so was I. We talked for a while before PM came and started class. We tried to concentrate and take notes for five minutes or so. But it seemed clear that Ritika and me were both attracted to each other and we found it near impossible to pay attention to the Mole theory or whatever was being taught. Sitting on the back bench, Ritika and I started talking again. We talked nonstop for the whole one and a half hour class.

A couple of weeks later, a whole group of us from the tuition went for a movie Hum Tum, a Hindi movie based on the concept of Harry Met Sally, underlining the fact that a boy and girl could never be 'friends.' Again, there were people sitting between Ritika and me. It was our first movie together.

Soon, numbers were exchanged and we both affected the historic birth of talking endlessly through the night. A habit that would never leave me. There was so much to talk about, so many stories to share. Every minute we talked the closer I got to her. Ritz was a good listener. I spoke a lot; she heard tirelessly everything I had to say. She never got bored. She hardly ever asked to hang up the call before me. Several times I would fall asleep on the phone while talking to her in the wee hours of the morning and she would make all kinds of noises to wake me up. Sometimes they worked and sometimes they didn't.

Whenever the trio of Guda, Gadi and me were together in Gadi's car which was almost every evening first we decided who else to pick up. We were comfortable with maximum four members. We did not like being squashed up. The choice would often be between Sardar and Neel.

Sardar had taken commerce in the +2; however he had been in my section in the tenth grade and so I knew him pretty well. We started as a couple of guys who coincidentally sat together in class; slowly the friendship grew; and by the end of the twelfth grade he was one of my closest friends. We had plenty of comedians in our friend circle. Sardar was one of them. He was a natural with slapstick kind of humour. When in flight and in form there was no one who could stop the guy.

Sardar was an exceptionally talented individual; he played the guitar, he was a good painter and camouflaged in his short frame of cuteness he was a charmer who had a way with the ladies. Like me, Sardar was also never out of stock to make nonstop nonsense conversation, which most times had us who were listening to him in splits. Sardar was a good speaker and had good command over the English language. Though he never admits it, he almost always wears a fake accent especially in front of chicks. There is a Friends episode in which Ross uses a fake accent and Rachel makes jokes about it. I often used Rachel's lines at Ross for Sardar. I was the one who first got the guys to notice this about Sardar. We never missed an opportunity to take the piss out of him on this issue. God knows he deserved it, considering the millions of times he had done the same to other individuals.

Neel, along with Anish and to an extent Tushit, were the only ones who could counter Sardar.

Neel was very quick on his feet, he gave the quickest and most mercurial comebacks. Most people couldn't recover, not even Sardar. However, it was not always one-way traffic. Sardar too had his times on top against Neel. No time freakier than when Sardar pulled Neel's pants down outside a restaurant while we were in college. It was a busy setting near the bus stand and on the main road. There were easily more than two hundred people standing there and a lot of them saw Neel stark naked. Some seemed dumbstruck; some held their hands on their mouth finding it hard to believe what they had just seen. We were adult kids at this time not some toddlers. Neel didn't get pissed at all.

It was the kind of thing that only Sardar could do and get away with. He looked so innocent that people generally couldn't stay angry at him for long. Neel later told me that as he felt his pants pulled down and instinctively noted some of the expressions people around him had and heard his friends including me laughing hysterically; he said all that wasn't so bad. He said the real low point and maximum embarrassment of the whole incident was when he had to bend down casually and in the palpable view of everyone around him had to pull his pants back up. I guess there are the times when you wish you had worn your underwear. Neel seemed a little shocked only for a little while and by the time we got in the car he was smiling and okay and calling Sardar a MoFo! He said he would have his revenge.

Neel too, like Sardar, was in the school band. He was a good vocalist and played rhythm guitar. Akshit was on drums. Neel and Sardar lived close by and spent a lot of time hanging out together, taking long walks in the night and bonding on music.

Obviously, they would hang out with us a lot also. It was routine to load up in Gadi's car after the 5:30–7:00 pm tuition and drive around the small pretty town listening to good music, stopping by at cigarette shops to purchase Amul Kool milkshakes while people around us puffed on their smokes. Often we went to either Beldih or another club called United Club to stuff ourselves with junk food.

I was very focused in my aim to crack a medical college entrance exam. For this, I did not need maths; as the entrance paper consisted of only three subjects: physics, chemistry and biology. Unfortunately, Loyola did not at that time allow a science student to drop math. The twelfth boards were not that important (the medical entrance tests had nothing to do with board marks) in my endeavour but still again allowed you to fuck up one subject without it affecting your percentage. While this subject had been Hindi in the tenth grade, I was sure it would be math this time around.

I only studied math very close to the exam. I had to spend a lot of time mugging subjects that would decide my future and at the same time not compromise on the fun or masti of hanging out with my friends or playing football in the local park. I was not going to waste time reading a subject that would hold no importance in my

life. Besides, I didn't really enjoy math. My dad was open to my view and understood the logic behind it. The only request he made was that I at least try to get passing marks on the paper.

I would score a decent 88% average in the twelfth-grade boards, an exam that was very different from the pre-medical test I was preparing for. My mark sheet looked odd; there were a few high 80s, a 92 in biology and then the Elephant in the room, math, with a score of 55 percent. It stood out between the boring 80s. It also meant I had cleared the subject as the passing marks were 40%. To be honest, it was a very easy paper and this was probably why I had managed to pass. Of the twenty or so chapters in the syllabus, I was confident only in probability, basic calculus and statistics. The rest of the marks I scored were hit-and-hope efforts and I am lucky I had enough hits to pass.

Earlier on towards the end of eleventh grade I had joined math tuitions at Nimas. The idea being that it would help me pass the pointless paper without me having to put in much effort. These tuitions would be from 7 to 8 pm. Three days a week. There was a one-hour window period between chemistry tuition and math on these days. This would be the time we would hang out—Guda, Gadi and me. I was punctual initially but later started bunking a few times the math tuition to spend more time with my friends. Nima didn't seem to mind. He knew math was not important for me.

We spent a lot of time hogging diverse meals and desserts at a quiet classy place called City Café. All the staff and waiters who worked there knew us well. On some occasions when we had ate more than our collective budget permitted, the manager allowed us to pay the remainder the next time we came. This was not a chai-cigarette shop where 'credit' or 'udhari' was a common feature. This was a café situated in an elite hotel. And the fact that we were accepted on a credit basis meant that they trusted us. A lot of the time when Sardar and Neel were in full flight even the waiters couldn't stop themselves from laughing. Again, during these times, the jokes cracked would be funny but more pleasure would be derived from observing Guda's characteristic shaking laugh.

I don't know the details about the financial assets of Gadi's family but money was certainly not an issue. We spent hours and hours just driving around in his car—and I mean countless hours without fail every day. He never even spoke of the petrol we burnt up for fucks, roaming around in elaborate circles with no destination in mind. Let alone ever asking us to contribute to the fuel cost. Quite clearly for us, the road was home. He was his Baba's blue-eyed boy, the only one among his cousins who was genuinely a text-book good kid.

Perhaps it was fate that Gadi who was the personification of what most women seemed to want didn't get into a relationship for years. However, his time would come, eventually; first though he would have to break out of his shell.

Like I mentioned before, on these drives, we would listen exclusively to tracks hand-picked by Gadi. Though we never showered praise or even appreciation at Gadi for this, deep down we all respected his choice in music. There are literally hundreds of tracks on my playlist today that were first introduced to me by him. He had a refined taste in music. He was almost a connoisseur.

He was the kind of guy that parents generally liked. There was a safety and calmness in his demeanour. My mom told me several times that if it wasn't for Gadi I would have missed half the tuition classes I attended. I would often stay up till late in the night and after school I would jump into bed and go into very deep sleep. Gadi routinely came to my house half an hour before class and initiated the long process of waking me up. He would shout and shove me till I opened my eyes. I would go back to sleep. He would let me snooze. Then he would find tracks on my computer that even I wasn't aware of and play them on full volume. He had different tracks for different occasions and moods. To wake me up he would usually play fast positive numbers. Slowly, I would regain consciousness, change my clothes and head of with him for tuitions. Mommy was right. If it wasn't for Gadi, I really would have slept through most classes.

Gadi hated the cacophony that was invariably present in town and on busy roads, the sound of mindless honking by frustrated drivers. Most of all, he didn't want to disrespect the music by spoiling the charm with loud irritating noise coming from outside. So engine on, AC on, windows pulled up, we sat all the time except when

we went into the wild. The only request Gadi made was that we keep the car clean and we did that.

We went home when we wanted to. We went home if we wanted to study. We hardly ever got calls to call us back.

At the tender age of 16, we had the kind of freedom that most kids only experience in college. We didn't misuse this trust; I guess you could say we were good kids. We were focused and when we had to, we studied hard.

My parents had only one demand; I could do anything, buy the most expensive technology, stay out of the house for hours and go on drives at 4 am just as long as I didn't screw up my academic performance. And I didn't. Unlike most parents in India who pressured their wards to inhuman levels of cramming, my parents realized that apart from the books I should also experience the joy of being young and free.

However, if at all my dad ever felt that my studies were being neglected, he would get me back on track; sometimes he would have to be a little stern. Fun aside, it was clear to me that cracking that medical seat was the priority. I worked hard for it. No matter what time I got back after tuitions I would almost always put in a few good hours of hard-core cramming into the night.

Gadi's study schedule was a little different. He was one of those weird individuals who found it easier to get up early in the morning rather than stay up late. Often, I would be getting ready for bed after a long night when at the

same time Gadi would be getting up to cram. I had the responsibility to call him and wake him up around 4 am. Guda, laid-back as he was, never really pushed himself like Gadi and me. He studied when he felt like it. He was intelligent, so he did okay.

Rashmi was the only girl in our class who I came close to being friends with. I had briefly liked her in the tenth grade. She came to the same computer tuitions as me. She had Priety Zinita's dimples (but not the intellect; nor was she a snorter). Bhanu the prick had gone and told her about my crush. I guess she developed a liking for me too. We talked on the phone. But by the time she joined Loyola my crush had faded and I was just not that into her anymore. It was a tricky position to be in because for a while she continued to believe I still had feelings for her. My behaviour too naturally changed. I called her less. I spent less time with her in school.

Sarita was another who for a while I thought I could be friends with. She had worse teeth than me and I have really bad teeth. However, I tried hard to not let this affect me. Sarita once invited Bharat and me over to her house for dinner. Her friends from Convent, Shalini and Dona, were also there. Dona, in very relative terms, was hot. Bharat was gaga over her. Bharat, in fact, was the prime example of how a guy can transform into a 'woman' to get female attention. He was desperate. (That's okay. We all were in a way—biology and hormones.) He was hitting on Rashmi too.

Supposedly a sports enthusiast, Bharat no longer played football with us in free periods; he spent this time sucking up to the girls in class. We would walk into class tired and sweaty to see Bharat sitting with a bunch of girls, sometimes playing antakshiri or making small talk. He would have this gay smile on his face. Imtiaz was right. The girls weren't Victoria's Secret models either. I had always had my reservations about the guy but this sudden change in personality surprised me and to be honest disappointed me. 'To each his own,' I guess.

As for Sarita, I lost interest in her mainly for two reasons. One that she started dating a guy I heavily disliked, a guy called Ankit in my class. I mean the guy looked okay but had a medically moronic IQ. Every moment of his day was an attempt to look cool. He cracked the silliest of jokes, many times when class was in progress. He tried so hard to be funny that you almost felt bad for the guy. Sarita, when quizzed as to why she started dating Ankit said, 'I love his sense of humour.' I was there. Call me judgmental but in that moment I lost almost all regard I had for her.

And to put the final nail in the coffin; Guda, Gadi and me had the misfortune to see her eat. We had taken her to United Club and had ordered sufficient amounts of food. I will never forget how she almost jumped on the chicken cutlets, prawn chilly and dhamaka sandwiches. She devoured the food like a lunatic who hadn't eaten for days. She took piece after piece and stuffed it in her mouth even when it was full. I am not a sexist and I have seen all sorts of weirdos eat messy including myself; but

I have never seen anyone not even the homeless eat the way she did. We hardly got anything by the time she was done which was okay for me because after seeing Sarita, I felt like puking. We dropped her back and I made sure I never ate a meal with her or even be present when she was eating hers.

Gadi and I joined physics tuitions with a teacher called Banerjee Sir. He had taught Priety's mom ages ago; so obviously Priety was also one of the members of the tuition along with Rashmi, Chulu and Prachi. Priety, like I mentioned before was dating Bhanu, my friend and also a very able goalkeeper for the school team. Prachi, who was Rashmi's best friend was also quickly captured by Chulu. All this hardly mattered to me. Banerjee Sir was an excellent teacher. He made physics interesting. He was integral in making me confident at using calculus which helped me not only in physics but also in math.

The other decent-looking girl in my class at school was Alia; however she hardly ever talked to any guys, especially good-looking guys. It was a defense mechanism. She was smart. One time I was blabbering on about something in class. Alia turned to me and said, 'Samar, do you have to hit a word count every day?' I had no comeback. I was impressed. Though she had no intentions of being a friend, I still respected her wit and intelligence.

The Rashmi conundrum thankfully ended soon, at least for the time being. She didn't fall for Bharat, which was a

good thing. She started dating Tarun who was a nice guy and the perennial top ranker in our class. I felt relieved.

We started playing one-tip one-hand short cricket in a reasonably large space attached to my house. We played very seriously and took no prisoners. The teams were fixed. We played at any given opportunity; early in the morning, after school, in the evenings.

Sometimes we played individually and we started a trend which meant the person who made the lowest score would have to give a treat to the whole bunch at City Café. Poor Gadi—although a decent player, always batted in the midst of so much pressure, under heavy heartless sledging, with constant abuses being hurled at him that all this often made him end up coming last. He would then have to shell out cash to satisfy the appetite of guys who he probably hated in those moments. Such was the irony.

My house had become a hangout hub of sorts. Situated centrally and with lenient parents my friends felt comfortable. Cold coffee was a speciality and it tasted even nicer after a long tiring game of cricket in the mid-day heat. Hot crispy pakauris were a delicacy often enjoyed in the monsoon season when we came back drenched and exhausted after playing football.

While I would stay up all night to study when exams were close; like I said, Gadi followed a different routine. His most productive period would be from 4 am to 10 am. Sardar and Guda would not get up that early to

study. I would be the one who would be frantic as the sun rose. Satisfied with a night of toil I now had to convince the boys to come to my house and play cricket. Sardar and Guda never said no. The only condition they put forward was that Gadi too had to come. Gadi tried his best to resist but often succumbed to the perseverance and directness of our approach. Not only did Gadi have to sacrifice crucial study time to be with us but once he reached Sardar and me often took the piss out of him for being an idiot and not studying. This was mean of us but we were only kidding.

It was around this time I saw the movie The Godfather. Toward the end Al Pacino who played 'Michael' has a gripping scene in which he warns 'Fredo,' his brother, to never speak ill about the family in public; a thought occurred to me.

The next day I told all our close friends about the concept of a neo-family which I planned to introduce. It was simple; our whole friend circle—in fact, the whole world—was considered a huge gigantic family. All creatures, all except one, was a part of this family and this odd one out was Gadi.

This basically meant that everyone was effectively against Gadi pretty much all the time (at least jokingly). He was the first and often the only target of jokes. When focus did shift from him for a while and someone else was in the firing line even if we caught so much as a little smile on Gadi's face, everyone would revert to taking the piss out of Gadi. The rules were stringent. Gadi was not

allowed to enjoy other people being insulted; and when he did, he was offending every one of us, the whole family. We would come down hard on him. What started off as a little prank I had thought of became serious omerta. Rarely Gadi would hit back, maybe win a cricket game or two, even respond with a solid comeback. But this was very rare.

I had started falling for Ritika well and proper. Baby love. We talked for endless hours night after night. It was a shame that she hadn't joined Loyola. I would have loved to spend more time with her. She had a soothing vibe about her at all times; the way she talked, the way she smiled and how comfortable I felt in her marshmallow embrace.

For a while I controlled my urge to tell her how I felt about her. We took refuge for a bit in the comfort of being friends instead of having to deal with the melodrama and inevitable gossip that scathed a couple who were labeled of having a romantic relationship. No one was ever really interested in a boring friendship which suited us initially, especially Ritz. They needed masala. Ritz hated all the fakeness and the shebang that came with it.

Ritika tried her best to maintain a platonic relationship with me.

This carried on until one day after coming back from a party I couldn't help but tell Ritz that I was in love with her. I think she was expecting this; and though she didn't convey that she felt the same way for almost

a year I knew deep down she felt happy. I spent months thereafter trying to convince her that we were lovers, not friends. She had a big problem with terms like girlfriend or boyfriend which to her sounded lame. I agreed.

She told me straight up that she was never going to be my girlfriend but she didn't rule out the possibility of love and a relationship.

I soon got frustrated at the fact that my feelings for Ritz seemed to be one-sided. I would proclaim my love for her every time we talked, while she never even hinted that she felt the same way. I thought or hoped that she may be feeling what I felt. Even if she did, she kept it to herself till way later. This frustration was responsible for me losing patience. I told Ritz I love her and I want to be with her but this 'friend' tag would have to go. She would have to commit to something she hated, a romantic relationship. I told her that I did not have it in me to be 'friends' with her anymore. I liked her way too much for that. She had two options; either to accept our relationship or we stopped talking completely. We had become attached to each other and I knew this would be difficult.

We didn't talk for a week or so. I got a call in the evening. It was Ritz and she broke down as soon as I said hello. She said she would not be able to cut me out from her life and begged that we continue talking. I had made a strong resolve to not succumb or modify my demands; however hearing little Ritz cry, my heart melted and we started talking again.

It was a hormonal relationship. We fought a lot, we laughed, we cried. Another incident that comes to mind was when after a big fight I had told her that we would never talk again. I slammed the phone. And since I had been up all night the day before I went into heavy slumber.

I woke up a few hours later to see some forty missed calls from Ritz on my phone and our house-maid told me she had called several times on the home number too. I called her back. She didn't sound okay and she didn't say much. She just told me to come to Beldih Club in five minutes, that she needed to talk face-to-face.

We made our way to the Beldih lounge which was empty at that time. I could tell she had been crying. Unlike me who was very open about my moods or emotions Ritz was the kind of girl who suffered alone and hardly ever sought empathy from even her closest friends or me for that matter. She seemed like a tender, soft, sweet chubby baby girl; but inside her mind she was very strong—much stronger than me— and this strength was interwoven with heartwarming innocence. She leaned toward me looked into my eyes and out of the blue and very much out of character slapped me across my face hard. She said, 'Don't ever do that to me again!' I can't explain how good I felt instantly because this slap meant that she really liked me and was not going to let go easily. It was the first and till now the only time I had been slapped by a girl, a girl I was in love with, it felt amazing. We hung out at the club for a while before returning home. That night we talked till sunrise.

One day I was talking to Ritz on the home phone in the afternoon before chemistry tuitions. We were flirting. She said, 'But I am a silly girl.' I replied, 'I like silly girls.' A few minutes after I hung up and was about to leave for class my mom asked me who I was on the phone with. I didn't suspect anything and I told her I was speaking to Ritika. She didn't say anything and I left.

Later that night when my parents came back from a party and my dad was a little tipsy, he asked me, 'So, Samar, I heard you like silly girls.' I went red and turned around to look at Mom who was standing behind me. She was trying to control her laugh and viciously signaling my dad to not embarrass me any further. It was obvious that Mommy had overheard bits of my conversation with Ritz on the phone in her room and told my dad. I didn't say anything. I walked back to my room feeling very awkward. I was still young and immature. The fact that my parents now knew a little about my love life made me feel uncomfortable.

Intense studying was in swing. Whereas most of my friends including the class topper Tarun bought books which were written mainly for the board exams, papers that hardly mattered for me, books that provided insufficient knowledge to prepare for the competitive PMTs. I bought competition oriented books so I would be ready to fight it out with lakhs of students who appeared for medical entrance exams.

Tarun was also aspiring to earn a medical seat but he was not as focused as me. It was unclear to judge what his

priorities really were. His rank in class or performance in the boards mattered more to him despite what he said. He did not believe in neglecting a subject even though he knew that to qualify for medicine you didn't really need math or even english for that matter. All subjects were important for him. I scored a little less in the school exams but it didn't affect me because I knew I had to spend considerable time on topics that were not in the school portion but were important in the competitive exams.

Tarun probably put in more hours than me and topped in every single terminal but unlike me he didn't get through to a medical college. His ranks in all the entrances we gave were consistently below mine. To make things worse he didn't hit the 90 mark in the twelfth boards. He scored 89.25 %, which was a lot less than what students and teachers alike were expecting from him. He was shattered. I felt for him; he was a bright kid and had worked really hard but was just plain unlucky I guess. He deserved more.

The nights I spent burning the midnight lamp sitting on my table and mugging were adventurous and enjoyable. I listened to a lot of music in breaks and sometimes even played songs on low volume while I studied. There was a fixed pattern; I would sit down around 11 pm and study till around 5 am. When Ritz was up I would talk to her in breaks. I was selfish because I would usually talk to her only when I wanted to—when I wasn't studying. I didn't hide this from Ritz and most times she understood my behaviour. She wanted me to do well and that was more

important to her. She was smarter than me and she didn't study as much.

I qualified for a very decent med school. My rank was borderline. And such was the competition that even if I had scored 1 less mcq I would not have made it and would have probably had to become a dentist.

My dad would sometimes help with certain chapters but more importantly see to it that I don't lose focus. A line he often said was 'Purpose is the greatest motivator,' and he was right. I studied not by force nor compulsion but with inner passion and drive. The competitive exams quite simply were a process of elimination. Most students who sat for these exams had sacrificed few of the best years of life cramming and putting in unbelievable hours day in and day out.

The road to glory was long, tough and often painful. But I held my own; I saw to it that I was very much in the race and by the end had more than a puncher's chance. Ritz was a big support during these times especially when I felt a little low. She would pump me up and make me feel better. She would say that I was her James Bond and if I put my mind to it I could do anything. I loved her. She never said no when I wanted to talk or unwind no matter what she was doing. She really was the sweetest of sweethearts and she cared for me deeply.

#15

In class; Corny to be Horny

There were two girls in my whole batch at Loyola who were unquestionably beautiful and bordering on hotness. Neither were in my section. One was Krisha who was in the pure science 'D' section and the other called Saloni who was in the 'C' section with Sardar.

Kaushik, though an average-looking guy certainly had the ability to attempt and succeed in pulling off things that most people would not even imagine. He had guts and self-confidence and was a fine plotter.

After a couple of weeks the class teachers randomly mixed up the seating arrangement. This was to get the section to gel as initially all the girls sat clustered together and there was minimal interaction with the rest of the class. Kaushik was Nima's favourite student. It was quite a sight to see him working on teachers, sucking up to them ever so subtly and getting them to do what he wanted.

Nima was not the first teacher who Kaushik charmed with his pleasant yet inherently sham behaviour. I had seen him do the same the year before to get our English

149

teacher to unfairly give him a few extra marks that he needed to secure the first rank in class. He had shooed me away on that occasion. He needed alone time to lie without losing face.

The most disappointing aspect of his character however was that he lied frequently to both Chulu and me. We were supposed to be his best friends. And he was so clever in weaving his magic that we would often not know that he had lied to us. We shared everything on those three-way calls did Chulu and me while it seemed that Kaushik even planned out these conversations. What to say and when to say it. His false confessions would be mixed with just the right amount of truth so we didn't doubt his story. There was a time when pretty much our whole batch had turned against him. Only Chulu and me stood by his side and even then he lied to us.

On the eve of the shuffle of the seating arrangement Chulu mentioned a thought to Kaushik and me that most students in the D section had in their minds: 'I have a 1/40 chance of sitting with Krisha.' Kaushik smiled and replied, 'Watch me make this a 1/1 chance for me!'

He used his leverage over Nima and disguised his personal interest in a mathematical equation that he had come up with and which could be used to 'randomly' assort the class. Nima agreed and after rearranging rows and columns using a method that was supposed to be unbiased, Krisha sat on Kaushik's table. The class was stunned and shocked, mainly jealous. Only Kaushik could have pulled this off and Nima was either too thick

skinned to notice or didn't mind that he had been fooled. Chulu and I were beyond impressed and were happy for him. Krisha initially gave him the cold shoulder and didn't seem too glad as to what he had done. However, Kaushik was a fine plotter and it took him less than three days with arguably the hottest chick in the batch to seal the deal. He started dating Krisha amid all kinds of speculation.

Kaushik had wrapped up his master play so soon that most of the players or wannabe players in the batch had no other option but to pursue Saloni. Chulu, who was an ace dancer, had met Saloni who also danced when they were preparing for a school fest together. He had been fast in making a move on her (the fact that he was already dating Prachi was not an issue; we were 16; Saloni was hotter and that is all that mattered then) and she had accepted his interest and shown that she too was into him. I was the first person Chulu had shared this news with. I was very happy for him. Saloni was genuinely beautiful.

The next day was a controversial one. Tushit had also been interested in Saloni and talked to her once in a while. Rumours spread fast in school and Tushit knew that Saloni had said 'Yes' to Chulu. On questioning her, Saloni bluntly denied any such claim and basically accused Chulu of lying. Chulu was a very straightforward and honest guy and I couldn't think of any reason why he would lie. Tushit brainwashed me to an extent and tried to convince me that Chulu was lying. It was hard not to be affected by this and to be honest I didn't know which

party to side with. Chulu called that night and we had a long emotional talk. He was clearly hurt.

Tushit talked to Saloni for a few weeks but soon she started ignoring him too. I was summoned to speak to her and try to ascertain why she was doing what she was doing. The little rift between Tushit and Chulu had now ended and they were united in their common hate for Saloni. I walked up to her in an aggressive mood to demand answers and have a go at her for messing with the minds of some of my closest friends. Standing in front of her though I forgot everything, looking into those big black eyes, I spent the next five minutes flirting with her.

Later in college, she would tell me that she had a crush on me in school. But she told many things to many people and then denied them bluntly. Still, I was happy.

A few weeks later Sardar who was in her class and had been given the responsibility to play Cupid to help Tushit saw an opening for himself and started dating her.

Kaushik and Krisha, now almost inseparable, went on to break all kinds of social norms and boundaries that existed in school. Kaushik would always be with her, through class and in breaks and also at Tanki coaching classes. He stopped even speaking to anyone else; let alone hanging out with us. He was extremely possessive.

Soon people in his section observed on several occasions Krisha and Kaushik having their hands in questionable positions during class. It really was very 'corny to be

horny' in class. In breaks they would make their way to the top floor next to the chemistry lab and indulge in a very physical relationship. Usually, Kaushik would take his trusted devotee Murmu up with him and tell him to keep guard to see if any teachers or students were coming. I can understand this setting on an odd occasion or two but this happened every day. Every day Murmu sacrificed his break and spent that time looking out for Kaushik.

For a long time I did not believe these stories about Kaushik and Krisha, primarily because he denied them vehemently when I talked to him. I still trusted him at that time. But slowly more and more people reported sightings of them in class indulging in physical activity; and when Chulu told me he too had seen them in action I had no other option but to believe him. It didn't take long for the teachers to also become aware that something wrong was going on and while they tried to put an end to this Nima had the final word being the class teacher and he supported Kaushik blindly.

There was a guy in my class called Ritesh who had the reputation of being a good student. I thought it may be helpful to study with him especially since almost everyone else had joined Tanki coaching. One day his parents were going out of town and he asked if he could stay over at my place. I was happy. I thought we would study seriously. And we did until about 2 am.

Thereafter, what he said freaked me out and sent chills down my spine. A typical goodie-tushu boy, he suddenly out of nowhere started talking to me about pornography.

I felt a little uncomfortable. Then he suggested that we go to the bathroom and masturbate together. I was shocked and for a while I couldn't tell if he was serious or joking. Unfortunately, he wasn't joking. He tried to convince me by saying this was the only way we would get a true feeling of sex. I told him as politely as I could that I was not gay. He replied, saying, 'It is not gay, Samar. It is bisexuality.' I was scared and I didn't know what the fuck to do.

I told him its best we go to sleep. I couldn't wait for morning to come when he would have to leave. I woke up for a while around 5 am when I felt Ritesh quietly move his hand on my ass. I instinctively turned around and punched him as hard as I could. I could hardly sleep after that and I counted down time till 7 am when he left. I never spoke to the weirdo again. But I told my friends about what had happened and Anish who went to the same tuition as Ritesh took the piss out of him over the next two years. He would jump up if Ritesh so much as sat next to him and change seats saying he felt unsafe. Ritesh was textbook gay. He wore glasses with a pink tint, got the gayest haircuts and had a hobby of growing his fingernails. I do not have a problem with homosexuals per se just as long as they don't cross certain boundaries in the way they approach people. Ritesh was definitely guilty of doing that.

It was a fucked up situation to be in where one of my close friends Kaushik was getting blown in school by a hottie and I on the other hand was being offered hand-jobs at my house by a fuckin homo. Ye gods!!!

I realized that I was susceptible to mood swings which a lot of times depended on how my studies were going. This susceptibility would prove costly in later college years. I would easily get depressed and feel very low if I didn't study well for a few days for whatever reason. One incident comes to mind in which I had accidentally skipped a question on a school physics paper. It was only worth 4 marks and the paper itself was not really that important. Still, I was in tears when I reached home and I found it almost impossible to study for the next test. Little things like this would really get to me.

I was pushing the limits when it came to my sleep cycle. I would stay up when everyone was sleeping. If I stayed up all night, I would sometimes go roller-blading around the town early morning just to release pent-up energy. I did all kinds of weird things. On many occasions I woke up at absurd times. Waking up when it's dark, around 7 pm, when you went to sleep around 2 in the afternoon would usually be accompanied with a sense of doom and depression. Sometimes I would hardly sleep for days and then suddenly fall asleep for more than twenty hours at a stretch. One time I managed to sleep the whole twenty-four-hour day. I would have no idea about which day I went to sleep and on which day I got up. I had no proper orientation of time or date. I was flirting with madness and loving it.

There was a time when my exams were a couple of weeks away and my family had gone out of town and I was living alone. My sleep cycle had become completely reversed. After a few days of pulling all-nighters and catching sleep

in the day it became a habit I could no longer control. I had to normalize my schedule mainly to accommodate the exams which I would have to give in the day. The time I slept. I tried taking sleeping pills at night but they were of no use; no cell in my body was ready to sleep at this time. I tried to struggle through the day without sleeping. I even gave up studying just so I could stay up throughout and hence be able to sleep at night. This attempt too was in vain.

I got super depressed and irritable; it took me a good ten days to marginally normalize my sleep schedule. These ten or so days were the first time I felt proper depression and helplessness for a considerable time period. The only saving grace was that I was going through all this by choice and with only one intention in my mind to do well academically.

There is a time when you are pulling an all-nighter when you feel really hungry usually around 2 am. I was lucky that our fridge would be stocked up with food. Many times there would be leftover chicken and I would hog shamelessly with bread. Other times there would be chocolate Nutella which again I used to devour with bread. Late-night hunger is such that even if there is no quality food you feel satisfied with and are able to enjoy items you usually avoid eating. Besides food, I would make sure our maid made and kept at least eight to ten cups of coffee for the night to come (the coffee would be kept in a huge metallic 'dekchi' container).

The best-case scenario would be when I stayed up all night studying, made a few calls in the morning and got my friends to come over pick me up and go on long drives, talking about life and having special 'chai' at some discreet tea shop. Sometimes it was Gadi who got his car while sometimes it was Tushit. I had also started driving by this age and though I wasn't confident in heavy traffic I would often take my car out in the early mornings when very few vehicles were on the road.

Bhuvaneshwari mandir was one of our favourite locations to drive to. Not because we were overly religious but because the drive was very scenic and the place itself surreal and awe inspiring. When we went there at night you could see the whole of Jamshedpur as it was on a hill. The steel works along with a lighted city. It really used to be quite a sight.

Sometimes I would wake my parents up around 5 am when my dad had to go for golf. I remember once I walked into their room said good morning and then spoke nonstop for a while. They were snoozing and comfy in bed but still they were listening to me. Instinctively, I then asked them 'Do you know why I am speaking so much?' They said no. I told them it was because I had been up all night alone and hadn't talked to anyone for hours so I felt an innate need to speak. They laughed out. I was good at this. When I was happy, I kept people around me happy. I made them laugh. When, I was happy.

Football still raged on in my heart and soul. Many students who were serious about their academic future

had given up on several activities so they could maximize their study time. Not me, not Chulu and Anish. We were now in the senior team.

The year before we had witnessed a gripping final in which our senior team had been dominating the game but conceded a goal against the run of play. It was a good team; true champions stand up when things are going wrong. The champion on this day was a senior of mine called Ian Huntley. A naturally gifted sportsman of Australian descent. In that final when we were trailing, he took the game by the scruff of its neck and single-handedly won us a penalty and then converted it to take the game into penalties, which our team won.

It was a great feeling just watching and our whole school was there. Some were using metallic bins that they had smuggled out of class as drums and chanting songs and abuses at the other team. We all ran out on the field after the game was done. Vicky, who was the main and prolific striker in that team had fractured his hand in the semi-finals and had not played the finals. The team carried him on their shoulders around the pitch after the game with chants of 'three cheers for Vicky!' twas an emotional moment. It was a dream to play in the final for Loyola—a dream Anish, Chulu and I shared—and we were all there that day. Anish and I had become very close by this time mainly because of our common passionate interest in the beautiful game.

#16

Tsunami Christmas

Toward the end of eleventh grade, an excursion to the Andaman Nicobar Islands was planned. I had gone for a Bombay-Goa excursion in the ninth grade. But this time I had decided not to go. This trip would be during the end-year holidays and with no pressure from school this was a time I could utilize to study the extra PMT material.

There was a while before the deadline to make the payment for the trip. Gadi who was going spoke to me at great lengths, trying to convince me to go. I told him there was no point because once I get fixed on a decision, it is very difficult to make me think otherwise. He was wasting his time, I thought.

Ritz and I continued to talk late at night. There was a comfort, a feeling of relaxation while talking to her. It was as if my thoughts and voice were linked and I didn't have to play the role of mediator anymore. Conversation flowed naturally. We got very close. We talked every night. I am pretty sure our phone bills by this time were

going through the roof but neither our parents questioned us about it.

I hadn't expected this but slowly Gadi had started influencing me. I was giving the trip serious thought now. My parents had left the decision to me. Ritz was also keen I go. She said it was a beautiful place. She talked of beaches and volleyball.

One day Gadi again asked me to go. I said no.

Ten minutes later, I called him and said, 'Bhai, I am also coming.' I am going to sound like a real asshole now but since I decided I would go, I pondered that many students in the class were not going for pretty much the same reason I had earlier decided to pass on the trip. I couldn't have this. I didn't want to be the rabbit who slept and let the tortoise win. I was good at turning people. Gadi had taken more than a month to convince me. On that Monday morning, in less than ten minutes at school, I turned three people who like me had decided not to go.

Tarun, Ritwik and Nakul would now like me spend the next two weeks on the excursion. The guilt that came with abandoning the books for a while felt a little lighter, plus they were okay guys. I wouldn't say that I convinced Guda because he was going to go anyways.

Apart from Guda and Gadi, many other friends of mine were also going; Sardar, Tushit, Aarush, Vineesh a.k.a. 'Venom' a.k.a. 'The Human Virus,' Anish and many more. Kaushik and Chulu were not going. Of course,

it was a batch trip and some girls also accompanied us. However, it would again essentially be an all-guy affair.

There was a while before the trip though; and the most important annual soccer tournament was coming up. We had a very good team. While Anish, Chulu and I were in the eleventh, the other guys were twelfthers. We had a few gifted players like Arnav Mitra, TT and Deb. We eased through the group stages. I scored a hat-trick in the second match which consisted of one penalty, one well-guided header and to clinch it I scored a typical poacher's goal from less than five yards.

After every match; at night I would describe in detail to Ritz how the game had been.

We played a good team in the quarter-finals but held out to win the game 2–1. The semi-finals ended up being a sad affair. We were confident. We were playing well but on that semi-final day, it was like most of the team hadn't turned up. We tried our best but somehow the engine never started. I remember Chulu had an excellent game but apart from that, there were no positives. The match ended in the same score line as the quarter-finals, 1–2; but unfortunately, this time we were on the losing side. Anish's and my dream of playing in front of the whole school in the finals would have to wait. I was sad for ages. I couldn't even watch football for months. I got closer to Anish; he was hurting just as much.

The time for the excursion had come. I had spent days writing audio CDs with all kinds of tracks for all kinds

of times. I was taking my music player. The plan was we would first take a thirty-hour train journey to Chennai, stay there for a couple of days and then board a ship which would take three days to reach Port Blair, Andaman.

We gathered on the Jamshedpur railway station. My father had come to drop me. I walked over to him and asked for cash for the trip. He told me to walk around and ask how much money the other kids were carrying. After asking a half a dozen people or so, I came back to him. He asked me what was the highest sum an individual was carrying. I told him. He then gave me rs.2000 more than that sum and told me to have fun. Then he handed me some more money and said, 'This is only for emergency.' He didn't know that for me not being able to drink my fourteenth cold coffee of the day was also an emergency.

The train journey, which was long, didn't feel that way. Tushit and I ate junk food at every decent station. We all sat in the same cubicle. We felt like adults. We took the piss out of Gadi. The family was growing every day.

All our tickets had been booked randomly and they were not clustered together. Tushit and Sardar, the more street-smart guys in our circle in an hour or so convinced more than thirty people to change and then re-change their seats so we could all be accommodated in the same compartment.

I had stocked up Snickers and Mars candy bars and we would get up for a midnight meal and hog on these chocolates and other items people had brought.

We finally reached Chennai. There were huge posters of South Indian film stars on billboards. While we waited for the bus, Anish made the observation that if Gadi grew a mustache he would look very similar to these heroes. He was fair, he was fat—he just needed a 'tache'. Anish was a key member of the family now.

We did all the normal things in Chennai; we went to the mall, stuffed ourselves at McDonald's (this was a time when foreign fastfood chains hadn't opened in Jamshedpur so KFC or McDonald's was a big deal). We went to the beach, jumped around in the water and sang songs together. We visited Loyola College–Chennai, which was run by the same fraternity as our school. Father Scott, our school's vice principal, had also accompanied us on the excursion along with a teacher from school and her family.

We had been left alone in the mall but had been told to report back to the drop-off point at a particular time to get on the bus to the hotel where we were staying. Gadi and I arrived on time and within a few minutes everyone was there except Tushit, Sardar, Guda and Aarush. We waited for a good half an hour. People were getting irritated. Gadi and I volunteered to go and find them so the bus could head back. We would take an auto.

After a while, we found the rebellious bunch. Their excuse for being late was that they were looking for a soft toy gift Tushit wanted to give to some girl. We made our way out of the mall and sat on the sidewalk waiting for an auto. Sardar was in flow and in front of our whole group

went hard at Tushit for getting everyone into trouble for a fuckin teddy bear 'gainda' gift. He was at his hilarious best and he had everyone cracking up in laughter. I had taken my camcorder and I had these moments and in fact moments from the whole trip captured on tape until I lost the videos.

Tushit, Gadi and I sat in the same auto on the way back. Tushit started talking to the driver who like most people in Chennai didn't know Hindi. I can't explain the conversation they had. They talked about the movies. The auto wala said he was a big SRK fan. We could see the driver was enjoying the talk, chuckling away. Then Tushit started taking the piss, asking him about 'black, black balls' and more. The poor guy didn't have a clue what Tushit was saying but Gadi and I couldn't stop laughing. Tushit, like Sardar and Anish, was very good at taking the piss.

We boarded the ferry to Port Blair in the evening. There was a proper police checking before being allowed on the ship. Anish and Venom who had by this time started drinking were forced to chuck all the bottles they thought they would drink on board. I had never been on a long ship journey before. We had been on a cruise from the UK to Amsterdam once but that was just a single night journey.

We went to sleep in our bunk beds. The next morning, I felt like sleeping late. Gadi kept coming and trying to wake me up every half hour or so. He was very excited. He claimed that I had to see the view of the ocean from

the deck which was supposedly sublime. I finally woke up around noon and made my way up.

Gadi was right. The view was spectacular, something I will remember as long as I live. We were surrounded by what seemed like endless ocean. It was a majestic blue as far as our eyes could see. The view was the same for the whole horizontal 180 degrees. The ocean carried with it a permanent breeze which was refreshing and soothing. We never saw anything but water around us for almost three days. We spent hours just sitting around on deck and taking in the view talking gently as to not upset the symphony of natural music led by the sound of waves and the occasional whistling of the wind.

When we were not up on deck we would be hanging out in the recreation room, playing table tennis or pool.

After enjoying the day, we would reassemble on the deck after dinner. Though we could not see the water in the dark, the setting was no less romantic. The breeze continued to blow and the waves continued to be felt. We sat for hours, talking about all kinds of things. About singularity, about life. We lay back and looked up at the skies, the diamonds in the sky.

Eventually we reached Port Blair and straight away made our way to the hotel.

We had been made to change our hotels in Chennai on the first morning because a bunch of guys had vandalized the inn late into the night. Father Scott had been locked

up in his room from outside. Guys who were drunk had made a racket in the corridors and many hotel guests had complained that they were not able to sleep. This group was led by no other than the deadliest duo that Loyola had ever seen: Anish and Venom the 'Human Virus'.

I don't know how though the hotel staff had messed up their observation on which room's kids were responsible. Instead they told our teacher that the noise and vandalism had come from a room that was occupied by her seventy-year-old father-in-law. Anish and Venom had slipped under the radar, not that they were scared of being found. And funnily enough, our teacher was offended that her father was being accused. We had to find a new place to stay.

One of the best experiences of my life was when we were taken to the Central Jail, Port Blair 'Kala Pani' (a jail where Indian freedom revolutionaries were sent when captured by the British). It was a bit like Alcatraz in the sense that it was a dreaded punishment to be sent here and the fact that no one had ever escaped. We were seated in the middle of a U-shaped enclosure with jail cells up to three floors all around. Recorded in Naseeruddin Shah's voice, they played a light and sound show which told us some stories of past inmates. When they spoke of a particular person the jail cell they had been locked in was lighted up; and recorded dubbed voices of their views, goals and ideologies about the freedom struggle were heard coming from the cell. They told stories of the torture they had been made to endure, it consisted of screams of pain and suffering, yet they had not

succumbed. I was teary-eyed and taken aback as the show ended. None of my friends spoke much for a while till we reached the hotel. I think this show had made an impact on us and forced us to think about the sacrifices people made so we could live in a free India.

The almost-perfect evening was only tainted a little when I overheard some of the thick guys on the bus saying that the show was boring. One person claimed to have slept through it and he behaved like it was an achievement. They made other negative remarks about the trip and blamed our teacher that she got us here. I felt sick! There is a reason why I take digs at commerce students. Disrespecting 'Kala-Pani' or openly speaking against blood donation were just some of the views or thoughts you had to deal with when you were with quite a few of them; and it was mind-boggling to know that these people went to Loyola like us. Our school, our temple which we held in such high esteem and honour. Thankfully, there were at least some others in their classes who didn't think the way they did.

The next day we made our way to an island that had a wonderful beach and offered a variety of water sports. We had taken a small dinky boat to the place. It was unstable and the waves were causing it to bobble up and down. I was okay on the bigger ship but I felt seasick on this one. I threw up a few times before deciding I couldn't stay on-board any longer. With little distance left to the shore, I jumped off and swam to the island. My head hurt and when my friends decided to go snorkeling, I stayed back, putting balm on my head and lying down.

I got better soon.

I remember it was Christmas. Anish was wearing a Santa hat all day. A small party had been organized for us in the night. We enjoyed the food and drank lots of Coke. We were all tired so we went to bed early.

Gadi woke me up the next morning, shoving me violently around 6 am. It was the strangest feeling I had ever woken up to. The whole room was shaking heavily; the cupboards, the mirror, the walls, the bed; everything.

I was too sleepy to register much but I remember feeling for a second that we were on the ship again where I had gotten used to the turbulence and my endolymph had been conditioned. In the midst of this situation, my reaction was unthinkable and I didn't do it consciously so even I don't understand my choice of words when Gadi asked, 'What's happening?' I said, 'Bhai, it's an island. They probably get loads of quakes here. Go back to sleep.' This line was close to what Will Smith had said in a similar situation in a movie called Independence Day. I still can't comprehend why I used it in real time.

I don't know about Gadi but I certainly went back to sleep. A few seconds later Gadi shoved me again. This time, a little more oriented, I noticed the behaviour of other kids who were running out their rooms. It was a fuckin earthquake! We walked out of our rooms and waited outside. It was an indescribable feeling. The earth beneath our feet and the buildings surrounding us were all shaking. It lasted for a while before finally stopping.

Anish rushed back into his room to check if the whiskey bottles he had stocked up were okay. They were intact. Anish and me went back to sleep.

The plan was to go to another island that morning. An island that is no longer on the map. Had the quake hit an hour later, none of us would be alive.

Again, I was woken up by Gadi and asked to receive a call from my mom. As I said hello, I could sense the relief in her voice but soon she started screaming frantically; she was shocked that I had been sleeping in the building which was dangerous after a major quake. It really was a big one, crossing 8.5 on the Richter scale. Without knowing it, we also experienced a historic event called the tsunami (an underground burst of a very strong and ruthless wave) which was by now on its way like us from Chennai. Ironically, the wave reached Andaman in three hours whereas we had taken a good three days.

We were lucky that our hotel was on high ground so the waters never reached us. However, one time, I had gone into town with a friend called Ajay to make a call. Suddenly, we saw a huge crowd of people running towards us, screaming, 'Water! Water!' We were shit scared and sprinted back to the hotel as fast as we could. Ajay broke down.

There were huge cracks on the road. There were buildings leaning on each other. We checked out of our hotels and for the night we camped out on a field close by. It was the safer option because buildings could fall but it was

unlikely that the earth would split beneath us and take us in. There were several after tremors and even these were strong, hitting around 6 on the Richter. It was a very unusual feeling lying on the ground and feeling it vibrate forcefully under you, like nature's massage.

We were not aware at that time that many lives had been lost to the tsunami and the quakes. So we as a group at least most of us were not scared.

During the course of this night when most kids were asleep, Lisa, a girl Aarush was dating, told him, 'I am feeling cold.' Aarush replied smugly, 'I am there na...' Lisa turned around in horror to find that Anish the devil had overheard this conversation and was giving her his trademark evil smile. Most girls were petrified of Anish. Lisa was no different. She requested that Anish keep this to himself. Not only did Anish tell everyone but he took the piss out of the couple on this topic pretty much all the remaining time we were together. A lot of this was again recorded and for years we'd see Anish on camera making us laugh and embarrassing Lisa and Aarush.

Anish later said that maybe if Lisa hadn't made that hideous request for him to stay mum, he might have done so but he considered it an insult and a provocation. You never told or expected Anish to be nice. He was the number one badass in the batch and he had a reputation and image to protect.

By the next day, ships had started running. They said it was safe. That was the initial plan—that we would return to Chennai on ship. However, many kids, including me, did not really want to board a ferry in the aftermath of what had happened. By now we had caught a bit of the tsunami news on TV somewhere between politics and news about how the Indian cricket team was doing in Bangladesh.

I noticed we had a new keeper; long locks, well built and with a very Jharkhandi swagger about him. They were playing and replaying a little incident like some Indian news channels do to exaggerate and create a controversy. It showed Bhajji having a go at Dhoni.

I knew about Dhoni from before. He had played in the state team under Gadi's dad and had done really well in an A-tour. This was the first time I had seen him play for the national team though. Born in Ranchi like me, an aggressive wicket-keeper batsman, I liked him straight away.

The tsunami videos were scary. They said it was a very rare event and I also remember someone saying that it had hit after thousands of years. It wiped out so much in such little time. I had only seen waves this high in the movies and these movies were about the end of the world. We certainly didn't want to spend three days in the ocean anymore after seeing its might, power and destructiveness. Deep down, we were kids; and as the seriousness of what had happened sunk in, we were naturally scared.

The next morning Gadi and I went to the airport to explore the option of flying back. It was the first time I had seen cracks so big on the roads. The auto had to zigzag its way at times. There were a lot of people at the airport and conspicuously many foreign tourists. We were told that the runway had been damaged and it had to be repaired before any plane could take off or land. Obviously, many people wanted to leave Port Blair ASAP. There was a backlog. We inferred that it would easily be a week before we could fly out even if we bought tickets straight away.

We were not aware that by this time we had become primetime national news: 'Loyola kids stranded in Port Blair.' A lot of the kids' parents worked for Tata Steel and even if they didn't we were from Jamshedpur and the Tatas looked after their town and its people. Calls were made on a very high level and we were told to wait at the airport till further informed.

Sonia Gandhi made a visit to the Port Blair airport. Obviously, there was high security and commandos everywhere. Somehow our teacher maneuvered her way through and held Sonia Gandhi's hand and explained our situation. Then she pulled Tushit and me forward so we could meet her. At that time the most powerful person in India told us that she would make sure we were okay and that we would fly out as soon as possible. She was very pretty.

I don't know if it was the Tatas influence or Mrs. Sonia Gandhi or the fact that thanks to TV India was now

concerned about us—maybe a combination of the three—but we flew out a couple of hours later. We flew directly to the Kolkata. I have never felt as relieved as I did when the plane touched down.

We collected our luggage and got ready to walk out. By sheer chance I was at the start of the queue. The guard at the exit told me to wait a while. I did not know why. As I walked out I felt hundreds of clicks and flashes from cameras that were focused on me. It took a while to register that all this press was there for us. I gave a long interview to the Star News channel to a cute journalist who I recognized. Apart from that, I gave several interviews to local news channels and papers that had also crowded around us. Many of us got our few moments of fame; even if it was a rather sad time for the world in general.

We took a train to Jamshedpur. Everyone seemed happy now. Most of the journey was spent witnessing the continuous grilling of now the most famous couple on the trip Aarush and Lisa. Sardar and Tushit joined in. They had now become more creative in their approach using the camera, Sardar holding it and asking questions like a reporter while Anish and Tushit answered. Tushit screamed out, 'Kya saare hade paar the?!' which basically meant 'Were all boundaries compromised that night?' The camera often shifted to catch the priceless expressions Lisa and Aarush had on their face when brutal jokes were being said out.

When this got monotonous, we indulged in other nonsense activities. For some reason I have never known Sardar convinced Father Scott to wear a pugga turban. He was all smiles as Sardar went about tying the material around his head. He looked very funny. We took videos and photographs. This was not a common occurrence. Father Scott wearing a pugga; it really was quite a sight. Sardar really could work and change anyone. I mean this was the vice principal of a top Christian school. A figure who we respected and maintained discipline in front of. Sardar shattered that image and now when I think of Scott I instantly get the image of him wearing the pugga; and often it brings a smile to my face.

While at the Kolkata airport we had been thronged by the press. When we returned to the Tata station similarly a huge crowd of people were waiting for us but it was not the press—it was our parents. I found mine, hugged them and we made our way back home just in time to catch the last broadcast of my interview on Star News which had been playing all day. My dad had seen it.

Ritz called me that night and we talked till the morning. I had called her once from Port Blair to let her know I was okay. She had been worried and had been hooked to the media channels all the time since the news of the tsunami broke till I reached home.

A few weeks later, Father Scott called a few of us to his office. Anish, Tushit, Venom, Sardar and I stood silent, waiting. It seemed he had gotten to know some of the secrets of the excursion and that some of us had been

drinking. I don't know if he knew it was one of us that had locked him up in his room. Sami sat in his chair and stared at us almost trying to read our expressions. A few seconds later, the silence was broken by a little but very audible fart. It was Sardar the bastard! Everyone tried hard not to break out into laughter. Even Scott was too perplexed to react and slowly signaled us to go back to class, almost too embarrassed. Sardar's fart had saved the day; otherwise, our parents would have been called. It would have gotten messy. Sardar was very proud about this.

#17

The President

It was time for the eleventh-grade final report card. I had done okay. Either way, I wasn't nervous about the marks. I walked into class before Mommy and asked Jenny mam if I could take a quick look at my card. She showed it to me. I stared for a while I was flabbergasted. I treated math like an extra subject but still I expected to score passing marks which was 40%. I had done well in the other subjects but in math I had been given 39%. I was used to flunking in hindi but it hurt that I had failed math.

This also meant that I would not get a rank. None of this really mattered and maybe if I had scored in the 20s or less I would have been less upset; but to be left stranded on 39, it certainly pricked. A huge big teardrop made its way down my cheek. Jenny mam saw this. I didn't know what to do so I just ran out of class and without telling my mom went to a friend's place.

Jenny mam handed over the report card to mommy and told her about my reaction. The thing was people were not usually failed on 39 ... a paltry 1 mark less than the

passing score unless the teacher had a personal vendetta against a particular student. It was common practice to give a grace mark when it was touch-and-go. It is not as if the teacher was the Dalai Lama either because one time he had given Kaushik 4 grace marks to get him from 36 to 40. Obviously, Kaushik had worked him for this, worked him in a way only Kaushik could. Nima, our math teacher, had done this! The sob had done it on purpose and I knew exactly why.

I went to him for tuitions but all parties knew that I was not that serious about the subject and I had very low expectations. After the eleventh-grade exams during the school break Nima's classes had started but I chose not to attend them because I was studying the three subjects that were tested on the PMTs.

I bunked a continuous three weeks of classes before going on the penultimate eve of the report card. Maybe he misunderstood my timing; maybe he thought I wanted to show my face to boost my marks a little for the next day; I find this hard to believe however because like I said I had made it very clear that I didn't give a shit about math. I wasn't a Kaushik either. Even so there can be no justification for what he did next. He seemed to lose it when he saw me and started shouting loud, using words and expressions I didn't understand. Mixed with his trademark 'Ahh! Bloody!' he said a lot of hurtful things. He was shaking. He walked over to me, held my collar and dragged me out of his house. I tried to tell him that I was busy preparing for the medical entrance exams and that's why I hadn't been attending. It didn't seem to

matter. I stood there outside his door too shocked to do anything. Then his wife came over and again in anger tried to convince me that I was the reason he was having blood pressure problems. What a load of shit!! The 'angry old man of Loyola' failed me on 39 the next day.

You know, he was known to be strict and that's why many students didn't like him but it was thought that he is a good person and a good teacher. I too respected him greatly but all that changed after he did this. He got personal and failed me to stroke his ego. Susceptible to mood swings, I was low for a while.

I finally talked to my mom who was rather worried. She scolded me a little for running off like I did. Then she went on to tell me that I should not think too much about what had happened. She reminded me that it wasn't that important. I told her I was with my friends playing cricket and I'd come back home later.

Many of my friends had gathered for the post report-card game of cricket. Generally, we didn't like to be home straight after our marks had been revealed to face more scrutiny and analysis. Gadi, Guda, Tushit, Chulu, Aarush, Sardar, Anish and a few more guys were there. I was bowling to Gadi and the game was close. I sledged him heartlessly as always but today with a little more spite. While Guda and Sardar were used to this as it was norm in our short cricket games at my house, the rest seemed like they were feeling for Gadi. I was a keeper-batsman. I didn't bowl much but that day with so much pent-up energy inside me, my viciousness for Gadi not

to mention the stunt Nima had pulled, I managed to bowl quick and bounced Gadi. He tried to fend off a delivery which rose sharply around his rib cage. It caught a leading edge ballooned up in the air and a simple catch was taken at short cover. I ran up to Gadi and let him have it. I told him to 'Fuck off!' mixed with certain words in Hindi which I will leave to your imagination.

I hope it is evident that almost all the things we did as a group of guys was in good humour. All parties knew that. I believe it is the most important factor that has kept us together even years after school. Oh, and though the concept of 'family' against Gadi was used, it did not mean other guys in our circle (including me) didn't have to face the music from time to time. No one was spared.

After the game ended, I sat with Guda and talked for a while mainly discussing how disappointing our first year in the +2 had been. Guda described how he had thought life would be in the +2 and how different it had turned out to be. We weren't desperate from a physical point of view but certainly the lack of intellectually stimulating women in the batch sucked! Guda, like me, had seen other batches before us and expected that we would have the same kind of interpersonal relationships and maybe the same kind of gender-mixed friend circles. It wasn't so.

We were very different from a Kaushik as one of the main things we wanted to do if we got close to a girl was to introduce her to all our friends, the guys, the bros. This continued in college too; luckily, there were quite a few classy women in college but that was a while away.

Kaushik, who considered me his best friend, had never even introduced me to Krisha.

We had to make do with a very androgenic life, which we enjoyed but there was a definite sense that something was missing.

I didn't get to spend much time with Ritz either. She wasn't in my school and she didn't live close by. We met and talked at tuitions and on the phone but rarely met. This would change to an extent in the twelfth grade.

The twelfth grade started and since it was just the beginning my friends and I were taking it easy. We hung out all the time, had a lot of night overs, bunked classes, watched movies and like always went on long drives.

My dad around this time probably made the biggest contribution to my ambitious academic journey. He had a long harsh talk with me. On this occasion, he sensed I was losing focus and helped get me back on track. A medical seat required serious sacrifice and if I wanted one I would have to work hard. It wasn't going to be easy. I took his advice and started raking up the hours. My friends tried to convince me the first day then the second day but after a few days they stopped. They knew I wouldn't come. I was not Gadi. I was more selfish and more focused.

When I was studying seriously I let nothing disturb me. Sure, I took breaks, hung out with my friends for a while, went on a drive or two but at no time did I let my priority

fade. Certainly not after my father had this talk with me. I would only go for the morning drives around 4:30 if I had studied all night till then. There was a different kind of pleasure after knowing that I had worked hard all night. A morning glory so to say. The rising sun looks and feels very different if you have been waiting for it all night.

I joined a test series tailored to the needs of an aspiring medical student. It was run by Aakash Institute, the number 1 coaching portal for PMTs. There would be a test every Monday afternoon lasting three hours and in the same pattern as the PMTs. Most importantly, Aakash would give a national rank after every test. They had several centers all across the country where students gave the same mcq exam. The rank was important because it gave you an idea of where you stood in comparison to other students in the country, the same guys you would compete with in the PMTs. My rank usually varied from around 500 to a 1000. There was a guy called Sankulp Dudeja who topped every single one of these practice exams. Years later, it came as no surprise that I ran into him at a college fest that was being conducted by AIIMS, the premiere medical college in the country for which lakhs of students give the entrance exam but only thirty or so qualify. Sankulp Dudeja was an Aiimsonian. This was a huge deal. I had nothing but respect for him and other students studying there. I walked up to him and shook his hands.

It was a one-year test series and in this period all topics from physics, chemistry and biology were to be

covered. While the school exams only tested topics from the twelfth grade, the PMT portion consisted of both eleventh- and twelfth-grade chapters. And the questions were a level or two higher than in school. It was hard to juggle what to study and when to study it. None of my friends paid much attention to the eleventh standard portion whereas I had to.

These practice tests I was giving became the priority. They allocated topics from all three subjects that would be tested each week and I studied accordingly. I was not the kind of guy who would sacrifice everything just to be politically correct and put in fourteen to sixteen hours a day and have no life whatsoever. My parents were always liberal and understood the path I was taking. So with no hesitation, I effectively dropped maths so much so that I did not even try to pass anymore (Fuck Nima! I dropped out of his tuition) and hardly studied English. And again, thanks to my parents, I was allowed to bunk school often.

I really haven't ever got much from classes whether in schools in the UK or India or even in college years later. Whatever knowledge I imbibed was totally through studying alone. School was a waste of my time academically speaking. There came a point when I only went to school if I wanted to take a break and hang out with my friends.

I got into a routine that involved bunking school on Fridays to cram as much as I could and then continue the same over the weekend. I would again bunk Mondays and study till the exam. I would hardly sleep through

these days and the only thing that kept me up in the test would be adrenaline and the countless cups of coffee I took right up till I had to enter the exam hall.

I would be exhausted by the time the test ended and would invariably ask my driver to drop me straight to Guda's house and tell him to go back home. We would call Gadi from Guda's place and he would come pick us up. We would then pick up Sardar and drive around, listen to good music, get a bite to eat and fool around. This routine too became fixed. My friends would be just as happy as I was that my test had ended. We didn't drink, we didn't get stoned but just the company of my pals was the best way to unwind. I would usually attend school on Tuesdays and Wednesdays and on Thursdays depending on my mood.

I wasn't the quiet boy in class. I was loud. Besides, since I only attended a few days of school a week I would be pumped when I was in class. Mrs. Reena Singh, who taught us biology and was probably the sweetest teacher I had ever known would help me when I got stuck on certain mcqs and asked for her help, even if they were out of school portion.

However, this did not mean I always maintained discipline in her class; and once, she told me, 'Samar, you should stay at home only. That way even you study and without you the class can also study.' I don't know how she meant it but I smiled and took it as a compliment. The thing was even if I messed around during class I wouldn't do it in a cheap way like an Ankit for example.

Most teachers had a soft spot for me. And even when they did shout or chuck me out of the class they usually did it with a smile on their face. It was again things like this that really got under the skin of many of my classmates.

On one particular Monday after the test when we called Gadi, he lost it outta the blue. Gadi was a good student and academia was important to him. He was pissed and finally had noticed the humongous elephant in the room, the fact that his cramming hours and his time management in general to a large extent depended on us. He told us he could not come because he needed to study. School exams were coming up and he went on to say that just because I had given a paper it did not mean he too should take a break. He tried to say all this with so much intensity and it was so obviously preplanned that it was hard not to burst out laughing. For perhaps the first time that I can remember Gadi stood up to us; to heavy pressure and for once said no.

His stand did not last long. He joined us an hour later.

I had found an original method to motivate myself and it worked. What I did was that when it was really late, around 3 am or so and I was studying, I would take a break and go to the bathroom. There is an eerie silence at these times in the night, a silence I had begun to enjoy. I would stare at myself in the mirror and try to look through my own eyes. After a few minutes of intense concentration, I would get a sense of depersonalization and a feeling that I was looking at myself from a third-person view. It often gave me goose bumps, a feeling of altered consciousness.

I would then imagine myself a couple of years later in a medical college living the good life. This imaginary version of me would then converse with the present me and give a pep talk and try to inspire. It told me that if I wanted this good life, if I wanted this version of me for real, the ball was in my court and I could make it happen. It was a sort of modified meditation and it helped a lot. I didn't do it all the time which I thought would make it less effective and less divine. But when I was feeling down, at times burdened by the insane amount of pressure that comes with the race, I would indulge in it and I would instantly feel better and stronger. I would feel pumped, full of energy and positive.

Ritz was smart. She didn't shower much affection but when she did, she meant it. I had been telling her that I loved her for more than a year now. Hoping, praying, wishing that she would one day say the same to me. It was frustrating. I hated the concept of platonic relationships and I was too immature to even understand what it meant.

I have to admit here that I took the help of Kaushik to close the deal with Ritz. I had explained my situation to him in detail. I was sure Ritz loved me but I needed her to say it. He told me a few things I should say to flip her and I added and improvised a little on my own. I remember telling her that for a year I had felt like a tennis ball uncomfortably balancing on the net and unsure which side to fall in a Sampras versus Agassi match. I then went on to tell her that she has exactly two minutes to decide if she wants to commit totally to 'us.' I hung up and told her

to call only if she wanted to say yes; otherwise, we would talk the next day and I promised her that we would still be friends. This was a lie; it was simply 'all or none' now. These were very nervous moments … the next minute or so. The phone rang. It was Ritz. I could feel palpitations. She said, 'Samar, I love you.' It was one of the most satisfying moments of my life. We talked for a while and then went to sleep. My first girl—I was 17.

Ritz started coming over to my house once in a while. We would do all the baby stuff which now seems very clichéd. We would hold hands and listen to lame Bryan Adams songs. We would hug each other for ages; after a while it used to feel like the edges of our bodies had melted so we could fit into each other like two pieces of a jigsaw. She never wore perfume but I will never forget the soothing aroma of shampoo from her hair when we hugged and I rested my face on her neck. It felt so natural, so comfortable.

One afternoon my parents had come back from work a little earlier. I could hear the car being parked outside. I was scared and fidgety I started jumping around not knowing what to do and what to say. Ritz seemed calm and she had a huge grin on her face. She wasn't nervous at all. She was enjoying my moments of fear and embarrassment. In fact, she took the piss out of me later, saying my 'bad boy don't give a shit' attitude was fake. I introduced her to my parents. Later that night, my dad asked me, 'So she is the 'silly' girl?' I didn't reply and again went back to my room red faced.

I remember going to her house the first time. Gadi and Guda had dropped me off. We were brothers and if one of us was in love that meant all of us were happy. I met her mom who just like Ritz was a sweetheart. She made veg sandwiches for us talked to me gently for a while and then left us alone.

Ritz was saying that she was heavy and there was no way I would be able to lift her up. I took this as an insult and a challenge. I leaned forward, swept her off her feet and held her like Srk held Preity Zinta in Veer-Zaara, her head resting on my left arm and her feet dangling off my right one. I kissed her on the forehead and told her I loved her. She was a little tense. We were in her house. She begged me to put her down and I did. I called my loyal friends who had been roaming around while I was with Ritz and they came to pick me up.

I was happy. While it was impossible we talk more because we already talked as much as we could. We did spend a lot more time together after she had said yes.

The school presidential elections were coming up. The councilor of each of the five classes in our batch would compete and the guy with the most votes would be declared the Student President. Though I was in the B section, my allegiance lay with the D section councilor and my close friend Tushit.

Our councilor was a guy named Shashmit. He was a talented person and I respected him. However, the majority of the guys in my section who were supporting

him I didn't like at all. They didn't like me either. Shashmit was more politically correct and less flamboyant in comparison to Tushit. The teachers and especially a teacher named Meenakshi Roy supported him openly. This was wrong because it was the students' job to elect their president. The teachers were supposed to be neutral and unbiased. She made sure she told whichever class she taught that it was prudent the kids vote for Shashmit.

We were unsure whether it was just the twelfth graders who would vote or the entire +2. Meenakshi Roy did her best to convince the kids to vote for Shashmit. Jenny mam also supported Shashmit but this was understandable purely because he was the councilor of her section and she had a right to support him.

Tushit wasn't even present in school the day when it was announced that the elections would take place. We called him and told him to get his ass to school ASAP. Crucially, even Guda was absent that day but again we called him and told him to come straight away. We told him that his vote could make the difference. We knew it was going to be close. Shashmit had a lot of things going for him but Tushit was, well, Tushit.

On the day of the elections, in the few periods before it, Tushit, I and the rest of the people in our group did everything possible to try to get more votes. We helped Tushit write his speech. I single-handedly convinced several students in my class to vote for Tushit. I was good at this and I flipped quite a few people even Alia who didn't particularly like me. On seeing this, one of

Shashmit's followers, a tall well-built Bengali guy came up to me and said it was okay I vote for whoever I want but it was wrong that I was getting other people who were going to vote for Shashmit to change their mind. He was pissed and I rather enjoyed it.

I told him that these were democratic elections and campaigning for a particular candidate you support was part of the game.

Around 80 percent of Shashmit's followers in my class were Bengalis. They formed and thought like a herd of sheep being led by their leader. I don't judge people based on caste, creed or religion or anything else for that matter. But these guys were sick and stupid. In class they would sit at the back and make animal noises and laugh. The jokes they made to interrupt class were so lame that after a while teachers just started ignoring them. They didn't maintain any class or dignity and what was worse was that their jokes were not funny once you had crossed the age of 10. They desperately wanted Shashmit to win so that they would get more power.

We were still unsure if the eleventh graders would be voting. There were mixed reports. In the last recess before the elections I suggested that Tushit and I just spend a couple of minutes in each section of the eleventh grade and request the kids to vote for him. At the very least, we would get a few girls on our side. Tushit was very good-looking. It couldn't hurt, even if they didn't vote we only needed to spend ten minutes on them.

As we were walking up to the eleventh-grade corridor, Meenakshi Roy was walking towards us. She seemed bubbly and asked us where we were going. We told her we wanted to have a word with our juniors before the elections. Her expression changed and she told us many times, 'No! Kids … only the twelfth graders are going to vote.' We asked her if she was sure. She said she was absolutely sure. She then shooed us away. I will never forget that grin on her face and the fakeness of it all. She too was Bengali.

As we headed back, I made a very important contribution to the election process. Something just didn't seem right. I looked at Tushit and said we should go and speak to the 11thers. I had a gut feeling that Meenakshi Roy had lied to us. We quickly made brief speeches in front of each class and requested the kids for their vote.

Before going to the auditorium, I pulled Shashmit aside to have a quiet word, I informed him that I was going to vote for Tushit because he was my friend and I told him I'll try to get as many votes as I can for Tushit. I wished him luck and said, 'May the best man win.' I think he appreciated my honesty and we shook hands. He was a classy guy.

There was a fat fuck called Utkarsh Dey in my class who was the biggest piece of shit I had ever known. He would spread rumours about me, bitch about me. I would just smile. That ugly asshole hated me and he was on Shashmit's side. So he hated me more now.

Seated in the auditorium, we heard all five councilors give a speech as to why they should be elected. Tushit was very nervous and he didn't speak that well; luckily for us none of the candidates spoke well that day. Tushit was by far the best-looking guy on stage and though this was not a criterion, we knew several girls especially from the Arts section would vote for him based purely on this. Shashmit had the backing of the faculty though; and like we expected, it was close. Very fuckin close.

The voting procedure started. My gut feeling was right. The eleventh graders were also voting. Meenakshi mam had lied to us, straight up and with confidence, staring into our eyes with no shame at all. She had been at Loyola for half her life. There was no doubt she had given countless hours to the school; however, unfortunately her whole life revolved around school gossip and politics. I hadn't expected her to fall to this level. This act of hers before the election was her first big mistake.

The voting process was over and now they were being counted. It was a tense few minutes. One of the kids had voted for George Bush!

The vote count went down to the wire; it was announced that with 117 votes, Tushit was the new school President. Shashmit had gotten 116 votes. True story. It was the closest elections the school had ever seen; it was decided by one solitary vote. In the midst of all this joy and jubilation it was hard not to feel for Shashmit who was a good kid.

It was a tough win and the closeness of the result showed that every vote was essential. Had we listened to Meenakshi Roy there was no way we would have won. Tushit had his looks to get some A section votes, he had me in the B section, he had Sardar in the C section to influence people, he himself was from the D section and he had Anish and Venom in the E section. After school, a whole bunch of guys including me were treated to ice cream. Later in the evening, there was a party at Tushit's house.

Kaushik always had a thing against Tushit from the start. I was close to both of them and I tried hard to maintain my neutral stance. I had tried to convince Kaushik to vote for Tushit. He had said he wouldn't. After the elections when the result was declared Kaushik came and told me he had changed his mind in the 'last moment' and had voted for Tushit. I told Tushit who was standing next to me and Kaushik and Tushit hugged. I was gullible. I realized later that Kaushik was lying. He had only changed his position now after Tushit had already won. I can bet my life on the fact that Kaushik had lied. There was no way he had voted for Tushit. He only claimed to have done so to get in with the flow. Kaushik was like this, selfish and self-centred—always. He would do nothing if it didn't have something in it for him.

Toward the middle of the twelfth grade, Chulu had broken up with his girl Prachi. Well, she had broken up with him. It was quite hilarious how it happened. They were at Chulu's house in an uncompromising position. The first time they had gotten so physical.

Prachi had nervously asked if this is all Chulu wanted. Chulu had misinterpreted her question and replied with a philosophical 'I want a lot more!!.' He obviously meant it in a different sense but Prachi didn't know that. She walked out of his house and called him in the evening to end the relationship. Chulu wasn't severely affected. He told us about what happened and his 'I want a lot more' line stuck. We laughed till our jaws hurt. And in our yearbook where every person was given a nickname, Chulu's read 'I WANT A LOT MORE!'

I don't know how we got the idea—maybe we were just trying to be cool—but after a few days, Chulu and I made a bet. There was a decent-looking girl in the D section called Nisha who came to tuitions with us. The game was simple the first person to get with Nisha would be the victor. He had gotten close but not closed the deal. Amid much public interest, I had won. Chulu was one of those guys who was always very honest at least to his friends, in this way very different to Kaushik.

In a strange turn of events, Chulu then started dating Nisha. They became pretty serious and their relationship would go on into college. There was no tension between Chulu and me, we religiously followed the law 'Bros before Hoes.'

It was around this time Tushit started dating Dona. Tushit was easily a few leagues above her in every way. It was an act of desperation and I knew exactly how he felt. I had done the same before when Ritz was still on the fence. I had started dating a girl just because I thought I

had to. I had ended the relationship in less than a week. Well, actually I had gotten Tushit and Chulu to end it for me. I was a coward. I bunked a week of school after ending it so I didn't have to face her. I was told she had cried once in the recess. Like me, Tushit also soon realized that Dona was a mistake and ended it.

It was football season. We were in the 12^{TH} grade and along with Anish I was a senior member of the team. This was our last shot at the dream of playing in the final in front of the whole school. Anish was the captain and probably the most important player in the 11. I was also important. Anish helped us to concede less being the leader of a solid back 4, marshaling his troops like a Maldini. He was a good organizer and was also the last man. We used the offside trap to great effect. On the other hand, I scored most of the goals at the other end to win the game. Anish was a central defender and the rock on which the team was built. Chulu played left back and was an aggressive yet reliable player. His game reminded me of an ex-United star Gabriel Heinze. Bhanu was our keeper and he was good.

Our first game of the group stage was against a school called Rajendra Vidyalay. It was tight initially but after Nishit scored the first goal for us they seemed to get demoralized and from then on we controlled the game. I scored the next, lobbing the keeper. Toward the end they got a penalty for an unintentional hand ball in the box. Bhanu saved the shot but they scored of the rebound, it was too little too late. We won the game 3–1.

It used to be a special feeling walking into school in our Loyola jerseys and track pants after we had won a game. We would be happy and pumped while the other kids sat through period after period of tiring classes looking on at us. Announcements of the match would be made, match score and goal scorers. Hearing my name echo in every class on every floor of the school (a school that was my second home) would be the closest I would get to feeling like a Messi in the nou Camp. Kids would clap and cheer if we had won.

We played the next game on a small ground with good grass cover. It was the best type of pitch for someone like me who has a bag of skills and tricks but deplorable stamina. It was a weird game. We dominated it from the start but somehow we just couldn't score. I hit the bar two times in that match once from a free kick and the other after I had dribbled past their back line. I put the ball in the back of the net a little later only to realize I had been flagged offside. Theoretically, even a draw would have been a good result for us but we wanted to be ruthless. Finally, about ten minutes from time a guy called Subhashish scored for us. A few minutes later, I too scored a tap in. We won the game 2–0. The next game was a cake walk. We won it 6–1 and I managed to score a hat trick. My second hat trick in the two years of this competition.

Our road to the semis was pretty easy. I am not exaggerating here; I scored in every single game of the competition except one. In the semi-final for the first

time in the tournament we went behind and were trailing 1–0 at half time. I thought about Huntley.

Within five minutes of the restart, I netted a diving header into the roof of the net from a corner. As I ran to celebrate, I heard the opposition coach scream at one of his players, 'Keeping him quiet was the only job you had and you couldn't even do that.' This player had been man-marking me the whole match. It felt good that I was considered that important. They had obviously done their research and identified me as the guy who scored. A few minutes later, Marco, one of our midfielders volleyed in a beauty.

We were in the finals!!! The dream was now a reality. A huge group photo of the team after the win was present on the front page of a famous local newspaper the next day. Gadi, who had been appointed manager of the team under Coach Remo also had the job to record each game. Throughout the tournament, before and after games, for breakfast and lunches and Amul Kool milkshakes and Red Bulls; Gadi, Anish, Chulu and I always hung out and drove around in Gadi's car.

A chemistry test was scheduled the day after our semi-finals. The players had been officially allowed to miss the test and give it later. We went to confirm this with our chemistry teacher Mrs. Geeta. She didn't seem too pleased but she had no option to allow it as the order was from the principal. She noticed Gadi who was standing behind me and went hard at him saying he was not on the team and he would have to give the test. Gadi wasn't

expecting this; he didn't say anything. I interrupted the teacher and said, 'Mam, he is the team manager. His name is on the list and though he doesn't play he does a lot of work and most importantly he has been with the team from the start for all the matches. Therefore, like us, he hasn't had enough time to study.' She was stunned. She had no comeback and had no option but to allow Gadi to miss the test too. Had I not interrupted I am certain Gadi would have had to give the test for which he was unprepared.

Gadi was shy and sweet, so sometimes he needed people like me and Sardar or Anish even to stand up for him. This changed in college. Yes, we often targeted Gadi but no one but the inner family' had the right to give Gadi a hard time. We were very protective of him.

There was a two-day gap after the semis and before the finals. I had decided to stay back at home. Bharat, who was also part of the team had come to my house with bad news. At some school function weeks back, Anish and Venom had come to school a few pints down. This was a big thing and someone had ratted them out. Bharat told me they had been suspended. The only thing that concerned us was that Anish may be barred from playing in the finals. We reached school to find the deadly duo, Anish and Vineesh- the Human Virus; standing outside the principal's office.

They smirked as I walked over to them. I could tell that even Anish was scared not because the principal had called their parents but because he didn't want to

miss the big game. I talked to a few teachers and our coach. Luckily, what we feared didn't happen and Anish was given the green signal to play. We had made the argument that the whole team that had worked so hard for this should not suffer for a single act of disobedience by one of its members.

On the eve of the finals Anish met with a dangerous accident on his Activa. He hurt his head and lost blood. He was taken to the hospital and a CT was done. The doctors concluded there was nothing serious but advised him not to play.

There was no way Anish was going to miss the game though and he arrived on the day of the finals with his head bandaged up. You could see a collection of blood on his forehead making the bandage red in the middle.

The scene was set. The crowd was cheering loud as we warmed up. The game started and within a few minutes I ran past their left back and swung the ball into the box, more out of hope than conscious precision. It fell almost perfectly at the feet of Sayan my striking partner and he tucked it away with ease. We were up 1–0 and our crowd went mad as did our team. But soon it became clear that we were playing a quality opposition. It became a scrappy affair with tackles flying in from all directions. I got a yellow card for a slide tackle that didn't get the ball but got the player. There was no malicious intent. Remo called me over and told me to calm the fuck down.

It was incredible to watch Anish that day. He really showed that he had bags of courage and strength. Lots of long balls were being played in and Anish was heading every one of them away. Every time he did this his head would get shook up, he would bleed and we would all be scared but he fought on. He never complained. He never shied away from using his head when it was needed. The guy has guts and he proved it that day. Most of us, even if we had played with a head injury would have tried to use our feet more but not Anish. He didn't miss a single clearance. I had the best view looking back and my heart skipped a beat every time he heroically cleared the ball with his head. Respect!

We conceded two quick goals before half time. There was a definite weakness on the right side of our defense occupied by Robin and Bharat. This only surfaced now because we were playing a fast team. Both the goals were scored from the right side. Remo gave us a memorable half time teamtalk. He acknowledged that we were all giving it our best. There was nothing more we could do. He said cup finals don't come often and he asked us to give it our all in the second half. Before walking out, I told Anish to make sure we didn't concede another goal and I promised him that I would score. I was confident and pumped.

I gave it my all. There were some frustrating moments. Slowly, as time passed by, I started feeling a sense of doom. I tried to motivate myself by thinking it takes only ten seconds to score. With some five minutes left, I won us a free kick just outside their box. I had beaten

their defender moved the ball forward and then felt his leg on mine and gone down. It was a perfect position for me. I had already scored from a free kick earlier in the tournament. As I placed the ball, a few of their players who disapproved of my dive (well it wasn't a blatant one) walked over to get in my face and put me off. Anish walked over from behind me and told them to fuck off. I walked back and there was only one thing in my mind. I told myself whatever happens I am going to think about this moment a lot in my life so I should really try not to screw it up. I screwed it up. I ran to take the kick and I don't know why my right foot almost froze. Maybe there were too many thoughts in my head; maybe the pressure got to me. I didn't get any elevation or any whip. The ball trickled harmlessly past the post. I fell to the floor and wished the earth eat me up.

A few minutes later, the game ended. It had been a good battle. We had fought hard and there was no shame I suppose in losing to on the day the better side. This wisdom was not present then. It felt like shit; it felt worse. I had scored in every game of the fairly long tournament except the finals. I had a golden chance with the free kick and I had fucked it up. My team had counted on me to convert that opportunity. I had let everyone down. I sat alone on the field. Some tears dropped down my eyes, knowing I was going to feel the pain for a long long time. Again I couldn't even watch football for months for whenever I did it reminded me of our failure.

PMTs and tests did not matter anymore. The only comfort was talking to Chulu, Anish and Gadi late into

the nights because only they were feeling melancholy similar to me. Most people in school knew I was good at football but had I scored and won the game for Loyola it would have sealed my place among legends. I came close but I didn't quite hit the level a Huntley had hit. It took years for me to get over that moment. I was right. I did think about it a lot.

Life is strange at times because when I made it to the college team something happened in my debut match which gave me some comfort. It was like losing the love of your life and being down for ages. Thinking, knowing, you will never love again, then meeting someone else, someone who didn't make the earlier loss okay but in a way made the pain of it bearable. More on that later.

A few weeks later there was a fest at Ritz's school. We had planned to take part in an event called 'comic dance' which as the name implies had to be a dance performance that would make people laugh. As usual, we had left things till very late and the first time we got together to plan and practice what we were going to do was on the eve of the event. Tushit, Sardar, Neel, Gadi, Guda and me got together and decided on the theme and songs that our dance would revolve around. We had decided to dedicate the dance to the Mumbai bar dancers who were facing a rough time then.

At the event, we saw schools using elaborate props and well-planned-out steps in cohesion. There was a Mangal Pandey dancing like he was high on something. At that time, we felt a little scared. We had no props and we

had hardly practiced; almost the whole Convent school was in the audience. This could turn out to be quite embarrassing. But, but- we had Sardar.

We showed the evolution of bar dancing starting with songs of old which had dancers surrounded by men smoking hookah and lying on a mattress. Then we moved on to more recent tracks. On paper there were six of us but it was the Sardar show from start to finish.

He danced on 'Kajra Re' playing Ash wearing a sphagetti top a white skirt and heels. Tushit and I were by his side trying not to laugh and concentrating on our own performance. The little prick nailed it. I swear if Ash were there, she would have been impressed too. I could see hundreds of girls in the audience rolling over in laughter; even the judges couldn't control themselves. This was not all; the last song was even better 'Deedar De' whose video shows a girl shaking her hips to the beat and shaking it fast. We had seen Sardar do it the night before. He was fuckin amazing. I really can't explain in words the performance; only those who were there and saw it will understand. Tushit had told Sardar that every second he keeps shaking his hips the better our chance would be to win this thing. Sardar nailed 'Deedar De' on stage too. It was the last song in our performance and Sardar was doing it solo. The rest of us just formed a line behind him and clapped. If 'Kajra Re' had the audience in splits, 'Deedar De' made them laugh so hard that their stomachs hurt.

Sardar got a standing ovation when we walked back to our seats. Everyone knew we had won even before the results were announced. Ritz was also somewhere in the audience and like everyone else she had enjoyed the show very much.

Anish and Venom were the two bad boys in our batch. They maintained a sense of class though. They were a tag team.

We were fast approaching the end of the twelfth grade, the last few months of our last year in school. Things would never be the same again. We would never wear our school uniform again. We would never wear our school tie again.

A few girls from Convent started a trend which in the end would come back to haunt them. They targeted the more known guys from Loyola like Anish and Tushit and sometimes even me. They would get on their scooties in the evening in groups and throw firecracker bombs into our house. Not only was this dangerous but far more importantly, it was insulting.

It didn't take long for us to realize we were being pranked. Anish lived by the rule that if someone hits you once then you have to hit them back ten times. We did exactly that. We had our sources in Convent and it wasn't difficult to get the names of these girls who were acting a tad too smart for our liking. They didn't even try to remain anonymous.

We would gather at my house in the evenings and work out a plan of attack. Neel would handle the camcorder while Anish and Venom would be the chief bombers. We bought tonnes of fire-crackers. We bought aaloo bombs and chattai bombs with double the fire power to the ones that had been used against us.

There was a group picture of the girls who had been doing this on a social media site. We printed it out and every day that we hit one of their homes, one by one, we crossed out their face on the pic. They were quick in the sense that they would usually chuck the bomb and then run away immediately. We would spend a good five minutes on each target, bombarding their homes with no mercy. If they were the Japs attacking Pearl Harbour then we were the Allies dropping nukes; well kinda!

They tried to hit back once when we were at Anish's house for Christmas lunch. We heard bombs going off where our vehicles were parked. We ran out as fast as we could but they had left by the time we reached. We had not expected that they would show so much courage. We were all already together and we would have to hit back. They knew we were together. This time we would hit so hard that they would never think of retaliating. We were told that the bunch were at Aisha's house.

We agreed that bombs weren't enough. We had been bombing them for over a week now and the fact that they attacked us again proved they were not scared. We had to change that. We had to introduce fear. We bought eggs! Lots and lots of eggs. I think eggs were my idea.

We drove to Aisha's house and pasted it with eggs. One window was open and I threw an egg right through it. We had many eggs, so it took a while to finish. Without knowing it, we had hit on a weapon so deadly that it would be used again but in a different war.

They hadn't anticipated this and they were taken aback. A few minutes later they called us to settle on a compromise and work on a truce. They were scared. They finally realized that we had no boundaries and there was no way that we would ever let them have the last word.

They called us to Aisha's house to formally end the war. Our egg nukes had done the job. We agreed to the settlement and gave our word that we would not attack again unless instigated. After all this negotiation, Anish had the final say. Aisha had a fluffy dog called Poodles who was hanging around us. As we walked out, Anish still had a couple of eggs in his pocket and he gently bathed Poodles with egg yolk while Aisha screamed at him to stop. We all laughed and walked out triumphantly.

Venom 'the Human Virus' was dating a girl called Usha. I don't know much about their relationship but I do know how Venom ended it. Usha was really into him; however Venom didn't feel the same way after a while. So one day he called her and said he had to end it. She was broken and asked why. Venom told her that his mom had overheard one of their conversations on the phone and said she would not allow it; therefore he had to stop. This was obviously a lie. Venom, like Anish was a characteristic badass. And then to say he had to

break up because his mom wouldn't allow the relationship was so out of character that it was hilarious. Even more surprising was the fact that Usha bought his excuse and actually believed it. We were at CCD when Venom first told us about this and he had us in splits. There was a reason he was called 'the Human Virus.'

Anish and Vineesh were in the E section. In general, the average IQ of a commerce class is far below than the average IQ of science sections. One time, when I was trying to convince a guy from their class to donate blood as part of an activity of biology club saying it would save someone's life, he had replied rudely and said his blood would become impure. What the fuck can you say to something like that?! I was baffled. Although they were in the commerce section, Anish and Venom were smart. They hardly even talked to anyone else in their class. So while most of the rest of the class were united in their dumbness, Anish and Venom stood out.

They were big and strong too. They treated everyone else like shit. Quietly the E section hated them but couldn't do anything about it; and as for Anish and Venom, they truly didn't care.

Sushil Agarwal, Shia Khan and Onit were a few guys in their class. Sushil, who had been in my section in high school used to be one of the guys, one of our close friends but we often took the piss out of him. He was a good student. He had taken commerce to be a CA. This was the first time he was with guys who thought he was special. He became fuckin Stephen Hawking. They

respected him. They heard what he had to say and what is more he even got female attention. He must have been over the moon. He obviously started spending more time with these guys who appreciated him.

They formed a group in their class that called itself FFC (fire fuckers club). Sushil was the president of FFC while Shia and Onit were also members on the board. They had posters and boards all around class with FFC written on them. Almost everyone in their class were members of FFC except Anish and Venom.

I played basketball for school too. I was not as good at the game as I was at football. However, I made the starting five primarily because we only had two quality players on the team, Prash and Kirti. I played a decent defensive game. I was good at scrapping for rebounds. I read the game well and did a job. Our coach always played me.

We were in the finals of the annual Jyoti basketball tournament. Quite a few people were there watching the game including a senior from our school who had passed out named Sajid. The game was close—very close, in fact. We lost it by a mere 2 points. I had fucked up two pretty straightforward lay-up opportunities. The fact was I had hardly practiced. I couldn't play all sports if I wanted to crack the PMTs. I probably shouldn't have even been on the team but the coach had no choice. I was better than the bench players which included Sushil and Puneet.

Kirti had been fouled out in the crucial dying minutes and it cost us. As the whistle blew, Prash who was our

captain smashed his hand against the pole in frustration and fractured his wrist.

Sajid caught a hold of me after the match and had a right go at me. He had seen me miss those chances and had found out that I didn't practise much. He was on the team in his school days and his anger and frustration at my performance was genuine. He talked about Loyola and told me I had let the school down. I was already feeling like shit and I had to try hard to hold back tears as Sajid let me have a piece of his mind. It hurt because he was right. I just heard what he had to say without saying anything in return. I didn't explain to him that the only reason I didn't come for practice was because in a few months I would be competing with lakhs of students from all over India in the toughest most important exam I would ever give and hence I needed to study.

Somewhere though, deep inside, a bit like how I had felt after Ritz had slapped me I felt good that Sajid cared enough to not only come and watch us but also to have that talk with me. I respected him even more. Jai Loyola! Man.

The school's annual sports day was coming up. This was a big event. The whole school would do a march past and then there were several track and field events. There were four houses: Cheetahs, Leopards, Jaguars and Panthers (my house).

Each house had a captain and a torchbearer. The torchbearer would be the best sportsman in the house.

It was a big honour to run with the torch and light the fire to declare the sports day open. Bharat was our house captain. I had no doubt in my mind that I would be the torchbearer. I represented the school in football, cricket and basketball. I had also won awards in badminton and table tennis. Kirti was probably my only competition. He was a very talented basketballer but this was the only sport he played for school.

Shia who was in my house wanted to be the torchbearer and claimed he deserved it more than me. I don't know how he came to this conclusion because he hadn't represented any of our school teams nor had he ever taken part let alone win other sporting competitions. Things would get ugly.

He went to Meenakshi Roy and poured his heart out to get her help and see to it that he becomes the torchbearer not me. Meenakshi Roy had nothing do with the sports activities in our school just like she had nothing to do with the elections and I don't know why she took his request personally and waged a war against me.

She made a variety of hideous accusations. Shia had gotten emotional and told her that he and I had been good friends in high school and that I had stopped being his friend because now I was in the science section and he was in commerce. I remember breaking out in laughter when I heard this. She got pissed at my reaction. How fuckin childish and stupid could you get? Even so, this was a baseless claim because I had many friends in the commerce section like Anish, Venom and Sardar. And

though I take the piss at times for fun, I have never had anything against people in the commerce section in general.

As torchbearer, I had the responsibility to supervise and try to improve the march past practice that took place every morning in school. Every day, marks were awarded based on performance and they would all count in the end to see which house had won. On one occasion I had told a girl who was out of uniform to dress accordingly because we would lose marks for stuff like this. I wasn't rude and there was certainly no anger. I don't know how this news leaked to Meenakshi Roy 'MR' and she accused me of harassing girls in my house. I didn't even know how to react.

Then she found out that I bunked school often and quoted this as a major reason that I should not be made the torchbearer—my lack of discipline. I had to attend school every day from then on. Thanks to MR, my preparation suffered but it was important to me that I become the torchbearer. I suppose this was the only charge that she had made that had some substance.

One afternoon I found myself sitting next to Shia and Sushil on the football pitch in a free period. We discussed the matter at hand. His CV baffled me. He said he played football for the Dhatkidih team. This was his only reason. Dhatkidih was the name of the place where he lived. They would have little local tournaments once in a while. He had probably played a couple of these. It was almost hilarious that he considered this reason enough

to be the torchbearer. What was even worse was that Sushil supported him in his argument. I thought he had at least half a brain and would know that Shia's claims were baseless. But of course, they were FFC.

The whole of the E section apart from Anish and Venom was now against me. The Fire Fuckers Club had released a death notice of sorts. Anish and Venom not only supported me but they did so openly and so their section hated them even more. Anish who was the captain of the Cheetah house was once told to give his views on the matter in a class by some teacher who knew this was a burning issue. He had walked up in front of the class and said, 'I can guarantee that no matter what you guys do, which teacher you go to for help, Samar will be the torchbearer, not Shia.'

You know, if it was Kirti, not Shia, against me, I would have been okay. I may have even accepted the decision to make him the torchbearer. Kirti was a good sportsman. However, he was least bothered about this and was actually passively on my side.

Bharat, as the captain of the house had a huge role to play to decide this. On the surface in front of me and our friends, he supported me. Later, MR had told me that Bharat had cried in front of her and said he supported her and Shia but could not do so openly because he was scared of my friends. Bharat really had no character. He was a typical girgit, someone who changes colour depending on the situation and for his own self-interest.

He was friends with us because my friends were funny and popular—because they got female attention.

This strong stand MR had taken against me for no reason whatsoever was her second big mistake.

The matter had gotten out of hand and neither side was ready to back down. It was decided that Remo Sir would choose which one of us deserved the honour. He took a while but eventually sided with me.

On the other hand there was some unrest in the Cheetah house too as to who should be the torchbearer. Robin clearly deserved it but Anish was the house captain and he made sure that his best friend Venom got to run with the torch. He had gone and spoken to Remo and told him that if Venom wasn't chosen then he would boycott the sports day. It would be impossible to have a sports day with one of the house captains absent and so Robin was made an offer he couldn't refuse. He got the consolation that he would receive the sports award at the end of the year and was made to stand down. I doubt he liked the compromise but as they say he had no other choice.

Gadi, Venom, Prash and I were the torchbearers of our respective houses. Sports day came and went. Our house finished second overall while the Jaguar house won the cup. Shia caught a hold of me after and threatened to hurt me physically. He said Bharat had cut a deal with him that he did nothing untoward till the sports day ended but thereafter could do whatever he wanted. Shia didn't act on the threat he had made which was a good thing

because had he touched me, Anish would have torn him apart.

It was the last paper of our twelfth-grade pre board exams. I had hardly slept through the week and I was drained by the time the exam ended. Meenakshi Roy was the invigilator. There is obviously an outbreak of noise when a paper ends and especially if it is the last one. Almost everyone in the hall was talking.

Meenakshi Roy went in front of the batch and said the commerce section was more disciplined and they would be let out of the hall first. It was stupid of her and also untrue. I thought five minutes couldn't really hurt that much. Then MR went on to say that the science sections would be punished for their bad behaviour and would have to wait an hour before being let out. She actually got the grill gates locked. The woman was serious.

MR, who had earlier blamed me for being biased against commerce students now openly was advocating a science-commerce divide. This was her third big mistake.

I couldn't take this shit. I was mentally and physically exhausted. I wasn't going to sit for an hour to satisfy MR's whim. I turned around to Guda who was seated behind me and told him I am going to try to pull something off and I would need his help. While MR was looking the other way, I closed my eyes and jumped off my chair with a shout onto the floor. I pretended to lie unconscious for a while before Guda came and picked me up. As I sat on my chair, Chulu, who was to my right started clapping

and saying, 'Oscar … Oscar.' It was very difficult to not burst out laughing. MR came over and asked me what was wrong. I acted gingerly and told her I hadn't slept for a while. She had no choice but to allow me to leave and since I was a little disoriented Guda was given the responsibility to take me out. As I was leaving MR made a sly remark saying that people like me don't study the whole year and then breakdown during exams. Guda hugged me as we walked out and told me that I am a dude. After all I had also saved him from the torture of waiting in the exam hall.

I had done okay in the pres, apart from math in which I had scored 23 percent. After the eleventh grade where I had been failed on 39 percent, I had totally given up the subject. This was in a way a sort of rebellion against Nima.

Ritz came over to my house and for the first time ever she held me close and we made out. It was the first time I had kissed a girl. To be honest she had kissed me; she had almost caught me by surprise. Several times before I would try to manoeuvre myself into a position to kiss her; she would let me get close and then push me away. This time out of the blue she made me hers for that brief moment. It felt sublime. We hugged. I tried to kiss her again; she pushed me away. She was a funny one.

The board exams started and they were going okay. Though I didn't care about math in the school tests, I wanted to at least pass the paper in the boards. I walked out after giving the math paper confident I would get 50+.

I ripped apart my math textbook and literally burned it in front of school as students looked on. No more fuckin numbers! No more fuckin maths.

Chemistry consisted of three main units: physical chemistry, organic chemistry and inorganic chemistry. We had a day break before chem. I finished two sections throughout the day and just had inorganic chemistry left to do. I hit a mental block and no matter how much I tried, I just couldn't study. I called Ritz and we talked for a while. She tried to motivate me but it didn't work. Nothing was going in. My brain was tired and had shut down. I hung up soon, thinking it was unfair to waste Ritz's time because she too was studying for the same exam. I tried again but I was not able to concentrate or register much.

I put the TV on and there was nothing interesting playing. I remember I ended up watching 'the budget' discussion on NDTV for an hour or so. I didn't know jack shit about these things nor was I in the slightest bit interested. I still don't know why I watched the show for so long. I guess it was better than inorganic chemistry. It was now around 3 am and I called Ritz again. I had become very frustrated by now. We talked and talked and every time I told her that we should hang up so she could study, she dismissed the idea and said she wanted to talk. Ritz was like this for people she loved. She could be extremely selfless. I loved her.

Not only had I hit a mental block that day but because of my lopsided sleep cycle I could not even sleep. I finally

fell asleep around 5 am while I was still on the phone with Ritz. She made sure that I had slept before she hung up.

The next day, a few hours before the paper, I was very nervous. I hadn't revised a whole unit. My baby brother came into my room and I don't know why but I shared my supposedly complex situation with him. I was teary-eyed. He noticed the gravity of the moment. He was only six but he gave me the best advice. He told me, 'Bhaiya, the night is gone and there is nothing you can do about it now, so don't worry. You still have some time. Just wash your face, have a cup of coffee (he knew I loved coffee), get fresh and study as much as you can.' The simplicity and the inherent truth and logic behind his words made me feel better instantly. I did as he asked and my chem paper too was decent.

A month or so before the boards, school had ended and we had had our official last day in school. It was an emotional affair. Tushit, who wasn't known for being a sensitive person had broken down in the morning. I too was feeling goose bumps. A couple of guys from each section would speak in front of assembly mainly talking about the time they had spent in this glorious institution. I too had spoken on the last day. I was witty and funny; I got the school to laugh a few times. Anish too had spoken well.

Sardar and Neel had gone on the dais together and were very funny. They also made a point that there were no boundaries between science and commerce students citing their own friendship as an example. Hinting at

MR they had made the point that this feeling of unrest and disharmony had been planted in our heads and was not something we wanted or felt. They were right.

Kaushik—who had become public enemy number one by now thanks to the selfish nature he possessed had been slapped hard that day by a guy called Abhishek. And he was told that he is going to be beaten up bad after school. Gadi and I had gone to Anish to try to save Kaushik. Anish asked us, 'Should I save him??' Gadi and I both requested him to. He went over and talked to Abhishek and after a while called Kaushik over and worked out a truce. Later on, Kaushik would badmouth Anish, which I found disgraceful because it was Anish who had saved him that day and he knew it.

After school ended a whole group of us went to the highway dhaba for lunch. All our shirts had been written on with good-bye messages and memories by our friends. A sense of hollowness could be felt when Gadi dropped me home late in the evening. It felt like there was something missing. Being alone gave a chance for the feeling to sink in and for a while it hurt; school was officially over.

The PMTs were coming up and I soon started studying hard-core, putting in twelve- to fifteen-hour days.

The forms to sit for the entrance exams of the various med schools in the country had come out and it was a job on its own to fill out these long documents without any mistakes. One day I didn't feel like studying so I decided

to utilize the time in filling out the forms. I called Guda and we went to Gadi's house. We spent the entire day tediously filling out these papers. We ordered lunch at Gadi's place.

I had studied hard but I knew not hard enough to have a realistic chance at cracking a government college seat. The Kasturba Medical College in Manipal was my primary target. There was a good sports infrastructure in Manipal and my seniors, mostly engineering students, had told me it was a fun place.

The inconsequential board results came out and this time we were at Gadi's house to check the results. Like I said I scored an average of 88% and in my extra subject math scored a passing 55 percent. Gadi had scored 90 in math and 87 overall. Ritz scored 92.6%. I was happy for her (well after the initial two minutes when my ego was hurt).

We had organized a dinner at which most of my guy friends had come; along with Ritz and Parul who was a cute-looking girl Tushit had started dating. Rashmi was also there. After dinner we went on a small drive in Gadi's car and Ritz was sitting next to me. Every time Gadi who was showing off his driving skills took a sharp turn Ritz would be pushed up against me thanks to the centripetal force. The windows were open, the breeze pleasant and again I lay charmed smelling Ritz's hair as it swayed about in the wind and on my face.

I had enrolled in a crash course at Aakash Institute in Delhi to help me prepare for the upcoming PMTs. On

the day I was leaving for Delhi, Gadi and Guda took me to Ritz's house in the morning; and I spent some time with her. We did not know when we would meet again. This was an uncertain time and here I was saying good-bye to the biggest support I had. As I held her up in my arms I noticed a big fat teardrop rolling down her cheeks. Her eyes were watery. She hugged me tight and it felt like I never wanted to let go. I was moved too. It was time to leave. I leaned over close to her ears and whispered, 'Ritz, I love you.' She said the same to me and told me to take care and that we would talk on the phone so not to feel alone and lonely.

Gadi noticed straight away that I was a little shaken. He tapped my shoulder and said it would be okay. He said I would see her again but for now I should concentrate on my preparation for which I had worked so hard. He was a good friend—actually my best friend.

Many of my friends came to drop me off to the station when I was leaving for Delhi. They also got me a souvenir gift and a huge coffee mug from CCD knowing that caffeine was a big part of my life. It was a touching gesture and I would use that mug a lot.

#18

ddd-ily

For the first time in my life, I joined a hostel. It was situated close to Aakash Institute where we had classes pretty much all day. I was not used to sitting through classes so long but the teachers were good; and for once, I found the lectures useful.

My roommate, a fellow medical aspirant named Aditya was specially-abled. He had an issue with his leg and because of this he couldn't walk properly. He was a very sweet guy and we got on well. In the room opposite to mine lived a sardar called Taran who was a good student and very serious about his preparation. I would go into his room in breaks and sometimes we would discuss and solve mcqs of certain chapters together. He was a very nice guy and almost treated me like his younger brother while I was there.

I would attend classes all day and then study late into the night. The exams were coming up. This was crunch time. The all India CBSE-PMT was the first and perhaps the most important exam. I narrowly missed out. Quite honestly, I was very close. I had panicked in the middle

and because of this I couldn't finish the whole paper; quite a few of the questions I missed were ones that I could have easily solved. It made the difference.

I was alone in the big city and my inability to clear the CBSE-PMT led me into depression. There was a bunch of papers left but I stopped studying for a while. I did okay in some of the other papers and I felt I had a chance on the Manipal exam. It was touch-and-go and it occurred to me that the fortnight or so I had skipped mugging because I was dejected may prove costly. The Manipal result was declared. My rank was in the 3000s, which meant I could probably get a dental seat but in all probability didn't have a realistic chance at getting a medical seat. Again I went into depression and in my head started thinking of the drop year I would take to study and give these exams again the next year.

A family friend of ours, Prita Aunty, informed my mom that there was a college in Belgaum called Jawaharlal Nehru Medical College (JNMC) which was well-known and a good med school. Thanks to Aunty I filled out the form for JNMC and also told Priety about it. The paper was tough but there was less competition.

The day I returned from Delhi, my parents were worried because I looked down. My beard had grown and there was a constant sadness in my eyes. My mom had cried just looking at me. As fate would have it, the JNMC results were declared late that night. My rank was 194 and this was a good performance. I was called for counseling. I wasn't sure if I would qualify but I had a good chance.

Priety too had gotten a decent rank somewhere in the 500s and had a shot at getting a dental seat which she was okay with. A few days later I also cleared the COMED-K exam which meant regardless of what happened at the JNMC counseling I would have a medical seat. I had also done well on the CMC, Vellore paper. But since CMC had only seven seats for the general category I would not qualify; nevertheless, my score was very decent and it gave me some confidence.

#19

Welcome to the Cradle of Infantry

I went for the counseling at JNMC with my mom. The first thing I saw as we got off the train was a board which read 'Welcome to Belgaum- the cradle of infantry.' Belgaum had a military base and also the only commando training center in India. It was like love at first sight. I fell in love with the campus and the place straight away.

My rank 194, this number now meant more to me than just the fact that Saeed Anwar had scored this many runs in a match against India. I met Prita Aunty's son Gaurav 'Gauravi' whose rank was 207. We bonded straight away. I was very nervous. I really wanted this seat and I had already fallen in love with the college.

It was a tense few hours and I sat there in the hall counting every rank for which the student hadn't turned up and which increased my chances of making it. It was tight.

After a while though it became a mathematical certainty that I would get a seat and I was relieved more than anything else. The MBBS seats had gone up to rank 201.

I had just made it. It felt like heaven when the principal handed me a provisional MBBS registration certificate. We didn't know then that we would be seeing a lot of each other in the coming few years. Gauravi had been put on the waiting list. Eventually, he too got a seat. However, they made him wait a good month or so before informing him. While I went home over the moon and ecstatic, Gauravi had to deal with a month of doubt. I can't explain how it felt sitting next to Mom on the flight back. I was very happy and made her laugh through the journey. It was the most content I had ever felt. Roughly one and a half years of dedicated cramming had been rewarded.

Ritz was the first person I had called from the hotel to tell her that I was going to be a doctor. She started screaming on the phone. She was super happy for me. I also called Kaushik and he too was genuinely very pleased and he congratulated me. I got a piece of paper and wrote 'Dr Samar Kumar' on it several times just to see how it looked and how it felt to write that.

#20

Unde ka Funda!

There was a good two months before college started. These were some of the most relaxed times of my life. I didn't have to worry about PMTs anymore. Everything was sorted. My parents were very happy.

I spent most of the days traveling around with Gadi. We explored new areas. There is a very scenic road in Jamshedpur on the bank of a river. We call it Marine Drive. At one point, there is a confluence of two rivers, the Subarnrekha and the Kharkai which meet and then go forward as one, forming a reverse Y shape. We call this point the 'rivers meet.' You can appreciate the different colour of the water in the two rivers and then a third colour as they merge.

We used to hang out at this point a lot but had never thought of crossing the river. Since we were in the mood to be adventurous we took one of the boats that the local fishermen used and asked if they could take us to the other side. We stood out as a group on the boat which was filled with villagers. Neel was singing the title track from the movie Swades, 'Yeh jo desh hai mera …' we

had to trek for a little while on the other side before we reached a very beautiful little mandir. I was still an agonist but God (if there is such a thing) had been very kind and I folded my hands in prayer to say thankyou.

I also spent a lot of time with my baby bro Sachin. We played a lot of cricket and football. I also talked to him a lot. He was growing older and more mature every day. I confessed a story that had flashed in my head when I was with him. I told him when he was little and had just begun to start walking, he would walk very shakily and in an unstable fashion, giving the impression he could fall at any moment. It is a particular swagger that kids have and it is irresistibly cute. I remember many a time I would put him on the bed and as he would walk toward me I would give him a gentle push. This would be enough to make him fall straight on his butt. It was rather mean of me to do this but the way he fell was so funny and so endearing that I would do it over and over again. It is not like he would cry or anything.

I was going to be away for a few years and I knew I would miss Sachin a lot.

Gadi, Guda, Chulu and Neel were all going to different engineering colleges; but all of them were situated in Bangalore. I would be lucky in the sense that Banglore was just an overnight distance away from Belgaum as was Mumbai. Pune took five hours by car and the sweetest of all, Goa was just a two-hour drive. Years ago, when I had first watched Dil Chhahta Hai, I had hoped that I get into a college that is close to Goa. I hadn't even heard of

Belgaum but my wish had been answered. Not only was Belgaum close to Goa but in itself was a very beautiful green place. The weather and climate was amazing. It must be one of the best places in India weather wise. The temperature was always comfortable even in the summers; it never got that hot. Belgaum was sometimes called 'the New Zealand of South India,' and as lame as that sounds, it was an appropriate description.

Chulu had done well. After having a very up-and-down examination period and the two years of school before that, he had made up for his lapses towards the end. Gadi wasn't happy. I was the only one who Gadi felt comfortable sharing this with. The truth is I agreed with him. He could have done a lot better and I wasn't too happy either. He was smart and it's not like he hadn't studied. I tried to motivate him and urged him to do well in college to get a good placement. He did.

Sardar and Venom had both qualified for B-Com courses in colleges in Bombay and they were to stay in the same hostel that overlooked the 'original' Marine Drive of Bombay. The queen's necklace would have a whole new meaning for me in the coming few years.

Anish joined B-Com at St. Xavier's College in Calcutta. Whenever I flew to and fro from Belgaum, I would always have a few hours' transit time in Calcutta and I would always spend this time with Anish.

Tushit had grafted hard, scored a decent SAT score and was going to a college in America. Tushit was not really

considered the kind of guy who studied a lot but he had worked very hard for the SAT exam and we were all very happy for him.

Ritz had been confused what she wanted to do for a while. She had played with the idea of becoming an architect but unfortunately or maybe fortunately she had fractured a finger on her right hand the eve before the exam. Obviously, she couldn't do well on the test. She had scored well in the board exams and she decided to use this score to get into a Bsc course in Statistics from Lady Shri Ram College in Delhi, pretty much the best college in India in the courses they provide.

Similarly, Aarush who had scored over 95% in the boards used this score to get into a very respectable technological college in Singapore.

Imo joined the National Defence Academy.

Priety took the dental seat in Belgaum; her college was a renowned one and part of the same university that my college was under. We shared the same campus. Bhanu decided to chase his passion for journalism and joined a Mass-Com course in Manipal. Manipal was close to Belgaum and Bhanu would often come down to see Priety.

Kaushik decided to take a drop year to prepare for the IIT exams. This was a brave move. He had taken the tough but correct road to success. He would get very lonely in the coming months. Studying alone for a whole year is not an easy prospect. I offered him all the support

I could. All his indignations aside there was no doubt that he was still a very close friend and I sincerely wanted him to do well.

Everyone now knew where they were headed for college and everyone now had time to kill. Our hangout group multiplied as did the cars. We hit coffee houses and random picturesque spots in the town. There were night overs now every day. And there would often be multiple night overs at different people's houses on the same night. We would all meet in the middle of the night, joke around and simply enjoy each other's company.

We indulged in a bit of healthy harmless vandalism. One day late into the night Sardar spotted an old man shitting on a distant road. He told Gadi to turn the car so we face him and to put the high-beam lights on. Sardar got out of the back window and for five minutes had a real go at the poor man. Sardar was funny. He laughed at him as did we all. The old man was trapped. He couldn't do anything but smile in vain. It must have easily been some of the most embarrassing moments of his life.

Our nuclear weapons, 'eggs,' that had won us the war at Aisha's house had not been forgotten. One eve, we were hanging out at City Café; Sardar, Guda, Gadi and me. Someone had made a joke on Sardar. Gadi's only mistake was that he was also laughing. Then when we were leaving and all except Sardar were in the car, Gadi did the unthinkable. He moved the car forward as Sardar walked up to it and then did it again. Gadi was elated, almost bobbling up and down in delight. Sardar was shocked.

Gadi then took the car away, leaving Sardar. We drove for a while before coming back to pick him up. Sardar was waiting and had his game face on. He sat inside and instantly smashed an egg on Gadi's head. While we had left him, he had gone in to City Café and gotten an egg. We all broke out in uncontrollable laughter. Ironically, Gadi then had to go to Sardar's house which was close by to clean up. Sardar shouted in front of his mom and dad, 'See, Mummy, he is the driver!!' and kept chanting 'Driver! Driver!'

One evening I took Ritz to the same river crossing that I had been to before with the guys. We got on a boat and she had this camera which she never let go of. She was continuously clicking pictures. She was so happy that she seemed like a girl with all the money in the world shopping in London.

Multiple night overs were the flavour of the times and many a time we would all play football till three in the morning at Mody Park which was always lighted. One such night, we didn't play football and just sat around and talked. One topic led to another and finally we were talking about eggs and war. Once in a while we used to hit an innocent biker or someone on a cycle with an egg but later we felt guilty. We needed cause. We needed to punish people and not target the innocent. Meenakshi Roy came out as the numero uno target; almost everyone there had an issue with MR. She was very much like the 'Queen of Hearts' from Alice in Wonderland. Even her voice sounded similar.

Tushit said I know where she lives!

On the way we went to the station and picked up one hundred eggs. We thought out the whole attack and planned it meticulously. It would be a fast stun attack and we would be out of the neighbourhood before anyone had any idea what happened. We had to finish the 100 eggs and scream out at the top of our voices the most hurtful and choicest swear words aimed at MR.

Tushit, Mr. President, had declared that the mission would be considered successful only if for the next week or so people asking directions or giving them would refer to MR's area as the one that has a house that stinks of eggs. We had covered the number plates of each car.

The mission was a great success and we rejoiced and hugged each other like brothers coming back from war when we reunited at Mody Park. She had made three huge mistakes and I honestly felt that this statement we had made was not mob mentality but had meaning. I felt she deserved it. The score was settled and I wish her all the best in the future.

At the age of 17 years and 11 months, I got on the train with Dad waved good-bye to a tearful mommy and made my way to med school. My friends too left for their respective colleges some before me and some after. We promised to stay in touch on social media and group e-mails. We did. Good-bye Jamshedpur … Enter BELGAUM!!

#21

Goa: An Initiation

College had started. For the first few weeks, I had no roommate and it became a norm for several people to have lunch and tea in my room. Like in Jamshedpur, my room had become a café of sorts.

There was a definite 'white-swan glory' when we would wear our white aprons for lectures and practical classes. It was still a while before we would get to carry stethoscopes and have clinical classes in the hospital but for now the aprons felt good.

I had hit it off with Gauravi from the day we had met and soon we became very close. The class got used to seeing us together and this would continue pretty much through college.

I did finally get a roommate. His name was Rahil, though through college he would be more commonly known as Chetu's brother. Chetu was Rahil's cousin and was also in our batch. He was a truly gifted guitarist and blessed with very obvious good looks. He would come into my room a lot with a couple of other guys and we would talk

about and listen to music. Metallica and G 'n' R became the base of a solid lucid and inherently sober relationship.

Chetu was the kind of nice guy who if he wanted could have been bad. Most 'nice' guys are forced into being nice because they don't have a choice. They don't have affairs because they can't. They don't cheat because they can't. Chetu was different. He had a girl from school and he was serious about her; so even though we were in a college where chicks were dying to get with him, he never cheated. I admired this about him.

Easily, one of the most exciting phases of this period was the introduction of the batch as a whole to dissection classes. I remember going into town with a bunch of my friends to buy all the tools for dissection along with gloves which were important initially but then used only by a few after a couple of weeks. For the first week or so we were just made to sit around our respective cadavers, the long-dead formalinized human bodies we had the honour to dissect. I decided with the permission of my table mates to name our cadaver and we named him Shashwat, meaning immortal.

The best thing about our batch was its diversity. It was a 'mini India' of sorts. Students from all over the country were present in sufficient numbers. No one gave a shit about whether you were from the North or the South of India or from the East or West for that matter. We also had quite a few students from Malaysia and Canada. We all got on really well. I went and announced when we were in the lecture room waiting that everyone from

the batch should stand in front of the class and give a brief introduction of themselves. I told them to take this opening-up process seriously, that there were guys and girls sitting here right now some of whom one day will marry each other. I was right.

When Chetu went on, I purposely blurted out, 'So you have a girlfriend?' towards the end of his intro. I knew he would respond honestly. He smiled and said yes. I had told Chetu about Ritz. So when I went on he asked me the same question; I lied, I said, 'No.' Yup; I was already well on my way to becoming a text-book jerk.

The only drawback of this rapid bonding within the batch was that it became almost impossible for me to decide who to invite and who not to as my birthday came up. Mine was the first birthday in my batch and a big one too. I was turning eighteen. I got Gauravi's help. The rule was simple; we would call the guys who we got on best with and as for the girls the best-looking ones would be on the invitee list before we even thought about the rest.

I was late for my own party because there was a football try out in the evening that day. Sumeet and I had made the college team. The party was okay.

The next day turned out to be a controversial one. There was a huge collection of guys who were super pissed that they had not been invited. They saw this as a missed opportunity to make inroads. I tried to explain that since I had to restrict the total number of invitees some names had been missed out and I was sorry. They didn't seem to

understand. They even started to get a little aggressive. I finally had to tell them to fuck off! And with Gauravi, I walked out of the room. I had to have Gauravi with me in these moments. I felt safe with him. He was big and strong and not many would think of touching me when I was with him.

After the initial heavy security that we the first-year students were afforded, seniors now began the ragging process which would last months. There was never any physical ragging and most times it used to be quite fun. Most times. Usually, different kids from the batch would assemble in my room in the evenings and share their ragging stories for that day. Sometimes the seniors took ragging of individual students whereas sometimes a group of students were grilled together.

Keshav Sir and Tyagi Sir were the first seniors to take my ragging. They were two years senior to us and after making me dance around to hideous tunes and indulge in other embarrassing activities, they let me go, but not before letting me know that I was one of their friends now. They handed me study material and asked me to call them whenever I needed any kind of help whatsoever. I would get close with both of them in the coming months.

I talked to Ritz a lot in the initial few weeks. We would share our college experiences and talk about other things. I really missed her. Like before, she was always there for me. Soon I would let her down.

The longest and easily the toughest ragging I faced was from a super senior of ours called Mukhya ji. There was a rule that when you face a senior you don't stare into his eyes; you have to look down at your second button until he gives you permission to look up. I had been focusing on my second button for almost half an hour while Mukhya ji abused me no holds barred. I wasn't used to hearing so many swear words thrown at me. They sounded much worse in 'thet-Bihari' Hindi.

After a while I was told to make a diagram of the female reproductive system; I thought it was like a test or something so I took my time and even labelled it. Then they told me to paste it on the wall. I was then instructed to fuck the diagram and make noises at the same time. The seniors present there were laughing and I felt very awkward. When I was let off, I went into my room and felt like crying. I got a fever too. However, Mukhyaji was a good man; and like with so many of the others I eventually got very close to him.

She walked up to give her introduction to the class. I had almost forced her to go on stage. 'Hi, my name is Tanya but you guys can call me Tanu.' I was really into this girl. She ticked a lot of boxes and she was very cute. It didn't take long for me to realize that she liked me too. I moved fast. I had asked her to help me get a cake on the eve of my birthday and we had gone out a couple of times for juice.

One of Tanu's friends was called Megha and Gauravi liked her. I suppose it was a blessing in disguise that

Megha fell a little ill and was admitted in our hospital. Tanu was always with her.

Gauravi, me and some other guys we were close to went to meet Megha in the evening and then decided to stay the night. I was working on Tanu, Gauravi was working on Megha, while our friends sat there trying to help in any way they could. The first evening I was there I slipped my hand beneath the quilt Tanu had over her and held her hand. This was the first of a few times I would cheat on Ritz. I felt guilty but I wasn't mature enough to be a part of a committed, honest long-distance relationship. I just wanted to have fun. Tanu looked at me and smiled. Later in the night, when everyone was asleep or at least acting asleep, Tanu and I kissed.

We kissed and whispered till the sun rose. We were on the third floor of our magnificent hospital and the view from the room window was amazing.

Vishal Singh on paper was the rank one at our college. Like some but not all the students in my batch he had bought the seat by paying money and had not actually qualified. I had no problem with that. It only annoyed me that he had not just bought a seat but the fact that he was supposedly rank 1. There was a ceremony on the first day of counseling and Vishal Singh was given a garland of flowers and officially honoured for topping the entrance exams. The event was soaked with obvious hypocrisy. Vishal along with Gauravi also had a thing for Megha.

The girls from the hospital were messaging us the next night and telling us that Vishal Singh was with them and refused to notice all the hints they were giving him to leave. We wanted to stay at the hospital again but Vishal Singh had to leave first. Finally, after boring them to death Vishal finally left.

The evening before, a friend of mine Raghav and I had brainwashed Megha that Gauravi was the right guy for her. Megha already liked Gauravi but we drove the point through. Megha had accompanied Vishal to a Gurudwara a few days before; I guess he thought he was in. Somehow, news of our actions leaked and Vishal Singh now held Raghav and me responsible for Megha turning him down and choosing Gauravi.

We were lucky on the second night. The other patient in Megha's semi-private chamber had been released, so now Tanu and I effectively had a whole room to ourselves. This was not officially allowed but we asked Raghav to work his charm on the nursing student who was asking us to leave and after a few minutes she allowed us to stay. We only had to vacate the room for a while around 3 am when a check was to be done.

We went to the college grounds situated close to the hospital. And it was here amid the beautiful Belgaum breeze that I took my first puff of a cigarette after another friend of ours Chondu from Kolkata (a heavy smoker) had lit one up.

Tanu and I made out till the wee hours of the morning. She put her hands through my hair and in an instant knew that I had smoked. She did not approve. We played with each other and I formally asked her out. She said yes. That night I had smoked for the first time in my life. The evening after, I drank for the first time. I had asked Gauravi to get a bottle of vodka and with my friends we drank to celebrate the fact that I was now dating Tanu. This would become tradition, so whenever any of us started dating a girl, he would first have to sponsor a celebratory alcohol party at the hostel for the guys.

By now many of the big groups that had been formed initially slowly reduced in size. There were eight of us that got very close. We shared everything with each other, we played sports together, we hung out together, we studied together. We even tried to help when one of us was chasing a girl.

This was an elaborate circle consisting of Chondu, Mochuu, Gauravi, Raghav, Sumeet, Hanu, Dev and me. Chondu was a short guy from Kolkata. He was here on a management seat, he had not qualified for JNMC like the rest of us however he was very smart. He was also the only guy who smoked. Soon I too started smoking but for months I never bought my own ciggies. I always used to take a few from Chondu's box. He didn't mind initially but later one day told me that it was now time I bought my own cigarettes, so I did.

Mochuu was Gauravi's roommate; therefore, I knew him well because I spent a lot of time hanging out in Gauravi's

room. Mochuu was the sweetest guy in our batch. He was from Mumbai. His parents too were both doctors and worked hard. They had been successful in raising a son who had a golden heart. He was in a relationship with a girl from Mumbai called Sheetal and though he heard and even enjoyed stories of our promiscuity he never ever indulged in anything that he wouldn't be able to share with his girl. He shared everything with her.

I had known Gauravi a little from before. Our parents had known each other for decades. He was a very 'Bihari' Bihari. He had an amazing sense of humour, a quality that not only had us in splits most of the time but was also heavily appreciated and enjoyed by the girls in our batch.

Raghav was from Hyderabad, an intelligent, eccentric individual; textbook tall, dark and handsome; and along with Chetu probably the best-looking guy in the batch. We bonded fast. He had called my name from behind while I was walking back to my room one morning wearing my school football jersey. He asked me about football. Soon the topic of conversation shifted to analysing who we thought the hottest chicks in class were. We sat together in class and soon our friendship was sealed. He would come to my room in the nights with Chetu and we would have coffee together and listen to some classic rock. Unlike Chetu, Raghav like me wanted to have fun and he was willing to break hearts for the same.

Dev was Raghav's roommate in the first year. Dev was a darker individual than the rest; and though we were tight

as a group, it was clear that unlike Gauravi and Mochuu, Raghav and Dev didn't really like each other that much. I could understand why. Raghav was a very confident and sometimes irritatingly cocky individual and while I actually liked these traits in him, Dev, on the other hand didn't.

The other two spots in our group were filled by two Jains called Sumeet and Hanu. I had gotten close to Sumeet earlier because he was good at football. They were both quite classy individuals. Hanu, like Gauravi, added muscle and strength to the group. He was a good kid but not scared to express himself. Hanu was the first guy to go introduce himself to the class after I had made the announcement. This was actually a deal we had cut. I had agreed to make the suggestion to the class if Hanu agreed to be the first person to come and speak. This ensured that I didn't look like a dork if no one responded.

Hanu had come to my room one evening (it was supposed to be friendship's day) and had shook my hands and invited me to his room where there was a little party. He was the kind of guy who never shied away from taking the initiative and I liked this quality in him. He liked a girl from Patna. I did not know how he would be like at first but soon it became clear that once he got his girl, which he did, he was a one-woman man. Sumeet was very good-looking but he didn't have the gift of making riveting conversation or charming women nor did he seem in any way to care about or be affected by this. He was a gifted sportsman, a bright hardworking student and a loyal friend.

Chondu and I were summoned for ragging by a super senior of ours called Manu Sir. Manu Sir had an aura about him. He was by far the biggest and strongest guy in college. He was the kind of guy people used to be scared of.

His approach to ragging was very different from the ones we had encountered before. He took Chondu and me on his famous bullet and made us eat at all the selected classy food places near the college. He cleared the bills with nonchalance. Initially, this seemed rather nice of him; but soon, when we were full he let us know that we would have to continue to eat till he said so. With no choice left and not wanting to get in his bad books, we ate and ate till our tummies hurt. He finally dropped us off at the hostel and said that he knew that we were going to cuss him like hell once we were alone. We denied we would do that but as soon as we reached our hostel rooms Chondu and I shouted swear words at Manu Sir. I had to deal with that horrible heavy nauseated feeling for the best part of an hour while Chondu burnt down cigarette after cigarette in an attempt to feel lighter.

Manu Sir was a born entertainer. One evening we sat with him at the Nescafe next to our hostel. All eight of us were there and for more than an hour he made us laugh almost nonstop. He was amazing at doing impersonations. He did his Sholay routine which had us laughing out like crazy.

We were making a lot of noise and during this period someone from the second floor of the hostel shouted at

us to stop. I think they were studying. Manu Sir walked over to the window from where the noise had come and screamed out, 'Who the fuck is that?!' There was dead silence. No one spoke a word. We were all impressed but especially Raghav and me. We talked about Manu Sir a lot—his persona, his panache. He did this ultra-cool skid thingy on his bullet which added to his glam. He was a Rajput and he was very proud of his heritage.

Another aspect of Manu Sir's ragging repertoire was that he made us run up to cute senior girls and ask them their names and numbers. He knew most of these girls and I enjoyed this. He would ask me to dance at the juice shop when some fast track was playing. Another thing he did was to ascertain whether the junior had made it to med school by working hard or by paying money. He asked me several questions from twelfth-grade physics and only believed me once he was convinced that I knew my subjects and had made it here on the back off effort. He didn't have a problem with people on donation seats but he had a problem if they lied about it. He didn't take more than two minutes to figure out Chondu's secret.

We had started drinking by this time. The late-night drinking sessions involved all eight of us except Hanu who never drank while Sumeet drank very rarely. Raghav would get pissed if Hanu would munch on our drink snacks and not drink. According to him, the rule was that you could only eat the junk food if you drank. Initially drinking only once in a while, we soon started drinking often. There was this circular bench below the library where we would often meet after slogging a few hours

to take a break. Soon it became dangerous to meet there because in no time our plans to return to the library would be eclipsed by drinking plans. It was the place where unconsciously or subconsciously 'mood ban jaata tha.' We drank a lot; and with the alcohol flowed more and more conversation, camaraderie and brotherhood.

There was a guy called Sohail one year senior to me who had called me specifically to his room for ragging. A bunch of his friends were there. They looked meek and in comparison to seniors like Mukhyaji and Manu Sir who I had already faced, I wasn't even in the slightest bit afraid. They had basically called me to force me to break up with Tanu so Sohail could go for her. This was not all. They actually tried to make me believe that breaking up with Tanu was for my own good claiming I should just concentrate on my books in first year and this is what they had done. I had to try hard to not break out into laughter especially when he said something like 'What you think we can't do all thisss?' I happily gave him her number and wished him all the best, knowing that there was more chance of Bangladesh winning the World Cup than Tanu ever falling for this moron. These guys were very frustrated and desperate, a kind of people I would see a lot of in med school.

Tanu and I started dating properly. We went out a lot. Sohail and his gang had no effect on me. I would hang out with Tanu at all the parties and other get-togethers. In the nights I would juggle calls between Ritz and Tanu. I often took Chondu's help and made him lie to Tanu that I was asleep when in fact I was on the other phone with

Ritz. In retrospect I wish I hadn't done these things. I was well on my way to seriously hurting two women who loved me with all their heart. I was stupid and I was a punk.

It was one of those mornings where you woke up to see your friends sleeping in all kinds of positions knocked out from the night before. One of those mornings where you wake up with a headache and a 'bad' hangover; (yes, there is such a thing as a 'bad' hangover … and yes there can be a 'good' hangover, a tequila sunrise) one of those mornings where you wake up at noon with a feeling of guilt that you have missed all the morning classes.

However, this morning was a little different. There was a palpable frenzy being created by the guys who had come back from class. The first internal exam dates had been put up on the notice board and they were just a week away. Oh shit!! I waited for a few minutes to calm myself down as well as wake my friends up and break the news to them. First tests at med school—it meant a lot psychologically. I made my way to my room, put a Do Not Fuckin Disturb sign on the door and opened the anatomy textbook. The schedule for the next week or so was more or less fixed. I would cram from noon to around 3 am taking breaks only to smoke cigarettes and jack off.

Keshav Sir who had been drinking with us that night came to my room and wrote out a list of topics I must read because there was a high chance they would be asked.

I met Raghav in the evening. He looked a lot more at ease compared to the rest of our batchmates who were evidently stressed. He had left early in the morning to hang out with Anamika, who was a senior of ours and who Raghav had started dating. I realized soon that Raghav didn't even know about the first internals till I told him then. The glow on his face vanished and was replaced by a nervous sense of doom. Raghav like me didn't compromise on having fun but when it came to academia he was a very serious student. More serious than me.

I was with Gauravi at Nescafe and lamenting about the fact that I was unprepared to face these exams. Gauravi was the right guy to talk to in such situations. This time was different because Gauravi offered a solution that had never crossed my mind. He told me that Hanu had with the help of some seniors managed to leak the physiology and biochemistry papers and now effectively we just had to study anatomy. I strongly opposed this and told him I didn't want the paper.

I questioned Hanu and told him what he had done was not right. I told him we should study no matter how fucked up the situation seemed. Hanu was a very good student which is why I was even more surprised that he had taken the decision to do this. He told me to trust him and almost became a little emotional as he said, 'Samar, you don't think I study?' He argued that this was only so we could score good marks and pump up our internal assessment marks for the university exams at the end of the year.

Sumeet, Raghav and I were the only ones in our group who had decided not to take the paper. Now it felt even more shit! At least before there was a comfort in knowing that all of us were going through the same thing. That had changed.

On the eve of the anatomy paper, I was in Gauravi's room and he was explaining a topic to me: knee joint. Jemur Sir was the HOD of the anatomy department in our college and he was strict. A guy passed our room and shouted, 'Jemur madarchad' Jemur's a mofo in the hostel corridor. The batch was stressed out and this became the perfect opportunity for everyone to unwind. Soon the whole hostel wing including Gauravi and me ran out of our rooms and started screaming, 'Jemur madarchad.' We created such a racket that the warden had to be called. There was no way to tell who had started it though and you could not collectively punish a whole batch. It was funny as hell and this became a common terminology thereafter. 'How was your anatomy paper?' ... 'Jemur Madarchad!! ... 'Which subject did you flunk in? ... 'Jemur Madarchad!!' Jemur was a nice guy who never did us any harm. This was just funny!

Anatomy was the first paper we had. I didn't do too well on it. I counted and recounted the marks I thought I would score on each question and the total was coming around 25/50 which was the passing score. Even if I passed, I wasn't happy with my performance.

I was lying in Gauravi's room trying to get some sleep when this irritating senior kept blabbering on about how

to pass physiology and biochemistry. I had been using standard textbooks for both the subjects and now this twat senior told me there was no way I would pass the papers after studying from these books. I already felt like crap after anatomy and there was no respite as the next two tests were on the coming consecutive days. I decided to rid myself of the moral stance I had taken called Gauravi and told him I too wanted the paper. Raghav shared my view and he was also in. Now Sumeet was the only guy who didn't take the paper but we didn't feel good about that so we kept going to his room through the night and blurting out questions that were going to come on the paper.

Eventually pretty much the whole batch had the paper and there was a collective sigh of relief when the questions for physiology were read out and all of them matched the paper we had bought. We sat quietly for the duration of the exam and regurgitated the answers we had memorized so many times the night before.

This was the first time I had indulged in an activity like this. Though the paper had obviously gone well I didn't feel good about it at all.

Keshav and Tyagi Sir who had heard about this were disappointed in us. They came to Gauravi's room where we all were and gave us a piece of their mind. They argued that whoever had chosen this path before had failed in the university exams. They had a go at me saying that I had studied so much and I didn't need to resort to this. I felt like shit and decided I would not sit for the

biochem paper on the next day. I got some vodka and drank alone. My friends tried to convince me to at least sit for the exam but I didn't change my mind.

It was in this conversation with Keshav and Tyagi Sir where we had been told that everyone now knew that we had leaked the paper. They claimed that not only our batch but the whole college knew, that we were collectively the black sheep. This was perhaps an exaggeration because quite frankly no one gave a shit but it left us feeling hollow.

As they left, the eight of us reaffirmed the bond of friendship we shared and decided that even if we were boycotted or looked down upon we would always be there for each other. We decided that this group that we were all a part of would henceforth be known as 'the Untouchables.' We soon realized that the name was kind of stupid but still somehow it stuck.

The papers were over and though most of the guys had ensured they score decent marks, none of them were pleased. We never did this again.

Raghav, originally from Andhra, knew very little Hindi when college had started. We would obviously change that. However, as the process of this change was going on Raghav often spoke Hindi in a manner that was hilarious and tough to understand. There would invariably be a fight if Raghav started speaking Hindi ordering food at some restaurant as the waiter would get offended. He didn't mean to be rude. It was just the way he talked, very

crude and unpolished. To be fair to him we mostly used slangs in Hindi and so Raghav picked these terms and phrases up before anything else.

Ragahav stormed into Gauravi's room and looked very worried. He was a hyper type of personality on good days; today he looked even more paranoid. His father who was a very strict was coming to visit and he had just found out. With questionable knowledge of the Hindi language like I mentioned before Raghav went on to proclaim, 'Mera Baap Aayega . . . Mera Maa Chod Dega!' There was silence for a few moments. I turned to Gauri and instantly everyone in the room broke out in laughter. Raghav looked confused. We obviously understood he meant what he said in a different context but the way he said it and the fact that despite our reaction he failed to realise his mistake was very funny.

One evening, I was in my room with Gauravi when a bunch of first-year NRI dental guys stormed in drunk and aggressive. It was Simran, Reetinder and a few others. These guys were a good few years older than us and also bigger. Simran came over and pushed me. I knew Simran through football and I didn't understand why he was pissed. I asked him but he didn't give a straight answer. He claimed that I had been bad-mouthing him to the chicks. This was bullshit. Later, we would discover the real reason behind this rather rude visit.

Simran and Reetinder were Punjabis, the typical Canadian NRI types. The type that think they should be treated better and score more women because they

lived in a foreign country. Having lived abroad myself I knew very well this sort of people and I detested them.

Soon the news of this insult spread to all the guys in the hostel. This was fuckin dental! We had been trained by our seniors to passionately hate the dental fraternity. My friends first Hanu and then Raghav came to me and said that we must plan to retaliate. This thought process was only strengthened by Keshav and Tyagi Sir who suggested the same. The plan was simple. We would wait till the morning and strike early. We didn't need many people but the batch was pretty close then so most students in the hostel decided that they would come too.

It was later that night that Vishal Singh called me and confessed that it was his Megha story in which Raghav and I had played spoilt sport which was the reason these guys had come pumped to my room to fight Vishal's cause. Vishal, also a Punjabi, was the kind of guy who looked up to these people because they lived outside India. It was a very cheap admiration society. To his credit though Vishal pleaded that we don't physically hurt Simran and Reetinder; and if we did he deserved to be targeted too. However, things were no longer in my control. The whole batch was pissed and there was no way they would back down now even if I tried. And Vishal, despite everything was still our friend and there was no way we were going to hit him.

The next morning some forty of us made our way to the lower floor and beat the shit out of Simran and Reetinder. They would stay in check for the next few

years before they needed to be reminded again that the Indian youth didn't follow Gandhi's principle of ahimsa. The Canadian duo weren't expecting this and though they incurred no long-term physical damage a statement was made that day and they were made aware of the fact that they couldn't fuck with us. Also since so many people came to fight that morning it showed that the batch was firmly united. The number was more to scare; only a few guys actually fought.

We were hanging out with a senior of ours called Vijay 'Jaat' Sir when we were summoned to a room to settle on a compromise between the two parties. There was a heavy senior NRI contingent and they seemed pretty pissed. I had requested Jaat Sir to come with us; he was genuinely hard and trained in martial arts. I felt a lot safer with him behind me. The whole series of events were discussed and of course there were two sides to the story. For a while I thought one NRI senior called Rishi would strike me. I would be lying if I said I wasn't scared. Again, having Jaat Sir there meant a lot in a number of ways not only for us but for them too. We walked out unscathed.

When we reached our rooms we saw Manu Sir with Mukhyaji and a few others from our window entering our hostel. Manu Sir looked at us peering and shouted, 'Boys, you have done your bit. Now it is time we do ours. No need to fear, Manu Singh is here!!' They went and scared the shit out of the NRI seniors who had been getting big on us and warned them that they would have hell to pay if they ever touched us.

We had become very close to Jaat Sir. He could mostly be described as a gentle giant except for the odd occasion when he would lose it. He looked scary on his bike and with his biceps; deep down though he was a very sweet person. He had a definite issue with the English language; he often asked me to spell-check simple words like pant which he was confused may be spelt as paint. This added to his charm. He was rather cute to be honest. He never let this weakness in English get in the way of his exams. He had to read the same chapters more than others not because he wasn't smart (he was very smart) but because of his language problem. He never shied away from putting in the long hours when he needed to.

He was also good at football and this was one more reason we bonded like we did. We would go out for walks in and around the beautiful green campus in the evenings and just talk. He was shy. The kind of guy who wasn't comfortable saying good nights or exchanging other formalities. If anything, I changed this a little in him. I would say good night and not leave till he responded. He would try to deflect initially but soon started replying. He had this smile. I would always go with him for juice after football.

Belgaum was close to Goa and it was about time we made a trip to the hallowed land. Sardar, who was studying in Bombay made his way to Belgaum. Initially, the plan was that only Sardar and I would go to Goa but Sardar soon convinced Gauravi and Raghav to come with us. He had only just met them but they liked him straight away; Sardar had this air about him.

We boarded a bus. There was a sense of intense excitement as we reached our stop. This was the first of several trips we would make to Goa. We spent the first evening by the beach sipping beers and munching down on chicken starters. We also tasted crab. There was a minor hiccup as it took a while for us to find a place where we could stay that was in our budget. We even contemplated the idea of spending the night on the road; we eventually found a decent-enough place.

Again we spent the next day by the beach. There is this calming effect that can be felt on shore. I can happily spend hours just looking out into the ocean. We also indulged in some water sports like parasailing and the water jet scooter. Goa is different, where at other places I would be drunk after three to four beers, in Goa, I would be drinking pretty much all day and still be sober. Goa has this effect on you; it increases your capacity.

It is a place that emits a lot of positive vibes. Almost everyone there has come to have fun. People look happy. People smile. The tedious tiredness and frustration which can be seen on so many faces elsewhere are more or less absent in Goa. People are generally nicer to each other.

Later that evening we went to a mind-blowing club called Paradiso. We had found a couple of senior girls from our college and they had offered to give us a ride. The club was amazing. The dance floor opened into a large balcony of sorts which faced the ocean and overlay a small beach with palm trees. We ordered shot after shot of vodka and soon got wasted.

There was this guy who talked to me when I was getting some fresh air at the edge of the balcony. He was smoking something but I could tell it wasn't a cigarette. Not at all afraid to try new things I immediately accepted his offer to smoke a few puffs. He told me it was the finest Bombay Black in the market. I pretended to know what he was talking about. I didn't have a fuckin clue. I passed it to Sardar. He seemed to have a better idea and said the stuff was good. I must mention here that Sardar did not actually smoke but he knew his shit and was almost a non-playing connonsiueur. It definitely hit me but I was so drunk that I couldn't appreciate the high properly.

Soon my head started to hurt. I found a relatively quiet corner and sat there holding my head. Sardar was sitting opposite to me. A couple of Australian girls walked over and sat next to us. The one sitting next to Sardar was chubby and loud and the one next to me was cute but didn't say much. The girl who sat next to Sardar went hysterical, telling her friend that Sardar looked exactly like one of her cousins. Again she was very loud and my head was hurting. I didn't react for a while but when she kept shouting that Sardar looked exactly totally absolutely ditto like this cousin of hers the stupidity of her observation annoyed me so much that I unconsciously let out an unappreciative tsk or groan or whatever. I would regret this for years. The chubby one noticed my reaction and told Sardar, 'It seems your friend doesn't want us here,' and they left. I wish I wasn't so smashed because this was a definite opportunity.

How the fuck could an Aussie look exactly like fuckin Sardar?! was beyond me.

A few minutes later Sardar came running to me and said that the guy who I had smoked with earlier was asking him where I was and he had casually mentioned that he thought I was cute. I couldn't stop Sardar who went into a laughing frenzy. He told me that we would get great food and unlimited alcohol if I only took one for the team. For our perks depended on me giving myself up to this guy. On the other hand, if I didn't want to face sodomy, Sardar said, 'bhag bhosdi!' which basically meant 'let's get the fuck out of here.' I was scared and we left.

Outside the club were several egg thelas and we all hogged on double omelets and bread. We had blown most of our money on alcohol and now we were hungry. The two senior girls we had come with had left earlier and we would have to take a taxi to our hotel.

We didn't have much money left so Sardar started negotiating the tariff with a bunch of taxi drivers who were around us. Sardar was usually good at such things but this time he almost got us beaten up. He had played all his cards; that we were students, that we were running short on cash, that unlike a lot of people there we were Indian. We didn't mind them charging a little extra for the foreigners but we were Indian and we didn't want to be cheated.

To be fair to the drivers they heard us out and reduced their demand from rs.1000 to rs.500 but said they would

go no lower. Sardar had tasted blood and he kept pushing. I would have settled by now. Sardar said he had been in Bombay where he traveled a lot on taxis and rs.500 was too expensive for the distance we had to cover. The drivers asked him what he thought would be the right price. There was a long moment of silence. I was trying to think what the little Sard would say. What he said next shocked everyone. He said the right price would be around 60 rupees. Even I knew this was an absurd assumption. The drivers' expressions changed and they got super pissed instantly. They were actually trying to help us and they took Sardar's 60 rupee offer as an insult. They wouldn't talk to us anymore. They stood there making crude jokes saying whether it was our principal who had told us to come to Goa and get drunk. I felt like killing Sardar.

There was another group of drivers at the entrance who we were now banking on. They didn't budge a bit from their rs.1000 demand. Eventually I went back to the drivers we were talking to before and apologized for Sardar and then asked if rs.200 would be enough because we were in a bit of a bubble. They agreed to help and we got on the taxi.

This wasn't all. Five minutes into the drive on a very lonely road Sardar spoke again. He told the driver that it was shameful that they were cheating Indians, their own people. The car swerved to a grinding halt. The driver was furious and told us to fuck off and get out of his car. He could have cut us into pieces and thrown us in the ocean without anyone finding out if he wanted. That

is how isolated we were. Again we were shit scared and again we all apologized on Sardar's behalf claiming he was too drunk. Now I really felt like killing Sardar.

The next morning we made our way to the beach. There was a small crowd around a guy who was orchestrating a game that involved the player putting money on the line and then he had to guess which of the three identical cups had a red paper under it while the other two had black under them. They were being juggled around. If you were right then you would double the money you put on.

The guy was juggling the cups fast but it was still easy to follow the red and I soon won rs.400. The game seemed easy and everyone loves easy cash. My friends too got excited and wanted me to play more. We started talking about how much money we had collectively. The guy who was observing our conversation again juggled the cups and I again guessed right. He said, 'Guys, you have won 8000 rupees.' I hadn't even made a rs.4000 bet. We got super excited. Then he said, 'But you have to show the money you have bet to get the prize.' We pooled in all our money and it was 3000 something. He had heard that we had around that much. He said, 'You can't win a bet on 4k if you didn't have that money to bet.' He said, 'I would have to play again.' Confident that I wouldn't screw up now we put all the money on the line. He juggled the cups just like before but this time I didn't guess correctly. They had done something. We had been played all along. He took our money and didn't say a word. We were literally broke.

We stood around for a while too shocked and too fucked to do anything. One member from the crowd which had gathered came over to us and told us to fuck off or we would get beat up. It then occurred to me that even the people around the game were 'set' so dumb idiots like us get attracted.

We walked around in silence. We told a couple of people in the shacks close by what had happened to us and wondered whether the police could help. They said there was no point involving the police because they already knew of such trick games that were being played on the beach and they had been paid off.

We seriously had no money. We couldn't even get back to Belgaum. Every one of us had only brought cash. We didn't have ATM cards. We strolled over again to the site where we had been screwed and talked to one of the guys involved. We begged for empathy and explained that we were medical students and we didn't even have any money to get back. He heard us out and soon returned 1k back to us. We thanked him like he had saved our lives, in a way he had.

You would think that after going through an experience like this we would have caught the first bus back to safety, back to Belgaum. But no!! This was our first trip to Goa and we wanted more—in the words of Chulu, 'A lot more!' We decided we would take a shitty non-AC bus back and stay in Goa till our money ran out. We would have to spend wisely. We weren't too good at that.

Sardar and I were lying on the beach recliner seats sipping slowly on a pint of beer so it lasted longer. We didn't have any more money to blow after this. Gauravi and Raghav were in the water. We saw Gauravi slowly walk over to the game in which we had lost all our money. He stood there and seemed to be concentrating.

He walked over to us and claimed that he had 'understood' the game. This was a faux game. Now, we all knew that. There was nothing to understand. We had 300 rupees left and Gauravi asked if he could take a 100. He was confident he would win back some money. Sardar and I burst out laughing. Then Sardar took out a 100 note from his pocket and gave it to Gauravi. He said he didn't mind losing the money but what was more important to him was that Gauravi got to play. Sardar and I couldn't stop laughing.

Gauravi walked over again and observed the game for a while before he made his bet. A few seconds later, Gauravi could be seen holding his head in dismay. Sardar and I went into a hysterical fit of laughter. We could tell Gauravi had lost the money. He walked over to us and his expression said it all. Sardar and I just couldn't stop laughing. Gauravi went back into the water.

Sardar and I were still sipping on what we thought was our last beer. It was then when a group of these irritatingly wannabe guys came and sat next to us. It was a hot day. They ordered beer after beer after beer! and lots of starters. We were hungry too but mostly we too wanted more beer. They were so loud and so happy that

in a while Sardar and I got extremely jealous. Fuck this! Sardar called the waiter over and ordered two plates of chilly chicken and two bottles of chilled beer.

Gauravi walked toward us a little later and was surprised that there was food and drinks on our table. As he began to question us Sardar told him to relax and enjoy. We ordered more starters and many more beers.

We were having the time of our lives while still working on an escape plan. It was obvious that we couldn't pay for our order. The only alternative was to take advantage of the crowd and fuckin run.

After we were done we all started to leave the shack one by one in order to not draw attention until only Sardar was left. No one had asked us to pay by then. Sardar then wandered around for a while and when he saw an opportunity to leave, he ran. We met at our rendezvous point and celebrated the fact that we hadn't been caught. We were confident now. And soon we were hungry again … Ye gods!

This time we hit a proper restaurant and not a beach shack. We knew this place. We had eaten a few meals here before. We had had money then and we had paid. The staff recognized us and I think they even liked us. This would change. We chose this place not only because they served amazing butter chicken but also because there were many tables and it was always very crowded. We thought this would aid and in a way abet our plan.

We ordered a sumptuous meal and then waited till we felt a little lighter. We had to run. Gauravi volunteered to be the last one to leave. Unlike before, this time, we were carrying our bags. We carried out all the bags so Gauravi had nothing to carry. We walked out slowly again one by one till we were on the road. Gauravi snug under the cashier as he turned the other way. I saw Gauravi running towards us a little later and screaming, 'Bhago behenchod! [Run bitches run!]' There was a guy from the hotel chasing Gauravi. We ran our asses off. We jumped on a bus and when Gauravi got on we left. Gauravi had outrun the waiter and now we were both full and safe. Gauravi was undoubtedly the 'hero of the day.'

We caught a bus to Belgaum in the evening and this very eventful Goa trip came to an end.

#22

Blood Brothers

We were refreshed. We started putting in the long hours. We didn't want a repeat of the first internals. We wanted to be prepared this time. This meant a lot of mugging. I would usually study in my room whereas most of my friends chose the library.

Raghav would often come back from the lib see me by the window and then come to my room. I would usually try to get rid of him as soon as I could. I was very rigid about my studying environment. I always had to keep the door locked. I couldn't tolerate any kind of noise. I definitely couldn't study while there was someone in my room. The library was clichéd. There would be loads of dental girls dressed in their best attire sometimes even wearing makeup and they would pretend to study. For them going to the library was a fashion statement more than anything else. I enjoyed the comfort of my room. I could smoke whenever I wanted. I could scratch my balls whenever I wanted. And I didn't need to look good or dress properly.

We would often hang out at Nescafe when we took breaks. We had the best cold coffees, milk shakes and

other junk food served there. We even got close to the guy who owned the place and his baby daughter called Shivya. Chondu would always get her a chocolate bar and she liked him best. It was also the place where we would smoke cigarettes. Raghav and Gauravi had also started smoking. No matter what anyone says cigarettes really do help when you are under stress. As does Red Bull.

The workload was relentless. It is not easy studying human anatomy in such detail and then memorizing the facts that inherently have no logic whatsoever. We were studying a lot now. We still had the odd drinking night but on the whole we were slogging hard.

The essence of the personality that Rahil my roommate had was based on moral fiber. He would always do the right thing, always choose a politically correct path. He never swore, he never drank and as for cigarettes he didn't even let me smoke when he was in the room. Though I was nothing like him I respected his stand, for a while at least. One of the few similarities we shared though was that we both found it extremely hard to wake up in the mornings. It was important to attend classes not because we would learn but because if we didn't maintain a 75 percent average attendance we would be detained and not allowed to sit for the university exams.

Several times I would wake up around noon and feel guilty and shit. Then when I turned, I would see Rahil also in bed and having missed classes. This gave me a sense of calm and I would go back to sleep.

On one of these days Chondu came to my room just as I was getting up and told me he had given proxy for me in class. I didn't know what this meant. Gauravi explained it is when a student in class answers to more than one roll call and hence falsely gets his friend marked present when actually he isn't in class. It felt fuckin amazing. I hugged Chondu. This became a common practice in the coming years. We gave a lot of proxies; fearlessly, if you got caught you could get into serious trouble depending on the professor. We ensured that the eight of us, the Untouchables, always got attendance. We would work out how many of us were missing then assign a roll number to everyone present for which we had to give proxy attendance. I don't think I would have qualified for first-year unis if my friends hadn't bailed me out with proxies and vice versa.

One night I was alone in my room and trying to sleep. The All-Out mosquito spray had run out; it was after midnight and there were shit-loads of mosquitoes in my room. Far worse than the actual bites was the feeling you got when one of those bitches stormed past your ear with that typical and intensely annoying buzzing noise. Of all the animals in the world, I hate mosquitoes the most (they suck your blood!). After a couple of hours I had reached the heights of being pissed and finally realized no matter how many pillows I stack over my head they would not let me sleep.

I made my way to Gauravi's room; it must have been around 4 am. It was locked. I knocked; I kept knocking. Eventually, a dazed-out Gauravi opened the room and I knew he was a brother because there was no irritation on

his face when he saw me. I had tears of frustration in my eyes and told him I couldn't sleep in my room. He didn't say much. He pointed toward his bed and said, 'Ynha so ja.' I asked him 'And you?' He was like 'Tere bagal mein.'

Now the kicker of the whole story is that the next day we had some really important classes that we just couldn't miss and that was one more reason I needed to get some sleep.

Gauravi, like me, wasn't really the very disciplined type but that morning when Gauravi woke me up uncharacteristically a good ten minutes before class (five minutes was usually enough) he looked the real deal. A clean white apron almost glowing, shaved, spic-and-span. I asked for five minutes to snooze. When he woke me up again, I got up in bed looked at him and told him, 'Bhai, I know this class is really important but I have thought deeply in the last five minutes and I am not going' I went back to sleep. A few hours later I woke up to find Gauravi sleeping like a baby right next to me, dressed in formals an apron and black shoes which seemed to have recently been polished. I burst out laughing and woke him up. Incidentally, Mochuu too hadn't gone to class. However I will never forget how Gauravi saved me that night and with arms wide open.

On a rare occasion when I was studying in the library Rahil came over to me. He seemed pissed. He told me I had no right to wear his clothes. I was confused and I asked him when I had done that. He pointed to the T-shirt I had on. I had to look down because I honestly didn't even know what I was wearing. I apologized to him

and said it would not happen again. Rahil was like this; very childish, very uptight, very anal.

I started getting the odd message from girls in the campus; wanting to hang out, wanting to play around. Gauravi and I would shortlist such candidates and if they ticked enough boxes I would have a mini affair. One such girl was called Faiza. She had messaged me on a social media site.

Bhanu and Priety broke up; so I made a move on Priety and she reciprocated. I was still dating Ritz and Tanu when all this was going on. I was stupid. I really was a jerk; karma would eventually catch up and screw me over. For now though I was a hero. Every triumphant performance would be celebrated and toasted to.

Raghav and I who had earlier made a pact to see which one of us would date more girls through college started taking it seriously. Raghav was close but at least for the first couple of years I was leading. We took each other's success like it was our very own. We bragged. We 'kissed and told'. We were pricks, assholes even. We were stupid and shameless, dirty and ugly; filth.

A few of us were summoned to Jemur's room after dissection one day. When inside his chamber I noticed I was wearing sandals. The initial excitement of wearing neat clothes, a tidy apron and black formal shoes had vanished. I often wore sandles; however Jemur was strict about such things. To make matters worse I noticed that I was wearing two different types of sandles. They

looked different—the shapes were different—and if you looked closely even the colours were different. Holy fuck! I quietly moved from the front row to the back and stood in a position where he could see only one sandle. Luckily for me Jemur didn't notice. I was relieved. I decided that I would never again wear different types of sandles, at least not in college.

A girl called Rini M had her roll number next to mine. We helped each other as much as we could during exams. Sometimes in medicine you just need a word here or there or a hint that reminds you of what you need to write. I was a good student then and I helped her a lot. A favour she would return ten times over in final year. She was a good friend and a nice person. The other people in my unit were Samar 'Sasa' Sahil, Ruby, Sampriti 'Sam' and a Karanataka boy called Sanpreet Buchi. Sasa and I were the comedians in our unit. Ruby, who was from Malaysia worked real hard and was an ace student. Sam too was a hard worker. Buchi was diligent; a well-mannered, courteous, modest young kid.

Nasir Sir was by far the coolest senior on campus according to me. He was two years senior to us. I'd be lying if I said I didn't look up to him in a certain way. He scored good marks. He chilled out all day. He was good at football and studied late into the nights. He was a big movie buff. I saw all kinds of flicks with him and on his recommendation. My laptop came in very handy on some of these movie nights. We watched them with sincere attention. No one spoke a word. No one texted their girl.

We saw classics, we saw old, we saw new. Raghav was also often a part of these movie marathons.

Nasir Sir had a car, a red Swift with a top music system and a huge woofer in the back. He had gotten his car after he cleared first year. I decided this is what I would do too.

He would take us to football in the evening sometimes through the heart of the campus crossing the dental college and have his system playing at full volume songs that could be considered offensive like 'Smack That!' My personal favourite was a track called 'Till the Rush Comes,' which he also played quite often. He had this attitude, this air of confidence about him.

Apart from watching movies we were often in Gauravi's room playing a card game called 29, where Nasir Sir and Gauravi would be partners and I would be with Mochuu. We spent a lot of time playing cards and taking the piss out of each other. Nasir Sir got close not only to me but with most of my friends too especially Gauravi, Mochuu and Raghav.

Pranit Sir was another senior I got close to. He was one year senior to us and from Calcutta. I met him initially through Chondu. He too was a smoker. It was a well-known fact that Pranit Sir was brilliant at anatomy. He really was. Anatomy was easily the toughest subject we had in first year. Even though he was in the second year, he still remembered his anatomy. I was always okay with the theory part but I sucked at practicals. I remember on

the eve of the anat prac I would take my book and a pack of cigarettes and just stay in Pranit Sir's room. He would tell me what to study and how to study it. It felt like shit the night before and I would sometimes just break down under the pressure. Pranit Sir removed all that. He made the anatomy stress go away and made the subject easier. He was a good man; and again, like Nasir Sir, he was pretty close to our whole group, the eight of us. We would often drink together and go on bike trips once in a while.

Late into the night we got some shocking news. Nasir Sir had been in a serious road traffic accident. Though he had a car he liked bikes more and he had been racing with one of his friends on the way back from hilltop. He was admitted in the hospital and was unconscious. He was critical. He had lost a lot of blood to internal bleeding and with that his spleen too had to be removed because of excessive internal damage.

We went to the hospital the next morning to give blood (we were both O positive) and see him. I have never felt more scared than I did when I saw him bandaged up, lying in bed and breathing into a mask. I prayed to God that he gets better.

His mom was present too and it was confusing whether to sulk in your own misery or put up a brave face out of respect for the sadness in her eyes and the unique pain only she could feel.

Tanu called me later that day and was getting a little mushy on the phone. I lost it on her. It wasn't her fault but

I was feeling like shit. I couldn't stop thinking about Nasir Sir. I told her that I wanted to break up. Besides, Ritz had sensed something was up and had asked that I come clean. Ritz meant more to me than Tanu at that time and so I did what I had to do; end my brief relationship with Tanu.

Chondu had earlier gotten tired of playing the middleman and had slyly confessed to Tanu that I was still with Ritz. Tanu wanted answers. I told her I am not going to answer anything. I just wanted to break up. I broke her heart, I saw her cry, I walked away.

Nasir Sir was still unconscious and I was still fucked in my head. As for Chondu, I dismissed his sense of guilt and assumption that we would never be friends again. I told him I honestly didn't give a shit, that my friends were more important to me than some girl who I barely knew and I told him fucking up once or twice when it involved chicks was very common. I myself had done it. I forgave him.

Nasir Sir was popular. Seniors and juniors alike were deeply concerned about his health and we were all glad to hear that the operation that had been performed on him was successful and he was now conscious and out of danger. I felt like hugging him. I thanked God. I was relieved.

We were supposed to leave for home while Nasir Sir was still in the hospital. I had met him but hadn't gotten a chance to talk to him properly. I wrote a little note, burnt out the edges and asked Keshav Sir to hand it over to him. Unfortunately, this note never reached Nasir Sir.

#23

The Boys Are in Town

This was our first break from college. It was the winters. The festive season was on. Almost all my friends were in Jamshedpur; Anish, Venom, Sardar, Gadi, Guda, Neel, Aarush and Tushit were all in town. When we had left for college only Anish and Venom drank; now we all did except for Gadi but we would change that.

For the first few days we went to a highway dhaba for dinner and drinks. We drank on the khatiyas and told each other tales from college. Anish was overjoyed. He kept coming over and hugging me and telling me how happy he was that I had started drinking. This elation was real and honest. Boy did he love his alcohol.

We would revert to our old pastimes and play a lot of football and cricket in the day but everyone knew the real fun would be in the night. Even now when Anish and I got drunk we would invariably talk about the final loss and how things could have been different. We often wandered across the line and became a little depressed. It could well have been di Baggio lamenting his missed penalty in the World Cup. This loss had hurt us just as

much. In the coming years I drank a lot with Anish and we often talked about this.

One night we booked a resort on the Dalma Hills just outside of Jamshedpur. We planned to stay there for the night. That night, it was Anish, Sardar, Gadi and me. We took a lot of alcohol and junk food. We started drinking at 7 pm and drank till 7am. It was and still is the craziest night of my life. The room stunk. You know there is this special aroma that comes from a room when you have been drinking and smoking inside it all night. It is worse than shit!

We started slowly working on Gadi who had not joined us for the initial few drinks. We tried everything from sweet talking to violent behaviour. He was a tough nut to crack. Finally, we stumbled upon a winner, we gave him pacts of our friendship individually asking him to drink just one glass if he considered us his friends. He drank one, two and then three glasses. After that, he didn't stop drinking for a while. This led to the best part. Gadi got up, walked gingerly to the balcony and puked. It is usually norm to go with your friend if he is puking, put an arm around him, get him water and make sure he is okay especially if he is drinking for the first time. Anish, Sardar and I couldn't stop laughing. We were on the floor, rolling over in laughter. Gadi must have fuckin hated us.

Anish then started something new. He started screaming, 'Gadi, we want a hat trick.' We all joined in. He never let this go. He kept on saying 'hattrick! hattrick!' and kept

making Gadi drink until Gadi puked for the third time. Anish was cock-a-hoop. We hugged like we had won an Ashes test on the last day.

We were wasted as the sun came up and with us the most innocent fat little boy Varun Singh too was wasted. The night had been a hit. As we left I downed two glasses of vodka that were left and the little sobriety that had come with a brief rest was eclipsed by another high.

Venom had not been allowed to join us that night but he was the only one who saw pictures and then like in the Hangover, Anish deleted all the pics. This was a good decision.

It was routine to first go to the eggnog party in Beldih club on Christmas and then to Anish's place for a classy Christmas lunch. This tradition had started in high school and lasted forever. Both Anish's mom and his sister were great cooks. His sister Ani would go on to be a professional chef.

We all had to go back to college a few days after New Year. There was no pressure. We hung out pretty much all day every day. The only difference was that instead of the chicken rolls we used to have in Gadi's car we now were guzzling in beer. This setting where we would drive around Jamshedpur and at the same time be drinking would be known as car-o-bar.

It was the 31st and a huge party was organized in Aarush's flat, which was empty. Again Venom had not been given

permission to spend the night with us. We met him for a smoke in the evening and he said he would drop us off. You could tell he was pissed. Along with one of his cousins, Anish and I were in the car. It came as no surprise to me that he lost control of the vehicle on a bend. He was at a high speed and the car swerved and skidded. That must have been the longest and quietest moment of my life. The car did a 720 almost; there was pin-drop silence which was eventually followed by a loud thud. The car had hit a huge light post. As soon as we stopped, Anish asked everyone if they were okay. No one was hurt. The light post though fell a few minutes later. The Human Virus had scared the shit out of us. Anish and I went to the party and got wasted.

Anish's girlfriend Sara was also at the party. They had been dating since eighth grade and the 1st of January was conveniently their anniversary date. Anish had a habit of disappearing a few minutes before the clock struck midnight on New Year finding Sara and kissing her. For a badass he really was cute with his girl; in fact they were both very cute together. This was one very obvious trait of Anish's personality; for a typical gunda, he really was a genuine gentleman with the ladies.

Ritz was also in Jamshedpur and I spent some time with her. We would go for drives and sometimes coffee. It was nice being with her even though I probably didn't deserve it. I called her for the New Year's party but she wasn't into getting wasted. Plus she had a thing against several of the females at the party so she didn't come. She was pissed because I hadn't wished her and she had heard

that I had been dancing around with girls she considered trash. I had tried to call her at midnight but I couldn't get through. She didn't believe me. The next day after the party I drove to her house and waited for more than an hour till she came to the window to forgive me. We spent the whole day together.

Earlier in the day when my friends were going home, I didn't have the balls to go back. My parents knew I had started drinking. It was on this holiday that I had my first beer with Dad. This had been a big occasion. However, I reeked of alcohol. This was confirmed by Venom in the morning who had told me that he could smell a whiff of alcohol when he got close to the others but with me he could smell it from ten meters away. I didn't want to go home like this. I had tried to force Gadi to stay but he had to go. He had gotten a call from home. He passed me a couple of rs.20 notes and pleaded that I got an auto and went back whenever I felt like. Quite melodramatically, I tore apart the notes and threw them back at his face as Anish and Sardar broke out into laughter. To not let him go I had put some of his favourite audio cassettes as blocks in front and behind each wheel of his car. He begged. I didn't back down. Then he got pissed and stormed off breaking his cassettes in the process.

I was still close to Kaushik then. I would always visit him when I was home and try to motivate him. I had no option but to go to his house early in the morning, wish him Happy New Year and pass out on his bed. His mom had opened the door. I am sure she realized I was drunk. I stayed till I got a call from my parents.

We played drinking games. I would team up with Venom; and Sardar would be with Anish. Whichever team drank more would be the winner. Puking would lead to instant disqualification. I have never seen anyone drink like Anish. We were all smashed and the game was close. We were just hoping someone would puke. Anish took a whole bottle of whiskey which was half full and downed it neat. Yes, neat! We lost but I gained a lot of respect for Anish. I'll say it again; I have never seen anyone drink like Anish could.

It was time to leave for college. This had been a good trip. College friends are special but there is a different charm catching up with friends from school. They have known you for longer. They have seen you grow from being a kid and vice versa.

Shakib 'Shak' Sir was a super senior of ours at JNMC. He was a PG student. He was always full of energy and always ready to go to Goa. He was also from Jamshedpur and he opened up to me soon after I had told him I too was from Jamshedpur. I met him through football. He was quite a personality. He was Muslim and had married a Hindu girl as early as the first year of his UG college days in med school. This did not stop him from being a player at JNMC. He had seen the highs and lows of life like none of us had.

He had been found guilty of ragging a kid in med school who happened to be a minister's son. He had gone to jail. He had been suspended from college for three years. He was quite a bit older than us but this never showed. He

was not down or depressed about his past. He lived in the moment and had limitless energy. He also shared in a few days that he too had had a major problem with MR in his Jamshedpur days. I liked him even more.

We drank a lot in his flat. He was a good and useful guy to know. He had several connections in and outside college. We often compared his personality to SRK. He hardly slept. He was always up. He was a workaholic and he never seemed tired. Deep down, he was a good man.

It was my first official game for JNMC. We were playing an engineering college called GIT. They had a good team (a couple of players who had played India u-19s) and also the home support. When we had run out on the field the crowd had chanted, 'Doctors suck! Doctors suck!' It was almost embarrassing. Our keeper Devansh Sir was shit and they were toying with us. We were down one goal within the first five minutes and what was worse was that they looked like they would score a lot more. The crowd too had become louder. This could be a long game. We substituted Devansh Sir with our reserve keeper Shak, and Shak did a far better job.

I won us a free kick just outside their box and stood up to take it. The position was very similar to the free kick I had screwed up for school in the final.

The keeper rather stupidly stood on the same side as the wall leaving a huge space open on his left. I ran up and with minimal effort put the ball through this space into the goal. Just as we had started celebrating the referee

blew and said the kick would have to be taken again because I hadn't waited for the whistle. The keeper noted his mistake and now stood near the left post. MoFo! This time I would have to get the ball over and above the wall then get it to dip and bend away from the keeper. I did just that! I scored! The crowd was silenced. The whole team ran to me. I had run to the corner flag. We eventually lost the game 1-3 but my goal certainly shook the crowd and I think we earned some respect.

Karan Sir, who was our best defender and someone I would get very close to in the coming few years invited the whole team to his flat that night. It was an amazing place. The whole house was painted green. It was also known as the pimp plaza. It had UV lights in all its rooms and it was a good place to party. We drank vodka shots. They talked a lot about my goal. This was my entry into the college football scene, a scene I would rule.

When I was alone for a moment and a little tipsy I thought about the two most important free kicks in my life, one I had screwed up and with it ended the chances of winning the cup for school and the other that ruffled the net and marked my entry in to college football. I had become a star. I wondered if given a choice which one I had wanted to score more, whether I would sacrifice the college goal if it meant I scored for school. I still think about this from time to time. I called Anish.

The second internals were coming up. We had studied hard for these exams. There were a lot of topics in the portion; double or even triple what we had in the first

internals. The study routine was again simple. Study, smoke and then study some more. It was like playing a Beatles song on loop.

Gauravi and Mochuu had started a new thing. They would keep a bucket of cold water in their rooms at all times especially on the nights before the papers. Whenever someone felt sleepy they would shove their heads into the bucket and stay submerged for a while. The idea was that it would freshen you up and help fight the temptation to sleep. I don't know if it worked because I never tried it. I guess it must have. I just smoked!

The exams came and went. It was a tough three days. I had hardly slept. The thing with subjects like anatomy and biochemistry is that they are so volatile that sometimes it is better to store information in your temporary memory. It is easier to reproduce the answers that way but that means no sleeping because if you sleep your temporary memory fades. The best way to make it work is not sleep at all. We went to Nescafe after the last paper feeling totally drained but more so satisfied. We had worked hard. The exams had gone okay and we were proud of ourselves. This was in stark difference to the crappy guilt and shame we had felt after the first internals. Raghav and I talked about this.

We drank through the night for a few nights.

I had started taking part in public speaking events in school but there were a few who were better than me like Bhanu. I got better in college. There was an inter-college

fest being held at JNMC called Trinity. It consisted of three-parts; sports, literary activities that involved public speaking and cultural events like dancing and singing.

There were quite a few teams taking part but we comfortably won the football tournament. In the literary section I bagged a bunch of prizes. There was an event called mock press, where you would be given a famous personality and a subject on which you had to speak and then answer questions from the press. I had been given 'Andrew Symmonds- on sledging and racism in the modern game'. I really liked mock press and I always did well on it not only in our college but also in events elsewhere. I won the second prize in debate. A couple of professors I would get close to in later years came up and congratulated me. Then I won an event called point-counterpoint where you were given a topic and you had to speak for or against it, changing when the buzzer was pressed. Basically, you had to speak both for and against the motion and change on the will of the guy with the buzzer for four minutes. I had to speak both for and against the concept of homosexuality. It wasn't easy but I had a definite creativeness and spontaneity when I was on stage, so I did well.

The awards were given in the auditorium on the last day and in front of the whole college. My batch clapped furiously every time my name was announced. I did exceedingly well in the speaking events at different fests in and outside JNMC; to reward my performance, after a few years, I was awarded a special prize from college; a certificate and a cash prize.

#24

My Roomie Is a Psycho

The first-year university exams were coming up. The seniors had told us that this was one of the biggest hurdles we had to clear in college. There was a huge incentive to pass because if you failed you would lose a semester and fall behind your batch. You would never attend classes with them again. If you passed, second year was an exciting prospect. We would start attending clinics. We would finally get to carry stethoscopes and in a way it meant more freedom.

It was also time to change rooms, change hostels. We moved from the first-year hostel called Chanakya to another one next to it called Charaka. I had been in Banglore for a short break hanging with Gadi and Guda when the rooms were allotted. When I came back I realised I hadn't been given a room. The rest of my batch had been moved into double rooms with common washrooms in each wing. I wanted a room with an attached bathroom. The warden told me there was one such room in Charaka currently occupied by a senior of mine called Ravnish Sir.

I did not know this then but Ravnish Sir had also been instrumental in our fight against Simran and company. I told the warden I wanted the room. Room 13, Charaka. It was sealed, my home for the next few years. All I had to do now was actually go and meet Ravnish Sir and tell him I was going to be his roommate.

I went to his room in the evening. A couple of my seniors called Amit Sir and Anand 'Jadoo' Sir were already there. Both had glasses of beer in their hands. A good start, I thought. I told Ravnish Sir how I had got the room. When I went on to say how lucky I was since I had gotten a room with an attached toilet, Amit and Jadoo sir started laughing. I was confused. I didn't know why but something seemed fishy. It sounded and looked like a sarcastic laugh. Ravnish Sir seemed a little embarrassed. He offered me beer and I obliged. I left the room a little later after taking an extra key from sir and told him I would move the next day.

A rude shock awaited us. The list of candidates whose attendance was short and hence would be detained from giving the first-year exams had been put up. My name was on the list. It was a weird list. It stated that out of a batch of 150, a total 117 students would be detained. This unity in indiscipline was perhaps again the only thing that saved us. The minimum attendance required was reduced from 75 percent to 70 percent at first and then finally to 65 percent. It was a frantic time as each day a new modified detainee list would be put up. There was no way I could study if I wasn't even sure that I would give the exam.

Mochuu only cried two times in first year. First when in the physiology department he was told that he would be detained and then again at the same place a few days later when he was told that he wouldn't be detained after the reshuffle of the minimum requirement. He was cute like that Mochuu. Chondu, who had fallen ill in the middle of the year had missed many classes and he wasn't eligible to give any paper. After a lot of uncertainty, he had finally been diagnosed with GB syndrome and he had spent a lot of time at home. Like Mochuu, I too was eventually allowed to sit for the exams. This came as a huge relief and now I went into overdrive. I had never crammed the way I did for these exams. I took myself to levels and gears I didn't know I had.

I had settled well in my new room and worked up a decent bonding with my roommate. I certainly liked him more than Rahil. He too was a smoker. And after screwing up his first year, Ravnish Sir, like me, spent a lot of time with his books in this period. This helped me. I had a partner and together we started pushing ourselves. He was sweet. He would always get me tea or coffee from Nescafe and after every hour or so of cramming we would share a smoke.

I gave up shaving, getting haircuts, even taking showers to an extent. There was only one thing on my mind and that was to clear these exams. Nothing else mattered. Gauravi who would often come down to my room in breaks when I would accompany him to Nescafe or other times to talk to Ravnish Sir while I studied. I could be rather rude. Gauravi and Ravnish Sir got on really well

primarily because they were both from Patna and they had a bunch of common topics and friends back home to talk about. Sometimes I would get pissed if they kept going on and on about some bloke from Patna or talk about fights and food. There was no way to stop them.

The thing was Gauravi was very different to me when it came to studying styles. He was clever, the kind of guy who worked smart rather than hard. I had to cram more than Gauravi. That was just the way I studied. My aims and expectations too were higher than Gauravi's. To be fair, Gauravi could tell when I was in study mode; and so on these occasions he would usually leave soon.

I also hung out a lot with Raghav and Sumeet during breaks and sometimes we would discuss certain topics to break the monotony of studying alone. Every night at around 10 pm, when Sumeet returned from the library, we would spend an hour or so in the common room and try to memorize cycles in biochemistry.

Though Chondu wasn't going to sit for the exams he came back to college and he spent a lot of time in our room. He too got very close to Ravnish Sir. Most nights we would get Chondu to sleep in our room and all three of us would talk and smoke cigarettes. This part of the day was the only time I could relax. I was studying pretty much all the other time.

Ravnish Sir had this quality about him. He was very good at impressing impressionable people and on some occasions like with Chondu influencing them heavily.

After a while, some people would start calling Chondu 'chhota Ravi.' Ravnish Sir knew how to act and behave. There are infinite takes to his persona, some good and some bad but there is no doubt that he is your text-book 'filmy dude.'

My daily routine started at around 9 am. I would get up, smoke and sit straight away on my table and start mugging without even brushing my teeth. I would brush a couple of hours later and sometimes shower. On good days, I would study almost nonstop from 9 am till around 3 am in the night only taking breaks for beverages, cigarettes and junk food.

Ravnish Sir was funny when he brought his A-game. This comic relief was essential so I didn't lose it. He saw life as a movie and he was undoubtedly the hero. Almost everything he did and said in public had ulterior motions attached sometimes without him even knowing it. We also connected on certain levels. He often told me that I was the only person who really understood him and to an extent, I did. I didn't always agree with his thoughts and views; but, yes, more often than not, I did understand him.

He was in love with a girl called Shruti in his batch. It was an almost impossible attraction. But alas! Ravnish Sir had seen too many fuckin movies—movies like RHTDM. Ravnish Sir had even nicknamed himself 'Maddy,' a character from this film. He had seen too many SRK movies. He was a die-hard romantic and he went to great

heights to make his love story a reality. After a while, you actually felt for him.

He even got me to do things I usually wouldn't have done which he thought may help his cause. On one occasion he raked up Shruti's internal assessment marks by feeding money to the peon and then got his friend to talk to the clerk pretending to be Shruti's father. She clearly didn't want any of this. He got a professional artist to make a huge portrait of Shruti standing by the lake. It was amazing; the painting, he got it sent to her room. He also sent her packets of delicious and expensive chocolates along with flowers and cards and indulged in all the other clichéd acts you can imagine. One part of me started wanting Shruti to miraculously fall in love with Ravnisha.

I will never forgive Raghav for what he unknowingly did to me one night. He was in my room as was Ravnish Sir and Raghav not knowing about Ravnish Sir's madness for Shruti casually mentioned he had seen her with a guy who he had been told was going to be Shruti's fiancé. Raghav soon left but my night was ruined.

I had decided to take a break that night and sleep early to start afresh the next day. My plan was chucked out of the window. Ravnish Sir engaged me in a conversation he refused to end and for most parts was very repetitive and futile. I could tell he was shaken with this news. I felt sorry for him and I gave him my full and undivided attention for the first couple of hours. After that, he kept speculating on ridiculous thought patterns, trying to figure out if Shruti had 'been' with that guy. A lot of the

stuff he said that day was disgusting. I had not known this dark side of his character; in simple words he was pretty cheap that night.

It was like Raghav had opened his Pandora's box and then left me to face the music. He said something. He asked me for my views. Then he did this again and then again and a few more times again. I was losing patience and I didn't know what to do. When I hinted that I wanted to sleep, he held my hand and again asked me stuff about Shruti and whether I thought Raghav was right. I mean this was a one-sided love story and it was very hard to discuss it. We had started talking around 10 pm after dinner, up to roughly 2 am I didn't even mind. I wanted to be there for him but soon after that I got pissed. Every time we said good night, after around two minutes he would call my name light up a cigarette and start talking again. This carried on till five in the morning.

Toward the end, I was actually almost crying in frustration. My study routine and my mind both were fucked. I realized to an extent why Amit and Jadoo Sir had been laughing when I had said that I was lucky to be moving in with Ravnish Sir.

Vijay 'Jaat' Sir came to my room the next day and woke me up. It was around 1 pm. We went for lunch. I told him of the night before and spent more than half an hour cussing Ravnish Sir. I fuckin hated him in that moment. Jaat Sir just kept giggling and enjoying me venting out my frustration.

Roughly a couple of weeks before the university, I had studied all day and hit a mental block. I had dinner but my sleep cycle was so set that I could not possibly sleep then. I couldn't study. I couldn't sleep. I didn't want to waste time. So after lying in bed for a while I decided I should go for a run and figured that it would be easier to fall asleep if I was tired. At around midnight I put my tracks and trainers on and like a madman started jogging around the campus. The people who saw me must have thought I was fuckin crazy. This tactic didn't work. There was only one thing left to do. I went to Pranit Sir's room and had a couple of large pegs of scotch neat.

Every day that passed brought the exams closer. These exams were very different, unlike in school when you felt comfortable after finishing the portion once, here the more you read the more you seemed to forget. It was all about revision and then re-revision. Ravnish Sir had fucked up one night for me but other than that he was very helpful and a huge support. He voluntarily vacated the room in the last week before the exams. He knew I liked to study alone especially when it was crunch time. My nervous system was shot. I was drinking coffee and tea pretty much all the time and smoking more than twenty-five cigarettes a day toward the end.

The exams finally started. There would be two papers of anatomy, two papers of physiology and a paper of biochemistry—a total of five papers—and, yes, the theory exams started on Monday and finished on Friday. No fuckin break. Earlier I had been aiming to score more than 65 percent and get first-class but now I just

wanted to pass. This was a very mentally and physically exhausting time for me as it must have been for most of the others going through the same thing.

The anatomy and physiology papers had gone decent. I had stayed up the first three nights and then slept long before physiology-2 because I knew I had done well in the first paper and I could afford some sleep and in the process afford to lose some marks. Biochemistry was a tough subject. I sat down to study when . . .

. . . I had been searching for my biochemistry text-book for over two hours now. I was the kind of person who underlined a lot, someone who made a lot of little notes around the text. To revise, I could only read from my own book. If I tried using another book, I would take double the time. This is why I kept searching. I became certain that someone had flicked it. Ravnish Sir was with me. I broke down. It seemed certain now that I would flunk biochem.

After a couple more hours, Ravnish Sir finally managed to convince me that I should start with another text-book. I was drained physically and emotionally. I somehow started studying. Like I expected, I took a lot more time on each topic than I wanted. Every now and then I would see a green book on my shelf and jump up. Hoping it was mine, I would run to it and open it only to be disappointed. Even after I had started studying I kept looking for my book in breaks. Someone had nicked it.

I was obviously behind my friends initially as they had started hours before me. However, as time passed I gained momentum. I surprised myself and finished the portion as the sun rose.

The paper itself was a pleasant anticlimax because it was very easy. I would have passed even if I hadn't touched the subject in the night; nonetheless, I had been put in a tough situation and I had come through. I was proud of myself.

The whole batch screamed in unison as the paper ended. We were free now, well, at least for a few days before the practicals. We were in my room and it felt weird that we didn't have to study. We had gotten used to the routine so much that now when we had nothing to do we were almost confused. The answer was simple: win or lose, you gotta booze. We drank like crazy that night in Gauravi's room. I must have puked multiple times. We even got into some trouble. We didn't give a shit. We were not going to let anyone take away the glory of finishing our exams. The practicals were a few days away. We spent most of our time for the next couple of days drinking in a hotel room we had booked.

The university practical exams started. No matter how well you scored in the theory papers, to pass, you had to clear each subject's practical exam too. Unlike most people who found the theory exam tough and the practicals easier, I was relatively speaking the opposite kind. I had never been good at practical papers of science subjects right from school.

Pranit Sir helped me a lot for anatomy and I somehow managed to scrape through in physiology and biochemistry.

The exams finally ended and we went home for a short break. We moved around in Gadi's car, driving around roads and parks that had become ingrained in our memory. Gadi ensured the drives didn't become boring; where I would be pleased to know even one route from one point to the other Gadi knew several and his choice of roads and with that the music he played would often depend on the collective mood of the individuals sitting in his car.

Our seniors had told us that it would be almost three weeks before the results were declared. They were wrong. I had managed to block the concern for the results and like before spent most of the day hanging out with my friends. It was on one of these drives that Gadi got a call from my mom asking to speak to me. My phone was discharged. Mommy hardly called, so I knew this would be important. I took the call. Mummy sounded happy. She told me that Keshav Sir had called and given the news that I had passed first year with a respectable 62.8 percent. It felt amazing. I finished the beer I had in my hand and then went home to check the results online for myself.

The results had been declared in less than a week. I certainly wasn't expecting them so soon. Apart from Chondu who hadn't given the papers, the remaining Untouchables had all cleared. Hanu had scored a

mammoth 70 percent and Sumeet was right behind him. Rini M had unfortunately flunked one subject, anatomy, this was enough to send her to the other batch. Basically this would make her lose one semester and also mean she would no longer be a part of our unit. I would miss her. Megha had also flunked. Gauravi had told me this and said it was an awkward situation he was in because on one hand he was chuffed at passing but on the other a little sad that his girl had not made it. Tanu had done well; she didn't seem to give a fuck though.

There was an OBG conference on the next day in Jamshedpur and Gauravi accompanied his mom. This was perfect timing; with the results declared, there was no pressure on us anymore and we had a great time.

There was no time interval before Gauravi and my friends hit it off. This trend would continue. I always felt good when my friends from school met my friends from college and got on. Whereas initially I would be a little tense eventually it occurred to me that the bonding was very natural. I suppose the fact that we were drinking beer may have helped to break the ice and made it easier to open up.

Gauravi had been educated on the concept of 'family' against Gadi and other such shenanigans. He even picked up on a strange but very particular accent that we the Jamshedpur boys often used when speaking to each other.

It was a special feeling hanging with Gauravi, showing him around Jamshedpur with Gadi and a few others. We

had both cleared major exams. The beers tasted better; the highs felt smoother.

We were hanging by a lake when Kiran started working on some green material on a newspaper. I didn't know what he was doing. Sardar, who was also with us explained that Kiran was rolling a joint; a marijuana joint. For a few minutes I thought I wouldn't smoke because this was drugs; all my life I had always thought I would never do drugs. Kiran convinced me that marijuana wasn't really a hard-core drug; it was like a little baby one. Weed can be dangerous as a gateway substance in the sense it may lead you to try other more dangerous things. Weed itself, however, is not that bad. Gauravi too agreed. We smoked up. I had smoked some hash before in Goa but like I said I was too drunk to appreciate the high. This hit however was totally awesome; the ganja mesmerized my soul 'like a virgin touched for the very first time.'

I tried hard but couldn't get Sardar to take a few puffs.

We got in the car and for the first time this multidimensional perception of music which felt like sugar syrup flowing into my ears blew my mind. I could feel each single instrument, every single note, feel the crescendos and diminuendos like never before. It was like a beautiful symphony being played under the control of my mind. When you smoke the herb, for the first few times at least, there are text-book symptoms you feel. You feel thirsty—very thirsty. Then a little later, you feel hungry. Gauravi was a big foodie even before he smoked up and by now we were all hungry. We went to

our favourite place City Café. I have little recollection of what happened there. Because I zoned out, I ordered a four-course meal, which started and ended with dessert. My birthday was just a few days away so I paid for the meal. I remember walking out of the café feeling totally satisfied.

Also, unknowingly, we had been initiated and seen but a glimpse of the magic that was Mary Jane, a substance that would go on to become a huge part of our lives.

#25

Elvis Ain't Dead

Classes started. We entered the world of clinical medicine. We now had postings in the hospital every working day from 9 am till noon and yes, we carried steths. It is hard to explain how stethoscopes feel around your neck when you earn the right to wear one. It probably feels a little like how a policeman feels when he finally gets sanctioned to carry a gun. Not only did I have a gun but I had the best one, a state-of-the-art Littmann stethoscope, the AK-47 of steths. A gift Nana and Nani had sent me.

The only sad part at the start of second year was that quite a few kids from our batch hadn't cleared the exams. The batch strength had been reduced from 150 to 107. While it was obvious that a few would flunk simply because they hadn't worked hard enough, there were others who no one would have guessed would fail. Vinay was one such student, a hardworking kid from Bihar. He had failed anatomy by a few marks; he didn't deserve to.

While the whole now-reduced batch attended lectures together in the mornings and in the afternoons, we were split into small units for the hospital postings. Rini M

was the obvious name missing and I think we all missed her. Ruby was an intelligent girl and a very good student. Even if I have mentioned this before it requires another mention. She was Malaysian. It is not easy to come from a foreign country and not only clear but do exceedingly well in a very Indian education system. I had a lot of respect for her. Samar 'Sasa' Sahil was, well, he was Sasa. Apart from the same first name we also shared other behaviour patterns like the fact that our aprons would often be dirty, we would wear sandals to class, have borderline attendance and so on. We were not the disciplined types. Sampriti 'Sam' was a close friend of mine. We had gotten close in first year. She was small, very small and would go on to be one of my few supporters in the years to come. Buchi was a gracious guy. He was of paramount importance when we had to take case histories of patients who only spoke Kannad. Suresh, a very straightforward guy from Bihar finished the unit and to it added simplicity.

One of the best parts about hospital postings was that every once in a while you could go for a cup of coffee or tea and some sandwiches at the hospital Nescafe. A lot of the senior doctors also had snacks there and wearing a white coat in such company made you feel special and a part of something bigger. You felt proud.

My father often modeled his parenting decisions in comparison with how his father had treated him when he was my age. Baba had gifted my father a car when he was doing internship after completing MBBS. Things had changed. I had done well in first year, so my wish was granted. I was gifted a car. A spanking-new gray-coloured

Swift. It would accompany me in many an adventure and I would slowly bond with the car.

I felt genuine gratitude and with an intention to repay the faith that had been shown in me and also mainly for my own ambitious goals I started putting in the hours again. I started studying hard when even the highest-scoring students in my batch were taking it easy. Little things changed like to take a break instead of walking down to Nescafe; we drove to a place called Shiv Sagar which served the best vada pau and chai in Belgaum. We also went to a place called Prabhu a lot when we wanted to eat a heavier meal.

A self-assigned rule of sorts made its way into my life. It involved cramming to the limit on Sundays. Saturday night would usually involve parties and drinking and so I would consolidate on Sundays, the only totally free day we got in college. I would get up early around 9 am and then clean my room even the dirtiest little corner while the cleaning staff (most of whom were my grandparents' age) in our hostel tried to stop me from getting my hands and in fact my whole body dirty; I did not have it in me to get such old citizens to clean my mess. I would shower and then sit down and slog till the evening and then I would deal with other errands like laundry and so on. I was transforming into a more mature and adult man—or so I thought.

Belgaum was located in a very scenic setting of India. There were several destinations a short drive away that were breathtakingly beautiful. You didn't even need to be drunk to enjoy the majestic touch of natural elements

around you. Our seniors had taken and shown us most of the places in first year, some we found on our own. There were several hilltops and waterfalls surrounding Belgaum. After studying all day, late in the night, a few of us would drive down to some dhaba situated on the beautiful meandering highway roads and have chai.

One evening with Gauravi, after class, driving around aimlessly we saw one of our seniors Karan Sir standing alone at Nescafe. Karan Sir was the defensive rock of our college football team. We knew him from football but weren't at that point as close to him as we were to some of the other seniors primarily because he with another senior Shukla Sir lived outside campus in a flat and also as rumour had it spent most of his free time in Goa. We joined him and started talking. We instantly had this connection. It was very palpable.

He was from Chandigadh, a well-polished, calm individual who loved sports and music. He was at least relatively speaking one of the classier types. Oh and with the baby face, the innocent smile and a body that attracted female attention wherever he went you could almost argue that God had been unfair, that he had given too much. Honestly though especially for someone who had so much going for him he was filled with a lot of humility and grace. He never showed off.

After an hour or so of random conversation I asked the obvious question, 'So you guys want to drink beer?' Both answered in the affirmative. We drove down to Nidhi bar, picked up nine bottles of Kingfisher beers, parked

up next to a lake and drank into the night. We talked. We bonded. It was a known fact that Karan Sir had just missed out on clearing his first-year exams by a few marks. No grace marks had been given by the college. He told us he had been broken initially. Jaat Sir had told us before that Karan had jumped into him in tears on coming back to college. However he had managed to move on. He had cleared his university supple paper six months later and then subsequently the next university papers. He really had moved on and had used the extra time at hand productively to live a more complete life.

We felt for Karna even though he exuded nothing but confidence. And once the elephant-in-the-room bullshit exam topic was out of the way we bonded even more.

Gauravi later told me that this was the way people should live, that he was impressed by the way Karan Sir carried himself. Because even though 'we' didn't feel it there was a certain taboo about not clearing first year in the first attempt. Sometimes it so happens that a good student— for example, Karan Sir—is left stranded while a bunch of morons make it. It adds to the misery one is bound to feel and the tufts of depression and negativity that are thrown in the way of the detractor.

As for the night we drove to Karan's place. A huge green flat located opposite Shiv Sagar. The whole place had a mystic yet soothing feel about it, something that made you at ease. Karan Sir was a Chelsea fan as was evident by the hoardings in his room. Che Guevara was also up on the wall. We played some music. I was liking Karan Sir

more and more. He was the first person I had met that listened to Elvis. I had jumped out in excitement when he first played an Elvis track, telling him that I was a big fan. It became clear soon that so was he. We ordered biryani from Niyaz (one of the best-known biryani houses in Belgaum) and bore testament to the fact that beer does spike up your appetite.

Karan Sir had been a state swimmer and he was also preparing for an all-India medical intercollegiate festival called Pulse that was held by AIIMS every year in Delhi. Gauravi too was a keen swimmer and he started joining Karan Sir in the evenings. I was never much into swimming so I would stay back at Karan Sir's flat which was usually empty and watch a season called House MD, which revolved around the lives of doctors. Unlike Grey's Anatomy for example which was all glam House showed a more realistic portrayal of doctors' lives; and based on the character of Sherlock, Hugh Laurie killed it as House. I got addicted to the show and watched it pretty much every day. Childish as it may now seem watching House made me want to study more and so I did. It inspired me.

I would be waiting for Karan Sir and Gauravi by the time they got back from swimming. It became a routine to then indulge in BnB (beers 'n' biryani). It really did become routine; our bodies and minds got totally adjusted to it.

One night we were taking vodka shots instead of beer. It was pretty late. Gauravi had passed out on a mattress next to me and only Karan Sir and I were up when his iPod played 'Are You Lonesome Tonight' by Elvis. I guess

this is not really a guy-guy song but this was not about the lyrics or the music. It was about the voice of maybe the finest showman the music industry has ever seen. I loved Elvis to bits; and in that song, in a green flat with optimized levels of vodka inside me, I felt sublime. The song ended. I asked Karan Sir who like me was tipsy and comfortable on a mattress in the room to play it again ... The thing was the iPod was placed next to the fixed speakers and you had to get up to replay the song every time and I suppose loop wasn't an option or we were too drunk. We made a pact that we would exchange this role on alternate occasions—that we would play Elvis all night. We would play this song over and over until we both passed out. I do not exaggerate when I say we must have played 'Are You Lonesome Tonight' more than thirty times that night. You know there is this brief monologue when Elvis speaks in the song; he does it better than anyone ever could.

We were at the flat one evening and didn't feel much like drinking. It was then when Karan Sir first asked us if we wanted to smoke marijuana. He too like us was inexperienced with the substance. He had done it once before in Goa and got some back. Gauravi and I had also done it once. Feeling a little like Alice, we decided to smoke. We did everything by the book as to how to roll having never done or paid attention to it as an art before. There was a lot of excitement and anticipation as we rolled our first joint. We lit it up ... and poof! There was magic.

Karan Sir was good with gadgets. His laptop had been connected to the speakers in his room and the sound was

perfect. The hit struck very fast. We smoked. We sipped water. The beautiful Mary Jane was in my mind and starting to unlock doors I never knew existed. Music—what can I say about the music!? It had an all-access pass to my soul and body and sometimes ever so gently it linked up the two and allowed me to feel pure nirvana to a certain extent.

The mind was now at a place it had never been before. It almost felt adventurous and with a sense of nervousness of the unexpected there was also a charm, the same mystic charm in her eyes that I would fall in love with. Conversation kept us a little grounded. All three of us were high. Our mouths were drying up but we could talk. You can't really speak more than two lines to Gauravi before walking into a joke. Gauravi was always funny but that evening in front of Karan Sir and me, he brought the house down. We laughed till our stomachs hurt. 'Maybe it was the ganja ...'

Stumbling upon weed was serendipity. There was no way we were not going to smoke it the next day. The only issue was that Shukla Sir was in the flat this time and he had university exams in the morning. He had been staying out for the past few days but today he was home. It was the main reason we didn't call Mochuu with us that night to keep the number and the noise down.

Shukla sir was a special character. He was from a small town in Bihar called Siwan. He was deep. He was funny. He was Bihari—there was certainly no doubt about that—but he was from what can I say, a 'cool'

Bihari mind-set. Not the Bihar in my hostel room that would keep me up all night with questions like 'Was she looking at me?' ... and then spend hours trying to draw conclusions from acts that were purely random except it was her, my roommate's lover, making them. An impressive intellect with an IQ sharper than anyone else I had ever met. He did well in quizzes. He did shit in exams. 'A mischievous smile but very sad eyes,' as one girl described him is perhaps the most concise and apt judgment of Shukla Sir.

Shukla Sir had a way with women. After dating quite a few ladies from the nursing faculty he was deservedly given the nickname 'Nursing King.' He was erratic (read erotic . . . hehe); no, his behaviour was erratic. Sometimes he would be superconfident and make the first move while at other times he would be unable to get out of his shell. Sometimes he fitted right in. Sometimes he stood out. Once he had actually locked his rather goodie tushu girl inside his room all night so we could get high in the living room. The poor chick had knocked for a while and then gone to sleep.

He smelt something cooking and asked us what we were up to. We told him we were going to smoke weed and since he had exams we would do it in Karan Sir's room and not make much noise. He had that excited and evil grin on his face and he assured us that the exams were not an issue and he would, in fact, join us. I was quite shocked. Still new to the college world I could not imagine anyone behaving like this on the eve of university exams. Time changes people and it would change me too.

The more the merrier. We sorted the material, laboriously picked out the seeds and rolled a few joints. Clichéd, though, it may sound, there is a definite synergy if you mix weed with certain bands or songs none more so than Pink Floyd and the Doors. Chetan Bhagat was right! We started initially with Floyd. 'High Hopes' was the song that was played countless times and often to begin a trip. As we breathed in the first few puffs of marijuana the music would take you in. Everyone would be silent for the whole duration of the song, every single time. We wouldn't want to break the melody of the music which quite frankly was simply genius. We all got high; Karan Sir and Gauravi passed out.

Shukla Sir and me stayed up watching TV for ages. Weed had started its most dangerous effect. Ironically, this is an effect that makes everything better. It makes movies better, it makes music better, it makes TV less diabolical, it makes the breeze feel better, it makes food taste better, it makes cigarettes better and so on.

We watched TV and we talked. I know I have used this word a lot but I really connected with him. We shared the same madness for cricket and we talked a lot about the game, mainly about cricket in the nineties. We discussed how childhood Sundays used to be when India was playing. How it felt that by watching the game you could actually make India win. And how depressing it was when after watching a whole day's cricket the team lost. Or about how beautiful life was the morning after India had won. We talked about how we watched every match ball by ball when we were kids and this included test matches too.

The more we talked the more joints we rolled and burnt down. Also an avid smoker, Shukla Sir and I drove to the bus stand for chai and cigarettes when we had finished everything at the flat. The night had never really begun. The night never really ended.

For all his faults and the gaping holes in his personality, Ravnish Sir was still a great friend and a good roommate. No day passed without laughter and conversation. He was a big SRK fan; the more filmy type, I loved Shahrukh too. So we talked a lot about the Badshaah. Ravnish Sir would tell me stories about him and how he had managed to get the love of his life by using an out-of-the-box approach. Ravnish Sir also had a crazy affiliation with a movie called Rehna hai tere dil mein and especially a character in it called Maddy. He even had this name printed on his bike. Funnily enough several people on the campus actually called him Maddy. At the most absurd of times Ravnish Sir would blurt out words and lines from the movie. He was funny—you had to give him that— and on the whole I was happy I was his roommate.

JK Sir who had been out of town for a while returned. Gauravi and I were both close to him; he was one year senior to us. Initially, he had his reservations especially about me. I think he thought I was one of those noise makers with no real substance. He was also close to Karan and Shukla Sir. JK Sir, also from Bihar (if Shukla Sir was 'cool' Bihar, JK Sir was 'angry' Bihar) completed our pentagon. One car, five seats, five people. He was well read and had a flair for literary brilliance. His personality was a little darker (he had written an article in the college

magazine titled 'Pus-filled Pungent Desires') than the rest of us but he added much-needed spice.

The first evening all five of us smoked up together was a Saturday. Still a little hesitant and partially scared about whether what we were doing was right we made a policy decision to smoke up only on Saturday nights. We called it TGIS—Thank God it's Saturday. And this was really how it was for months. We maintained discipline. I remember I would have goose bumps sitting through the last evening lecture on Saturdays, excited about the night ahead. I crammed even harder on Sundays now feeling totally at peace with the magic I had felt the night before.

We really did enjoy smoking up. The flat became the base camp. We felt at ease with each other. The french connection was palpable and the environment perpetually positive but honest. We all enjoyed each other's success and we were all there when one of us was down. In a few weeks I had gotten closer to these guys than I had with some others who I had spent years with. We were in a way very alike. We burst out laughing together at some jokes and when a joke was shit we all took the piss. We were different too, very unique each one of us.

Conversation flowed when we were high. Lying comfortable on the floor in the flat, listening to soothing music, making a circle and passing the joint with honour, it could well have been the Olympic torch. It was as if we were in each other's mind; for a lot of times, you would be thinking the exact same thing someone said and vice versa. 'Out here in the perimeter, there are no

stars. Out here, we is stoned immaculate.' We respected the substance.

One time Gauravi got a call when he was about to be passed the joint, so obviously, it was passed to the guy next to him. Gauravi hung up and said, 'You know what you guys have made me? A 'grass'-hopper.' We burst out laughing.

Ravnish Sir was originally in the same batch as Shukla and Karan Sir, so they knew him well, as did JK Sir. So while this may sound odd, a group of five guys talking for hours and days about one individual, it wasn't, because Ravnish Sir was like that. He had innumerable ramifications and points that could be discussed regarding his personality. A lot of the times we would be rolling around in laughter as each one of us individually described moments, actions and deductions about the great man.

It was not all good though, he had skeletons in his closet; and though he tried hard to keep them locked in, there were times when the darker shades of him surfaced in his views or arguments and left you feeling a little sick.

He watched old movies to check out Hema Malini. I mean how the fuck could you want to check out Hema Malini from twenty years ago I will never know.

It was when we were once discussing the behaviour and outlook of some of the not-so-presentable Biharis on campus that Shukla Sir and Gauravi (both from Bihar) came up with a concept. They proposed that there should

be an exam called 'Bihar Exit Test' or BET, that students from Bihar would have to pass before they went to college in some other part of India.

Apart from Karan Sir the rest of TGIS was all originally from Bihar; and unlike many, we were actually proud of our heritage. It gave something to everyone. To me, I believe it gave spunk and wit. So this BET concept was not to insult Bihar or Biharis in any way but actually a hypothetical concept that would help refine the image of the state and clear its bad name.

It was a weird situation in college where there was the odd professor who would screw your viva once they knew you were from Bihar. I speak from personal experience. On the contrary there were idiots who would hide the fact they were from Bihar and lie about being from Delhi or some other place during vivas. These were people low on confidence. On the whole, most professors didn't hold a grudge for things like this and most Bihari kids were okay; however there were some absolute nutcases. Everyone would admit that Biharis do make things interesting.

Ritz and I still spoke a lot. I had a tendency to stay up on weed nights even after everyone passed out, so I would talk to her then. She was a good listener. I would tell her in detail all the things I was doing. I told her about work. I told her about weed. I told her about all my friends. I tried to share highs and trips with her. She was sweet but she didn't fully understand. I doubt I would have been friends with her if she were a guy. It had been a while

since we had met. I wanted synergistic perfection; only problem was that I think I loved her.

We started a tradition on weekdays that involved gathering at the flat around 10 pm, making and sipping tea and smoking cigarettes. We never smoked up on these days. It had its own charm. Other than the five of us, other people too would be invited. Sometimes Tyagi Sir, sometimes Jaat Sir and more often than not Ravnish Sir—Ravnisha! They called him Ravnisha. Ravnisha came into his own once in a while and proved why he was such an important 'absent' member on TGIS nights. I even got the feeling that sometimes we would have tea with him all week, hear him talk and see his moves and then enjoy it on our own on Saturday nights.

We always had one or two of us bringing new observations and info about Ravnish Sir, so we never ran out of topics to speak about. We didn't gossip. We didn't give a fuck who he was fucking. We just tried to enjoy his character and we did.

I would inevitably sandwich these tea sessions with hours of mugging. Not many people studied like me. I was invariably doing well on tests and papers. Second-year medical school is a little weird in India because it is longer than a year. It consists of three semesters or one and a half years.

The Saturday routine was well and truly set. It began as soon as class finished around 5 pm. Sometimes we would all load up in my car and go score weed while sometimes

we already had it. We were novices and it took us a lot of time to roll joints. We were all assigned little jobs; so if I was crushing the grass, someone else was picking seeds, someone else clearing tobacco and someone else rolling. After rolling a few joints, we kept them safely in the drawer in the living room.

We would then make our way to a highway place called Sai Dhaba. The danger was that we had fallen so deeply in love with weed that we may forget alcohol. We didn't want to let that happen. Alcohol adds a little energy, a little spite to life. Vodka shots had become a trademark Saturday night fancy (and with no palsy). Karan Sir had quality portable speakers and an iPod with good music. He almost reminded me of Gadi in some ways. Sai Dhaba was a quiet place. It was scenic and you could feel the refreshing Belgaum breeze.

We sat in little enclosures that drowned out the outside noise, so it was just our music and our words—just the way we liked it. Shots were routine as were the pieces of lemon and salt. You can't really go to a dhaba in India and not taste their butter chicken. It is almost considered rude. So we ordered plates and plates of chicken, prawn and everything else. It was weird because even after drinking for a while we were all still essentially sober and this was because vodka, with all due respect, was just a filler; the real business was smoking up at the flat later.

I can still sense the excitement that used to almost be radiating through me on the drive back from the dhaba to the flat. We were tipsy, which is why we had done the

work earlier so now we could just relax into our positions, take out the Js and start smoking them. The mind was clear and sharp. It was like we were boarding a ship and all leaving together. There was a sense of safety I felt with these guys around me.

Every Saturday night was an adventure because after we smoked up we could think up anything and then do anything. A lot of the times we went to a hilltop situated on the road to Goa. It was a beautiful and breathtaking getaway; you could always feel the wind there and it had a view. And with quality trippy low music in the car this place became my personal favourite.

It was on one such occasion when after reaching hilltop we realized we had cigarettes but no matchbox or lighter. It would be considered a crime to go to hilltop feel the orgasmic breeze and then not smoke. It was a lonely place. We had no choice but to slowly make our way back and hope for a miracle. It was one of the most fucked-up feelings ever. I saw a couple of guys on a bike driving fast heading in the opposite direction to us; I instantly gave an SOS dipper signal with my lights, honked and then waved my hands frantically from my window. They stopped. They were drunk. We shared our predicament; one of them smiled and handed me a matchbox and I remember clearly it had two sticks. I could not stop myself from hugging the guy. He had most certainly saved the day.

Sometimes we made our way to the bus stand for tea and smokes very late in the night. Music still hit like it does

when you are 'stoned immaculate'; unfortunately, unlike the rest in the car who were just buzzing, I used to be buzzing and driving too. It was a short trip to the bus stand and I used to be very, very careful.

I would have major subjective time issues with marijuana, sometimes with my friends and sometimes alone. If I drove back from the flat to the hostel, a five-minute journey would feel like forty minutes. Dogs sat around in circles on the road, ruling the world. The world is asleep. The Indian roads are intense.

For months we maintained this discipline, this Saturday night routine. We all looked forward to the night. It meant something. One Sunday morning we were at Prabhu for the after-morning-glory meal when I got a call from Shukla Sir at the flat asking if we could get some biryani and parathe for him. I went to the flat.

India was playing a test match at home. Shukla Sir and I started watching the game. We talked cricket. Sunil Gavaskar was commentating. He explained a particular delivery with such detail and so intricately that Shukla Sir and me burst out laughing. He then spoke of strategies being applied in the game and went on. We both really enjoyed this bit of commentary from the original little master. Shukla sir and I both agreed that this guy knows a lot about the game.

I hadn't noticed it then but there was a reason Shukla Sir had suddenly gotten hungry in the morning. The fucker had sneaked in a morning joint while we were away. The

act was small but it meant more because for a while now we had hardly broke the Saturday law except on very special occasions. We always smoked together. We never smoked alone. Shukla Sir changed all that that morning. He made it okay to cheat, to break code. He then spent the high enjoying breakfast and watching a cracking game of test cricket. It is us. We keep test cricket alive.

I scored two packets of weed. It was a random beautiful Belgaum evening. I can't explain how good I was feeling about things in general. It was a natural high of some sorts. I really did have a lot going for me. The weed was only magnifying my confidence levels. For the first time ever I rolled a couple of joints and drove alone to the Goa hilltop. I got out and smoked down the joints one after the other. I zoned out. It felt like I was flying. The wind caught my hair and my T-shirt and played gently with my consciousness. It blew me. The experience was smooth and perfect. It was one of those moments where you felt like you should thank God for letting you experience it. If I were a religious man, I would have probably claimed enlightenment. It was my first real spiritual experience with nature and marijuana. I walked around the hills alone, taking pictures.

I waited for the high to let go a little before I drove back to the hostel more than satisfied and truly charmed. Nature had played quite a spell on me.

I did the same the next day except it started raining at hilltop. I was out of my mind and the trip was out of control. The cold rain, the Belgaum breeze—it was very trippy. I can't explain; but these two trips alone with

weed, music and my car to hilltop changed me forever. They left a very positive and lasting impression on me. They ensured that in the coming years when the positives had to be stacked up against the negatives I would usually have a softspot for the substance.

Nevertheless, for a long time we indulged in what can only be called responsible 'nasha.' Slowly, we had started a little fire that was spreading in the college, smoking weed. Geographically speaking, we only represented the northern side of India at JNMC; there was a south India in the reckoning.

Our first internals came up. There was really no pressure. I had studied hard. Weed had only strengthened my resolve to read well. Still we respected the exams. I certainly wasn't fooling around. I scored above 75 percent in three out of the four papers. This small exam, these good results, for a while became a major reinforcement supporting the conclusion that weed wasn't so bad.

As for TGIS, the sessions continued. Chocolate munchies, preferably Ferrero Rocher; for dinner, biryani or butter chicken fixed from Niyaz. 'Hi, two butter chicken, two jeera rice Karan, Kiran Nivas' would be the fixed order. We didn't have to say anything else when we called Niyaz. Kiran nivas was the name of the big house that had the flat and Karan the name of their favourite customer. They knew us well.

I was introduced to two new characters by Karan Sir; one was from America with roots in Kerela and was called T

while the other was his girlfriend Jhailini (okay, I admit that's my name for her) from Sri Lanka.

T was a genuinely shy character and usually kept to himself. In his whole batch he was only really close to Karan Sir. It took a long time for me to get him to open up but once he did we shared a strong bonding.

He was very funny, a keen observer and witty in his own way. He too shared our interest in the topic of Ravnisha and some of his descriptions depicting the behaviour of my roommate were hilarious. You can be quite sure that no one could ever even imagine interacting with a character like Ravnisha in the civilized world. And T was from America. To encounter a unicorn Bihari like Ravnisha was—well, Ravnisha and his actions never let us down.

Jhalini was like a little kid but she didn't look like a little kid. She had this funny gait, this demeanour. She loved Karan Sir true and pure. Naturally gifted at sketching and painting, Karan Sir made her draw portraits on his wall. We had a Jim Morrison, which was beautiful. I can still see it in my head: Morrison in his mystic pose captured smoothly by Jhalo. Oh, I also called her Jhalo and soon everyone started calling her that. While when it was just the guys we would dive into our biryani packets; when Jhalo was around she would add finesse to everything. She would take us out on the roof and set up a candlelit dinner. She would place the butter chicken in big bowls. She would take out spoons and plates. She actually used the utensils in the kitchen. And to be honest the extra

five-minute wait would usually be worth it. It would feel like we were kings devouring a feast.

Jhalo was just stupid on weed and even otherwise. She was actually one of the few people with whom I found it hard to tell whether she was high or not.

T and Jhalo joined us sometimes but not every time. T was big, he would be more excited when we smoked in bongs or did submarine shots; the joints we usually made did not appeal to him much.

I was out one night with a girl called Anjali. We were flirting but we weren't doing anything else. I wasn't even dating her at that time. I had parked in a nice little private place or so I thought. After a while, we saw two men approach the car. I walked out and locked Anjali inside. One was wearing khaki colours while the other was an older man in his casuals. One of them slapped me hard as soon as I reached them. I could hear Anjali screaming. They claimed to be police but I had my doubts. They asked me for money to let me go. They had taken my driving license and unfortunately I didn't have much money on me.

I had to call back at the hostel. I don't know who I called and what I said but within five minutes there were at least forty bikes and a few cars at the site. My friends had come to fight. I had told them that I had run into some local goons claiming to be police and trying to make easy money. I mean the guy said he was police and asked for money in the same sentence. We hadn't even done anything wrong. I was wrong; they really were police.

One of my seniors who spoke the local language settled proceedings and helped get my license back. I left pretty much unharmed.

My affair with Anjali became public even before it was conceived. She suffered though as a result of my immaturity. People spread all kinds of baseless rumours about her and me and why they thought we were caught. It was all a load of bullshit stories spread by frustrated guys who probably spent their days jacking off thinking about her, or chicks who were fat, dumb and ugly. She was a bright girl; I screwed up her reputation that night. I should have just paid the money and not tried to act so hard. What was done was done. I went out to get wasted with Gauravi and the guys. I returned to the hostel, called Ritz and talked to her for a while. Then I called Anjali and asked her out. I was wasted. She said yes.

People were literally staring at me the next day. Rumours were twisted and spread fast on campus. More or less, everyone; the guys and the girls now knew at least one version of the story of the night before. I became the number one badass on campus. I didn't seem to mind.

Our Floyd was a very young, careless and free Floyd—very Syd we were. This British spunk made its way into our nature after a while. 'Hanging on in quiet desperation is the English way' ... 'Kicking about on a piece of ground in my hometown.' Music wise soon we would be graduating to classic Doors and with Syd Barrett; Jim Morrison made his lingering entrance, the two rockstars who I believe truly changed me with their music.

Karan Sir was not really the cheating type. If he wanted, he could have brought the campus down. And to be fair to him he had broken up with Jhalini when he started dating a girl from the dental fraternity called Suhani. We all loved Jhalo. She was an essential part of the flat now. Of TGIS. Thankfully, Karan Sir and Jhalo's ups and downs didn't adversely affect our friendship with her as a group.

Suhani was hot, arguably with Sahiba, the hottest chick in the dental fraternity. A very wannabe senior Devansh 'Lulli' Sir who was also the self-assigned goalkeeper of the college team had been chasing Suhani for a while. He played his nice-guy card, did all the gay things to get her, even got a car. Nothing worked.

Karan Sir who never used base-level approaches like messaging a girl to start conversation did so this time. He had called Lulli for Suhani's number. Lulli has this horrible habit of trying to make you believe that he is on the verge of scoring the girl and guilt you out the chase. He said that to Karan, he had said the same to me just before I had started dating Anjali. If he was genuine and right you may have thought about bailing but he was not even close to where he claimed to be. Girls would talk to him because he was safe—he was lulli. They would be polite but that was all. I told Karan Sir to ignore Lulli. He was a nice guy but I always found him irritatingly boring.

Karan messaged Suhani and after a few days they were going out. It was obvious that both were highly attracted

to each other. Suhani brought oomph! to the flat but yes sometimes we missed Jhalo. Suhani was fun. She was a very good sportsman. She fitted right into our evening TT routine and also on several occasions for the happy hours at the flat thereafter. Suhani—she had this face. I have shared this with people but not a single person has understood what I mean, not even Karan Sir. Basically, she had a trippy face. A little editing and you could stick it on a character from Alice in Wonderland.

Karan Sir had asked me for my car to take Suhani out for a date. I was over the moon. I really was very happy. I threw him my keys. I swear it was as satisfying, if not more than how it felt when I took some girl out for our first drive. This trend would continue. The guys didn't ask me for my car much but when they did and it involved a girl I would be happy to lend them the keys. Gauravi had done the same when he started dating a dental girl called Sneha. Apparently Sneha's friends had ambushed her in the hostel later and asked her how she could sit in Samar's car. I felt proud. My gray baby too was scoring and helping my friends score. No better feeling than that. Help your bro in the chase.

I broke up with Anjali. I was high. I missed Ritz. This became common; hitting on someone when I was drunk and then breaking up with them when I was high. Alcohol acted like an aphrodisiac while weed made me miss Ritz.

It was time to leave for Pulse-AIIMS. Traditionally only the selected third-year students would be allowed to go

for this event but I had done well in speaking events in college; besides, selected or not, I had to go to Delhi to see Ritz. Attendance was the only issue but I pleaded my friends give as many proxies as possible; and I was also told that if I did well I may get attendance credits for the time I had missed so I boarded the train. The whole trip lasted around two weeks and it was quite an experience.

Karan Sir and Jaat Sir were going as were Keshav and Tyagi Sir. A bunch of guys were staying at Karan Sir's place, so I decided to stay with Keshav Sir who invited Tyagi Sir and me to stay with him. Keshav Sir really looked after me. He always did and though several people had reservations about him he was always nice to me.

The morning we reached Delhi after a long tiring journey, we decided to get fresh and just relax. I called Ritz. She was pissed. She said I had to come see her straight away no matter how tired I was. It felt good when she got angry like that. Apart from the speaking events (in which I did okay) and the football matches, I spent all my time with Ritz. We actually did quite well in football considering we only had three proper players; Jaat Sir, Karan Sir and me. Ritz came to see us play. I introduced her to my friends. I had told her a lot about Jaat Sir before finally she met him. She met Karan Sir too.

Karan Sir killed it in the swimming pool, securing an all-time highest individual medal tally consisting of seven medals. He was in shape and he was fuckin fast. It was quite exhilarating watching some of his events. And it was even more awesome overhearing hot Delhi university

chicks openly checking out his body and also then talking about it. Ritz and I heard with glee and then went and told Karna.

Ritz and I hung out a lot. We went to all different parts of Delhi in an auto. We bought stuff, watched movies and hogged food and then watched more movies. We watched Chak de India three times. Well, we had corner seats. It felt liberating walking around so freely with Ritz. I didn't smoke much weed on that trip; but once or twice, I would leave Ritika for a while, smoke down a little spliff and come running back. When I was high I was a lot more attentive and playful.

Ritz and I were taking a walk around the India gate area which is my favourite part of Delhi. It was early in the morning. There was hardly anyone there; the streets were empty. I was grilling her about the fact that once years ago she had claimed that one of her guy friends who was hitting on her was better looking than me. I was telling her that it had really hurt; she cut me off and told me that it was the biggest mistake she had ever made and then she jumped into me and held me tight. It felt warm. She couldn't see because she was facing the other way but I saw a bus moving toward us. As I looked up, I saw it was full of some fifty pubertal school kids, boys and girls. They saw us hugging and went hysterical. They were shouting and smiling. Ritz saw them and I could tell she was instantly embarrassed but she smiled as did I. They were cute, they were excited. I waved and they all waved back with a huge grin on their faces.

One afternoon Ritz and I were having lunch at Pizza Hut, hogging on garlic bread, when I got a call from Karan Sir. He said they were one man short on the 4*100 swim relay and I should come ASAP if I could swim. I was stuffed but there was no choice. I had to go. Most guys were swimming freestyle and were fast. I swam a breast stroke which seemed to last forever. I looked like a pigeon doing frog stroke. Karan Sir and Devansh Sir were quick. Karan was very quick! They got us a medal. We got silver even after my dismal performance. Karan Sir took us from fourth to second position in his last lap. And I will have to for once give credit to Devansh 'Lulli' Sir. He was fast that day.

I hung around with Ritz in a big public park on the last day. We found a quiet place. I hadn't slept the night before. Keshav Sir had lost his car keys. I tried to fight it but I pretty much fell asleep in her lap. She played around with my face and hair. It was sad to leave but this trip had been a good one. We had spent quality time with each other and it had been rather enjoyable. We hugged and said our good-byes.

With a total medal tally of thirty-six, of which I had won four. Jnmc Belgaum was third on the overall medal list at Pulse. Most colleges brought unlimited students. We had less than forty. We had done really well. Everyone was happy. We were treated as heroes back in college, pictures were taken and articles printed. This had been a great trip and soon I went on another little trip this time to Jamshedpur.

Whenever flying home, I would have to take a flight from either Banglore or Mumbai to Calcutta. I alternated between Banglore and Mumbai so I could hang out with Gadi and Guda or Sardar and Venom respectively; I always met Anish at Calcutta. In all these permutations the only common factor was that we always drank. Apart from these short transit meets I often made small three to four day trips to Banglore and Mumbai, more to Banglore. As for the time with Anish in Calcutta, we always—and I mean always—went to this drinking place on Park Street called Oly's Pub. Toward the end of college years both Anish and me had become attached to Oly's simply because we had spent so much time there. The ambience, the furniture, the peculiar smell of intoxicated carpet, how you had to make your way to the balcony to smoke cigarettes all left an indelible mark. The waiters knew us.

Not many of my friends were home this time so I spent more time with my family, with my brother. I studied. Every hour or so I would go out for a smoke. I never smoked at home though, not then. The sanctity of the home was respected and at no time compromised. I would discuss medicine with my dad sometimes in the evening while my mom sipped tea and my brother played around and I knew he could tell I had been studying. It was a lot of fun. It felt good.

Soon it was time to go back to college. The route fixed. I met Anish in the morning at Park Street, Calcutta, guzzled in beer at Oly's. We called Gadi. Then I somehow caught a plane to Bangalore. I slept through the flight to meet Gadi in the evening and drink again.

This time we would call Anish. One time we hung up the call with Anish and started talking; he called back straight away and he was like 'You guys are talking about me, right?' He was dead-on. We were. We broke out into laughter.

After spending time in Bangalore, I would have to catch an overnight bus to Belgaum. Gadi always came to drop me off and we always ate KFC at the bus stand before leaving.

Some of my most cherished memories would be when the bus would stop around five in the morning for a tea break with roughly one hour to Belgaum. They always stopped and I never missed one such occasion to go out, take in the fresh air, take in the scenery and have a cup of tea in the early morning coolness and, yes, that billion-dollar baby of a smoke. I remember feeling totally at peace and inherently happy on these mornings. It exuded a silent energy that gave me a lot of strength.

Also Chondu and I had this thing where when either of us reached Belgaum early in the morning we would go to the other's room wake him up and share a smoke. He always called me a 'killer' and he would tell me that the campus would seem empty when I wasn't there.

#26

Open the Doors

It was a big weekend. Sardar and Venom were coming down from Bombay; and when I went to pick Gadi up from the bus stand along with Gadi, to my surprise, Neel had also come down.

Neel was dating a girl who worked for Red Bull and he had got a bag full of Red Bulls with him. It was early morning. I showed my friends around Belgaum; we stopped at a spot and downed Red Bulls. We sure were high on something. We drove back to the hostel where Gauravi and Raghav were waiting with Vodka; while the rest shaved, showered and got ready for class, we were smashed by 8 am. Bro hugs to the Untouchables were given with a 'proxy maar dena bhai.' To their credit, Hanu and Sumeet were good and brave giving proxies. We made a short trip to the ever-windy hilltop, had a few beers and walked around.

The plan was that we would go to Goa. Apart from my friends from school; Karan Sir, Shukla Sir, Gauravi, Raghav, Shak and Keshav Sir were supposed to join. Keshav Sir with his car backed out at the last minute. We

were in the hostel pretty glum when Shak stormed in; he said there was no way the Goa trip would be cancelled. He said he would take his Indica and told us that he could never disrespect Goa.

Shak drove his car and Gadi followed him in mine. We reached Goa in two hours flat. Gadi later told me that Shak knew every single pothole on the road even when it was dark. Shak played trance while we played rock. Venom was a talented roller. He rolled even when the car was drifting. We smoked weed nonstop for the whole journey and then all the while we were in Goa.

There was a liquor store run by an aunty just as you entered Goa. It was tradition to take shots at this shop so by the time you entered Goa proper you would be buzzing. This was a tradition Shak had started but many now followed.

Shak knew everything; where to stay, which clubs to check out, the best places for water sports, where to buy booze. Where the best chicks were. Many people we ran into in Goa knew Shak on a first-name basis. We partied hard late into the night. At one club, Shak accidentally bumped into someone and they both spilled their drinks. They said sorry to each other. Shak asked him where he was from. The guy replied, 'Israel and you?' Shak's replymade us all laugh including the guy. He said calmly, 'From your enemy country . . . Saudi Arabia.' They hugged and shared a drink. If only world politics were as simple as Shak made it seem. He really was a mercurial character.

By the time we woke up the next morning Shak had already stacked the fridge with Buds. We pretty much drank all day.

On our way back from Goa we stopped at this go karting place around midnight. They were open 24/7. We were into go karting and used to do a lot of it in Banglore too. It was at this place that I got a call from Ritz. She threw the kitchen sink at me as soon as I picked up. She screamed at me more or less all the gaalis she knew, starting with English and moving on to the really bad Hindi ones. Someone had told her that I had been cheating. She was obviously heartbroken and though I knew that this may happen one day to suddenly now find myself in a situation where I couldn't talk to her even if I wanted to left me shaken. She changed her number and we didn't talk for a long, long time. I missed her.

Sardar could make out that Ritz had come down on me and as a couple of teardrops fell down my cheeks he broke out into uncontrollable laughter and spread the news. I downed a few shots of Vodka to take my mind of Ritz at least for a while. I won the go-kart race! Drunk and pissed!

A few weeks later, I found myself lying in my room alone. It must have been around 4 am. I was stoned and I couldn't sleep. I kept staring at the ceiling when a thought occurred. It was Saturday night; and it was in that moment I decided that I would shift out, get a flat and live alone. Things were going well and I wanted to experience how it would be like to live by myself.

Normally, people take months to decide and find a place to shift. I called Mochuu the next morning who had himself just shifted into a flat with Dev. He knew a middleman who met me at Shiv Sagar. I fell in love with the first place he showed me. Another advantage was that this place was just a five-minute walk from Karan Sir's flat. The family that owned the place were very sweet people. By the evening I moved in. I called my mom and let her know. She didn't have any objections.

Moving out alone gave me even more freedom. I studied really hard. Slowly we had started smoking more weed but still it wasn't enough yet to hurt my academic performance. The second internal exams were on. I had read and re-read the portion. And even though my behaviour was a little undisciplined and overconfident. I had smoked up the night before the pathology paper. It was not reflected in my marks. I scored above 70 percent in all the papers. My internals were now set for the university exams which were still more than six months away. I didn't know what to do. I had already almost finished the entire syllabus in pretty much all the subjects again a good six months before the final exam. As of now second year was a piece of cake.

I started dating a girl called Sahiba who was a dental student. Full of confidence and panache, I moved quickly when it came to girls. There was a major difference in the way I scored; for a Karan Sir or a Raghav would not have to do much. They did their work in the gym and a lot of the female attention they got was in a way shallow and often with no strings attached. I, on the other hand, with

no abs or cut-throat good looks would have to make the girl believe that I loved her first before moving forward. I was good at this but it meant that when the relationship was over, the girl involved would invariably be severely hurt. I was sick and looking back now I almost feel ashamed. Maybe it was all the American boy-girl flicks I had seen growing up that left an impression on me that it was cool to be bad.

It was during these times that I went through a hip-hop Kanye-inspired pimp revolutionary phase. I was not alone. Picking up women outside the girls hostel around 7 pm, music and the beat drowning out all other noise. 'Can't Tell Me Nothing' and 'Gold Digger' were just some of the tracks that would be played. The very few times in my life I used cologne; I would have the AC on to smooth the atmosphere before she walked in. The music would progress and transgress depending on the mood in the car and I would often be high and sway.

It started with Anjali, then Sahiba and then a wild passionate affair which came later. There would be other girls there (near the pickup point) and you would get this weird look. Some you could tell hated you, even despised you. Some were just pissed off and a very few you kind of felt were jealous. Raghav had also gotten a Swift. Red.

Sometimes we switched cars just to confuse the shit out of the campus.

If picking-up time was awkward then dropping time was far worse. Firstly you would be struggling to get back to

the girls hostel by the 10 pm curfew. Often I would be at some discreet getaway point on the Goa highway and only head back around 9:55 pm. Driving back would be like you were playing need for speed.

A girl I fell in love with way later called it the 'walk of shame' to describe the walk girls would take from being dropped off and getting out of the car to the hostel. There would often be a crowd and they would often be judged in some way or the other. She, however, never took this walk of shame.

The responsible nasha, which had been going on for months changed and became irresponsible nasha. Starting the day with a joint and then smoking through the day became a common practise. It was the Dev-D phase at the flat in the sense the movie's soundtrack would be played on loop all day. The music really was something else. This was followed by a Gulaal phase. We were big Anurag Kashyap fans and also had a lot of time for Piyush Mishra. Shukla Sir I think led the pack.

I was dating Sahiba but deep down I was hurting about Ritz. This may sound selfish but I never expected her to leave. No one had ever left me before. To be honest, I don't think I truly loved her. I was just very attached. I only ever loved once but that was to come. It was just that it was 'baby love' we had known each other for ages. We met when we were sixteen. We met when we were kids. There was a lot of dependence on each other while I was sometimes there for her and sometimes not; she was always there for me. So tracks like 'Nayan Tarse' or 'Saali khushi' from Dev-D really hit the right place. I could

feel the pain in the song and it resonated with the pain I felt in my heart. As a group, we were heading towards depression but we didn't know it yet.

We smoked at the flat, we smoked at my flat, we smoked in the car, we smoked in the hostel, we smoked at hilltop and on Goa trips. We drove to football matches and smoked on the way back. We started listening to the Doors a lot. We were dissecting lyrics sung by a guy who had been dead way before we were even born. It was a special association. Songs were played over and over until they took a place in your subconscious.

As for studying, the wheels started to come off. I had always been plagued with annoying little OCDs that always accompanied me when I tried to study and then fucked the session up. I had learnt to somehow manage them and still get the work done. However, they started to surface more often; and every passing day I found it harder and harder to study. Maybe the excess weed aggravated the problem. I guess we were smoking too much pot or maybe I was more vulnerable because Ritz wasn't there anymore. It got a little lonely too in my flat. Ravnish Sir and his jokes were not there anymore to ease the tension.

I figured that since I was already so far ahead course wise because of the hours I had put in earlier, I could afford to take a break of sorts. I decided to totally give up cramming for a couple of weeks. This only meant I had more time to smoke up. We had started smoking hash. Hash was delicious. A weed high was a bit like beer with hash you got serenity, it was classy; it was more scotch.

Where before we had to drive almost half an hour to score marijuana, a local dealer had come up which meant you could score whenever you wanted. He was just a phone call away. We would score by the lake. 'Green' for weed and 'Black' for hash were the common code words.

Sahiba was nice initially. But in a couple of weeks the obvious lapse in our chemistry and her behaviour which was just too pink and girly for me started to put me off. She wanted to spend more 'time' with me. She wanted to go out on 'dinner dates.' I hated dinner with girls in general. I would have to eat in a civilized way and I wouldn't be able to enjoy my meal. I broke up with Sahiba. I didn't have any time for her. To be honest the main reason I broke up with her was because I simply preferred to spend my days in a flat somewhere getting high and listening to Morrison rather than walking around campus showcasing my girlfriend as a trophy and 'studying' together in the library.

The campus was filled with hypocrites and idiots. The dental batch consisted of roughly 70 percent girls, so most of the guys they had were very soon womanized. As a result the dental chicks expected their guys to be timid. They were always well dressed—overdressed. There were a few guys from dental who played sports and they were okay but unfortunately we never got that close to them. I never gave a fuck about how I looked especially when I went to the library. I would often go wearing a rugged black T-shirt, my trademark three-fourths pants and chhapals. Comfort was of paramount importance. Still Sahiba was a good person and she had fallen in 'love' with me.

I had gotten close to a bunch of guys in my batch who I hadn't known that well in first year. Sid was from Kolapur and I shared a special bond with him. We talked a lot about certain aspects of philosophy and spirituality. V-man was from Hyderabad. A magical person, he had an innate and very strong desire to explore nature. Trips to hilltops, waterfalls and trekking around were his priority. He would also often get lost and stay lost for hours on such trips. Harry and Sandy were both from Karanataka. Harry, a modest and honest face would go on to become the GS or the president of our batch. Sandy was quiet. Not only me but also the TGIS group hit it off with these guys. It was like one big family. The first and most important binding force was our love for substance.

Raghav was also now a permanent fixture at the flat. His Hindi had improved in leaps and bounds. Almost all of us had qualified for med school on merit and based on ranks. Harry was here on a management seat but he never lied about it; and whenever the topic had arisen, he was always blunt. Harry's behaviour spoke volumes about his character and I respected him straight way. He was a very popular and courageous leader and someone who I felt would do well if he joined politics or public service.

We smoked a lot. We heard a lot of music. There was a party at the flat where a large population of the smoker fraternity had been invited. It was almost a big North-meets-South get-together with weed again being the common denominator. There were more than forty guys in the flat that day. Gauravi had made huge

double-skinned joints that were being passed around and seemed to never end.

To keep things simple, we had just ordered some seventy packets of biryani from Niyaz. There were quite a few new smokers and a lot of them were having a hunger trip. They were feasting on the biryani. Rumour had it that when Shukla Sir found Gauravi roaming around and asked him what he had been up to, Gauravi had replied, 'Mai aadha ghanta se biryani kha raha hnu sir.' He looked exhausted and was sweating.

The 'nasha' was getting out of hand. There was no control. At any given point of time someone always had weed and someone always wanted to smoke. It became too accessible, too easy. From the love of your life, it became a bit like a slut. No offense intended, dear God of weed. It is a special brotherhood. You don't generally say no to someone who wants to join you when you are smoking up. Besides, I hadn't learnt how to pass an opportunity to smoke up. And dare I say the highs weren't as much fun anymore. The trips got repetitive and the charm started to fade ever so gradually.

The lack of contact with Ritz was hurting her too. She called one evening and we couldn't help but talk for hours. It had been a tough time, more so for her. I had my friends, my nasha, while she was alone. There was a temporary makeup of sorts which came at the right time because Pulse-AIIMS was coming up. It had been a year. I couldn't wait to spend time with her.

A new batch of juniors had joined campus. I wasn't much into ragging; and though occasionally it felt good to stare down scared shitless kids, make them dance to dreadful songs and so on, it wasn't a major part of my character.

There was one kid though called Anunay 'Kiddo' Kidzi who I became very close to after ragging him with my friends at my flat. We had made the poor kid dance to 'Kajra re' over and over again. And while one of his batchmates who was also being ragged seemed very nervous, Kiddo took every task with a smile. We dropped them back to the hostel and asked Kiddo to explain to the other guy that nothing should be taken to heart and we were only fooling around. Like Keshav and Tyagi Sir had done after the first time they ragged me we assured them that now they could count on us as their friends.

We never ever indulged in physical ragging and it was important that this line was drawn. Later, Kiddo told me that he was given V-man's number as he too was from Hyderabad and had some family ties. V-man was supposed to protect Kiddo and help him settle in. On the contrary, the first thing V-man did was to bring Kiddo to my flat. You can tell a lot about a person based on how they respond to being ragged. We liked Kiddo.

Kiddo too smoked up and he started getting invited to the flat. One night everyone was asleep, most of us lying on mattresses on the roof. There were just too many people to be accommodated in the rooms plus the Belgaum weather was beautiful, not to mention it was a sublime starry night. Inevitably, we ran out of cigarettes. No one

but Kidzi could be bothered to ride with me to the bus stand. We went on a bike. I talked a lot to Kiddo that night. We were the only ones who stayed up all night to witness the sunrise and welcome it with a good-morning joint. Playing classic Dylan through the night we talked. He told me I reminded him a lot of his elder brother who was also studying medicine in Manipal. This touched my heart. I bonded more with him than most other people. It was a very natural and effortless bonding.

I needed some weed a few days later and unfortunately our dealer was unwell and resting at his house. I really wanted to score; so I called Kiddo, got a bike and drove to the dealer's house. It was a very pleasant and green drive but it took a good ninety minutes to get there. After scoring the weed, on our way back, I saw a farmer in the distance working alone in a field. It was hot. So I stopped the bike and with Kidzi and a bottle of water walked over to this farmer. We asked him if he wanted to smoke ganja with us. He smiled. We sat down next to him and lit up a J, which Kiddo had rolled. We got high and talked. We even played some music on our phone. It was a wonderful experience and something I had always wanted to do with or without weed.

It was time for Pulse again. Karan Sir wasn't going but Gauravi and JK Sir were part of the college team this time. We stayed at a nice little place close to the AIIMS campus and it goes without saying that we smoked a lot of pot. It was a different thrill altogether, getting high in the capital. We watched a Taare zameen par, full movie

spoof on MTV every day called Bechare Zameen Par, and it was hilarious.

As for the events, more or less, the same trend continued. I won some speaking events and we did okay at football before losing 3–2 in the quarter finals but not before I had scored one of the best goals of my life. Gauravi had told me later that it was a world-class goal. Now close to 20, it was still compliments like this that meant the most to me. Like before, I spent a lot of time with Ritz. I introduced her to Gauravi, JK Sir and his girlfriend Kanika who was also on the trip. We hung out together a lot.

One night, when the girls were with us, we decided to sleep on the roof. It was cold. I hugged Ritz and fell asleep in her arms. Neither of us so much as moved. The next day we woke up in the exact same position that we had slept. JK Sir had placed an extra sheet over us because he saw us shivering sometime in the middle of the night. It was the most romantic night I ever spent with Ritz.

The constant use of marijuana made the two weeks seem a lot longer than it actually was. We thoroughly enjoyed our time in Delhi and I personally felt good about the time I spent with Ritz.

We were on the train to Belgaum when the 20-20 World Cup final between India and Pakistan was being played. We had obviously followed the tournament in Delhi. We were getting constant text updates of the score and it was going down to the wire. Last over—Joginder Sharma!? Dhoni is a brave man. At one point, the game seemed out

of reach and it looked like Misbah would take Pakistan home. Joginder Sharma then bowled the most important delivery of his life and even though it was shit, Misbah somehow managed to get himself out. Pakistan had been bowled out a few runs short. India were the world champions. The train literally stopped for a while in the middle of nowhere. Almost every compartment had people screaming and cheering with joy. And though it was a shame that we hadn't got to actually see the match live, the celebrations on the train and the end result in a way made up for it.

The Delhi haze slowly faded out as I tried to reengage myself into a more disciplined college routine.

I went home for a short trip. Things had changed since my last visit. I had changed. I started smoking at home usually behind a huge tree in my garden which became my sutta tree and in the veranda late in the nights when my parents would be asleep. I had also discovered a place in Jamshedpur where I could score weed. I smoked up a lot. I smoked up in the nights in my room by the window and used scented mosquito spray and incense sticks (agarbattis) to neutralize the smell of marijuana. Floyd often got me through the night. Whereas before smoking up would be a special event, it was now replaced by a constant need to be high. And when I couldn't smoke up for some reason I would be irritable and fidgety. I found it impossible to concentrate on anything else apart from grappling with my mind. How, when and where to smoke would be the only questions in my head.

My parents did not pick up anything wrong in my behaviour. They had no idea that things were getting a little topsy-turvy. Deep down, I had a gut feeling that I was getting on the biggest roller-coaster that life had to offer and I wasn't even wearing my seatbelt.

Back in college, the second year university prelim exams were coming up. I tried to get back to the cramming routine but I just couldn't do it. My concentration span was shot. I would never be at peace. The OCDs were bigger and badder now. This made it almost impossible to revise huge chapters and complex subjects. Every day I gave in to the urge to smoke up some days within twenty minutes of starting to cram and some days after a couple of hours. I needed help and I didn't even know it. Life dragged on. Weed became the only thing that gave me temporary peace and that is why I smoked so much. On the whole however the highs started becoming mundane. The trough that follows the high which was usually slept off earlier now spent more time in my conscious mind. It is a dull low phase with an unexplainable kind of tiredness that creeps into the soul. It started lasting hours. And during this time I would not be able to do anything productive, these lows started fucking up my mind.

I decided that I needed to change things. Living alone had not been working for me anymore. I couldn't study. I was talking to Ritz a lot and she felt the same so I decided to move back to the hostel; and move back with Ravnish Sir.

I was really banking on this hostel move to make things better. It didn't. I tried studying with Ravnish Sir like before but like at the flat I could not concentrate for considerable periods of time. Ravnish Sir, who had an idea what I was going through, tried his best to cheer me up, get me to study and try to make me stop smoking weed so much; unfortunately he failed on all accounts.

I tried everything. I tried to study with Sumeet. I tried to motivate myself. I tried to stop smoking up. I even started going to the temple on campus and praying. Things didn't work that way and neither did my methods. Every day started getting progressively worse than the one before. Not only could I not study but I also started losing interest in everything else that my life had to offer. The car, the girls, the music, the football—all things started to lose their shine. This was the beginning and one of the main factors that caused my life to spiral out of control. The seed for the vicious cycle that my life would soon become had been sown.

The car that was earlier used to get around and have fun now simply became a closed area where I could drink alone and listen to depressing music, sometimes talk to Ritz. I would find a desolate spot on the green campus, park my car there and drink. It would often be raining.

The prelims were less than a week away and saying that I was unprepared would be an understatement. I had a big fight with Ritz one night and woke up to a bunch of messages that made me miss her. I called her and told her that I was coming to Delhi. She tried to stop me but

couldn't. I was short on money. I had more than 2 lakh rupees in my account when I had joined college and Papa always sent money in excess and for long periods. I don't know how I had managed to blow my cash.

Sahiba and I had broken up but we were still friends and I asked her to lend me 5k. She agreed straight away. Mochuu and Chondu accompanied me to pick her up and take her to the ATM. I was smashed on beer. We went on a little drive and I made out with Sahiba in the car. I was in freefall and in this situation I had no conscience. I got the money but I also managed to rekindle hope in Sahiba's heart. She had no idea that I was going to Delhi to be with Ritz. I would return her money; and thankfully, a little while later her heart too recovered.

The trip was very last minute and I had not had time to make reservations on the train so I bought a rs.50 general ticket from Belgaum to Delhi. With no reserved seat, I spent most of the thirty-hour journey sitting by the door and taking in the landscape. It was long, consisting of two full nights and one whole day. I smoked cigarettes like a chain smoker. The habit of smoking in the toilet, staring at myself in the mirror, looking through eyes which were getting darker and darker was established.

Delhi was exceptionally cold when I reached in the morning. I was shivering. I met Ritz outside her college and we had breakfast at McDonald's. Ritz had made plans for the next two days. She argued that now that I had come we might as well travel and have fun. We took a bus to Dehradun and then made our way to Masoorie.

We had a good time. The warmth in Ritz's arms and the purity in her eyes made me feel better and more relaxed than I had been in months. We often just fell asleep in each other's arms. We went around Masoorie too. It is a lovely place.

It was time to leave soon. There had been some mix-up in the tickets Ritz had booked for me which basically meant we had to pay an extra 1000 bucks. We were on a low budget as it was. We were both out of cash. I had no choice but to board the train with a mere 29 rupees in my pocket and a pack of twenty Classic Mild cigarettes.

I told Anish later that circumstances may leave you lonely at times but there is a special friend who will never leave you and this friend was called Classic Milds. It was a long train journey and I had to go without food. There had been a certain excitement on my way to Ritz which was obviously absent on the way back and so the journey seemed to suck more! The joy of being with Ritz had partially eclipsed my worries and for a while at least made me feel better. Slowly the depression started to take its place again. I was helpless. I didn't know what to do. I was trying everything.

I sat through the prelim exams as a mere formality. Obviously, I did shit in them. Still, marks wise, these papers weren't important for me as I had already made good internals in the earlier exams.

Raghav and I, who were more or less in the same boat actually held hands and prayed to the weed God one

evening that our university exams be postponed. A couple of days later, quite miraculously, our prayers were answered. The exams which were scheduled to start in around three weeks would now be held another three weeks later thanks to some government elections that now had to beld in our college. We had been handed a lifeline.

We decided that our best bet would be to go home and study there. It would curtail the weed intake too. Ruby and Ramia walked up to me just before I was leaving for home and told me that I seemed very low and they wished I studied hard at home and return to my old bubbly, obnoxious self. Their concern was genuine and from the heart and it meant a lot to me that they cared enough to notice the change in my mood.

Papa had been instrumental in keeping me on track while I was in school. We weren't doing drugs then but when he noticed that I was ignoring my books he would help get me back. However I was older now and I had been doing well. He gave me freedom and since he hadn't been with me for the past few months he didn't have any idea how much shit I was in.

Mommy had a one-week conference in Jaipur and my father and Sachin were accompanying her. It was not important at all for my dad to go and so he asked me if I would be okay alone for a week. He said he would happily stay back if I needed help. He asked me this very casually. I didn't ponder and still believing that I could manage on my own I told him to go with Mommy. This was probably

one of the biggest mistakes I have ever made in my life. I should have made Dad stay. He could have helped me. He was a great teacher. He would have maintained discipline. I should have opened up to him and asked for help. I didn't.

Frustration hit new levels. Chapters I had read multiple times before and that should have been mopped up in twenty minutes or so were now taking hours. Jamshedpur was cold, not that it would have mattered had it been any other way but the big woollen jumpers and socks added to my general lack of comfort and with it brought new types of OCDs, ones I had not dealt with before; and every day they broke me down little by little. After a few days, drained emotionally, I had no option but to break my resolve and start smoking weed.

I hooked up with a girl called Sania, a cute little junior from school. This was the only high point of the trip but it didn't help me study. By the time my parents got back, I had taken the decision to head back to the college and study there with my friends, saying I couldn't study alone. Still having no idea that their son was unwell, Papa immediately booked tickets for me to get back to Belgaum. He never so much as questioned me or asked why. He had complete faith in me. This was now the last throw of the dice.

The place changed and again I tried everything I could to kick-start my preparation for the university. I tried to study in my room. I tried to study in the library but again nothing worked. The only constant was the increasing intake of substance. It didn't even feel good anymore and it would be hard to explain to people who haven't

experienced addiction why I continued to smoke so much. To break the monotony of weed, I sometimes resorted to drinking alcohol and especially beer. They say it is a sign of depression when you start drinking alone. I often drank alone. Ritz tried her best to help me but she couldn't.

A couple of weeks before the university papers, I took a decision that I was going to skip these exams and appear for them in the next semester. I had decided I would lie to my parents and if things worked out and I cleared the papers six months later then they would never know. I had thought this decision would at least rid me of some of the tension that was brewing up in my head and making life unbearable. I was wrong.

My friends were now studying like machines as it was crunch time. Raghav had managed to take help at home and he was back with a vengeance. I was alone and seeing my batchmates in that exam mode added to my melancholy. I started living at the flat. I spent a lot of time with Shukla Sir who was also like me fighting severe depression albeit for different reasons.

Waking up in the morning would be the worst time of the day. Every moment, every minute was painful. Getting through the day was a challenge. We didn't talk much. We didn't have much to talk about.

The exams came and went and I didn't sit for them. It was a million times tougher taking refuge at the flat while the papers were on than it would have been to actually appear. Life sucked!

#27

Lytic Cocktail

I got a call from Ritz that changed my life forever. She told me Sardar and Vineesh had been accused of rape and had been taken into police custody. This was national news and all the news channels were flashing their pictures and reporting the story in such a way that my friends had already been found guilty. They weren't.

I knew for a fact that this accusation was not true because Sardar had called me earlier and told me details of what had happened before they had been charged. Real guys don't kiss and tell but immature guys like we were back then share every little detail. They had made out and gotten a little physical but certainly not had sexual intercourse and none of this was forced. Nevertheless, this news sent shockwaves through the country and left us feeling helpless.

I woke up early next morning to a frantic call from my mom. She was shocked and went on about how disgraceful it was that my friends were 'rapists.' She started having a go at me too. I felt like smashing my phone. I mean she had known them from school. They were good

kids. Sardar had three elder sisters; and though on the surface he was a punk he truly respected women. Vineesh too, under the rough exterior, was a nice human being incapable of such a ghastly act. I tried to explain things to my mom but it is hard to talk someone out of a belief that modern media has brainwashed into their minds.

It was a tough time. Tushit called a lot and we spent hours just talking. We were both very close to Sardar and Vineesh and talking to someone who was feeling the same helped numb you for a while. It took a while to sink in. Low and sad for ages on the phone, Tushit sometimes broke the misery with crude jokes and we would force ourselves to laugh; even if it was a very dark kind.

What hurt most was that apart from parents even some of our so-called friends started to distance themselves from the pair. Certain school-teachers jumped in on the opportunity to give interviews, have their few moments of fame and make false claims and accusations of how morbid these guys were right from school.

Tushit wrote a very correct and largely unemotional article affirming his support for our friends and also to let the world know that he was standing by their side. This was posted on social media sites and in the school magazine which became the only way we could fight for our friends outside while they went through torture inside. He asked people not to pass judgements and form opinions based on media reports and that the least these boys deserved was a proper just trial. I also wrote a piece, it was a little more expressive and brash but most importantly, like Tushit, I

made it clear that I was going to stand by my friends. Anish was the other guy apart from Tushit who had been torn apart with this news. We had to stick together and we did.

Ritz knew I was going through hell but she couldn't let her life revolve around mine forever. She too had dreams and aspirations. She had to show her mom the world I remember her telling me. She had been trying to let go for a while now; I just hadn't realized it. She had stayed to help me give my exams but when that failed, she had to be brave and leave me. I didn't make this easy for her. I was very possessive about Ritz—pathologically possessive. She loved me and only me and that was all I had ever known. I would give her a hard time even if she said that she though Hritik Roshan was hot. Yes, that's how weird I was.

It had been tough the last time Ritz had left. She had left because she had found out that I was seeing other girls. This time was worse. She was leaving because she had found another guy. I remember clearly the first time she told me this. It felt like someone had struck a dagger soaked in vinegar through my heart.

Still harbouring thoughts of winning her back I remember once asking her a couple of days later if she held hands with this guy. After a brief pause, she had said, 'Yes, we hold hands.' I hung up the call and broke down alone inconsolably. It was perhaps the most painful moment in my life till then.

The guy she found was a good man; and Ritz deserved someone like him, someone who wasn't selfish, someone

who would be there for her, someone who would spoil her. She deserved all the good things in the world and more. However, I did not have this perspective then. My life was falling apart. I was in excruciating pain. A pain I probably deserved.

A few days later, Ritz uncharacteristically asked for help. She called me and said she urgently needed around 80k rupees and that she would return it in less than a week. I didn't have that kind of money in the bank but I had to do something. I may even have thought that this was an opportunity to win her back. I was desperate. I asked a few people if they could lend me some money; one senior of mine took me to see a guy called Javed bhai who it seemed could. However he wanted something as return or a safety and so he suggested I keep my car on the line. He said he had some work with it and then he would return it in the same condition when I repaid his money.

I thought seriously about the offer and told him I will let him know. As fate would have it, I ran into a Bihari batchmate of mine called Avi who had a lot of money in his multiple accounts. I asked him if he could lend me the cash. He didn't even think for two seconds before saying yes. I called Ritz. It was quite an anticlimax. I told her that I had the money. She told me she didn't need it anymore. A few days later, I overheard Javed bhai at a restaurant telling someone that some kid had almost fallen in the trap of giving him his vehicle to borrow money. He went on about how he would have ripped it apart, taken out all the parts and replaced them with cheap, low-quality products. I patted him on the

shoulder and said, 'Hi, I am that guy. Thank god I didn't give you my car.' The dick didn't even look ashamed or embarrassed; he just smiled.

I had behaved very instinctively. I had 80k cash put in socks in my cupboard. We didn't even lock our rooms anymore. I had done something like how a senior of mine from med school called Rahul Sir had once sold his bike for flight tickets to go and see his girlfriend in Delhi. This was a famous story. By the time I finished college, I would also leave the campus with many stories and some would become famous.

I made desperate attempts to win Ritz back while still dealing with the shock of Sardar and Vineesh, the slump in my academic performance and my addictions. Things were worse now than they had ever been. I had skipped my university exams. Every day I had to lie more and more to my parents giving them false marks and percentages. This started making me feel uncomfortable. Ritika had left. She had found another guy and my filthy mind kept projecting images of her that burnt me from inside. Even when I was with people, I would often be lost in the darkness of my mind. I spent a lot of time with 'me.' I became my own friend of misery.

Two of my best friends were in jail for a crime I knew they hadn't committed. There was no way to contact them to tell them that we were behind them. Again my mind projected images of how they were living in jail, of how they were being treated. I was real close to these guys. We had grown up together. Knowledge of their

pain and the shitty situation they were in hurt me. The most painful realization I suppose was that we could do nothing to help. There was no option but to let the law take its course and have a quiet faith in the justice system. Unfortunately the Indian legal procedure is slow to say the least and even in a best-case scenario, it would be quite a while before they could be free.

The above stated factors combined to make my life a lytic cocktail of vicious cycles and self-loathing depression.

One night I was particularly pissed while driving back to the hostel from the flat. We had been drinking Old Monk for hours and perhaps for the first and only time, Shukla Sir and I got into a bit of a verbal fight. I was piss drunk and it was late, around 3, the roads were empty; even so, I should not have been driving. This moment is etched in my memory and will be forever. I could have died and what is worse I could have killed. I was driving over a one hundred kph, and I was a little late into the right turn from Nescafe to Chanakya hostel when the car skidded and for a moment I lost control. It seemed to be heading into a collision with Nescafe as the car drifted left, the little shop where Shivya and her family lived. I could have killed them all. Luckily I regained control of the vehicle, broke hard and pulled it back onto the road.

One senior who had seen this from the Charaka hostel roof told me the next day that I was lucky to be alive. It was stupid. Drinking and driving is always dangerous and should be avoided.

Ritz called once in a while to check up on me. She told me she was missing me. Yeah, fuckin right! I tried to emotionally blackmail her back into my life. Well, I didn't try. It is just how I was back then. I was truly fucked! When I told her more about my depression and suicidal thought patterns she freaked and called my mom and told her everything. She told her about the exams I had bunked, about the excessive 'drugs' I was doing and more. I guess she figured that if she couldn't be there for me through this time, it was better my parents knew so they could help me. Ritz, Ritz, Ritz—I have never doubted your intentions but you shouldn't have made that call because it changed everything forever for me. She cut her losses and left. I was actually getting a little better when she did what she did.

After speaking to my mom for hours, it was decided that I come back home for a while. A part of me felt a little lighter because I didn't have to lie anymore and I thought maybe my parents could help me now since they knew everything. They were not angry. They were just worried and they just wanted me to get better. I had tried everything and nothing had worked. Even on that journey before going to Jamshedpur, I decided to go to Delhi first to meet Ritz. I called her up in the morning and told her I was waiting outside her hostel. She was shocked and asked me to go back to the railway station where she would come and meet me. I was bemused. Why wouldn't she just come out?!

She came to the station restaurant and I hugged her but I could feel she was stiff. She didn't hug back. A few

minutes later, the new guy in her life joined us. I had no words. Ritz hadn't told me till the very last second that he would also be coming. I think she was scared to face me alone. It was funny that he was wearing a red T-shirt and blue jeans—exactly the same colours I was wearing—and had in his hand the same phone that I had. He claimed his phone screen was more damaged than mine referring to a glass crack. Then I showed him my screen which was shattered in all directions after I had smashed my phone against a wall talking to Ritz. 'My girl, my girl, don't lie to me, tell me where did you sleep last night!?' RIP the fucked-up beautiful spirit of Kurt Cobain.

I couldn't stand the thought of getting on a train again to reach Jamshedpur so I called Keshav Sir who was in Delhi and he helped me get a flight ticket to Calcutta. I will be eternally indebted to Keshav Sir for this. He called me home, poured out some expensive scotch, heard me out about Ritz and treated me like his little brother. He paid for the tickets and asked me to look after myself.

Anish was waiting for me in Calcutta because he too was heading home on the same train as me. It was the first time we had met after the Sardar-Vineesh news and we hugged long and hard. We didn't say much. The most effective way to deal with pain though is laughter and alcohol and we indulged in both. We got wasted on beer in the two-hour window period before our train. As always, we found a quiet little corner at our favourite pub, Oly's. We had very little money. We drank cheap beer and smoked cheap cigarettes. It was a shit-shit time!

#28

Rock Bottom

After a few weeks of sobriety when I actually believed that abstinence would help, Anish and I settled into our more usual routine. It had been a weird couple of weeks mainly because I just wasn't used to spending time with Anish while we weren't drinking.

We pretty much fixed the evening time when Anish would come and with Sachin and Rao, we would play cricket in my garden. Rao was our driver and also the go-to man at our house. My parents encouraged all types of activities they thought may help create positive energy. We were serious about our evening game and though it wasn't the way I had planned it I got to spend time with my baby brother. After the game, Anish and I would drive down to the lake and light up a cigarette.

During the day while we still entertained the hideous thought of being sober we once got ourselves a cupla' root beers. It tasted like piss and didn't give the buzz. It was the crappiest decision of our lives to even think about root beer and driving around drinking that shit I felt really

low. Thank heavens, a couple of days later better sense prevailed and we started purchasing 'real' beers.

The fact was that for the first time in our lives we were not drinking to have fun but because we actually needed something to allure the pain. Anish's life, though not as badly fucked as mine, was still crap. He had managed to fail his B-Com exam. He had checked the results at my house and I just couldn't stop laughing. It was the best five minutes I had had since months. I kept asking him, 'How the fuck does someone fail B-Com!?' He laughed along sheepishly. Once the premiere athlete in our school, he had gotten excessively fat and looked even fatter in his cricket attire, which included a Shane Warne–type white cricket hat, a tight yellow T-shirt and white shorts.

It was a text-book beer belly he now had and to add to that he went skinhead. He looked like one of those British football vandals who lived on chicken curry and beer. With the goal to join the Indian Army, he was physically a long, long way off; and of course he had the special honour of having to give his B-Com exams again in six months.

One evening we were smoking at a cigarette shop next to the golf course when one sweet little kid ran up to us and asked 'Bhaiya time kya ho raha hai?' Anish turned to him and without changing his expression bluntly said, 'Kalyug! Chal rah.' The poor kid looked stunned and walked away. I looked at Anish and we broke out in laughter.

Jokes apart, there was no doubt that the mutual support we gave each other concerning the situation Sardar and Vineesh were in was the only thing that held us together in that period. I can't imagine having to go through it without Anish and I am certain the vice versa is also true.

The day started early around 9 am. We would literally watch the shutters open at the local liquor shop called Cocktails. We would drive around till 1 pm, usually drinking beer, listening to music, stopping for the occasional cigarette and talking about life and how unbelievably shit it had become.

While most conversations had an air of darkness when talking about Sardar and Vineesh, once in a while to break the melancholy, Anish and I would crack the silliest of jokes, taking the piss out of our friends in jail and laughing till our mouths hurt. We were sipping beer and driving around when I turned to Anish and said, 'Dude, my 2000 rupees is fucked!' He asked me what I was on about. I told him I had lent both Sardar and Vineesh 1000 bucks each when they had come down for the Goa trip; now since they were 'in' for the long haul, it was hard to see that money coming back. Angad looked at me and we burst out laughing. We then went on to discuss whether it would be appropriate to ask for that money back when they got out.

I also spoke to Anish a lot about Ritz. He followed the 10,000 rule which he had picked up from some TV show. According to him, it took 10,000 drinks to get over a girl you loved and he assured me that he would take

them with me. The evenings, as I mentioned were about cricket, cigarettes and chicken rolls; and sometimes a casual beer thrown in with a drive.

Once in a while Anish would force me to play an over each in the garden in the midday heat. We were such clowns that we took stuff like this seriously. I bowled a ball which Anish drove perfectly through covers for a boundary. I walked up to him and gave him some trash talk. I told him to go fuck himself! He threw slangs back at me and like Aamir Sohail he pointed the bat to the boundary. The next ball I produced a vicious bouncer which narrowly missed his head as he danced down the wicket. Just thinking of stuff like that now brings a smile to my face.

Jamshedpur is a small place; there were limited roads on which you could drive around drinking. One of these roads was of course the Marine Drive. We spent a lot of time there. There was a particular spot where if you looked over the wall you could see a lion in the nearby zoo. It was a decent view and we would check in with 'Sher Khan' almost every day when we got a little tipsy.

My parents had no clue that we were drinking every day (whatever the reason). Despite now knowing the truth, I still don't think they could even imagine where I was in my head and how I had been living my life. I was a good actor and I never blew cover in front of them. They thought I was getting better. In a way I was, though it was not the path they had wanted me to take.

Gadi, Guda and Neel had come down to Jamshedpur for a couple of days; and we had gone to Hudko Lake with Anish and booze. Like was tradition after getting a little tipsy, Anish and I jumped into the rather dirty water. I thought about Acanthamoeba. After a while, Angad dangled his shorts which he had taken off in the water over his head and laughed. I decided to do the same. The water was very dirty. After a while, it occurred to me that my dad's car keys were in my shorts. I checked the pockets. I had lost the keys. Things got worse. A while later when I was searching for the keys in the water I managed to let go of my shorts and lost them too.

My friends are idiots and once they knew I was naked and didn't have any pants they started laughing. After twenty minutes or so I started contemplating the idea of getting out of the water, which was now cold and going home naked or maybe borrowing someone's underwear. Miraculously, Anish happened to step on my shorts a little while later and saved the day. I still got roasted at home for losing the car keys but at least I had pants on.

There was a senior of mine from school called Rahul Singh. I was very close to him and liked him as much as was possible heterosexually. He was in town for a few days and we shared our love for substance. I picked him up from a tea-sutta shop behind our school one evening. I had rolled a couple of joints and as he sat in the car, we lit one up. We drove around Marine Drive. We finished the first joint and then decided to smoke the second one on the sand/gravel beach next to the river. As we smoked the herb, we got high.

The environment was different and refreshing. The sun had just set and there was a breeze. I was looking at a road on the other side of the river, staring at the headlights of some car meandering down. It was then when I saw a very clear image of the Hindu faith sign Aum form briefly in front of the car light. I was mystified. I asked Rahul what he could see and he said I can see life. I never asked him exactly what he saw. Perhaps it is for the best.

Rahul had a lot of insight about a bunch of things and this made conversation with him enjoyable. We talked in detail about marijuana. We shared a common love for ganja but like me, 'quality hash' was his number one love. He explained how on some hash trips he could feel like he is dissolving into the atmosphere. How you could feel the wind blowing right through you like you weren't even there. And the magic that could be felt in such moments. Many people smoke up and most have a reason to do what they do. As for Rahul and me, the priority of marijuana trips was connecting with and 'feeling' nature in a way that was otherwise unimaginable.

One day there was a pooja at my house in the morning. Anish had been invited. There came a point when the pandit asked me to repeat after him. He spoke out shlokas and prayers at a brisk pace while I did my best to say them right after him. A few minutes later, the pandit stopped for a bit and then said 'Haath aage badhao [Move your hands forward].' I was so dazed and zoned out that I repeated after him, 'Haath aage badhao.' Anish looked toward me and by the time I realized my mistake it was

very hard for us to control our laughter. The pandit too was a little flabbergasted.

This was the longest time I had spent at home since leaving for college. The beers in the morning, the smoke in the evening—there were certain things that made it bearable but the main credit goes to Anish. I spent enough time, drank enough beer, laughed at enough jokes with him to somehow find myself again. It wasn't sudden but my self-confidence too returned little by little. I was ready to head back to college. I guess after hitting rock bottom, the only way now was up.

#29

And I Love Her'

I had gotten used to an almost embalming type of depression that came with Belgaum before I had left for home. When I returned, this feeling came again; but it was milder, more manageable and I was definitely better. Still, it took a few weeks for me to get going. When I did, I ran faster than anyone the campus had ever seen.

I really needed to get back into the studying groove. I had flipped through a few chapters at home but the syllabus was huge. My parents had not pushed either. There only concern was that I get better. Skipping a semester was one thing and a one off but it meant that it was essential I clear this time; otherwise, I wouldn't be able to graduate with my batch. Again I couldn't study much for a couple of weeks.

Just when I was starting to get a little frustrated I don't know from where and how I suddenly stumbled upon a source of limitless energy in my soul. It felt so good. I had been dealing with this feeling of constant lethargy and darkness for so long that finally when I got some respite it was unbelievably soothing. Getting up in the morning

didn't suck as much anymore. I started studying and then I started studying a lot. The OCDs got better. A sense of purpose and focus returned to my life and I was pumped.

Just two weeks prior, I had been in the habit of sleeping around twelve hours every night. I hated to get up. I would continue to lie in bed for hours even if I was up until my body hurt. Now I was sleeping only around three hours every night. I found time to do so many things. Cramming would be the priority. Red Bulls, weed and cigarettes kept me going; and soon I started hitting speeds that allowed me to fly; what I didn't know was that there was no landing gear on this flight of mood.

Throughout first year and the early parts of second year we played football more or less every day in the evenings. Post-game juice also every day. My favourite was orange juice. It would taste holy after an exhausting game of footy. We played when a tournament was coming up and we played even when there wasn't. We were lucky that being so close to Goa we got to take part in quite a few football events.

Karan Sir like me was very passionate about the game and neither of us missed footy in the evenings. Apart from us, others too had a keen interest, people like Jaat Sir, Nasir Sir, even Gauravi.

Sports and physical exercise produce endorphins in the bloodstream and they give you a kick. I had lived on this kick all my life without even knowing it. When we didn't play footy, we played a lot of table tennis. We almost

always played TT when we were high and for hours on end. The tight finger-biting close singles games against Shukla Sir or the doubles rivalry when Shukla Sir and I would team up against Gauravi and Karan Sir were very enjoyable. Other days it would be cricket, the legendary and very big seniors of ours like Manu Sir and Mukhyaji would join us and a bunch of people. The cricket games were intense and accompanied by a lot of sledging. People took it very seriously. I often drove to the field a few minutes earlier and shared a joint with Gauravi before the game began.

This was the best thing in the early phase of the TGIS concept. Yes, we smoked up and yes, slowly we started smoking up every day; but apart from that we did a load of other things that kept us going. Even after getting stoned, sometimes we would take a tennis ball and very sincerely play catch-catch or donkey in the living room. I mean people would be diving around, putting their bodies on the line, taking catches and getting competitive while they were stoned; and it was around 3 am. We even made a small tennis court of sorts with chairs and with TT rackets and a ping-pong ball we would play tennis. We would play five setters. We would play for hours. We would be stoned.

The major screw-up that happened before was that with the excess weed we slowly had started to lose interest in other activities. We stopped doing the stupid things that used to keep us happy. Activities that had kept us afloat. Before, when we were high, we were full of ideas and energy; later, we didn't do anything after smoking up. We

just sat there. This static existence eventually had led to loss of drive and an amotivational syndrome.

I managed to revert this back to how it used to be. Apart from cramming I got involved in a bunch of other things.

One night I conceived the idea of taking out a short monthly college magazine and this kept me busy when I was not studying. We started playing sports again. I have to give credit to Karan Sir because he literally forced me to play footy even sometimes when I didn't feel like. Apart from the usual evening game on college grounds, he found a decent local team that we trained with early mornings, around five. Life was regaining some of its colour and spark.

Some college fest was going on. I made my way to the lecture hall for mock press. This was the first time I saw her. She had just joined college. She was two years junior to me. A small little girl, she walked up on stage and announced that she was Deepika Padukone and would speak about her new film. I don't have words to describe her performance. I can tell you though that as she finished speaking, the jam-packed audience in the hall let out a collective 'Oh my god, how can someone be so cute? Is she an angel?' sigh. It was palpable.

I had been spellbound through her performance. It felt like an altered sense of consciousness. I turned to Harry sitting behind me and said, 'Bhai, I need her number.' It was time for us the press to question Deepika Padukone. A couple of people asked her questions and she gave very

nimble and intelligent responses. I raised my hand. I told her, 'Hi Deepika, we all know you are exceptionally cute—(there were some mutters and muted laughter in the hall; they knew me and they thought I was playing her, I wasn't)—but your role in the movie hardly affects the script and you are basically just eye candy. As an actor, don't you want to do more challenging and candid roles?' This was the only question she stumbled on a little but she did all right. Midway between this, our eyes had met. I felt like a little kid and it felt like she was my first-ever crush. I had goose bumps. I was in love. I had never felt like this before.

I knew we would be perfect for each other and I hadn't even met her or talked to her. (Well, I had but she was Deepika Padukone then.) I didn't just think it. I somehow knew it. I could tell that there was something very real, true and beautiful between us.

A few characters later it was time for me to go on. I got to play Rahul Gandhi on being prime minister. It wasn't one of my better performances. When I started after a little while the audience had stopped paying attention and some were talking. I slammed my hand hard on the table evidently annoyed; the sound echoed through the mike and the stunned crowd looked at me. I screamed, 'No one is listening to the prime minister!' They broke out in laughter and paid attention for the next three minutes or so. I didn't know this then but this line stuck with her and she too at first sight had developed a little crush on me. Before the event was over Harry gave me her number. I love you, Harry.

I had sunk my teeth in the college magazine project. I found a bunch of people and formed a team. There was no doubt that this was my baby. I was the editor in chief but I needed help. I chose Praki because I had read one of her articles in the annual college mag and liked it. Plus she was cute, not the type of cute that I wanted to date but someone with an endearing smile who exuded positive energy. She was one year junior to me and I also asked her friend Gauree to join.

Many a time I would be standing with Gauravi while Praki and Gauree would be walking past. I would scream 'Gaureeeeevi,' making it sound like 'Gauree.' And as she turned to me, I would turn to Gauravi and have a big smirk on my face. Yes, this was lame but I thoroughly enjoyed it. I played with them like they were kids. They were my kids. It felt liberating to actually for perhaps the first time develop a platonic relationship with cute girls.

The cramming continued, sports became routine, I was smoking up every day but in intervals, I started spending more and more time with my mag which I had renamed from Hep-X to simply the Doors. Not only me but the people I had taken aboard were also working hard on it. It really was my baby.

I messaged her later that night. I wasn't even sure of her name. My Deepika Padukone—oh, she wasn't Deepika. 'Hey, my name is Samar Kumar. You may remember me as the idiot who played Rahul Gandhi at mock press.' She replied and after a while she called. Her name was Zoya. I had never been as nervous and excited as I was when I

took her call. I could tell that she was not dumb. I used to feed on this quality that most girls I dated possessed but she was not just some pretty face to me. She was the one. I did not want to play her. I was in no rush. She had a younger sister in her batch called Shaila.

For months I had thought Shaila was the older of the two. She certainly looked older and more violent. They looked pretty similar. Shaila was her evil little almost 'twin.'

I ran into Zoya the next day at the college coffee shop. We talked and flirted. She had exactly the same eyes as mine: hazel. She had a magical face. It was hard not to stare. We talked and we bonded straight away. We unearthed a bunch of similarities. Like me, she had stayed in the UK in the exact same time frame while I was there. Like me, she was originally from Bihar and had roots in Ranchi. We had almost returned to Delhi after England where my father would have joined Apollo Hospital. Her dad with the same degrees as mine worked at Apollo, Delhi.

We were both huge Eminem fans. When I jumped up in excitement as she said Eminem and told her that I too was a crazy fan, she thought I was playing her. I could read her look so I said, 'Okay, quiz me. Ask me anything about Eminem.' She asked, 'What's his real name?' I replied, 'Marshall Matthers.' Then she asked me about his old and not-so-famous tracks. I got nothing wrong. It's not like she was impressed but at least she knew now I wasn't lying. Not only Eminem, we also bonded on Metallica and other classic rock bands and

on Pink Floyd. I had never ever met a girl who was so fuckin cool and on top of that she looked like an angel. Cherubic.

We walked around campus and I told her stuff about Belgaum. She wasn't too excited about the place and though it was minute, she had obviously been rubbed off with a little bit of a Delhi DPS girl snobby attitude. To be fair to her, college life largely depends on the kind of crowd of your particular batch and hers sucked. However, Belgaum really was beautiful and I wanted to show her. Carefully, I led the walk to the spot where my car was parked and casually asked her to go on a drive with me so I could prove to her that she was wrong about the place. She casually declined.

She would at later times when we got close shamelessly take the piss out of my car pickup-drop chick routine of yesteryear. She was witty and smart. She did actually at times make me feel stupid. These were traits I loved about her. An overly confident individual especially when it came to women, she often put me in my place.

We walked around some more. We were near the co-op shop when out of nowhere the class of a batch of MBBS students one year junior to me had finished and more than fifty girls walked past us. I could see them staring. They knew Zoya was new and they also knew that I was a badass. I swear that by this time I had made my peace with God and told him I wasn't going to be a punk anymore. I just wanted Zoya. I really was ready to commit to her, to spend 'time' with her, even go to dinner

with her and do all the stupid things couples do which earlier I found ridiculous.

We had been seen together and this news spread like wildfire. I had an idea what was going to happen and I felt sad and helpless. After a while, when she was leaving, I asked her, 'So I'll see you?' She said, 'Yeah, sure ... I'll see you,' and then she smiled. My heart skipped a beat. My alter ego inside me said quietly, 'No, Zoya, you probably won't.' Then I asked her, 'Hey, listen, I am bad with faces. How will I tell if it's you or Shaila?' She smiled very confidently and said, 'You'll know when it's me.' I would have married her right there if I could. I was in love. It was like we were kids—chaddi buddies. There were no perversions in my head at all and this connection felt very pure and right.

I went to the flat and smoked up with the guys but I was alone in my head. I was with Zoya. For the first time in my life, I tripped on Zoya. After the honeymoon period of the trip, I lay alone, closed my eyes and waited for the inevitable.

Text message ... Zoya ... 'boy what have you done in just 2 years?' ... The police episode was the obvious first topic she brought up and laughed. She told me she had been ambushed by a bunch of some thirty girls in her room—girls she didn't even know, a lot of them from dental! These seniors had come with the intention to protect Zoya from big bad evil Samar, like they were her fuckin sister. And in the process, they had told her tales about how big an asshole I was. I'm sure these were exaggerated.

Zoya told me that they just didn't stop, eventually she had to politely ask them to leave; and when they still didn't, she had to tell them, 'Okay, fuck off. Thanks for the concern but I am a big girl. I can look after myself.' She even got a few letters warning her not to get with me. It was astonishing to me that girls had gone to that extent; they didn't even know her. True story.

I mean I would understand the odd warning from a friend or acquaintance. It was true that I had been a prick but this was too much. These girls had affectively passed a fatwa against me. You know, sometimes you fall for a girl and you can tell she likes you too but she has this friend—this really close ugly fat friend—who goes out of her way to keep her away from you. The whole dental fraternity became that ugly friend in this case. I have said it before and I will say it again I had promised God I was serious about this one. He wouldn't listen. He wanted me to prove my love like Prospero had asked of Ferdinand for his daughter Miranda in Shakespeare's Tempest

I had already pondered when I was walking with her whether I should tell her of my past and flip her before she got shot down but I figured it was too early. I had thought I would wait a couple of days. I had a premonition that something like this could happen but I didn't expect it on such a scale and so quick. Also, I can promise you that if she didn't look like 'God's gift,' like an angel, the repercussions of us being seen wouldn't have been that bad. What pissed me off even more is a major chunk of these girls who had tried to brainwash her were from dental. I didn't just hate them for no reason.

Zoya claimed that she had been unaffected by all this but that was obviously not true because we didn't hang out properly for years after that. We didn't even talk on the phone for years after that. Sometimes I would run into her on campus and she would smile and say hi. I would message her. Message her like ten times and she would reply once. Whenever she was with Shaila, I would almost get frightened by the looks and vibes I got from her little sister. I thought she hated me. She didn't. She was just protective of her sister and this I could understand.

A lot of football was going on and I was killing it. There were quite a few 5-a side matches being held in our college and I was scoring all kinds of absurd goals. The competition level was low and I was enjoying it. It was like Ronaldhinio on Coke, showing off, playing with the amateurs on a smaller pitch to suit his crappy stamina. I wasn't truly happy. I really wanted Zoya to see me play. I wanted to show her that I was fuckin amazing. She had already agreed to come watch me when we were on that walk but had changed her mind—unaffected by the fatwa, she said. It was obvious that was untrue. I scored a hat trick against dental. Gauravi played a song on the jukebox next to the field and announced that this song and performance was dedicated to Zoya. It was very sweet of him but she wasn't there.

I was working overtime on the magazine. The basic framework and most of the articles had been sorted. It was time to take it to the authorities and ask for help, guidance and affirmation. A very well-qualified surgeon, Mr. Ramesh Shinde, was the head of student affairs and

came across as someone who was easily approachable and friendly, so we went to him. I took my idea and my co-editors Praki and Gauree to meet him. He seemed very supportive and said he liked the idea. He told us to keep him in the loop and keep working on the magazine and also give him updates. It was apparent from the meeting that he supported the project. He also spent a lot of time asking me how come he hadn't seen these girls before and who they were. He joked around.

The magazine contained a brief editorial, articles about the importance of voting, a movie review on Gulaal, a list of quotes and songs, an unbelievably touching and well-written poem by my friend Sid on the concept of organ donation, an article about swine flu which was big then by another girl from Praki's batch called Heena and some more. I spent time fine-tuning.

As instructed, we had been meeting Dr. Ramesh Shinde on a regular basis and he had continued to be supportive. However, slowly he started changing his position. First he started raising senseless doubts and concerns about the magazine. The funding was not even an issue. I was ready to pay from my pocket. The magazine was there for everyone to see. It contained nothing controversial or obscene. I had with a few others worked very hard on it, spent a lot of precious time and worst of all he had given us an impression that he was with us. It would be tough to release a magazine in the college if the authorities were against it. I thought this was just about as low as he could get; then he went further.

He called a council meeting in the lecture hall. The council consisted of students from our batch who had been assigned posts like sports secretary, cultural secretary and so on. Harry was the president and Tanu was the co-president. Quite a few of my friends were on the council like Sumeet, Hanu and Gauravi. I had been at home because of my fuck-ups at the time the council was elected. I wanted to be the literary or magazine secretary. No one would have objected but in my absence these posts went to someone else. The council was in their formals and aprons after class. I walked in wearing my trademark black Aum tee, three-fourths pants and chhappals. After a little discussion Shinde asked me to change and come so I did.

When I returned, Shinde proposed a solution that made me lose it. He suggested that the official magazine secretary (an idiot called Manay who had probably never even written a single article in his life and had only got the post because some seniors supported him as he often used to let them borrow his laptop) also had a similar idea to release a monthly and that I work under him. It was at this point that I got up and verbally tore Manay apart in front of everyone there. He was fuckin lying. A lot of people knew I had been working on this and he had stolen the idea. He claimed to have had it before me and this was untrue. Shinde supported him. I was too hurt to be angry and I lost all kind of respect for that asshole. I stormed out of the meeting alone! It was my fuckin baby and these losers were trying to steal it and I could not let that happen.

I had to act fast. My dad knew that I had been working on the magazine and when I told him that Shinde had turned against us he realized I was hurting and gave me the green signal to use my money to publish. I did.

There was an event in the auditorium one evening and pretty much the whole college was present. It would be a good place to release and distribute. Shinde was there so I went and told him what I was planning to do. He didn't even allow that.

I lost hope and felt so wounded that I almost gave up. If it wasn't for Hanu I would have.

I got the magazines distributed in some of the classes with the help of my friends. I had given up on distributing. I was just happy it was published. Thousands of my magazines were stocked up in the council room and I didn't feel like doing anything. Hanu talked some sense into me and said that now that I had put in so much it would be stupid if I gave up. Still, many students didn't get a copy simply because I couldn't be bothered anymore. Ramesh Shinde had screwed me over. In school we had picked up 'eggs' against Meenakshi Roy; this time, I left it to karma. After all, who are we to judge and punish the actions of others?

There was some respite later when I got a bunch of messages from several close and distant friends saying that they liked the magazine. Even Zoya messaged, claiming to have enjoyed the read. This alone made everything worthwhile.

#30

Mad as a Hatter

The university exams were coming up quick. I was done with the magazine, the football and other college events for now. I started putting in more hours cramming. I would more or less be in the library from 9 am to 3 am taking breaks only for the occasional joint and cigarette. I drank more Red Bulls than the whole college put together. My dealer had started selling some class hash. Life was good. It was great.

'I was running fast but slowly going mad.'

The tragic news of Michael Jackson's passing reached Belgaum. MJ was one of the most well-known figures in the world. As a kid growing up, I heard many of his songs but with absolutely no doubt was mesmerised by his dancing. There was no one like him and there probably never ever will be. He was a kid. You could see this in him. He was just a kid and he definitely made the world a happier place.

I had been outraged at Bashir's controversial and largely false portrayal of MJ in that documentary they made about him.

The news wasn't sinking in and it did so in bits. I still spent most of my time with course books but in breaks or with my good night joint I would look up old MJ videos. I almost started missing MJ. I started getting affected and as days passed I started getting emotional. I don't think the world was prepared for his death. I certainly wasn't.

One evening, I don't know what got into me. I was sipping coffee at the coffee shop. I had a marker pen in my bag. I wrote on the wall, 'R.I.P MJ- king of pop forever.' Sometimes as a kid writing used to help vent out frustration but this was the first time I was writing on public walls. My wall in my hostel room was covered with graffiti. A couple of days later, at the library in the evening, I was tired studying and was getting bored. So I again walked up and with my black marker pen wrote on the wall, 'Michael, we will continue to listen to your tracks on our iPods forever and ever.' There were hundreds of people in the library and a lot of them saw me. The fact that I didn't consider anything untoward in my act showed the lack of insight I had regarding my condition. I didn't consider this a big thing; the college didn't think the same and soon my behaviour in the library became news.

One of the main reasons I used to prefer to study in my room earlier was because when at the lib you had to walk to the cigarette shop, two flights of stairs and a few hundred yards for a smoke. I smoked a lot when I studied. One every hour or so. Therefore, at the library these long cig breaks broke momentum and continuity. Thankfully,

this changed because while not officially, the authorities implied that it was okay to smoke on the roof of the library. This made life a lot easier.

There was a very irritating junior of mine called Janman. He was too cocky and arrogant. He was disrespectful and medically stupid. I had a problem with him. I was not the kind of guy who got irked easily. He had cleared first year and he had gotten a car. I had been in the same position. I allowed and understood the cockiness that might enter one's personality. However, he pushed it too far. One afternoon I was driving to lunch on the main road just outside our college when I heard someone honking nonstop from behind me. I looked back in my rearview mirror. It was him. I steered left and let him pass. As he overtook me, he showed me the finger and shouted out some abuses.

We were in a Gulaal phase then. The movie and the soundtrack brought out the Rajput in me. Something had to be done. I could not let Janman get away with this. While I hadn't planned anything, I was with Gauravi on his Dio riding to football when I saw Janman walking toward us. Gauravi stopped the bike and told me, 'Aa gaya tera dost . . . jo karna hai kar le.' I wasn't 'Dilip' but Gauravi most certainly was 'Ransa'. I walked up to him and first tried to verbally get him on track. He blatantly denied the car incident in front of Gauravi. Gauravi told him that though he has no problem with him, he would not tolerate any abuse by him directed at me. He didn't back down and slowly the volume and tone of his voice changed. I pulled him closer with my hands on his collar

and struck him as hard as I could. He was very white. His left cheek was now bright red. He started shouting and we grappled. Gauravi walked up to us, simply picked him up like an inanimate object and threw him on the floor. He was quiet now. I sat on the dio with Gauravi and drove away. I had never hit anyone before and though it didn't feel great, it had to be done.

Janman went and informed the hostel security head, an idiot called Koli and the matter was taken to that bigger idiot Shinde. He heard out both our versions of what had happened and then passed the judgment that we would no longer be allowed to keep our cars on campus. He called my parents and informed them about his decision. A week or so later, my car was taken to Jamshedpur. This was no doubt a big loss.

Just before the driver who took the car to Jamshedpur was leaving, I asked him to let me have five minutes alone with my baby. It was around 5 am. The roads were empty and Belgaum was beautiful. I drove around all the hot spots and around campus alone and said a silent good-bye and thank you. I would drive it again but never in Belgaum.

Not that it mattered but Janman never actually returned his car. He lay low for a while and then resurfaced on campus driving around in his repulsive-looking orange-coloured piece of shit. Shinde had obviously sided with him and behind closed doors I presume this was the compromise that was made, he got to keep his car. I could have been a bitch and informed higher authorities but I

decided to be the bigger man and ignored it. It did suck though, that now I had to walk again. The glam quotient of my college life more or less left with my car.

More important things were coming up. My university exams. I was well prepared and had momentum. The theory papers started and went smoothly. I wrote a real good Pharmac paper. Things were going so smoothly that before the forensic medicine paper which was the last one I smoked up less than twenty minutes before the start.

It was around 1:30 pm. The paper was from 2 pm. Forensic was a small subject and I was very confident. So I called my trusted junior Kiddo and asked him to pick me up and take me to the flat. I quickly rolled a J and let it burn. Then after the customary post-J sutta, at around 1:55 pm, I headed to the exam hall. I bought ten Center Shock chewing gums on the way to keep me up; for the glucose rush when the weed would start bringing me down. It was one of the best papers I had given. This was proved by the fact that I scored my highest marks in those exams in forensic.

Midway through the forensic paper a cute batchmate sitting to my right had turned to me desperately and asked for help. I knew the answer but I was high. I told her right there in the middle of the exam hall that I would tell her but only if she promised to go out on a date with me later. She looked stunned. There is a face you get to see in med school; it is the face that depicts a 'fear of failing'. She had that face on. She didn't just look

scared. She looked petrified and was sweating profusely. I didn't back down. I made her promise to at least have coffee with me before I passed on some answers. I found this incident hilarious.

A few hours prior to the microbiology practical exams, I managed to break my only pair of spectacles. My eyes, people say are beautiful but my vision is fucked. There would be a lot of microscope work and even otherwise I needed to see. I had no choice but to wear my brown faded power-corrected shades in the microscope part of the exam (to see if it was fuckin gram positive). I called out to Sid who was on a table next to me to show him I was wearing shades; his expression said it all. He forced a smile but he was scared and shocked. He probably didn't want anything to do with me. Quite obviously, everyone there was shaken at my decision to wear sunglasses smack bang in the middle of practicals. University exams are a big deal. People don't generally fuck around. In my defense; I was not doing this for a laugh. I really had no other choice. One of the micro PG students ran up to me and asked me why the hell I was wearing sunglasses. I explained my condition. She seemed to understand and walked back.

I don't like to admit it because this was one of the best phases of my life; but slowly the excess substance, lack of sleep and the rebound effect of the perennial depression of before started to take its toll on my mind. When you are depressed, not many people actually notice and very few try to help. You suffer alone. Mania was the opposite.

I was constantly happy and pumped but the world around me had a problem.

I cleared the exams with a very respectable 60+ percent score. My parents were happy but they asked me to come home for a while. I did not know it then but they had received several calls and even official letters from the college that though I was studying fine I was also in the process losing my mind. The college had actually sent pictures of my public wall graffiti home. I found this an overreaction. It was not like it was politically driven. It was just fun stuff and mostly about Michael Jackson. My mom did not know how to react.

#31

The Dark Side of the Moon

My parents were waiting for me at the Calcutta airport. They took me to a hotel, talked to me and shared their concern. I tried to convince them that I was fine but to no avail.

Later in the evening, I was taken to see a shrink. I did not know till I reached his clinic that I was going to be consulting a psychiatrist. I laughed out at my parents and told them I was not a lunatic. Walking in to see Dr. Ashwin, I felt fully confident that he would agree with me.

We talked for just a few minutes. First, he asked me to describe the last few months and then he asked me leading questions like whether I had started going on shopping sprees and if I was sleeping less than four hours a day. He stated several behaviour patterns that had crept into my personality before I even told him about them. Naturally, I started respecting him and eventually his diagnosis.

He told me that I had picked up a psychiatric condition called bipolar affective disorder (B.A.D) which included

pathological mood swings from severe depression to hypo and then full mania. Though he was right, he didn't have much time for me. I don't blame him there were many patients waiting. I was prescribed mood stabilizers. Lithium. Instinctively, I thought of Kurt Cobain and a part of me felt at peace. My parents had tears in their eyes as I took the meds for the first time.

My third-year classes were going on in college and I was worried about attendance issues but my parents again thought it was prudent I get better first and so they took me home and asked me to stay for a few weeks. Maybe I was too high but not a single part of me felt glum about this diagnosis. Psychiatric conditions are a taboo in India but I didn't feel ashamed. In fact, the more I looked up and read about bipolarity, the cooler the condition seemed. It wasn't easy and terming it cool may be a tad naive but it was interesting. My parents were worried and sad and this was the only thing that I felt bad about.

Lithium, like its look-alike paracetamol is a medical wonder drug and very effective. Within a couple of weeks, my racing thoughts, my 'unquiet mind,' were slowly numbed and my behaviour too became more socially acceptable. However, while the people around me rejoiced that the treatment was working, I started feeling a little sad. Mania is an incredibly seductive and liberating condition and feels fuckin amazing. Now that I was on drugs, my elated mood was brought down. I started sleeping more and more. And in relative terms, I was again on my way to face depression.

After a while, when my parents were convinced that I was okay to go back to med school, I made my way back to Belgaum with only one request that I stopped smoking up. They say marijuana is not addictive. I didn't feel that way and when I saw an opportunity, it would be almost impossible to 'just say no'. I was an addict.

Most of my ganja friends at college had been warned to not smoke with me much as it was adversely affecting my health. Yes, I will admit that maybe overindulgence had a negative effect but what most people don't understand is how much peace weed gave me. I had to find someone new and I found almost a perfect partner who loved the substance like I did. His name was Akhil Jok. He stayed in my hostel and for the next few months I spent most of my time locked up in his room smoking the herb.

There were all kinds of rumours flying around on campus. Earlier, when I was caught by the police just talking to a girl, people had spread the word that we were, you know—that was bull. Likewise, this time when I returned after being home, people spread rumours that I had been admitted in rehab. All kinds of idiots started 'caring' for me. I couldn't tolerate this fakeness. I especially hated it when random people asked me, 'Are you better now?' or said 'You look a lot better. Rehab was good for you.' I faded away from the public eye. Third year is pretty much the honeymoon phase of MBBS with relatively little courseload and so I spent my time with Jok getting high or at least trying to.

A concept that had come up at the 'origins' TGIS flat was that Gauravi had started cooking chicken every other night. The workload of the whole event was again shared by the crew right from shopping to kitchen work. Again, with not many utensils, I remember Gauravi making excess chicken and excess rice. He would use huge bowls to dump out rice on our plates and similarly then serve chicken. Conspicuously, Jok was not invited for such feasts. For the record, Gauravi made great chicken, he was a natural. A true foodie; Gauravi even made us watch cooking shows on the odd occasion.

One thing I didn't anticipate was that before when I smoked up it would just be the substance that would affect me. Now I was on mood-altering drugs, so it wasn't the same. 'Nasha' had lost its initial innocence.

I will be honest. I did not really like Jok initially. He was kind of dumb. There was only one real motive behind spending time with him and that was because he always—and I mean always—had weed or hash, mostly both. He used to score excessive quantities. He was a big guy and he smoked a lot. He seemed to like me. Guys in college are pretty shallow. He liked me because in that time and space I was 'something'. It wouldn't be too farfetched to say that on the campus I was a star. This would change with the perfect 'crash and burn,' which in a way had already started.

While I tried to attend enough classes to not be detained the real focus now was to just smoke enough weed to numb the numbness so as to say. With every passing day

I got closer and closer to clinical depression. In class too where before I would be talkative, now I just sat through postings, not really talking or listening to anyone. Nothing seemed to matter to or interest me. The only thing I thought about was how long I have to stay in class before I could go to Jok's room.

Jok hardly attended class in that period, so he would more or less always be there for me when I needed him. Eventually, we did get close and he became more of a friend and not just some guy I was using. I did not talk to him much at the start. The thing is if you are dumb and then if you start smoking up you become really dumb. I was fed up with life and it was very hard spending time with a guy who was nice but a stupid. Most of the times when he spoke I just stared at him but didn't register a single word. He never picked up on this. Weed lost its charm. We were smoking all day every day, quite obviously as with any drug, the body develops a resistance and it doesn't hit you like it did before. We smoked because it was all we knew.

The only thing I really cared about during these times was Zoya. I would think about her all the time. The happiest times would be when I ran into her in college and saw her smile. That pink smile. She had feelings for me but she maintained a distance. The 10:1 message rule still held but when that one message did come, it brought with it a lot of joy and in a way some hope.

Raghav, Gauravi and I were smoking up in the hostel room and watching Requiem for a Dream. They do this

crazy dance in the movie when they are high on heroin. We turned the lights off in the room and danced like them. We were not on heroin but we were high. It was a lot of fun. I should tell you here that the movie is very real and ends in a very real and dark place. I would be lying if I said that weed is that dangerous. Some drugs, though, really can fuck you up beyond all repair. FUBAR! As the movie ended, so did our weed. We were desperate to smoke some more. We went to the obvious person, Akhil Jok. It was one of those very rare occasions when even Jok was out of stock. When you want to smoke, when you really want to fuckin smoke, it is extremely hard to take no for an answer. We called all the dopers on campus and either no one had stuff or no one wanted to give some to us.

It was then when suddenly something occurred to me. Jok had told me months ago and then shown how somehow he had managed to drop a little packet of weed inside one of the speakers in his room. We had tried many a time to bring the weed out without damaging the speakers. And many a time we had come excruciatingly close. Scoring was usually very easy, so we had almost forgotten about that packet; however, this time we were desperate. I shared this with the guys while we were in Jok's room. Again we tried but with no avail. Gauravi then told Jok that he may have to dismantle the speakers a little to get the stuff out but he promised he would get them repaired. Jok burst out laughing. They were expensive BOSE speakers. We all knew there would be no repair (it wasn't lego) and Gauravi was just saying that. Even Jok knew but the cutie allowed the move. He was desperate too.

Gauravi did what he had to and soon we were smoking weed again. It was that evening when I started to fall in love with Jok. He may not have been the sharpest fella in the pack but he proved to me that he respected the substance and this was one quality I liked to see in dopers.

It was time for our third-year university exams. There were only three subjects and I had been detained in one of them; ophthalmology. I had missed the main posting because I was home at that time, recovering. This meant I had to appear for just two subjects; E.N.T and PSM. While it didn't seem much I would still have to study and studying was not that easy anymore. My condition was similar to how it was when I had decided to skip my second-year papers. I believe life is all about inertia; and since I had spent months in Jok's room, smoking up, being sad and depressed, it was very tough to start studying again.

To add to the woes, in some intracollege football match I had managed to dislocate my ring finger on my right hand. It would be touch-and-go whether I could even write the papers. The doctors at the hospital told me they would put some wire in and then when I asked, they said it would be about four weeks before I was okay to write. I didn't have four weeks—I had three. I told them about my situation and while they didn't do anything to help, one PG student in the orthopedics department walked up to me and told me that he could try something that would speed up the recovery. He said he would manually reduce the fracture guided by the X-ray but it would be extremely

painful. I had to sit for the exams, so I didn't even think twice and I asked him to go ahead. He quietly told me that it was okay if I swore a little during the procedure and again warned me it would hurt like a bitch.

'BEEEEHHHHHEEEENNNNCHHHHH-HOOOOOODDDDD!!!' my voice echoed through the whole department. I got up as soon as he was done. He firmly told me to sit down. He said the pain could make me go into clinical shock.

My finger however looked a lot more normal than it did a few minutes before. He placed a finger guard on my hand, bandaged it up and told me I could take it off in about two weeks. I thanked him. It is in moments like these that you develop respect for the medical profession. While I don't usually advocate the comparison of doctors with God but when you get a good doctor who helps you regain your health you do tend to feel like that.

I am an underlining person. I was never the joint studying or discussing-type student. It was tough to study the way I do with my hand bandaged up. I gave up studying alone. I went to Jok's room. He too was having trouble focusing, so we decided to study together. We didn't stop smoking up however; and since it was third year, we managed to cover ground at the same time. I became a joint-studying person after all, puns intended. Jok was good to read with; contrary to what people and even I thought he wasn't that dumb.

We would sit on the table facing each other with our books open and take turns reading out aloud and trying to grasp as much as we could. We were friends now, Jok and me. To counter the inevitable low after being high, we again started buying packs and packs of Red Bull and smoking countless cigarettes.

In the initial few months with Jok, I would have time for him when we were in his room but avoid hanging out in public with him. I never sat with him on his bike because people on campus would see me with him. The thing was when things were going good; I was a cocky asshole who never missed a chance to take the piss out of people like Jok. I could not be seen hanging out with him. He was not in the same league as me. Fuck! I really was an asshole. This changed. I no longer felt ashamed of accompanying him to Nescafe, going out for lunch with him, or sitting behind him on his bike. I even started passionately hating the dental bitch who had cheated on him but still borrowed his laptop. I put an end to that. Jok and I became friends.

Jok had a friend in our batch, a Malaysian called Naka. Now if Jok was dumb then this guy was dumber. One of the worst bum trips I had on weed was when on a break he joined us on the roof to smoke a fatty J. These custom-made double-paper joints lasted ages. Naka sat in front of me and started talking. He had just started smoking up, I could tell. He started with the obvious, saying how good it felt to be high and so on. Then he said, 'Samar, let's talk man. Let's really talk. Let's talk about life.' Fuck

in hell! I stayed mum till the joint ended while he went on and on. I felt like shooting myself.

Jok treated Naka like how I used to treat Jok. He got favours done, asked him to fetch us cigarettes or food and then took the piss out of him at the same time. I guess we are all gray in our own ways.

Our exams started and both the papers went decent enough considering how little time we had spent preparing. I was pretty confident I would pass. Unlike in the first two years where the subjects were more intense and I felt more important, I didn't care about my marks in third year. I just aimed to pass.

Zoya and I still shared messages in the 1:10 ratio. I had fallen deeper and deeper in love with her and the darkness over the last few months had introduced psychedelic spice and elevated the mystic wonder that I saw in her eyes. 'Matakkali,' she was. She was the one; and I felt helpless. While most people went out partying after the theory papers, I celebrated by staying alone at the flat and feeling like crap, thinking about Zoya.

I don't know how but it was like I had somehow forgotten to be happy about anything anymore.

The dreaded practicals started. We were supposed to maintain a journal that would be checked by several professors through the posting and signed off. This journal was needed to sit for the practical exam. I had been severely depressed at the time I was posted in ENT.

They were the Jok times. I did well just to somehow attend the classes. It was beyond me to maintain the journal. On the eve of the exam, I got the journal written and completed and then I took it to the HOD to whom I explained my condition a little and claimed medical immunity as the reason I didn't have the signatures. The HOD sign on the front page was most important. He signed it for me.

One part of the exam was being able to identify several instruments and say their use. It was a long list, something you never studied except on the night before the exam. It was unbelievably boring. I didn't even have Jok with me to read aloud (he was in a different unit with different practical schedule) so I could relax a little. Shukla Sir called me and said, 'When you take a break come to the flat. I want you to meet someone.' I went to the flat straight away. I walked in. Then Shukla Sir told me to walk to the kitchen.

There was a white guy there. Shukla Sir introduced me to Hubert, from Poland. They had sat next to each other on the bus. Hubert was on the Indian dream. He found our country fascinating and had plans to explore the Goa area. No one knew Goa better than us and besides, Belgaum was also a place that deserved time so Shukla Sir had got Hubert along.

We were in the living room when Hubert ran in from the roof screaming how beautiful the sunset was and took his camera, one of those DSLR types. We enjoyed this

moment. After a while I said good-bye to Hubert and left. I had to study.

I sat on my desk from 2 am to 6 am, mugging those instruments. I can't explain how bad it was. I wasn't asked a single fuckin instrument in my exam! Not a single one. The internal examiner raped me on my unsigned journal. He didn't care that I had got the HOD sign. He was one of those types. Out of the ten-minute viva, he spent six to seven minutes roasting me. He then finally got around to asking questions. Probably why he never got to the instruments. He asked me one question ... treatment of allergic rhinitis ... I started my answer wrong. I was confusing it with another type of rhinitis. He mocked me. In a split second my mind woke up and I blurted out the correct response. He didn't seem to be listening. I walked out with a sense of frustration; I knew the subject but he hardly asked me anything.

The PSM practical was relatively easier. Again I had a journal issue. I had been caught on the grounds of forging a few signatures. But the teachers in the PSM department consisted of very nice middle- to late-aged ladies who gave you an 'I care for you I am like your mommy' feeling. And so while they expressed their disappointment at what I had resorted to doing they seemed to understand my predicament.

#32

Othello Syndrome

After the exams ended, we decided to go to Goa for a few days to unwind. It was the first time since the first time that I was traveling to Goa without my car. I missed her.

Gadi had joined us. We did the usual. On the first night, I was smashed and too tired when the guys decided to go to some café. I decided to stay back and get some sleep. I was drunk. And for the first time I did the textbook drunk-dialing an ex move. I was all Zoya but she had worked hard to extinguish most of the hope for her in me plus she never took any of my calls so I called Tanu.

Sumeet had started dating Tanu after we broke up; and as one of his close friends I had an idea that he was in love with her. Looking back, I sometimes wish I had just gone to the fuckin café. I really shouldn't have made that call. I don't even know why I did.

We talked for a while and this continued even after I reached Belgaum. I discovered she still secretly liked me. I was still on meds and while they ensured that I wasn't manic, they didn't help me fight depression; they never

really stabilized my mood per se. When you are down and out sometimes your conscience goes out the window and you allow yourself to indulge in doing things that are wrong to try to compensate for the pain you feel. I can't deny that in those torrid times Tanu gave me some relief.

Tanu and I had a steamy affair and we kept it a secret as long as we could. She told me she was going to break up with Sumeet. But leaving someone like Sumeet is hard because he was just too good a guy. You have no explanation or reason to give. You desperately don't want to hurt him. We neutralized our guilt on the belief that what he doesn't know will not hurt him. Those stolen moments with Tanu were divine. I often borrowed Raghav's car.

The only person who knew about the affair during that time was Tanu's friend Namrita. This was good in a way because Namrita was majorly fucked up; hence, she could handle the shitiness of what we were up to. Namrita always fascinated me. Tanu would tell me about her. She had some serious issues when college had started; she used to attend classes and then down cough syrup bottles and be knocked out till it was time for class again. She was depressed and God knows she had her reasons but she wasn't the weak types. She did exceedingly well in all the exams and handled comfortably the insane pressure of med school while still dealing with her problems.

Namrita was Punjabi and she had this amazing heavy and glassy voice with a crystal sheen, inherently making her sound sexy. She was pretty but not in the boring

Barbie-doll way. She had beautiful huge dark puppy eyes and a thing for black nail polish. She would give me an all-knowing naughty smile when I crossed her at the hospital. She was strong, independent and intelligent. She smoked pot.

It was during these times with Tanu when I was telling her how much I hated Shinde that she told me things about him that sickened me. Tanu was the co-GS of our college and Shinde the student in charge. He had her number and Tanu told me every once in a while he kept messaging her, calling her to his chamber to discuss 'official' matters. Well, that's how he portrayed his behaviour. He never once called Harry; or anyone else from the council for that matter. And Tanu said after a while it became painfully obvious that this guy more than twice her age was hitting on her. It was a delicate situation. She found it hard to say no to office meetings. Had I been in the state of mania like I was a few months ago I would have taken a fuckin hockey stick to his chamber.

It also became clear to me why he had been so supportive about my magazine initially. It was not because he liked the idea but because he liked my two kids, Praki and Gauree.

I probably deserved a few hits from that hockey stick myself. Most people find it hard to deal with their partner cheating; in this case, Sumeet was being cheated upon by not one but two people. The girl he loved and a friend he considered close. We were close. We played a

lot of football together. Even on the field we were close in the sense that we had a very good understanding. People often noticed this about us. He played right wing while I played striker. Many a time I would know where he is and where to play the ball without even looking at him and vice versa. Several goals I had scored for JNMC were assisted by his crosses or through balls. We played for the same team. We wore the same jersey. There was a bonding and a mutual respect. I ended up being a fuckin John Terry.

Sumeet had found out about us. I think someone had seen us and told him. Then one time, when I was in the shower, he came to my room and went through my phone. He had left by the time I got out. It was my roomie Ravnish Sir who told me about this.

The way our results were declared in college was a little strange in the sense that first only a list of roll numbers that had passed all papers were put up on the notice board with no information about the marks or percentages scored. Also, suppose your roll number wasn't on the list, for two days or so till the mark sheets were released you wouldn't know if you had flunked a single subject or all. And if you had been detained in even a single subject like I had been in ophthal, your name wouldn't be on the pass list even if you had cleared the remaining papers.

There is this palpable frenzy at the hostel when results are declared. Guys run out, jump on their bikes and make their way to the notice board. When our results were released, Jok was out so I ran to check if he had passed

knowing that I would have to wait a couple of days before I knew my fate. Jok had cleared. I called him and told him. I was happy for him.

There was this lingering guilt about my affair with Tanu that was slowly eating up my soul and screwing with my mind. So on the evening of the results while most of the guys went out drinking I sat with Gauravi (who like me was awaiting his results) at Nescafe sad and insecure. I was not scared. If anything, a few physical blows would have actually felt liberating. I was just sad. Millions of thoughts raced through my mind and one thing they had in common was that they were all dark and caused a lot of pain.

I called V-man to ask where he was. He was with the guys drinking and there was a lot of noise. I felt, I will never know for sure but I felt that I was the topic of discussion. So when V-man asked me whether I wanted to speak to Sumeet who was drunk and asking to speak to me I didn't think twice and said yes. I was not used to hearing Sumeet's drunken voice. He very rarely drank. He asked me to come to the place they were at. I told him I would but I didn't have a vehicle. He told me to go to his room, find the room key on top of the door, open his drawer where his Dio keys were kept and drive down. So I did.

I felt better—a little hesitant, sure, but better because at least now it wasn't the dreaded silence or the worms crawling in my head I would have to deal with. I drove down. The ball was in his court.

It was perhaps the first time I was totally sober and meeting Sumeet who was totally wasted; normally, it would be the other way around. There were a bunch of people, most of them teetotallers from my batch who were drinking in excess of their capacity and creating a racket. After a minute or two of small talk I told Sumeet that we need to talk about Tanu. He said okay and took me outside where we found a quiet place and finally talked about the elephant in the room. Again, I was not used to being in such a position having intense and inherently emotional conversation with a person who was wasted while I was not. It was a position I did not feel comfortable in.

He poured his heart out. He told me that he had given everything to this girl. He had. And didn't understand why she had done this. As he spoke, I saw tears in his eyes. I felt like gulping cyanide. I tried to explain to him that it was not all Tanu's fault. He didn't seem angry at me at all and all the hate that he emitted was for Tanu. This made me feel worse. I told him over and over again that in my darkness and misery, sheer loneliness, I needed someone and Tanu had been the one who had provided me support. I told him that it was not just her that had cheated on him but more me. Breaking the bro code is far worse. I almost asked him to hate me, not Tanu. I wanted him to hit me. I really wanted him to hit me. He didn't; he was just too nice. When we finished talking, I went inside and did the only thing I could do, got wasted!

I would pay my dues though. While it wasn't Sumeet who hurt me, my own mind dealing with a bunch of issues

and primarily this one would in a few days take me to the darkest and scariest place I had ever known. I would fuckin lose it. Not the funny type but the type where you honestly start feeling that there are far more horrifying things in this world and in your mind than death.

Two days hence. I was at the flat and had had a topsy-turvy time. I had slept only a couple of hours the night I talked to Sumeet. The next day I had attended final-year classes and postings which had now started. This was followed by a night of ganja and again hardly any sleep. At the flat that night I was still waiting for my results and also dealing with things in my mind. Slowly I was heading towards a feeling of constant and pathological guilt. It started with self-hate concerning the Tanu issue and then I found many other things I had done or said to feel sick about, some of them genuine and some my mind was brewing up.

There are not many people in the world who have truly experienced severe anxiety or paranoia but those who have will know what I mean when I say I had never been so fuckin scared and more so ashamed of myself before. I had become a scared shitless kid—so fuckin scared that frankly it was embarrassing. Also, psychiatric symptoms were now popping up text-book style. Persecution. I started feeling the world was conspiring against me. I slowly started making myself believe that everyone even my closest friends even Gauravi and Shukla Sir hated me. There was only one punishment that would serve justice and that was death. I hadn't killed anyone; I hadn't raped

anyone; but I believed with all my heart that I deserved to die.

I was on the flat roof alone, smoking cigarette after cigarette without even realizing it. It was around 2 am. I could hear Shukla Sir and Gauravi talking inside. I thought they were talking about me. No one liked me and no one hated me more than me. Without so much as saying a word I left the flat and walked to the hostel. I made this journey barefoot and wearing my shades for the duration of the walk. I made my way to the hostel roof. And staring down, trying to judge the height, probability and percentages, for the first time in my life I considered ending it. It was in a way the longest few moments of my life and also in a way the quickest. I felt peaceful. It was a very quiet moment. It worked toward a crescendo and I finally asked myself, 'Are you going to jump?' After a few seconds, I replied 'No.'

Although suicide is defined as when someone takes his or her own life, what people don't realize is that it is not the person who jumps or pulls the trigger. It is the devil inside his head. The momentary sense of peace that had filled me disappeared and again I felt like shit as I walked back to my room. I had tried so many things and so many times to get better; when nothing worked, I felt like giving up.

I simply lay on my bed. I put a few songs on loop on my laptop. After a while, they started haunting me. I got up picked up my lappy and smashed it as hard as I could on the floor. It broke apart into pieces. I was no doubt out of

my mind but I regretted this move a second after I made it. I was attached to my laptop. Movies, songs and much more. It was a gift my dad had given me when I had qualified for med school.

Someone knocked on my door. It was Raghav. He looked tense. When he saw the battered laptop on the floor he knew I was seriously fucked up. We walked outside and he asked if I was okay. I hardly spoke. He told me Gauravi had called him to check up on me after I had left the flat. The walk back from the flat had been scary and all the while I was fighting the demons in my head. He picked up on this and tried to talk some sense into me. I looked into his eyes. I stared so long that it felt like I was staring through him and I am sure he felt the same way. Finally, I spoke. I asked him if he was still my friend. As I said this, I could see tears forming in his eyes. He asked me if I had ever asked him this question in the last three years and why the fuck was I asking it now. For the first time, I felt a little lighter. Raghav wasn't known to be an emotional person but that day he proved to me that he was my brother. He took me to my room and then stayed with me till I fell asleep. After ages, I got some respite.

It had been days since I had slept so well or slept at all for that matter. While one night of decent sleep would not be able to pull you back from the deep clutches of insanity, I did wake up feeling a little better. However, it was not long before the vicious cycle I had gotten so used to started again. I suppose you could argue that I should have made a better effort to help myself. To do this while

you are facing pathological depression though is easier said than done.

I called Gauravi and after talking for a bit told him about my suicidal thoughts. To be honest, I wasn't really serious about suicide when I had first told Ritika I was having such ideation; it was more a desperate attempt to make her stay. This time I was serious and I was scared. My parents would later blame some of my friends who they believed were enablers in times when they knew I wasn't well and should have been forced to stay sober. The thing is my friends like me were just kids. When Gauravi realized I was depressed and after trying to talk me out of it made no progress we did the only thing that we believed fought lows and that was alcohol. So Raghav, Gauravi and I went to the restaurant in Ramdev Hotel and started drinking beer. Coincidentally the three of us had all been detained in ophthal and were awaiting our results.

We were pretty drunk when Gauravi got a call. The results were out. We got in Raghav's car and drove to the college. We got out and sprinted to the notice board. I knew what was done was done but still, I closed my eyes for a second and begged God to bail me out just this once. I really needed the rub of the green. When we reached, hundreds of students from our batch had thronged the notice board. These fuck faces already knew if they had passed and also whether they had secured first-class or second-class grades.

Quite a few girls were standing there, all huddled up and fighting to get a look. I reeked of beer and I did not have it in me to push through. I saw Sampriti; I walked up to her and told her I was drunk and requested she take a look at my result and tell me. She wriggled her way through saw the notice board and turned towards me. We were unit mates. We had spent a lot of time together and we were good friends, so I could tell from the sadness in her eyes that something was wrong. I had passed PSM but failed ENT. I was shell-shocked. I was not used to failing exams. I stood there motionless. I needed to see the detail break-up of my marks and where exactly I had failed. But still, there was a crowd, people blocking the view and calculating percentages on their fuckin phones.

Gauravi and Raghav walked up to me. They had cleared both papers and I congratulated them. I was genuinely happy for them. Gauravi understood my need to see the marks and also why I wasn't barging in and seeing them for myself so he did the coolest thing ever. Stinking of beer, he pushed aside anyone in his path, tore the whole fuckin page from the notice board and then placed it in my hands. I had flunked ENT by a bare 2 marks. I was four marks short on the viva. That internal examiner who had fucked me over my journal had given me 6/20. The fuck had asked me one question—just one fuckin question—in a ten-minute viva and even on that he didn't hear me out.

As the Human Virus had once said, win or lose you got to booze. We changed from beer to rum and from Ramdev to the flat. Shukla Sir joined us. While Gauravi

#33

Kaminey

There had been a lot of melodrama. Many of my friends had come to the bus stand to see me off. I was completely zonked out of my mind. It was my first real psychotic episode. In less than a few hours I had managed to scare the shit out of quite a few people. No one had a clue what the fuck I was talking about; neither did I. I had packed in about five minutes. I was going home.

I reached Banglore at about five on a chilly morning. Gadi was waiting for me at the stop. I think my parents had informed him that I was a little unstable and may need help. It couldn't have been 'little.'

He took me to his flat and we hung around for a while, smoking cigarettes. I had to catch a Volvo bus to the airport. At the pickup point I sensed that Gadi was planning to leave me. It was a one-hour drive and then there was time before I would have to check in. He had an important class. I turned to him, looked into his eyes and said, 'Please, don't leave me alone.' We got on the bus.

We sat at the outdoor airport CCD. There was a good hour before I had to go in. I remember that time and Gadi also later told me that I was basically just sitting there and staring into space. I didn't say a word. Every few minutes, I smoked a cigarette. I replied in monosyllables when Gadi tried to initiate conversation. Though I was quiet on the surface, my mind was exploding with constant thought bombardment. Soon it got very tiring and there was no way to hit the brakes.

It was time to leave. I asked Gadi several times the detailed procedure I would have to follow to actually get on my plane. I had flown countless times before and here I was behaving like some villager at an airport for the first time. I really was fucked up. Just before he left, Gadi said something a little weird. He said, 'What if you find a cute girl sitting next to you on the plane and you tell her your story?' I had never in my life had that fortune. For years, be it trains, buses or flights, I would always check the passenger list near my seat to find any girl names close to my age and never, never have I had that.

There was a girl sitting on my left on the flight. Fuck! Coincidences really fuck me up especially when I am messed up in my head. Things you would be surprised by and then let go in a normal state of mind reinforced all kinds of false perception. And to my right was a guy who really seemed and acted like someone who had never flown before. The air hostess just in front of us was going through the safety procedure display while this guy was talking loudly on his phone in some vernacular language I didn't understand. Finally, when the air hostess requested

him to cut the call as the flight was ready to take off, he didn't seem to register what she said. I turned to him and told him to hang up. He told me to fuck off! He was smaller than me but looked scary. I looked left. I looked right and then I decided to sleep or go back into my dream world in which I was talking to all kinds of people from all over the world.

I woke up once for a little while in the middle when I got out of my seat almost in a hypnotic daze and asked the flight steward if he had any weed. I told him that I really needed to smoke some. He said he didn't have any. I was out of my mind but I remember this incident.

I woke up next when the plane touched down. I have a tonne of OCDs that I usually indulge in when the plane takes off and lands. I am a Cantona at heart but a Dennis Bergkamp when it comes to flying. I was too fucked to bother. Dying in a plane crash seemed a better option compared to living with the filth in my head so I didn't cross my fingers.

I got on a taxi to the train station. And though I clearly remember stopping on the way and buying a deodorant, I have no fuckin idea why I needed to do that. When the shopkeeper asked me which brand I wanted, I asked him to give me any. And for the first time, I saw and held in my hand a deodorant called Wild Stone. I don't think you will believe me when I say I was thinking in my head of a term to describe myself and I had come up with wild stoner. I was thinking this at that very instant I was handed the gray deo, it is true. These occurings, these

coincidences didn't even surprise me anymore. It was like the higher powers were having some fun with me.

Of all the railway stations in India, I hate Howrah station the most. There is a constant smell of fish and the presence of a cacophony of loud Bengali women. Not to mention the huge crowd. I felt like someone from the Matrix wanting to run away from people.

Every time someone even so much as casually glanced at me I thought they were staring me down. I really can't explain what I was going through. Perhaps if you have suffered from an episode like this you may have a better idea. Psychiatric persecution in overdrive.

I got on the train. I had a ticket though I can't quite remember how I got it. I got on my bogey but didn't go to my seat. I just stood there inside the door, holding on to a support; and as the train started I silently started singing a song. It was the title track of the movie Kaminey, a dark movie and an even darker song. I stood there in the exact same position for four hours singing the song over and over again, 'Kaminey … Kaminey'. It was a seater bogey. Everyone was on chairs and they were facing me. Naturally, the people sitting in the compartment soon realized that something was wrong with me. No one came up to me. No one talked to me. I'm pretty sure I startled quite a few of them with my behaviour.

There was almost pin-drop silence when a little girl suddenly started crying. I turned to her and our eyes caught each other's. I inflated my mouth with air and

tried to appease her making a funny face or at least trying to. She stopped crying instantly. I was trying to be cute. I was always good with kids but this time I think I scared her into silence. I hadn't shaved for a while and my eyes looked dark.

I was picked up on the platform as I got off the train at Jamshedpur by our driver. I reached home and tried to act as normal as I could to not freak out my parents. I could not. And though my mind and body weren't working in sync I could see the iceberg of concern and pain in my parents' eyes. I wished I could do something about this but I couldn't. I was loaded up on heavy neuroleptics and put to sleep.

#34

Waka Waka!

When I woke up, it felt like I had been asleep for days.
Who knows, maybe I had. My mind was still a long way
away from normal but there was relatively a lot more
peace. My thoughts weren't racing anymore. I felt good.
It was like my mind had just sat down after running a
marathon, sprinting.

I have had my issues with neuroleptics; they numb you
down. A free-flowing spirit like me almost felt like I was
being put in jail every time I was prescribed meds. But
this time I felt genuinely thankful that the meds were
there to bring me back. I can only imagine how insanity
would have torn people apart and for such long periods
before the advent of modern psychiatry and neuroleptics.

The football World Cup was on and I was looking
forward to spending time at home watching the games.
It was the one in South Africa. Just like my life at that
time, I felt this World Cup sucked. The matches weren't
as gripping as in some of the previous editions and the
vuvuzelas or whatever that fuckin instrument was called
which would constantly be blown through the matches by

a huge proportion of the crowd hurt my ears and annoyed me greatly. I didn't enjoy the tournament and the final too was disappointing. The game was shit and the team I was supporting lost. My Facebook status at this time read, 'Vodafone is no longer Hutch. Are you still with the Dutch?'

A few days after the World Cup we made a family trip to England to visit Mausa and Mausi and also to travel. We were staying at the Taj in Bombay on the eve of our flight to Heathrow when my dad asked me something. He said, 'Listen, you are not carrying weed, are you? I don't want you to get caught at the airport.' I almost burst out laughing and I assured him I wasn't.

Randhir Mausa picked us up at the airport and took us to their home in Leeds. It was always nice being with them. I met my cousins after a while. The ones who I had played with when they were toddlers, both now taller and bigger than I was. Life can be weird like that. Manu, in fact, was huge but thankfully he had lost that aggressive streak and also he didn't watch Pokemon anymore.

Though I was having a good time it had been days since I had smoked a cigarette and I was craving for one like hell. I had no choice but to for the first time actually ask my dad for money so I could smoke. And for the first time, he allowed me to. I know this can't have been easy for him but it meant a lot. Late into the night when everyone was asleep I sneaked out into the garden and lit up. The first time I was smoking in England I thought. Marlboro Red.

I also got to spend a lot of time with Sachin. Neither of us had anything to do, so we watched a lot of movies and a lot of football. He was older and more mature and slowly it felt like he had grown out of being my baby bro and become more of a friend. We got United jerseys—I think it was his first one—and like me when I was a kid, he wore it pretty much all the time.

With time I started moving closer and closer to sanity. I started speaking again. I started making sense again. Of course, the days would often be long and I was still dealing with residual depression but I was definitely getting better.

One afternoon I called Zoya. She never picked up my calls when I was in college but I knew she would pick up a call from an international number especially since she had family and friends in England. We didn't talk for long, maybe around ten minutes but it felt rejuvenating. She sounded worried. It had been quite a while I had been away from college and again all kinds of rumours about me had originated on campus. She obviously had an idea that I was not well. We talked about Kanye and what he had done at the MTV Awards and laughed. If I had it my way I wouldn't have hung up but she forced me to after a while. When I asked if we could talk the next day, she said no. Regardless, I called her. She didn't pick up. I was thinking a lot about her. Every day when I went to bed she was all I thought of; and even through the day, I would be thinking about her on and off.

I had a lot of fish 'n' chips, a trademark British dish I used to love when I was young and sometimes Yash would make an English breakfast for me. Sausages, beans, eggs and so on.

By far, the best thing that happened on that trip was when I logged on to Facebook one evening and there was a message from Tushit: 'Acquitted, baby! Acquitted!' At first, I didn't know what to make of this. A few seconds later, it suddenly hit me and there are no words to express how I felt. I felt my heart thumping. Was this what I thought it was??! ... It had been more than a year. I looked around to make sure.

It was confirmed. Sardar and Vineesh had been released with the higher courts judging in their favour and finding them 'not guilty.' While I had always known that they had been falsely charged it was a big relief that the judicial system in our country had come through; and though it took a bit of time, justice had been served.

Ironically, a few years later, Sardar would qualify for one of the best law schools in the country and go on to become a lawyer.

For now, it was time to rejoice. My best friends had been released. I thanked God and called Tushit and talked for long. Tushit had been a rock for me through this episode.

A couple of days later, I talked to Sardar. The asshole got emotional and tried to thank me for standing by them. I felt like slapping him but I understood where he was

coming from. Tushit also took the piss out of him for being formal and trying to sound grown up. I couldn't wait to get back to India and meet him. For now, we had Skype. The first time I saw him on the screen I almost broke down, not because it had been so long but because he looked famished and severely malnourished; I locked in my emotions and tried to focus on being happy. They had been living on a diet of rice and haldi water. He looked like a kid from one of those UNICEF ads.

I talked to Anish a little later and after around five minutes of mature adult conversation and joy, we got back to being punks. We started taking the piss out of the ex-convicts talking about things like whether we would hang out with them in public or not. Anish and I had mainly dealt with this whole episode with dark humour and it felt so good laughing our asses off and actually being happy at the same time. We gave them a couple of days before once again starting with the brutal trash talk and shamelessly taking digs at their character. Of course, this was all harmless banter. It was important too because it showed that we as a group would not change our behaviour or attitude because of what had happened. I am certain Sardar and Vineesh appreciated our 'normal' behaviour in the midst of all the drama. I knew for a fact that sympathy or empathy would not be appreciated by our friends who were already living with these emotions from a wide variety of people at that time. Reader's Digest was right; laughter really is the best medicine.

Obviously, though, we hardly showed it this was a very emotional time for all of us. Memories of the dark days

suddenly came back more vivid than ever. There had been times when we had feared the worst. The news was so good and brought so much relief that again it took time to sink in. Sometimes I had to remind myself that they really were out.

I called Zoya to share the news. She didn't pick up.

It was time to fly back to India. I was ready to live again.

Sardar and Venom already looked a lot better and hanging out with them almost felt surreal. I picked up Sardar and took a drive down Marine Drive, lighting up a spliff. It felt so fuckin good. Sardar and Venom were strong people. They didn't seem emotionally scarred and they didn't take long to get back into society. Sure, there was the occasional look they got from people who recognized them or sometimes the odd comment from some idiot standing by. Anish and I—we hit a few people. We had no time for bullshit. These fuckers respected the baseless news of India TV more than the Supreme Court of India.

A few weeks later, I carefully started asking them more and more about how life had been in jail. Not like that idiotic reporter who had asked Salman Khan how it felt to get out of jail not more than a few minutes after Salman had walked out. Sallu bhai and Sanju baba. We were big fans. Not so much the acting but more so the way they had lived their lives. 'Life is like a race and all you have to do to win is rise each time you fall.' As for the jail story, it will need a whole book and I can't do justice to it in a few paragraphs so I won't even try.

I had started studying. It was a little tough to start after such a long break; but again, since I had to give the remaining third-year papers first and since they were smaller subjects, I gained some impetus. I returned to college a few weeks before the exams and cleared them quite comfortably. Final year now loomed. Life started to sort itself out.

#35

My Girl …

Final year started. I was summoned by a medicine professor called Aanchal mam. She had supported me a lot at times when I had taken a stand against authorities in the college. There was a professor of ours who had no respect for women and often insulted them blatantly in public. His elder brother held a high post in the local government and he behaved like he was above the law. Karan Sir too had faced a lot of problems because of him. During one of my high times, I had walked into his chamber and literally told him to fuck off!

Aanchal mam understood to some extent my rage. I wasn't the only one who had issues with him. I think if it wasn't for mam intervening, I may have been beaten up by some goons for this act.

However, this time Aanchal mam was stern. She had supported me before but she also stated that I had crossed certain boundaries I shouldn't have. She was right. More lucid now, I understood her point of view and took everything she said very seriously. She said one last thing

before I walked out and this stuck with me forever. She said, 'And Samar, remember, no shit on the white coat.'

Since my third-year exams were carried on, I lost a semester of final year. Effectively on paper, my final year lasted only six months. This was a short time to read up on the most hectic and demanding courseload MBBS had to offer. It included both practical and theoretical aspects in great detail which required tedious and persistent effort.

I got into the routine of studying every evening. The best thing to happen was that Zoya too started studying in the library. She was a mint person and every time I smoked a sutta, I walked to her and asked for mint afterward. She always smiled and gave me one. She had this smile— this beautiful electric smile. Shaila too, who before had always given me the 'fuck off' vibes gradually changed and started to accept that I was Zoya's friend.

Although Zoya would always convince me otherwise I always got the feeling that my socially documented madness and misery caused her and her sister's behaviour to change and their smile felt like it originated from a feeling of empathy. Not that I cared much. I would go through everything again if it meant getting closer to Zoya. I was sure she was the one. The more I talked to her, the more I fell for her.

I was always okay with the studying aspect of med school but it was the exhaustive clinical postings that I didn't like so much. Final year meant a lot more time at the hospital. It was very tiring. I did my best to fulfil the

demands that were expected of me or any medical student just a few short months from being certified to handle the lives of human beings. It made sense too, spending more time at the clinics and with the patients. I always kept in mind Aanchal mam's words, 'No shit on the white coat.' Nevertheless, this did not make my life any less tiring; and though I didn't smoke up like I used to; the best part of my day was when after the draining day late in the night I smoked a quiet joint alone on the roof, put on some soothing music and messaged Zoya. The 10:1 ratio was abolished. Messaging was rampant and now it was mutual. This was documented by the fact that we both easily and always crossed the one-hundred-messages-per-day barrier after which our service providers started charging to send SMSes.

Zoya and I moved forward slowly and with no rush. I had never been in a chase like this before. I had no targets. To take a line from the American Pie movie, while before with girls I always felt like I was running and trying to score, with Zoya I felt I had already won. I was calm. I respected her. She was smart; she blew me out the water. It felt redeeming to even feel feelings like these and every day I spent with Zoya only made me more aware of how shallow and sick I once used to be.

One evening, when I was at the coffee shop, I saw her walking back to the hostel. I ran up to her and asked if she wanted to have coffee. She thought for a while but then said no. I told her to wait. I ran back to the shop, bought a 1 rupee coffee bite chocolate and returned to her. I put the toffee in her apron and said if we can't

have coffee I guess this will have to do. She smiled and walked off.

I am intelligent and it wouldn't have taken me two minutes to tell if she was being fake, you know, playing hard to get. Many chicks had tried this stunt with me. Zoya was different. Most importantly, she wasn't a 'chick.' She was one of my best friends first and romantic interest later. She was the only girl I had ever met that I would have been close to even if she were a guy. She was interesting, funny and charming. She was the one.

The more we got to know each other the more comfortable she became. While most girls on campus would think twice about being seen with me, Zoya was above all that. She did not care for public opinion once she considered me friend material, especially when it was formed on the base of unending gossip mostly spread by dental chicks.

Maybe barring Ritz, every other girl I had known I could figure out in less than two weeks. You know, ascertain their character. Zoya was not like that. She was very deep. I felt like Alice again, going on and on into the rabbit hole of her soul and I never felt like turning back. She never bored me. Morpheus again offered me the choice. He held out the two pills and like Neo, I chose the adventure. I chose to see how deep the rabbit hole goes. I chose the red pill and I did not even think twice.

I would be lying if I said marijuana didn't help me with her. I was wittier, more charismatic when I was high. You know how the average Indian girl is, they try to be

white and fight their inner natural nature which in all cases is gray. Even our gods are gray. Take Lord Krishna. Take Lord Rama. Zoya was very open about the darker shades of her character once she trusted me and also never judged me on mine. I could be myself with her without any inhibitions. Most of the chicks I had dated would go on and on about why I should not smoke up or smoke cigarettes or drink without having a fuckin clue why I did it. When I tried to explain, they just wouldn't be able to understand. While Zoya never encouraged me to indulge, she was the only one who actually heard me out and understood my side.

The others would try to be cute by playing the 'I am concerned for you, I care' card. They would be fake and stupid; Zoya was so much more.

Oh, I forgot to tell you the best part; she swore like a bitch, like Raghu Ram, like one of those bad boys studying in a government college. Half the world can say a decent fuck off! but Zoya was top notch with the really bad Hindi gaalis too, you know, the crude desi 'maa-behen' types. This was perhaps one of her biggest turn-ons.

We had both graduated from 'the school of rock' with flying colours and every day we found new music to share with each other and also dissect lyrics of older classic rock numbers. The same with movies. Cuckoo's Nest, the Matrix, Inception, The Beach and many more—we never ran out of topics to talk about. We spent hours and hours talking about Morrison. Unlike me, she wasn't a big fan

of the man despite being in awe of his music but I would like to think I changed that to some extent.

One afternoon, months later, we decided to go for lunch, Zoya, Shaila and me. Like with Zoya alone and now with Shaila there, I could eat normally and dirtily in front of them. Shaila had purple braces and multiple ear piercings. She was genuinely cool. No cliché. I remember staring at her mouth while she was saying something trying to figure out whose teeth were more fucked up, hers or mine. It felt so good not to be worried about chicken bits stuck in your teeth or if you opened your food-filled dirty mouth to talk. Hell, I could have spat there and they still wouldn't have given a fuck. This was no doubt a great feeling—actually, my first ever real date.

One time Gauravi and I drove to a burial site in the middle of the night when we were high. I hope I am not offending anyone and we certainly didn't mean to offend the dead; but in a way, we connected with them in a different way while we were there. We often used to go there when we were sober, walk around reading tombstones and there was one that had a picture of a kid just like us who had died in a road traffic accident. I still remember exactly his face. Going there high added a spiritual touch. Despite not knowing him, I somehow felt his spirit. It wasn't scary but at times eerie.

Nasha never stopped but I learnt to be more in control of my urge. It gave me a lot of peace at times when I felt nervous or paranoid. For a while there was a trend when every morning I would make my way to V-man's room.

Belgaum was cold and damp. I would jump into the quilt and force him to get up. He would make us 'green tea' and then invariably shove me and say, 'Bana toh ek!?' I would roll a joint and taking in the fresh morning air by the window we would smoke one down and talk.

Marijuana had a lot of positives, though I have to admit it wasn't all good but then how many things in this world are? Like people, nasha too was very gray and I was okay with that. I guarded against over indulgence and managed to learn to keep myself in check. Sometimes it was hard, akin to walking a tight rope across Niagara Falls, exhilarating but if you so much as slipped, you would be sucked into a vortex of darkness which was like a black hole and it was almost impossible to get back. No one could pull you out either without breaking you in half.

I was older and though it was difficult, I had to be less selfish. My parents had given me the best life they could and more freedom than I could have asked for. It was unfair on them because only I would get the pleasure of being high while if I fucked up they suffered more than me. They demanded that I give up weed totally and I promise you I tried but I loved the herb—I really did. I loved them but this was my life and I felt I had to do what I had to do.

I have met and read about several successful people who did well in life despite being stoners. Neurosurgeons, scientists, writers and so on—even the most powerful man in the world smoked cannabis. The White House is

black! What a campaign! I had followed the whole thing on weed. He gave such amazing speeches. 'Can we smoke pot, Mr. President?' 'Yes we can!' he said.

All good things must come to an end. The TGIS group which had been so close and seen all kinds of highs and lows together started to disperse. Karan and JK Sir left college to do their internship in Chandigadh and Delhi respectively. It was an emotional time saying good-bye and dropping them off one last time to the station. Luckily, Shukla Sir, Gauravi and T stayed in Belgaum and would do so till I was there.

I told Zoya everything. She knew my friends better than anyone else. I also told her of the several flaws in my personality; the hypocrisy in my actions and thoughts. While I expected my friends to not so much as even flirt with my girl, I didn't think twice about hitting on theirs. It would have been better if I was just an amazingly good-looking badass prick. Unfortunately I was more complex. I had something about me that made people get attached and expect stuff. I made them develop feelings for me only to let them down with my actions sooner or later. There are so many more things I can't write about. There are certainly many more than fifty shades of gray. And because of this, I sometimes thought that Zoya may be put off and grossed out when she saw the worms in my head but thankfully this didn't happen. She didn't easily resort to judging people and never judged me. I am certain that every other girl would have backed off. The thing is I wouldn't have told this stuff to any other girl or guy for that matter. She was my biggest fan.

Time went on and I could tell even Zoya who was usually hard to read was having trouble staying away from me. While messages and calls are great, it is different being with each other in person to observe expressions and eyes and so much more. I loved the way she walked, the way her eyes had a glimmer in them when she got excited. Sometimes I couldn't stop staring at her lips. She genuinely had pink lips and not the cheap generic Bollywood hip-hop dance-number types. In some ways, she looked like Apu the monkey. She was so cute. She was adorable.

My internal exams that were coming up coincided with some papers Zoya had to give. We started spending more time in the library and therefore more time with each other. We usually sat a few tables apart but always facing each other. Every few minutes, I would take a small one-minute break and just stare at her, enjoy her every move and expression. And, of course, the cigarette-mint routine continued. I may even have subconsciously started smoking more just so I could go and ask her for mint.

It was important I score well in the internals. They would count in the final university score. Having flunked ENT by a mere two marks and having my life shattered, I realized every mark was important. The internals went okay and apart from OBG which I hadn't studied much, the other subjects went fine.

Truth be told, I was so unprepared for OBG that I had taken my mobile to the exam and had Shukla Sir

messaging me answers. Funnily enough, this was not that big a deal especially since this was only an internal exam.

There were some kids who used phones in university papers—'device' they called it. They would have microscopic earpieces and tiny phones strapped on their body and someone dictating answers from the hostel. They were highly technical. I never did all that; but yes, occasionally most people in med school at some time or the other do resort to cheating. It is like giving proxies. Morally incorrect but you feel you deserve a break. I must mention here that medical science is a very tough read, hard to grasp and even tougher to recall. Phones were frowned upon but a little word here and there in the exam hall was the law of the land and considered totally acceptable.

My papers on the whole had gone okay.

This was confirmed in the results that were declared a few days later. I agree internal exams are not really a big deal; the portion to be studied is way less as is the pressure. However, for me, they meant more because apart from the marks they were also the first proper exams I was giving after my breakdown. I did not count third-year papers as proper exams.

Zoya and I started hanging out a lot more. We went on long walks around campus and sometimes beyond. There was no particular moment when she changed her behaviour. It was very gradual and subtle. After the long day, I would often tell her to message me exactly five

minutes before she came to meet me at the coffee shop and at this exact moment I would light up a small joint in the hostel. There was nothing in this world I enjoyed more than being with her when I was high.

It was only when she started fasting during the holy month of Ramadan that it first really hit me that she was Muslim and though I loved her for it (she had this Arabic swagger which just made her sexy), I also knew there would be people against the possibility of an 'us.' She was the real deal when it came to faith. She prayed five times a day every day, even if university papers were going on. Where I, on one hand, would not even shower when exams were on, she did everything to follow the path of Islam, a path she believed in. She knew her stuff; she knew the religion and actually knew quite a bit about other religions too. I would be devouring junk food, Red Bulls, cigarettes to keep myself going—she had nothing. Well, she had one thing; she had her faith. She was beautiful.

We went out on Eid to have some firni. I could tell she was excited. She was dressed in brand-new yet understated clothes. She had this bubbly glow on her face. She was happy and so was I. She looked gorgeous.

Goa trips resumed. We didn't have my car so we would have to travel by other means. Like with weed, there was another type of nasha that was now rampant on the campus. It was gambling. There were three guys in particular who had led the way. One was Chondu and the others were Jadoo Sir and Amit sir. I had never met a guy

like Jadoo Sir who no matter what was going on in his life was always smiling, laughing loudly and sharing jokes. He never seemed down or low despite sometimes being in sticky situations. He was just as jovial if he passed an exam as he was if he failed. A great guy to have around, he always had a very positive effect on your mood.

They started hitting casinos in Goa on a regular basis. Roulette was their first love. They used to hire a private taxi for their Goa trips and sometimes Shukla Sir and I accompanied them. Shukla Sir played more than me. I had a 5000 rupee cap which I tried not to cross. The best thing about these casinos was that they were situated in five-star hotels and food, drinks and cigarettes were on the house. Chondu and Jadoo Sir were so well-known there that the staff didn't even raise eyebrows when guys like me accompanied them—hardly played but feasted on the free liquor.

While Shukla Sir and I insisted on at least spending some time at the beach—how could you go to Goa and not go to the beach?—Chondu and Jadoo Sir didn't go anywhere but the casino. They soon became addicts.

There were times when they would be at the roulette table all night, return to Belgaum early in the morning, attend classes and go to Goa again in the evening. Chondu was luckier and shrewd whereas Jadoo Sir and Amit Sir plunged into severe debt. They borrowed a lot of money from a lot of people but they never stopped playing. The roulette table was where they made money and also where they lost it.

One night, when I was there, I very quickly lost most of my 5000 cap. I had just a single 500 rupee chip left. I was walking around looking gloomy when Chondu asked me what was wrong. I told him that the night had just begun and I had already lost my money. He asked for my last chip so I gave it to him and then he disappeared to one of the tables. A few minutes later, he found me and placed 5000 rupees of chips in my hand. As I began to ask him what he had done he just smiled told me to play and walked away. It was a James Bond moment if there ever was one. Chondu really was the James Bond of the gambling scene in our college. Short but smart, a very cute poker face—he looked the part.

I settled into a routine on these casino trips. I would play my cap, win some and lose some and then I would go and sit next to Chondu or Jadoo Sir. I would watch them play and at the same time be in constant touch with Zoya and of course, scotch. On one such trip, Chondu was having one of his rare bad nights. Round after round his chip set started getting smaller and smaller. I didn't understand why he continued to play. When he was almost finished, he gave me some money and asked me to fetch him more chips. I asked him if he was sure; he didn't say anything, so I got him his chips. He continued to lose. I could feel the frustration in his eyes. He was down more than 1 lakh rupees and he had just one 5k chip left.

He didn't play the next few moves. I convinced him to not play anymore after this. Just before getting up, he casually placed his last chip on 36. The ball spun and the number flashed on the screen. It was '36'. In a single

move, Chondu had made one lakh eighty thousand bucks. I felt ecstatic. I can only imagine how he felt. I hugged him hard. This was not all. He continued to play and his fortunes changed. By the time we left the casino in the morning, he had made 60k more. What a fuckin night!

One cold lonely afternoon, Zoya wanted some books from me and called me to the coffee shop. Like always, I smoked up and then went to meet her. After talking a while, I walked her back to the hostel. We were talking about something when I told her that she was scared of me. She denied. She was standing right in front of me and we were looking into each other's eyes. I moved a foot closer. She didn't so much as bat an eyelid. So I moved closer. Still, she stood there, staring back. We were pretty close now and I was probably more nervous than she was. I made a fist and moved my hand forward. She put out her hand, opening her palm. The upper part of my index and middle finger touched her for the first time. It was the most beautiful and romantic moment of my life. I felt a tingling sensation down my skin. I had touched her for the first time and it felt amazing.

I drove back feeling on top of the world.

Final year meant time at the hospital at weird hours. I needed a vehicle and since I did not have my car I had bought a second-hand Activa. I had also started living at a flat close to the campus.

There was a football tournament being held in Manipal. It would be my last for college. The team had a very

different look to it; quite a few seniors had left like Karan Sir, Mish and more. I had missed a few practices and also the last one because I was in Goa. To teach me a lesson, Chauhan Sir, our coach, put me on the bench for the first match. Pardon me for being grandeuristic but I was the talismanic goal scorer for college and it was stupid to keep me on the bench. Chauhan Sir was a nice guy and I was close to him. I liked him more than Remo. Everyone on the bench was ready to be substituted in whenever it was needed. I sat there wearing my jersey and a pair of jeans. Chauhan Sir asked me why I wasn't wearing shorts. I told him that there is no point if I am not playing (I had worn them under the jeans). I could tell that he could tell I was pissed.

We were playing a shit team but still the deadlock hadn't been broken. A part of me was sadistically happy. Soon, Chauhan Sir told me to get ready and he put me on. Within five minutes of me being substituted in, we scored two goals. One which I had scored in a one-on-one with the keeper and the other was a spectacular own goal by one of their defenders in which I was involved. We reached the semi-finals and were unlucky to be knocked out on penalties. I walked off the pitch in tears, not knowing when I would next be wearing a jersey and be part of a team (incidentally it's been four years). College football was done forever.

I was sad after coming back from Manipal and I shared everything with Zoya. We talked for hours and she was a lot of help. I had started depending on her a lot. Any event that took place in my life—good or bad,

everything—the first thought that I would have as soon as it happened was when I could talk to Zoya about it. In a way, Ritz had provided a similar 'shelter from the storm' for me before but this was different because while with Ritz it was a one-way relationship in the sense that she was always there for me but I was hardly there for her; with Zoya I enjoyed listening to her too and I loved being there for her. It didn't seem like a responsibility or boring in any way.

I was actually a little spooked that final year was going so well. I had done well in the internals. I had regularly attended classes and I was studying well. I was spooked because it felt a bit like second year when things were going so well but toward the end the wheels had come off. I did not want—actually, I could not afford for that to happen again, so I tried to guard against it.

The Cricket World Cup that was being held in India started. I was in Mumbai in a private taxi smoking up and listening to the radio when Sehwag dispatched the first ball of the tournament for a boundary.

Zoya was also into cricket and we watched as many matches as we could sat together in a café close to the college. I would be high and hungry for the India matches and gulp down cold coffees and devour pizzas for fun. Cricket and Zoya (and, yes, weed too) were a perfect combination.

We wanted this one for Sachin. I guess the whole country wanted this for Sachin. I wanted the World Cup more

for Tendulkar than myself. This would be Sachin's last World Cup and if anyone deserved his dream to come true then it was no other than the little master. He had given the country so much joy and for such a long time that it would have really hurt if his biggest dream wasn't realized before he retired. To put things in perspective, consider this; I am an ardent cricket fan 26 years old. I have never seen a World Cup without Sachin in it and invariably Sachin doing well in it. The country's favourite son has played five consecutive World Cups for India spanning over twenty years. This is no mean feat.

Someone had told me that Siddharth Malya and Deeppika Padukone were making out in some pub every time India hit a boundary. Zoya and I, well, we were like nervous but excited sixteen-year-olds and sometimes we held each other's hands.

I would happily hold on to this hand forever, I thought.

India was playing well and it was fun watching them play. I was nervous before the India versus Pakistan semi-finals. We had never lost to Pakistan in a World Cup before and though India were favourites I thought along the lines of probability and some part of me figured it would have to happen sometime. I just hoped like hell it wasn't this time. The tournament was being played in India and if we won, the final would be at the Wankhade, Mumbai, Sachin's home ground. It would be a fitting tribute and farewell to the little master. Sachin won us that game against Pakistan and like so many times before took us to the finals. Yes, he was dropped a few times

but that is sports. We were in the finals and playing Sri Lanka for the right to be crowned champions.

Zaheer bowled 3 maidens to start with. Sri Lanka was batting first. It was certainly a much better start than when we were playing the 2003 finals. Zaheer had been unlucky in that match and leaked 15 runs in the first over despite bowling some quick fiery deliveries. Somehow, barring Sehwag's firecracker innings we had never really recovered. Ponting had done serious damage. Despite a good start by India, Sri Lanka scored heftily in the later stages of their innings and reached a respectable total but by no means was it an impossible target.

Sehwag was clean bowled on the second ball of the innings with no runs on the board. I held myself together but when after playing two majestic drives Sachin got out, a couple of tears trickled down my face. I was scared. Virat isn't given much credit but anyone with half a cricket mind will know that his 30 something in that match was crucial. I felt like killing Dilshan for how he reacted when he got Virat out. His innings was I felt very similar to another crucial 30 something innings MD. Kaif had played in our win against Pakistan in 2003. Dhoni walked in; a spot above his usual position and with Gambhir took us home quite comfortably.

It was a gutsy decision by Dhoni to promote himself up the batting order but like so many times before, it worked. He played the definitive 'Captain's Knock'. I mean he had given Joginder Sharma the last over and still won. It was hard not to feel the stars were aligned

for him. Jokes apart, both Gambhir and Dhoni played very well under pressure; they both narrowly missed out on their hundreds. Gambhir managed to get himself out while Dhoni was unbeaten on 91* when the target was achieved. There was a joke that went around which stated that if Dhoni had given a couple of more overs to Sreeshanth who had been very expensive in that game he would have got his hundred.

The team took Sachin on their shoulders for a victory lap and you could tell Sachin was happy. The child in him never really grew; the magic in his eyes never vanished and this was one of the many reasons the nation loved him.

Having faced the odd problem or two of being a Bihari in Maharashtra, it satisfied me to know that 'a Chandigadh lad 'Yuvraj' with a Delhi boy 'Gambhir' under a captain from Jharkhand 'Dhoni' had won India the Holy Grail and dedicated it to a Maharashtran legend 'Tendulkar.' The air of divisive politics had been overcome in one way. As for the exact moment, the way it finished, Mr Gavaskar was spot on when he said that the last thing he wants to see before he dies is Dhoni hitting that winning 6 in the final and holding that pose which meant India had won the WC. I shared his view. It really was a perfect moment.

After watching the presentation ceremony I called Zoya, we were both ecstatic. It was late. We planned to celebrate on the next day.

We made our way to the campus after the match. The roads were filled with people celebrating the victory.

'Chak de India!' was being played over and over again. Hundreds of students thronged the campus roads. People had gotten bottles of alcohol and a lot of us were drinking and dancing. What a night! I had seen India win the World Cup; even if I didn't do anything else in my life I felt it had already been worthwhile.

I met Zoya the morning after and for the first time, we kissed. I felt like the luckiest guy in the world.

The final-year university exams were now just forty days away. The final-year subjects were huge and the portion exhaustive. No matter how much you studied, you never felt fully confident. I tried making the forty days into forty days and forty nights and studied like I had never done before. Zoya helped me to maintain my sanity.

One afternoon, I decided to go for lunch with Zoya. We went to a fancy restaurant—well, as fancy as you could get in Belgaum. Usually a chauvinist by nature, Zoya didn't even give me a chance to look at the bill before taking out her card and settling it. While we had lunch and talked about faith maybe for the first time the religion issue was briefly discussed. We had already started talking about marrying each other; and though once in a while we joked around that I would give up eating pork and she would give up beef, we never really talked seriously about the issue.

The exams started and they were the toughest and most tiring ones I had ever given. We didn't even have a proper break between the theory and practical papers. While in other years the practical exams were relatively easier, in

final year, they were tougher and more in depth than I was used to. I got some questions right, I got some wrong and once in a while I made very in-your-face blunders. I had no fuckin clue whether I would pass or fail and for the first time I didn't even care. I was just happy they were over. It had been a tough period.

It would be a while before the results were declared and my parents called me home. I delayed as much as I could so I could spend more time with Zoya. We went on one last walk around the campus the evening I was going to leave. We met Dr. Ramshekhran, a very senior medicine professor and also the ex-principal of our college. He was Aanchal mam's father and had also stood by me when I had needed help earlier. He was happy. He smiled and wished me luck. I could clearly tell that he was tipsy. He smiled at Zoya and me. I enjoyed this interaction very much and it was nice to meet him because I respected him greatly.

'I love you' was the last thing I said in Belgaum and 'I love you' was the last thing I heard. It was tough saying good-bye to Zoya and also very emotional. I could not hold back tears when the bus honked one last time signaling passengers to get on. We were certain we would marry each other and spend the rest of our lives together and this was the only thing that made me feel a little okay. I hugged her tight and got on the bus. I didn't sleep that night. I was constantly messaging Zoya.

I had experienced all kinds of highs and lows through college. It had been quite a journey. And even though I

wasn't sure if I had passed final year yet I started feeling nostalgic.

[[I had seen a lot in college. For the first time, a girl had left me. For the first time, I had fallen in love. I had walked in with more than 2 lakh rupees in my account when other students used to be sent rs.5000 monthly allowance. I had a car at a time when most professors who taught me drove around in scooters (and this would often be embarrassing); I was two-timing sometimes three-timing girls when most guys on campus went through years on the chase but never scored. I would be getting 'you don't know me but pick me up and show me a good time' messages from girls in all faculties. I was getting messages when most guys were arranging numbers. I had seen true desperation for the opposite sex, so desperate that instead of feeling sick you felt empathetic after a while. I, with a group of four guys had started the passion and love for marijuana. It would catch on. We affected and changed college culture. I scored more goals for my college than anyone else in my time. I scored the most girls. I scored the most weed. To top it all, I met Zoya, the love of my life, my girl]]. I guess I could have been a better doctor.

A few weeks later, when I was home, I got a call from Zoya. She called all the time so I didn't anticipate that this was one of the biggest calls I would ever receive. She said, 'Well done, Samar Kumar ... or should I say Dr. Samar Kumar, you are now a doctor, bitch!!!'

- THE END